THE
FUNERAL EFFIGIES
OF
WESTMINSTER ABBEY

In memory of

Nicholas Hugh MacMichael, F.S.A.

Assistant Librarian and Assistant Keeper of the Muniments
Westminster Abbey, 1956–1966
Keeper of the Muniments
Westminster Abbey, 1967–1985

THE
FUNERAL EFFIGIES
OF
WESTMINSTER ABBEY

EDITED BY

Anthony Harvey & Richard Mortimer

THE BOYDELL PRESS

First published 1994
The Boydell Press, Woodbridge
Revised and reprinted in paperback 2003

ISBN 0 85115 368 2 hardback
ISBN 085115 879 X paperback

The Boydell Press is an imprint of Boydell & Brewer Ltd
PO Box 9, Woodbridge, Suffolk IP12 3DF, UK
and of Boydell & Brewer Inc.
PO Box 41026, Rochester, NY 14604–4126, USA
website: www.boydell.co.uk

British Library Cataloguing-in-Publication Data
Funeral Effigies of Westminster Abbey
I. Harvey, Anthony II. Mortimer, Richard
736.50942132
ISBN 0–85115–368–2

Library of Congress Cataloging-in-Publication Data
The funeral effigies of Westminster Abbey / edited by Anthony Harvey &
Richard Mortimer.
 p. cm.
 Includes bibliographical references and index.
 ISBN 0–85115–368–2
 1. Westminster Abbey. 2. Funeral rites and ceremonies England –
London. 3. Great Britain – Kings and rulers – Portraits.
4. Nobility – Great Britain – Portraits. 5. Effigies – England –
London. I. Harvey, Anthony. II. Mortimer, Richard.
DA687.W5F86 1994
942.1'32–dc20 94–21012

This publication is printed on acid-free paper

Printed in Great Britain by
St Edmundsbury Press Ltd, Bury St Edmunds, Suffolk

CONTENTS

ILLUSTRATIONS

COLOUR
(The colour plates appear between pages 146 and 147)

BLACK AND WHITE

ACKNOWLEDGEMENTS

Colour illustrations: I, II, III, IV, V, VI, VII, VIII, IX, XI, XIV, XVI, XVII, XVIII, XX, XXI Malcolm Crowthers; X, XIII, Dean and Chapter of Westminster, Godfrey New Photographics; XII, XV, XIX, Dean and Chapter of Westminster. Black and white illustrations: 3, Malcolm Crowthers; 1, 4, 5, 6 Dean and Chapter of Westminster, Godfrey New Photographics; 2, 7, Dean and Chapter of Westminster; 8–53, Victoria and Albert Museum (pictures taken during restoration, 1933–5).

CONTRIBUTORS

JA the late Janet Arnold FSA, Visiting Professor of the History of Dress, University of the West of England, Bristol

PBB Patricia Blackett Barber, Curator of Uniforms and Medals, National Maritime Museum, Greenwich

CB Claude Blair MA, FSA, formerly Keeper of Metalwork, Victoria and Albert Museum

SB the late Shirley Bury, formerly Keeper of Metalwork, Victoria and Albert Museum

DHBC Hubert Chesshyre, LVO, MA, FSA, Clarenceux King of Arms

AH Avril Hart, Assistant Curator, Textiles and Dress, Victoria and Albert Museum

AEH Revd Anthony Harvey MA, DD, formerly Sub-Dean of Westminster

VK Valerie Kaufmann, Senior Restorer and Director, Plowden and Smith

SBL Sheila Landi FIIC, Textile Conservation Consultant

JL John Larson, Head of Sculpture, National Museums and Galleries on Merseyside

SL Santina Levey FSA, formerly Keeper of Textiles, Victoria and Albert Museum

PL Phillip Lindley MA, PhD, FSA, Reader in the History of Art, University of Leicester

Julian Litten DArt, FSA, FSA (Scot), Visiting Lecturer in the Theory and Practice of Medieval Craftsmanship, Christ Church University College, Canterbury

RM Richard Mortimer MA, PhD, FSA, Keeper of the Muniments, Westminster Abbey

NR Natalie K. A. Rothstein MA, formerly Curator of Textiles, Victoria and Albert Museum

JS June Swann MBE, formerly Keeper of the Boot and Shoe Collection, Northampton Museum

T and N see Bibliography

FOREWORD

Of all the religious and artistic treasures which a visitor may see at Westminster Abbey, the collection of eighteen funeral effigies in the Museum is perhaps the most intriguing. Carved in wood or in wax, these full-size representations of kings, queens and distinguished public figures, many of them in their own clothes and with their own accoutrements, constitute a gallery of astonishingly life-like portraits stretching over more than four centuries of British history.

This unique collection, although splendidly displayed in the Norman Undercroft at Westminster Abbey and admired by thousands of visitors, has never before been provided with a full descriptive catalogue. I am sure that this book, with its abundant information and its splendid illustrations, will provide a much-needed resource for scholars and give great pleasure to those who, like me, are fascinated by what they have seen and are keen to deepen their knowledge of these remarkable works of art.

METRIC CONVERSION TABLE

Inches	Centimetres
¹⁄₁₆	0.16
⅛	0.32
⅜	0.48
¼	0.63
⅜	0.95
½	1.27
⅝	1.59
¾	1.90
⅞	2.22
1	2.54
2	5.08
3	7.62
4	10.16
5	12.70
6	15.24
7	17.78
8	20.32
9	22.86
10	25.40
11	27.94
12	30.48
24	60.98
36	91.44
48	121.92

INTRODUCTION

Anthony Harvey

The Funeral Effigies at Westminster Abbey have been objects of interest to visitors since the seventeenth century; but their importance for the history of English portraiture, costume and funeral ritual has been recognised for a much shorter time. In a paper written in 1973, the late Nicholas MacMichael, Keeper of Muniments at the Abbey, was able to summarize the existing scholarly literature in a few sentences:

> The early effigies . . . were brought down into College Hall in 1907 where the Society of Antiquaries met especially to hear a notable paper by Sir William St John Hope . . . After this the true interest and importance of the 'Ragged Regiment' became recognized and they were placed on view to the public in the Undercroft. The waxworks had to wait for a while. They were eventually brought down from the Islip Chantry and examined, cleaned and restored at the Victoria and Albert Museum. Following this, in 1934 another important paper was delivered to the Antiquaries by Mr L.E. Tanner and Mr J.L. Nevinson, and from then on their value as portraits and the interest and finery of their costume has been fully recognized.[1]

MacMichael was writing on the subject of the museum in the Norman undercroft of the monks' dormitory at Westminster Abbey. This impressive vaulted room was first laid out as a museum by Dean Armitage Robinson in 1908; but it was not until 1966 that an exhibition was installed which attempted to display the 'Abbey Treasures' in some historical sequence. Twenty years later this exhibition (which was never intended to be permanent) was showing its age, and had in any case fallen far below modern conservation standards. A complete refurbishment was undertaken in 1985, and the museum reopened two years later, the effigies having been made the most prominent exhibits. They could then, for the first time, be seen to advantage in the round, in permanent display cases built and lit to stringent conservation requirements.[2]

This refurbishment initiated a new phase in the serious study of the effigies. Such repair and conservation work as was possible during the two years when the museum was closed revealed details that were hitherto unknown or had been forgotten, and showed how inadequate were the existing publications. The subsequent withdrawal from display of four of these figures for conservation (Sheffield, Pitt, Nelson and Elizabeth I) provided an opportunity for further scholarly study, and in the case of Elizabeth I, yielded an important discovery. A long-term programme of conservation, which can be undertaken by the Dean and Chapter only as funds become available for the purpose, is likely to provide further information. But in the mean time, given that a comprehensive account of each clothed effigy requires complete undressing and dismantling, a number of the wax effigies remains inaccessible to full examination by scholars, and any account of them has to rely on published reports of conservation work carried out up to sixty years ago.

[1] 'The Undercroft Museum and the Treasures Exhibition', *Westminster Abbey Occasional Paper* 31 (December 1973), 15.

[2] Designed by Paul Williams, constructed by Qualart Ltd.

The present volume, therefore, though it is the first attempt that has ever been made at a comprehensive publication of this remarkable collection, is necessarily incomplete and provisional. In the case of several of the clothed effigies much had to be taken on trust. For the rest, a wide range of expertise was required, and the project would have been impossible without the generous cooperation of a team of scholars. The main catalogue entries, which set each effigy in its art-historical context, are all by Dr Phillip Lindley; but the detailed accounts of conservation, clothing and accoutrements are the work of a number of specialists who showed a laudable willingness to make their expertise available in this way. Since the publication of the first edition we regretfully have to record the deaths of two of the contributors, Janet Arnold and Shirley Bury.

The editors owe a debt of profound gratitude to all the contributors, and also to Mrs Elizabeth Moss, whose generous benefaction in memory of her brother, Nicholas MacMichael, has made it possible to make this book readily available to the general public. We believe that this publication would have given particular pleasure to the late Keeper of Muniments, whose responsibilities included the guardianship of the effigies and who showed unfailing enthusiasm and ingenuity in providing interpretation of them for visitors. It is to his memory that this volume is gratefully dedicated.

THE FUNERAL EFFIGY:
ITS FUNCTION AND PURPOSE

Julian Litten

> The viij day of August was bered the nobull kyng Edward the vj, and vij
> yere of ys rayne; and at ys bere[ing was] the grettest mone mad for hym of
> ys deth [as ever] was hard or sene, both of all sorts of pepull, wepyng and
> lamentyng; and furst of alle whent a grett company of chylderyn in ther
> surples, and clarkes syngyng. . . .; and then cam the charett with grett
> horsses trapyd with velvet to the grond, and hevere horse havyng [a man]
> on ys bake in blake, and ever on beyryng a banar-roll [of] dyvers kynges
> armes, and with schochyons on ther horses, and then the charett kovered
> with cloth of gold and on the [charett] lay on a pycture lyeng recheussly
> (*piteously*) with a crown of gold, and a grett coler, and ys septur in ys hand,
> lyheng in ys robes [and the garter about his leg, and a coat in embroidery of
> gold] . . .[1]

'Pycture', 'personage', 'ymage' and 'cast'[2] were but four of the terms used between 1413 and
1553 to describe the full-length robed and crowned supine effigies paraded atop the coffins of
deceased monarchs and of their consorts at the time of their funeral.

In January 1769 Thomas Astle delivered to the Society of Antiquaries of London a manu-
script of c.1413 from the Anstis collection entitled *What shall be don on the demyse of a King
annoynted*, in which directions were given relating to the correct observances 'when that a King
annoynted is decessed.'[3] The instructions for use of a funeral effigy are clear: 'and yef ye carry
him, make an ymage like hym clothed in a surcote, with a mantell of estate, the laces goodly
lying on his bely, his septer in his hande, and a crown on his hed, and so cary hym in a chare
open, with lights and baners, accompanyed with lordes and estatez as the counseill can best
devyse.' And thus it was done until the funeral of James I in 1625 after which, as we shall see,
the practice ceased.

It is important to understand the function and purpose of monarchical funerary pomp.
Primarily the complicated panoply was seen as the only acceptable manner in which to translate
the remains of a monarch from his lying-in-state to the designated place of burial. However,
these regal obsequies also provided a convenient means for the crown publicly to display to any
potential usurper or pretender, its wealth and its power through the support it already received
from Church and State, in the presence of the nobility, the episcopate and the judiciary in the

1 J.G. Nichols (ed.), *The Diary of Henry
 Machyn* (Camden Society, London 1848),
 39–40.

2 London, College of Arms, MS I. 11, ff. 28, 30,
 entries relating to funeral of Elizabeth of
 York, 1503; W. Illingworth, 'Copy of an orig-
 inal Minute of Council for Preparations for

 the Ceremonial of the Funeral of Queen
 Catherine, the divorced Wife of King Henry
 the Eighth', *Archaeologia* 16 (1809), 24.

3 'Ceremonial of the Burial of King Edward
 IV. From a MS of the late Mr Anstis, now in
 the Possession of Thomas Astle, Esq.',
 Archaeologia 1 (1779), 350–7, quotes at 350–1.

funeral procession. Firmly grounded in French court mourning etiquette of the late thirteenth century, the English monarchial funeral emulated, in the main, that which was performed for their French cousins. In this the effigy had an important role to play.

Historians accept that kingship is often both a political and mystical phenomenon, namely that kings, as well as being human, are, as a result of their coronation anointing, frequently regarded as 'divine'. Whilst the coffin, therefore, contained the corporeal remains of the deceased king, the life-size 'hearse-statue' or funeral effigy represented his 'divine' body. Wide-eyed, and sumptuously attired in his original coronation robes[4] lent from the Great Wardrobe, with orb and sceptre in hand, the crowned effigy represented the deceased monarch on his final journey, to appear before the King of kings. Further, the opened eyes suggest the immediacy of the fulfilment of the words from the Book of Job: '. . . I shall see God; whom I shall see for myself, and mine eyes shall behold him and not another.'[5]

Originally it was the custom to display the corpse of the dead monarch during the funeral procession; this was certainly the case in October 1216, as recorded by Roger of Wendover, when the body of King John 'was adorned in royal fashion and carried to Worcester and honourably buried in the cathedral church there by the bishop of the place.'[6] This was corroborated by Valentine Green, who was present at the opening of the tomb in July 1797, when it was noticed that 'the dress in which the body of the king was found appears also to have been similar to that in which his figure is represented on the tomb, excepting the gloves on its hands and the crown on its head.'[7] There has been much debate since St John Hope published his 1907 paper, *On the Funeral Effigies of the Kings and Queens of England*, as to whether or not a clothed and crowned effigy was used at the funeral of Henry III in November 1272; on balance it appears not, and the contemporary account given by Thomas Wykes, canon of Oseney, Oxfordshire, implies that the robed corpse itself was transported in an open coffin.[8] Also, the contemporary documents and first-hand accounts relating to the arrangements attendant on the disposal of the body of Edward I in 1307 are so scanty that we know no more than that the corpse was embalmed, closely wrapped in cere-cloth and transported to the tomb, probably in a similar fashion to that seen thirty-five years earlier at the funeral of Henry III.

The first recorded use of a funeral effigy appears in the Great Wardrobe account for 1327 in respect of the solemnities attending the burial of Edward II at Gloucester abbey. Following the king's murder at Berkeley Castle, Gloucestershire, on 21 September 1327, the body was encoffined and remained at Berkeley until being taken to Gloucester a month later to await its funeral on 20 December. This delay, due to delicate political rearrangements which had to be completed at court, rendered it impossible for the corpse to be openly displayed during the obsequies. In any case, the king had been mutilated both before and during death, which, with his emaciated physique as a result of his incarceration, would have rendered it unseemly and undignified to have the corpse exposed to public view. Its place, therefore, was taken by a painted

4 Later effigies were depicted wearing parliamentary robes. The regalia on the earlier funeral effigies were part of the crown jewels. No details survive of the security arrangements in force to guard these items whilst the effigy lay in state.

5 Job xix, 26–7; cf. 'Be thou faithful unto death, and I will give thee a crown of life', Revelation ii, 10; E. Kantorowicz, *The King's Two Bodies: a Study in Medieval Political Thought* (Princeton 1957); M. Axton, *The Queen's Two Bodies: Drama and the Elizabethan Succession* (London 1977); D. Cannadine (ed.), *Power and Ceremonial in Traditional Societies* (Cambridge 1987).

6 Hope, 9.

7 Valentine Green, *An account of the discovery of the body of King John, in the cathedral church of Worcester, July 17th, 1797* (London and Worcester 1797), 4.

8 *In locello portatili deferretur ad tumulum*: H.R. Luard (ed.), *Chronicon Thome Wykes* (Rolls Series, London 1869), 252. For Edward I see Hope, 12–13.

wooden image in the likeness of the king, complete with a copper crown, presumably gilt, ordered by the Great Wardrobe and provided for the sum of £2 7s 8d.[9] However, for the funeral itself the copper crown was removed from the wooden effigy, which was then robed in state in items borrowed from the Great Wardrobe. It is also possible that the painted effigy with its copper crown was publicly displayed at Gloucester between October and December 1327 prior to the funeral taking place.

The funeral of Edward III took place at Westminster Abbey on 5 July 1377, two weeks after his death at Sheen Palace, Richmond, Surrey. The short space of a fortnight between death and burial could indicate that the demise of the elderly king had been expected for some time, and that preparatory decisions had been made during his final weeks at Sheen, amongst which was to make 'an image in the likeness of the king'.[10] Presumably also attired in robes lent from the Great Wardrobe, the effigy was used from the beginning of the funeral procession at Sheen, at the overnight halt at St Paul's cathedral and then on to Westminster Abbey on the following day where it was placed, together with the coffin, within a magnificent hearse ordered from Stephen Hadley at a cost of £59 16s 8d. These hearses usually remained in situ for thirty days, when the trental mass signified the end of the primary obsequies. Edward III's carved wooden effigy survives, and is on display in Westminster Abbey Museum. The survival of this and subsequent effigies up to and including that of James I is due to the Abbey authorities. The purpose of the pre-Reformation effigies was served at the completion of the trental mass. The robes and regalia were then returned to the Great Wardrobe; but the effigies, which were of no use to the Wardrobe, were retained by the Abbey, perhaps as part of their perquisites, or to mark the place of burial until such time as the monument was erected.

A carved wooden head is all that survives from the earliest of the female effigies in the Museum. Anne of Bohemia, the first wife of Richard II, died at Sheen in June 1394 but the funeral was delayed until August so as to allow preparations fitting for a queen and the sister of an emperor. The carved facial features may have been based on a death-mask taken by the London tallow-chandler Roger Elys (or Ellis) and it seems probable that the effigy was used during the lying-in-state at Sheen as well as for the funeral itself.[11]

The deposed King Richard II (d.1399) was not afforded the privilege of a funeral effigy – his encoffined corpse was transported from Pontefract to London, albeit with the face exposed.[12] No contemporary account has been found relating to the obsequies of Henry IV (d.1413) and the question remains open regarding the provision of an effigy. Henry V was afforded an effigy; dying in France in August 1422 the November funeral at Westminster Abbey was recorded by Thomas of Walsingham: 'There was placed upon the chest in which the body was a certain image very like in stature and face to the dead king, arrayed in a long and ample purple mantle, furred with ermine, a sceptre in one hand and a round ball with a cross infixed in the other; with a gold crown on the head over a royal cap, and the royal sandals on his feet. In such wise he was raised on a chariot that he might be seen of all, that by this means mourning and grief might grow, and his friends and subjects might the more kindly beseech the Lord on his soul's behalf.'[13] It appears from this that the effigy was dressed in parliament robes rather than those of full state. The effigy, which was made of boiled leather, has not survived; so unusual a material begs the question as to whether this effigy was of English manufacture, or was produced in France to accompany the remains back to England.

9 PRO, King's Remembrancer, E 101/383/3; 11 See below, 37–9.
 Hope, 14–15. 12 See below, 41
10 PRO E 101/398/9; Hope, 16; see below, 31. 13 Hope, 20–1.

The next royal funeral to take place in the Abbey was that of Katharine de Valois, the widow of Henry V, in 1437. Her effigy survives nearly complete, and is unusual in that it is carved from a single block of wood. As the right arm and the left hand are missing from the effigy, it is not possible to say whether the hands were so carved as to 'grip' sceptres. The six week delay between her death and burial was ample time to allow for the production of the effigy; indeed it may have been ready sufficiently early to have been used for the lying-in-state at St Katherine-by-the-Tower prior to the state funeral.[14] The groove round the brow allowed for the fixing of the crown; and it may be that a copper crown was used, similar to that provided in 1327 for the effigy of Edward II.

No effigy was made for Henry VI (d.1471), but whilst one was provided for the obsequies of Edward IV on 17 April 1483, it was not used during the progress of the cortège to Westminster Abbey. Rather it was kept in abeyance until the coffin had been positioned within the hearse in the church. That having been done, the effigy – the 'personage lyke to the symilitude of the Kinge',[15] with crown, sceptre and orb – was brought forward and placed within the hearse on top of the palled coffin. This effigy did not remain in the Abbey, for at the close of the funeral service it was conveyed to the waiting chariot and taken to Windsor via Syon. Its subsequent history is unknown and no part of it survives at Windsor.

Those who died ignominious deaths were not afforded a public funeral; consequently both Edward V (d.1483) and Richard III (d.1485), the last monarch of the house of Anjou, were buried privately and without the benefit of an effigy. The first royal funeral of the house of Tudor was that undertaken for Elizabeth of York, the wife of Henry VII, in 1502. It had been one hundred and fifty years since the consort of a king had predeceased her husband. But that was not in itself the reason for Elizabeth of York's sumptuous funeral, rather it was an opportunity for the house of Tudor to publicly display its splendour and wealth. Elizabeth of York died at the Tower of London on 11 February 1503, and the funeral took place at Westminster Abbey on 21 and 22 February. Organised by the College of Arms, with clothes supplied by the Great Wardrobe, everyone worked at double-quick time to ensure that everything was ready for the morning of 21 February. Over the coffin was placed 'a holly chest . . . wheron was a ymage or personage lyke a quene clothed in the very robes of estate of the quene having her very rich crowne on her hed her here about her shoulder hir scepter in her right hand and her fyngers well garnesed with rynge of gold and presyous stones.'[16] A photograph of the effigy, unclothed, was published in 1907,[17] showing it to have been a particularly elaborate item. Indeed, the whole must have presented a most creditable life-like appearance when dressed, with its gorgeous robes, regalia, long wig of human hair, and sparkling gemstones on the fingers. Unfortunately, only the head now survives, the rest having been destroyed in 1941.

The detailed account of Elizabeth of York's funeral in the archives of the College of Arms provides an important clue regarding the treatment of such an effigy following the completion of the first part of the burial service and the committal of the body: after the sermon 'the Ladyes departed after whos departyng the Image with the crowne and the riche robes were had to a secret place by St Edwardes Shrine.' Was it at this stage in the proceedings that the officers of the Great Wardrobe took into safekeeping the regalia and robes? Given that these effigies were sometimes used by the Abbey to mark the place of burial until such time as the monument was erected, and the need for the required sepulchral effigy faithfully to reproduce the physiognomy

14 Hope, 29.
15 See below, 45 n1.

16 Hope, 30; see below, 46.
17 Hope, pl. LX; below, pl. 4.

and physique of the deceased, it is possible that the funerary effigy proved useful source material to the sculptor commissioned to execute the monument.

The funeral for Henry VII closely duplicated that held six years earlier for Elizabeth of York. Henry died at Richmond Palace, Surrey, on 21 April 1509; the encoffined body remained within the chamber in which he had died until 30 April when, 'after all things necessary for thenterement and funerall pomp of the late kinge were sumptuously prepared and done the corps of the said defunct was brought owt of his chamber . . . into his grete chamber where he rested iij days and every day had dirige and was solempnely song with a prelate mytred and so other iij days in the hall and other iij days in the chapell[18] . . . and in every place, was a herce garnessed with banners scochines and pencelles.'[19] From this it can be assumed that the funeral effigy was ready by 30 April and was used during the solemnities at Richmond. The account of the funeral itself is explicit in every detail; for example, it records that 'on Wednesday the ixth day of May was the body put in a chayre[20] covered with blacke cloth of golde drawen with x grete coursers[21] covered with black velvet garnesshed with scochins of fine golde. Over the corps was an Image or Representacion of ye late king layd on quissions of golde aparelled in his riche robes of astate with crowne on his hed ball and scepter in his handes.'[22] The procession made its way to St Pauls Cathedral, where the body lay in state overnight and, on the morning of Thursday 2 May the cortège made its way to Westminster Abbey for the funeral service and burial. The setting within the Abbey awaiting the body was more sumptuous than that in the chapel at Richmond: 'In Westminster cherche was a marvelousle curiouse grete herce of ix principalles full of lights which was lighted agaynst the coming of the corps, which was taken owt of the chayre with vj lords and set under the herce the Representacion lying upon the Coffyn on a pall of golde.'[23]

As with other pre-Reformation effigies the head of Henry VII is based on a death mask, yet in this instance it is far more animated and life-like than any of its predecessors, exhibiting a less stylised treatment of official portraiture. Whatever the circumstances of its authorship and production, it remains one of the most powerful and expressive busts in English Renaissance art. A close examination of the head, based on a death mask, reveals that the left eyebrow had been ruffled by the cast, and the slightly drooping left side of the mouth faithfully reproduces the physical contortions of the king's fatal stroke. The way the body of the effigy had been fabricated was similar to that provided in 1502 for Elizabeth of York, and may indicate its production by the same workshop; a thin coating of fine gesso was laid over the lay-figure to highlight the physical contours. The supple nature of the completed effigy would have allowed for naturalistic posturing which, with the life-like head, must have made a deep impression on the crowds who saw it on its progress through the streets. The complete effigy, unclothed and *sans* wig, survived until its virtual destruction during the Second World War; the head is now exhibited in the Abbey Museum.

Three of Henry VIII's wives – Catherine of Aragon (d.1536), Jane Seymour (d.1537) and Anne of Cleves (d.1557) – had their funeral services at Westminster Abbey.[24] Though Thomas Wriothesley had instructed that for Catharine of Aragon there should be 'a cast or puffed Ymage of a princesse apparailled in her Robes of Estate with a Coronall upon her hed in her hearc(e) with Rings Gloves and Juells upon her handes',[25] as had been seen at the funeral of Henry

[18] This would have been for the 'official' lying-in-state.

[19] Hope, 23.

[20] Chariot.

[21] Horses.

[22] Hope, 23.

[23] Ibid.

[24] Three years before Catharine of Aragon's funeral, a clothed and coronetted effigy had been provided for the funeral of Mary, Duchess of Suffolk (d.1533) at St Mary's, Bury St Edmunds, Suffolk.

[25] Illingworth, 'Copy of an original Minute', 24.

VIII's mother in 1503, it seems unlikely that these directions were carried out,[26] and nothing survives at Peterborough cathedral, where she was buried, to indicate its former existence. On the other hand, a 'presentacion of the quenes grace in hir roobes of estate with a riche crown of gold upon hir hed in hir heere as aparteynith and a sceptre in hir right hand of gold and on hir fyngars rich ringes with rich stonis and aboute hir necke richli besene with gold and stonys and under the hed of the corps a rich pillowe of cloth of gold tissew'[27] was provided in 1537 for Jane Seymour's funeral, and accompanied the body on its journey to Windsor, Berkshire, for burial; the effigy has not survived. Although no effigy was carried at the funeral of Anne of Cleves (d.1557), the street procession was elaborate. Henry Machyn's detailed description of the event is as accurate as such an account could be, he being a mercer and society funeral furnisher.[28]

Arguably the most gaudy of the funeral effigies was that of Henry VIII. He died at Westminster on 28 January 1547 and lay in state in the chapel at Whitehall from 2 to 14 February when his body was taken, not to Westminster Abbey, but to Windsor by way of Syon, Middlesex, for burial in the vault constructed for Jane Seymour.[29] Again, a full description of this effigy is amongst the archives of the College of Arms: 'the picture was made veray like unto the Kings Majesties person, both in stature favowre forme and apparell, the which was laid a long upon the Cophyn with twoo greate Cussyns under his head. The Crowne Emperiall of Englande of goulde sett with precious stones, and under that a night cappe of blak satten, set full of stone and golde, was uppon his heade. His shurte as it apperid abought the coller and handes semed to be of fynne goldsmithes worke. The picture was apparrellid with robes of crymsyn velvet furred with mynifer powdred with armyns, the colore of the Garter with the George abought his nekk, a crymsyne satten dublett embroydered with gold, twoo braceletts of golde abought his wrests sett with stone and perle a fayre armering sworde by his side, the septure in his right hande and the balle in the lyfte hande a payer of fynne scarlett whoses, and a payer of crymsyn velvet showes, and uppon his handes a payer of new gloves, with many rings sett with rych stones on his fyngers.'[30] The safety of an effigy of such high quality would not have been left to chance, and may well have been secured by means of tapes and ties around the body beneath the clothes and thence through the pall to a separate coffin board beneath. Presumably the crown was fixed to the head by means of waxed twine, as would have been the sceptre and orb to the hands. Security of this type had been provided for the effigy of Elizabeth of York in 1502.[31]

Edward VI, the boy-king, died at Greenwich on 6 July 1533, and was the first monarch to be buried according to the rites and ceremonies of the Church of England, the funeral service being read by Archbishop Cranmer, who had also officiated at the baptism, confirmation and coronation of the king. The funeral took place at Westminster Abbey on 8 August, the first royal funeral to be performed there for almost fifty years. Following on behind the choristers, household servants and heralds, was 'the charett kovered with cloth of gold, and on the charett lay on a pycture lyeng recheussly with a crown of gold, a grett coler, and ys septur in ys hand, lyheng in ys robes . . . There was set up a goodly hersse in Westmynster abbay with banarrolls and pensells, and honge with velvet a-bowt.'[32] Had this affigy survived, the facial features would have appeared particularly unusual, in being white rather than fleshly.[33]

26 Hope, 31.
27 Ibid.
28 Nichols, 145–6.
29 A drawing of the interior of this vault, made by A.J. Nutt on 13 December 1888, showing the coffins of Jane Seymour, Henry VIII and Charles I, is in N. Oxley, *A.Y. Nutt: In Service to Three Monarchs at Windsor* (Windsor 1996), fig. 3.
30 Hope, 24–5.
31 Hope, 35.
32 Nichols, 40.
33 Noble children of both sexes had white lead-based cosmetics applied to their faces. This was considered to be a sign of beauty.

Whilst England returned to the Roman Catholic faith during the reign of Queen Mary, hers was a tragedian reign, and she died a lonely and unhappy woman at St James's Palace on 17 November 1558. Nevertheless, her funeral effigy (pl. VI) was of outstanding quality which, with its moveable joints at the neck, shoulders, elbows, wrists and knees, lent realism to its posture. 'Nicholaus Lisarde, Sergeant Painter' was paid £6 13s 4d for the making,[34] and it was 'adorned with cremesun velvett and her crowne on her hed, her septer on her hand, and mony goodly rynges on her fingers'.[35] When the funeral procession arrived at Westminster Abbey on the evening of 13 December 'was gentyll-men rede (ready) to take the quen owt of her charett, and so erles and lordes whent afore her grace to the herse ward, with her pyctur borne betwyn men of worshype; and at the cherche dore met her iiij byshopes, and the abbott, mytered, in copes, and sensyng the body; and so she lay all nyght under the herse, and her grace was watched.'[36] The burial on the following day was marred by ugly scenes when 'the pepull pluckt [down] the cloth, evere man a pesse that cold caycth [it] rond a-bowt the cherche.'[37] In this particular instance the hearse was not dismantled after the funeral, for nine days later 'was the obseque at Westmynster [with the] sam herse that was for quen Mare, was for Charles the V, Emporowre of Rome, was durge, and the morrow masse.'[38]

A broken left foot (minus the toes), a forearm with joint at the elbow and peg for the hand, together with the upper part of the left arm was all that survived of the funeral effigy of Elizabeth I in 1907. This is to be regretted for the extant account of its making shows it to have been a most rich item. The present effigy of Elizabeth I in the Undercroft Museum was entirely remade in 1760 to replace the dishevelled original, with the head modelled from the figure on her tomb.

A departure from court etiquette was witnessed on 8 December 1612 when an effigy was used at the funeral of Henry, Prince of Wales. This was the first time that an effigy was carried at the funeral of an heir apparent. The engraving published by Sandford in 1707 shows the effigy wearing state robes and lying upon the coffin, within a canopied late Renaissance hearse, possibly designed by Inigo Jones, and almost certainly fabricated from wood, plaster and canvas, adorned with bannerols, pennants, targes and other heraldic devices. The Lord Chamberlain's office paid the joiner Richard Norrice for 'makinge the bodye of a figure for the representation of His Highness with several joints both in the arms and legges and bodie to be moved to sundrie accions first for the carriage in the chariot and then for the standinge and for setting uppe the same in the abbeye', whilst Abraham Vanderdort received £10 for 'the face and handes of the Princes representacion beinge very curiouslie wrought.'[39] The firwood torso and legs survive in the Abbey reserve collection, and a painted wooden head which may possibly have belonged to it is exhibited in the Museum.

Prince Henry was deposited in a burial vault constructed a few months earlier by James I for the reception of the remains of Mary Queen of Scots, translated from Peterborough Cathedral on 4 October. Sir William Dethick, Garter Principal King of Arms, was of the opinion that following her execution for treason at Fotheringhay Castle, Northamptonshire, in 1587 'a representacion of ye saide scottish Queen' was fabricated. This is not the case, for a paper read at the Society of Antiquaries of London on 15 June 1769 included an eye-witness account of the obsequies at Peterborough: 'On Tuesday, being the first of August . . . [the] body being thus brought into the quire, was set down within the royal herse . . . Upon the body, which was

34 Hope, 26.
35 Nichols, 182.
36 Nichols, 183.

37 Nichols, 184.
38 Ibid.
39 Hope, 39; see below, 59–62

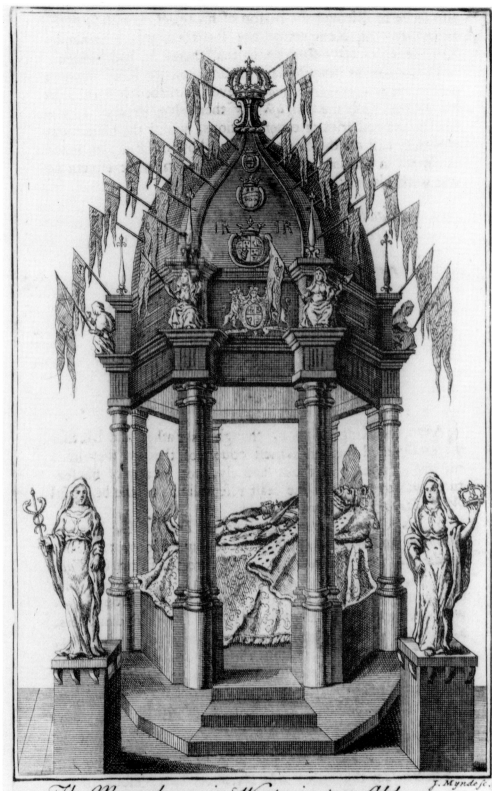

The Mausoleum in Westminster Abbey at the Funeral Obsequies of K. JAMES I.

1. The effigy of James I in its 'mausoleum', 1625
(Westminster Abbey Library, Langley Collection IX.1 (10))

covered with a pall of black velvet, lay a purple cushion, fringed and tasselled with gold, and upon the same a close crown of gold set with stones.'[40] It seems highly unlikely that someone meeting such an ignominious end would have been afforded a full state funeral with effigy; the cushion supporting a crown is more acceptable. The simplicity shown at the funeral of Mary Queen of Scots was to become the norm after the Restoration.

In 1619, seven years after the death of Prince Henry, his mother Anne of Denmark died. The armature of her effigy, similar to that produced for Elizabeth of York in 1502, was illustrated by Hope in 1907.[41] The delicately carved wooden head by Maximilian Colt, with de Critz's sensitive tinting, is on display in the Abbey Museum.

The remains of the funeral effigy of James I (d.1625) are no better preserved than those of his son, being the wreck of a headless mannequin kept away from public view, and in its present state belies the magnificence it once displayed. James I's obsequies were stage-managed in quite theatrical magnificence. Inigo Jones designed the hearse in the style of the continental catafalques, and it is possible that in so doing he was influenced by the connoisseur Charles I. Colt was once again commissioned by the Lord Chamberlain's office to provide an effigy and other sundry items, such as the depositum plate for the anthropoid lead shell ('Item: for a plate of copper with an inscription fastened upon the breast of the leaden coffin'), the targe ('Item: for a shield with his Majesties armes a garter comptment and a Crowne upon it') and the carved crest for the funerary helm ('Item for a crowne of wood and a lyon upon it for his Majesties creast').[42]

James I died at Theobalds Park, Hertfordshire on 27 March 1625. This was an awkward time, as the court was in preparation for the forthcoming marriage of the Prince of Wales to Princess Henrietta Maria of France. Nothing was to hold up this union[43] and the arrangements for the necessary obsequies were executed with some speed, the service at Westminster Abbey being fixed for 5 May. The king's features for the effigy were modelled on a death-mask, as proven in the Lord Chamberlain's account where part of the 16s 8d disbursed to Colt for 'the labour paines and expences of himself and his servants' included 'his journey to Theobalds for the moulding of the king's face for the better making of the premises upon special command'.[44]

On or about 29 March the encoffined remains were taken from Theobalds Park to Denmark House in the Strand and placed on a catafalque surrounded by six silver candlesticks. Meanwhile, Colt and his assistants were working on the effigy, Colt on the 'face and handes . . . curiously wrought,' for which he was paid £10, and the assistants on the body, 'with several joynts in the armes legges and body', for which they also received £10. This finished, John de Critz set to 'payntinge the face of Royall Representacion', for which he was paid £2, thereby allowing Daniel Parkes the freedom to prick-in the beard and eyebrows and set the periwig, for which services he charged £10.[45] The effigy, robed and holding Colt's *faux* sceptre and orb (£1 6s 8d the pair) and wearing a £5 'Crowne with Divers counterfeit stonns on it', was placed atop the palled coffin on its catafalque in Denmark House. It was then brought to the Abbey and placed in the hearse designed by Inigo Jones and erected under the supervision of de Critz's son.

The funeral was a protracted affair, with nine thousand walking in the procession from Denmark House to the Abbey. Once there, they were subjected to a two-hour sermon from Dean

40 'A Remembrance of the Order and Manner of the Burial of Mary Queen of Scots', *Archaeologia* 1 (1779), 357–62, quotes at 358, 361.
41 Hope, plate LXIV; see pl. VIII.
42 Hope, 41.
43 To expedite the matter the proxy wedding took place before the funeral.
44 Hope, 41.
45 Hope, 42.

Williams before the body was taken to Henry VII's vault. John Chamberlain described the events as 'confused and disorderly'.[46] This was the last time an effigy was carried at a monarchical funeral.

No funeral service was held for Charles I following his execution in 1649. The body was deposited privately in Henry VIII's vault in St George's Chapel, Windsor on 6 February.[47] The next state funeral to take place at the Abbey was that of Protector Oliver Cromwell. Cromwell died at Somerset House on 3 September 1658 and the funeral arrangements were entrusted to Kinnersley, the Master of the Wardrobe. The body, according to one republican journal, 'lay in Somerset House, the apartment hung with black, the daylight excluded, and no other but that of wax tapers to be seen . . . till the first of November, which being the day preceding that commonly called 'All Souls', he was removed into the great hall of the said house, and represented in effigy standing on a bed of crimson velvet, covered with a gown of the like coloured velvet, a sceptre in his hand, and crown on his head . . . Four or five hundred candles set in flat shining candlesticks, so placed round near the roof of the hall, that the light they gave seemed like the rays of the sun, by all which he was represented to be in a state of glory.'[48] Glory indeed! The public were so enraged by this blatant emulation of royalty that they pelted mud and street filth at his escutcheon placed above the gate at Somerset House.

Both Abraham Cowley and John Evelyn witnessed the public funeral on 23 November. Cowley thought that 'there had been much more cost bestowed than either the dead man, or even death itself, could deserve.' The hearse,' he observed, 'was magnificent, the idol crowned . . . But yet, I know not how, the whole was so managed, that methought it somewhat represented the life of him for whom it was made; much noise, much tumult, much expense, much magnificence, much vain glory: briefly, a great show and yet, after all this, but an ill sight.'[49] John Evelyn relished the vanity of it all: 'It was the joyfullest funeral that ever I saw, for there was none that cried, but dogs, which the soldiers hooted away with barbarous noise, drinking and taking tobacco in the streets as they went.'[50] Indeed, it was at this funeral that soldiers were first used to line the streets, not so much as a mark of respect on the part of the military than as a barrier between the affronted populace and the gaudy puppet atop the coffin. Nothing whatsoever remains of this effigy, though the Museum of London has one of the taffity escutcheons from the pall, and Westminster School has an heraldic pennant, snatched from the chariot by Robert Uvedale, a Westminster schoolboy, who 'darted between the soldiery guarding the bier and snatched from it the little silk banner - known at the school as the Majesty Scutcheon - and disappeared with it into the crowd before anyone could recover from the shock of surprise and catch him.'[51] In short, the funeral was a complete sham, as the body itself had been privately buried in the Abbey on 26 September.

46 N.E. McClure (ed.), *The Letters of John Chamberlain* (2 vols., Philadelphia 1939) ii, no. 473.

47 J. Litten, *The English Way of Death* (London 1991), 156–7.

48 *Commonwealth Mercury*, 2–9 September 1658.

49 Stanley, 160–1; according to James Heath, *England's Chronicle: or, the Lives and Reigns of the Kings and Queens from the Time of Julius Caesar . . . The third edition with large additions continued to this present year 1699* (London 1699), 413, the hearse was far more magnificent than that provided in 1625 for James I.

50 E.S. De Beer (ed.), *The Diary of John Evelyn* (6 vols., Oxford 1955) iii, 224.

51 T.P.J. Edlin, in a letter to *The Times*, 11 January 1999.

Its sacredness profaned by a commoner, the funeral effigy atop the coffin was never again to be used by the Crown in England as part of the official funeral observances. Francis Sandford records that 'a hearse with a funeral effigy was set up for [the] exequies' of Charles I's consort, Queen Henrietta Maria, at St Denis, France in 1699 following her death at the château of Colombes, near Paris.[52]

Of the remaining eleven effigies in the Abbey collection, six are associated with funerals: General Monck, 1670; Charles II, 1685; Duchess of Richmond and Lennox, 1702; Marquess of Normanby, 1715; Edmund Duke of Buckingham, 1735; and Catherine Duchess of Buckingham, 1743. The remaining five were specially purchased, either to maintain the series (Mary II, died 1694; William III, died 1702; and Queen Anne, died 1714), or as tourist attractions (William Pitt, 1778 and Horatio Nelson, 1805).

It seemed appropriate that Charles II should want to afford a state funeral for George Monck, Duke of Albemarle and Earl of Torrington (d.1670), who was so influential in the restoration of the monarchy. In addition to the full suit of contemporary armour, there also survived in 1907 a buff coat, a gilt metal ducal coronet with a black cap of estate trimmed with ermine, a red leather belt with gilt buckles, and a somewhat dishevelled wig. Francis Sandford included engravings of the hearse provided for the lying-in-state at Somerset House and the one for Westminster Abbey, in which the same effigy appears.[53] The warrant issued by the Lord Chancellor on 11 January 1669/70 to the Master of the King's Wardrobe gives a detailed description of what was to be provided, though the choice of artists and tradespersons to supply the demand was left to the Master. From the appended accounts[54] it is recorded that the sculptor John Bushnell received the order for the effigy, and it is possible that the model of Monck's head in the Abbey Library is Bushnell's 'squeeze' taken from death-mask. Fourteen other tradespersons were involved in providing the costume and heraldic apparel at a total cost of £133 0s 4d.[55] To achieve a greater likeness, Bushnell provided a wax head and hands for the effigy. Now, only the armour survives, and is displayed in the Museum. A false coffin was made for the lying-in-state, but its use to support the effigy in the procession to the Abbey is not recorded.

The funeral of Charles II was a private affair, being held in the late evening rather than in daytime. It has been argued that this departure from the norm was due to the king's deathbed conversion to Roman Catholicism; a more plausible explanation is James II's dislike of pageantry, together with a degree of parsimony on his part. However, due honour was paid to the remains as indicated by the arrangements issued under the Lord Chamberlain's warrant.[56]

The king died at Whitehall shortly before noon on Friday 6 February 1685 and the funeral and burial at Westminster Abbey were arranged for the evening of Saturday 14 February. The design of the coffin has been ascribed to Sir Christopher Wren[57] but this is extremely unlikely as the outer wooden case, upholstered in purple velvet, is standard undertaking of that period with gilt bronze coffin furniture of a type provided by top quality cabinet makers.[58] As 'Surveyor of the Fabrick' of Westminster Abbey, Wren was involved in constructing the vault at the east end of

52 Hope, 547–8.
53 *The Works of Horace Walpole, Earl of Orford* (5 vols., London 1798) iii, 249: according to Walpole Monck's hearse was designed by Francis Barlow.
54 Hope, 43–4.
55 Hope, 44–7.
56 T and N, 171: see below, 79.
57 O. Bland, *The Royal Way of Death* (London 1986), 74.

58 This coffin was exposed in 1977 when the vault was opened for constructional examination. The purple velvet-covered outer wooden case with its gilt metal fittings was no different in shape, design or decoration from other high quality coffins of the period. The viscera chest was similarly upholstered and furnished.

the south aisle of Henry VII's chapel, work beginning on Monday 8 February to be in readiness for the funeral six days later.

During the procession from Whitehall to Westminster the palled coffin was borne under a fringed canopy to the solemn beat of muffled drums and accompanied by many dozens of lighted *flambeaux*. There was no funeral effigy, instead a purple tasselled cushion had been placed at the head of the coffin, supporting an imperial crown of tin gilt with a cap of ermine-trimmed velvet. Purged of pomp, certainly; even so, this new style of royal funeral established a simple dignity and was undoubtedly impressive in its revised format.

Charles II's funeral effigy is an enigma. It does not appear in any of the eye-witness accounts of the ceremony; it is neither recorded in the Lord Chamberlain's records, nor in those of the other departments concerned with the organisation of the funeral. It is not known who was responsible for ordering its production, nor who made it,[59] or why it was provided, except perhaps to perpetuate the tradition as a grave-marker.[60] Whatever the circumstances of its production, this particularly life-like effigy, dressed in the deceased's own Garter robes, clothing and monogrammed underwear, was in readiness by the early summer of 1686 when, on 8 June, the Secretary of the Treasury sanctioned payment of £18 10s to Philip Packer, Paymaster of the Works, 'for a Press for the late Kings Effigies'[61] and positioned above the burial vault where it remained until the 1830s. Dean Stanley commented 'That as much as he excelled his predecessors in mercy, wisdom and liberality, so does his effigy exceed the rest in liveliness, proportion and magnificence'.[62]

Aware that the supine effigy had gone out of fashion following its usurpation at Cromwell's funeral, Frances Theresa Stuart, Duchess of Richmond and Lennox emulated that set up for Charles II, and added a codicil to her will on 7 October 1702 'to have my Effigie as well done in Wax as can bee and set up . . . in a presse by itself . . . with clear crowne glass before it and dressed in my Coronation Robes and Coronett.'[63] This was a late decision, for eight days after signing the codicil 'La Belle Stuart' was dead. In carrying out the request her executors secured the services of Mrs Goldsmith, arguably the finest wax modeller of the day, at a fee of £260. The effigy took just under a year to complete and, dressed in its assigned costume, was positioned in the Abbey on Wednesday 4 August 1703. Mrs Goldsmith had her own waxworks museum and it is not inconceivable that she showed the effigy there prior to its being set up in the Abbey. It is an attractive and delicately modelled waxwork and there is an irony inasmuch as it was set up within a few days of the death of Samuel Pepys, who almost fifty years previously lay awake contemplating Frances Stuart's admirable beauty.[64] Within the press is a stuffed West African grey parrot, common in London as pets during the late seventeenth century, which 'had lived with her grace for forty years and only survived her a few days'.[65]

One of the most enchanting of the funeral effigies in the Undercroft Museum is that to the infant Robert Sheffield, Marquess of Normanby, the first son of Catherine, Duchess of

59 It is possible that John Bushnell received the commission.
60 No monument was erected to Charles II, though in the nineteenth century his name was cut into the paving of the chapel above the vault, together with those of the other occupants. The last monarch to have a tomb erected in the Abbey was Elizabeth I (d.1603); the effigial monarchical tomb was revived in 1902 with the installation of Queen Victoria's effigy (sculpted by Marochetti between 1864–8) in the Royal Mausoleum at Frogmore, Windsor Great Park, Berkshire.
61 T and N, 171.
62 Stanley, 323 n4.
63 T and N, 176.
64 Robert Latham and William Matthews (eds.), *The Diary of Samuel Pepys* (11 vols., London 1970–83) iv, 230.
65 T and N, 176–7.

Buckingham, the illegitimate daughter of James II by Catherine Sedley. Robert Sheffield died at the age of three on 1 February 1715 at Buckingham House (now Buckingham Palace) and was buried in St Margaret's church, Westminster. The wax face of the effigy is expertly modelled and may well be based on a death-mask.[66] It has been suggested that this effigy might not have been made until 1735–6,[67] but this seems unlikely. It is to be regretted that when the figure was reassembled after conservation in 1986 the inclination of the head was altered, thereby giving the child a somewhat petulant appearance; however, some blame has to be laid at the feet of earlier conservators for excessively cleaning the features and removing some of the smooth finish and most of the original colouring. The eyelashes are of bristle, the wig of human hair, the eyes are of glass and the body, legs and arms of stuffed yellow canvas. He wears his own clothes which, unlike many of those supplied for the other effigies, are entire and uncut. The presence of the carved wooden crest lends credence to the argument that this effigy was carried atop his coffin at his funeral.

'The Most High, Mighty and most noble Prince Edmund Duke of Buckinghamshire and Normanby, Marquess of Normanby, Earl of Mulgrave, and Lord Sheffield, Baron of Butterwick, Son of John the late Duke by his third wife the Lady Catherine Darnley, natural daughter of King James the Second dyed at Rome the 30th October 1735 aged 19 years 9 months and 19 days by whose death all these Titles are become extinct, was buried the 31 January following in the same Vault with the late Duke his father.'[68] So reads the entry in the Westminster Abbey Burial Book for Edmund Sheffield, second Duke of Buckingham. He was a sickly yet courageous young man, having seen active service in Germany at the age of 16 under his uncle, the Duke of Berwick, and his mother decided that it would be better for his health were he to retire to Rome where the temperature and climate would better suit him. With him went Honoretta Pratt, the confidante of the Duchess, and she was in attendance when he died.[69] We do not know what instructions the Duchess had given to Honoretta Pratt in the event of her son's death; suffice it to say that a death-mask was taken as well as casts of the hands before the body was encoffined for its journey back to England.

A close examination of the death mask provides an indication of the duke's health at the last, and the posture of his dying. It is said that he met his death with great resolve, exclaiming that 'he would ride out the storm in the chair in which he sat'.[70] Whatever the circumstances of his demise, there appears to be a slight droop in the face on the left-hand side, with the head at an angle to the right of the neck, and the left eye protruding more than the right. From this it can be inferred that the head was inclined towards the left after the body had been laid-out, and that the modeller had to straighten it in order to execute his task. There are slight traces of 'pulling' at the eyebrows, the result of inadequate greasing of the face prior to making the cast. The consumption of which he had died had taken its toll, and the strain shows on the face, with its sunken cheeks and tight skin, especially at the temples. The hands are particularly well-modelled, but unfortunately display the duke's habit of biting his nails.

66 Possibly the work of Mrs Goldsmith.
67 See *The Illustrated London News*, 22 April 1933, where Tanner suggests that it was not made until 1735, 'when . . . the Duchess had the wax effigy of herself made'. Tanner omits to suggest another date, 1721, when the child's remains were translated from from St Margaret's to the Abbey.
68 WAM Burial Book ii (1728–55), no 141.

69 *Gentleman's Magazine* xxxix (1769), 461. The obituary to Honoretta Pratt records that the duchess of Buckingham 'prevailed on her to accompany the young duke, her son, when his declining state of health made it necessary for him to go abroad; he died while he was under her care'.
70 T and N, 185.

On learning of the death of her son, the Duchess started to plan a magnificent funeral for him. Obviously, there was to be an effigy, and Mrs Pratt had already seen to the primary stages of this. On the return of the body the Duchess 'showed an insensitive pride . . . dressing his figure, sending messages to her friends that if they had a mind to see him lying in state she would carry them in conveniently by a back door' at Buckingham House.[71] A further comment by Horace Walpole tells how it was at this time that she placed an order for her own effigy as well as endeavouring to arrange for the loan of a funeral car: 'But though Madame of Buckingham could not effect a coronation to her will, she indulged in pompous mind with such puppet-shows as were appropriate to her rank. She had made a funeral for her husband as splendid as that of the great Marlborough: she renewed that pageant for her only son, a weak lad, who died under age: and for herself: and prepared and decorated waxen dolls of him and of herself to be exhibited in glass cases at Westminster Abbey. It was for the procession of her son's burial that she wrote to old Sarah of Marlborough to borrow the triumphal car that had transported the corpse of the Duke. "It carried my Lord Marlborough," replied he other, "and shall never be used for any body else." "I have consulted the undertaker," replied the Buckingham, "and he tells me I may have a finer for twenty pounds." '[72]

Edmund Sheffield's funeral was set for Saturday 31 January, the body having lain in state at Buckingham House from Monday 26 to Thursday 29 January. The cortège went the long way: north from Buckingham House to Piccadilly, eastwards along Piccadilly, south down St James's Street, eastwards along Pall Mall, turning south into Whitehall and thence to the Abbey, 'the body in an open Chariot, the Effigies in Armour[73] lying on the Coffin, with two of his Grace's Officers of the Bed-Chamber sitting at the Head and Feet in close Mourning, bare-headed; the Chariot drawn by six grey horses in Velvet Housings, nine pages walking on each Side the Chariot, with Caps and Truncheons; four Bannerols of his Grace's Arms carried on the right, and four on the left. . . . In the Abbey they were received by the Dean and Chapter in their copes, the whole Choir in their Surplices, singing before the corps, to a Vault in King Henry the Seventh's Chapel, with the Ensigns of Honour born by the proper officers. The Funeral service being read by the Lord Bishop of Rochester, King of Arms proclaimed the Stile and Title of the Deceas'd over the vault; after which, the Chamberlain, Treasurer and Comptroller of the Deceas'd broke their Staves, and threw them into the vault.'[74]

Immediately after the funeral the effigy, still attached to its painted coffin board, and the feet resting against a carved represenation of his crest, was placed in a glass-sided cabinet that had been specially made for its reception. It is in this same cabinet that it may be seen in the Undercroft Museum, the effigy still clothed in its robes of state, though the gilt copper coronet is a replacement of the original, following a theft in June 1737: 'On Monday night last some villains concealed themselves in Westminster Abbey and having broken the glass case which was over the Effigie of the late Duke of Buckingham found means to carry off the Flap of his gold Waistcoat; some of the Blood of their Fingers was perceived on his Ruffles.'[75]

The Duchess of Buckingham supervised the production of her own funeral effigy during the winter of 1735/6.[76] Dressed in the robes which she had worn thirty-three years earlier at the

71 Walpole, *Letters* i, 234.
72 T and N, 185–6.
73 Unless additional supportive documentary evidence comes to light, this statement is untrue; the effigy was dressed in Parliamentary robes.
74 *Gentleman's Magazine* vi (1736), 55.
75 T and N, 186 n4.
76 Possibly the work of Mrs Goldsmith.

Coronation of Queen Anne in 1702, the Duchess kept the image at Buckingham House in readiness for her eventual funeral. Walpole described the eccentric events at Buckingham House during the last few days of her life: 'Princess Buckingham is dead or dying; she has sent for Mr Anstis [Garter King-at-Arms] and settled the ceremonial of her burial. On Saturday she was so ill she feared dying before all was come home; she said 'why won't they send me the canopy for me to see? Let them send it though all the tassels are not finished'. But yesterday was the greatest shock of all! She made her ladies vow to her that if she should lie senseless they not sit down in the room before she was dead. She had a great mind to be buried by her father [King James II]. Mr Selwyn says 'she need not be carried out of England and yet be buried by her father'. You know that Lady Dorchester always told her that Ad. Graham was her father.'[77]

The duchess died on 14 March 1743 and the funeral took place at Westminster Abbey on 8 April, with the same route as that used for her son in 1736 being adopted. 'Her effigy in wax (which she had by her ever since the Duke her Son's Funeral) dress'd up in her Coronation Robes, was placed under a Canopy of State, with two Ladies of her Bedchamber at her head and feet, and drawn in a car by six horses cover'd with black velvet.'[78] So went the haughty princess to her grave, after which a funeral effigy was never again to be used in this country. Hers was positioned adjacent to her vault, close to the effigy of Edmund Sheffield, standing in a case which she had previously ordered, and in which was also placed that of her long-dead son, the infant Marquess of Normanby.

The figures of William III (d.1702) and Mary II (d.1694) were purchased in 1725 for £187 13s 2d and were first exhibited to the public on Monday 1 March of that year, according to an entry in the Precentor's account book.[79] It can reasonably be assumed that both of these figures were the work of Mrs Goldsmith and that they might be the pair exhibited by her at her rooms in 1702. Mrs Goldsmith was commissioned by William III to take a death-mask of Queen Mary in 1694,[80] and in the following year informed the public that she had been allowed to make an effigy of her late majesty, 'curiously done to life in wax and drest in coronation robes'.[81] In 1702 Mrs Goldsmith was allowed to take a death-mask of William III to assist her in making an effigy of the late king for her wax museum. At the time of William III's death she had a rival in Mrs Salmon, who was offering to the public at her place of business, the Golden Salmon in St Martin-le-Grand, both an effigy of William III in his Coronation robes and one of him 'lying on a bed of state with his attendants in mourning suitable to the solemnity'.[82]

William III was five feet six inches high, his queen five feet eleven inches; this was allowed for by placing his effigy on a low footstool and by putting a slight distance between the two figures in the case, with a plinth between them supporting a crown, indicative of their joint monarchy. The bodies, legs and arms of both figures are made of stuffed canvas stiffened with wire, the heads and hands of wax. All the clothes were made specifically for the effigies, as were the gilt decorations and crown. At Queen Mary's funeral the coffin, upholstered in purple velvet, lay at the Abbey within a catafalque designed by Wren, the place of the effigy being taken by a crown on a tasselled purple velvet cushion.

'This day [Sunday 1 August 1714] at half an hour past Seven in the Morning, died our late most Gracious Sovereign Queen Anne, in the fiftieth Year of her Age, and the Thirteenth of her

77 Walpole, *Letters* i, 234.
78 T and N, 180–1.
79 T and N, 190.
80 Not an easy task, for Queen Mary had died of smallpox and the face would have been profoundly blistered.

81 *London Gazette*, 22–5 April 1695.
82 *The Post Man*, 10–12 March 1702; *The English Post*, 25–27 March 1702; *The Post Boy*, 31 March – 2 April 1702.

Reign; a Princess of exemplary Piety and Virtue.'[83] The funeral was arranged for Tuesday 24 August, meanwhile the body lay in state at Kensington Palace though the day following her death the 'Bowelles [were] taken to Henry VII's Chapel in Her late Majesty's coaches and put in [the Stuart] vault.' The night before the funeral the body was taken by a closed vehicle to the Palace of Westminster in readiness for the burial on the following evening when, carried by fourteen carpenters, the large coffin went towards the Abbey under its canopy of state to be met by 'the Dean and Prebends attended by the Choir in their habits having wax tapers in their Hands'.[84]

Queen Anne's effigy took a long time in the making. That an effigy was considered shortly after her death is proved by an entry in the Precentor's account book for the expenditure of £13 14s 3d 'for the head and hands of Queen Anne', perhaps being acquired from Mrs Goldsmith or Mrs Salmon.[85] Mrs Goldsmith had already had dealings with the royal household in 1700 when she went to Windsor to take a death-mask of Queen Anne's son, the duke of Gloucester, for her wax museum. There was a delay, perhaps due to lack of funds, in purchasing the robes, clothing and regalia for Queen Anne's effigy, and it was not until 1740 that the Precentor was in a position to do so, sharing the £67 5s cost with other officials of the Abbey. Unusually, it was decided to show the queen seated and, as with the effigies of William III and Mary II, the clothing and regalia, apart from the Star of the Order of the Garter, are no more than drapes indicative of clothing. With the demise of Queen Anne the House of Stuart came to an end as did the Abbey's policy of acquiring the effigies of deceased monarchs.

William Pitt, Earl of Chatham (d. 11 May 1788) was as much in demand in death as he had been during his lifetime. The City of London petitioned that he should be buried in St Paul's Cathedral 'as a mark of gratitude and veneration from the first commercial city of the empire towards the statesman whose vigour and counsels had so much contributed to the protection and extension of its commerce'; they were to be disappointed, however, for Parliament had already decided that the remains should go to Westminster Abbey, provided that the Dean agreed, there to lie 'near to the dust of kings'.[86] This was a great fillip for the Abbey and, accordingly, the funeral was held with much pomp and dignity on 9 June 1778 with the body being placed in a brick grave situated in the middle of the north transept. From that time this area became the recognised burial place of eminent statesmen. The minor canons and lay vicars, who augmented their income from showing the monuments and effigies to the public, realised that a figure of William Pitt would attract more custom and thereby increase their takings. An approach was made to Mrs Patience Wright to purchase from her the waxwork which she had modelled of Pitt from the life in 1775;[87] the overtures were successful and the figure, showing Pitt standing in his parliamentary robes and holding a scroll of paper in his right hand, was purchased at a 'considerable expense'.[88] Immediately the fee for being shown the monuments, the funeral effigies and the later waxworks was raised from 3d to 6d to offset the purchase of the new acquisition. The modeller, Mrs Wright, was already a celebrated wax modeller in her native America when she arrived in England in 1773, it is said on the encouragement of Benjamin Franklin who, recognising the combination of her talents as a wax modeller and fervent patriot, knew that her expertise would gain her entry into the presence of leading politicians where, Franklin hoped, she could make use of her opportunity to act as a spy. He was not disappointed.[89]

On 8 January 1806, two months, two weeks and four days after his death, the body of Horatio

83 *London Gazette*, 6 August 1714.
84 Bland, *Royal Way of Death*, 88.
85 T and N, 194.
86 Stanley, 241.
87 Walpole, *Letters* viii, 237.
88 T and N, 195.
89 See below, 167.

Nelson 'passed in sad procession up the Thames, amidst the booming of minute-guns and the tolling of bells. As it landed at Whitehall a storm burst over the city, and thunder and lightning welcomed Nelson home. On the following day it was borne along the streets of London through a sea of bare heads, in deep and impressive silence broken only by the sobs of the onlookers, to its final resting place in St Paul's . . . Night fell before the solemn service ended; the vast dome and cavernous depths of the cathedral glowed with torches; in their sombre light the coffin was committed to the grave.'[90] The crowds flocked to St Paul's following the funeral, not only to see the resting place of England's hero but also to view the impressive funeral car, modelled on HMS Victory. It was good news for St Paul's, but it could have been a disaster to the 'shewers of tombs' at the Abbey had not the situation been quickly rectified. Shortly after the funeral Catherine Andras, 'Modeller in Wax to Queen Charlotte', and for whom Nelson had sat during his lifetime, 'was requested to furnish a full-length figure for Westminster Abbey, for the robing of which his family furnished a suit of his own clothes, including the shoe buckles he wore when he fell.'[91] The waxwork, based on Hoppner's full-length portrait of Nelson at St James's Palace, arrived in the spring of 1806, a few weeks after the funeral at St Paul's had taken place. Those who had known Nelson remarked on its exceptional likeness. George Eyre-Matcham, Nelson's nephew, said that the waxwork was more like his uncle than any of the portraits.[92]

The waxwork of Nelson was the last to be placed in the Abbey. As it was, the funeral effigy had ceased to be a component of the royal funeral with the obsequies of James I in 1625, and the decision to exhibit representations of post-Restoration monarchs was taken by the Abbey authorities rather than by the court. The carrying of effigies at the funerals of Robert, Marquess of Normanby (1715), Edmund, Duke of Buckingham (1736) and Catherine, Duchess of Buckingham (1743) were peculiar to the wishes of the latter and had no connection whatsoever with the traditional role of the monarchical effigy. However, the provision of the later waxworks was an ingenious move on the part of the Abbey; they were valuable tourist attractions and a source of revenue for the lay vicars. For the present day visitor they remain, together with the earlier effigies, what they always have been: uniquely valuable portraits of England's monarchs and national heroes.

[90] C. Beresford and H.W. Wilson, *Nelson* (London, n.d.), 231.

[91] Letter from Charlotte B. Wolstencroft in *The Times*, 10 June 1935, quoting MS family reminiscences of Robert Bowyer and Catherine Andras; T and N, 198 n2.

[92] T and N, 198.

THE HISTORY OF THE COLLECTION

Richard Mortimer

The funeral effigies fall into three groups defined by their history and function. The first group consists of royal effigies from Edward III to James I, made for use at the funeral. Brought together probably in the early seventeenth century, they have shared the vicissitudes of the last three hundred years together. They are made of wood and plaster, and virtually all the clothing they once possessed has gone. This is the group sometimes known as the 'ragged regiment'. The next group consists of effigies made after 1660 for use at, or in association with, funerals; these have heads and hands of wax, and their costumes have survived very well. The last group comprises those effigies made in the eighteenth and nineteenth centuries for exhibition purposes unconnected with a funeral ceremony, though they are nevertheless remarkable portraits. Like the previous group they are of wax and have well-preserved costumes, sometimes even items of clothing belonging to the person they represent. The history of the effigies is surprisingly complex; they have often been moved about the Abbey, and even since the foundation of the Museum in 1908 their movements have been surprisingly unpredictable. As Nicholas MacMichael once wrote, 'there is in the Abbey a somewhat disconcerting tendency, to which one has to become accustomed, for inanimate objects to move and at length to reappear in a different place.'[1]

The earliest certain information on the whereabouts of the effigies as a collection comes from 1683, when they were kept in the upper floor of the chantry chapel of Abbot John Islip off the north ambulatory.[2] Henry Keepe describes those of Edward III, Philippa of Hainault, Henry V, Katharine de Valois, Henry VII, Elizabeth of York and Henry, Prince of Wales in one press, and those of Elizabeth, Anne of Denmark and James I in another. Dean Stanley, in his *Memorials of Westminster Abbey*, produced a quotation from *The Mysteries of Love and Eloquence* (1658), which seems to have taken the form of a verse tour of the Abbey and which implies that the effigies were in the Upper Islip Chapel at that date.[3] How long had they been there? Dean Armitage Robinson conjectured that they had 'remained beside the royal tombs, or in other places of honour, until 1643,' but had been removed to the Upper Islip chapel by 1658.[4] He then had to express surprise that they survived the Puritan destructions of 1643. But it seems more likely that even at that date they were already in Upper Islip. Robinson himself produced excellent evidence of an earlier restoration and rehousing of the figures, in the form of entries in the Abbey Treasurer's account for 1606.[5] This important document shows that the seven 'statues' of 'Henrie the seaventh and his Queene, Edwarde the third and his Queene, Henrie the

[1] 'The Undercroft Museum and the Treasures Exhibition', *Westminster Occasional Paper*, December 1973, 14. I would like to thank Phillip Lindley for his comments and my colleagues Enid Nixon and Christine Reynolds for their help with this chapter.

[2] Keepe, 133–4.

[3] Stanley, 322–3; Robinson, 49–50. Stanley, 323, says Stow describes the effigies as shown 'in the chamber close to Islip's chapel', the identifications being the same as in 1683, but he gives no reference and I have been unable to locate it.

[4] Robinson, 49–50.

[5] Robinson, 50–1.

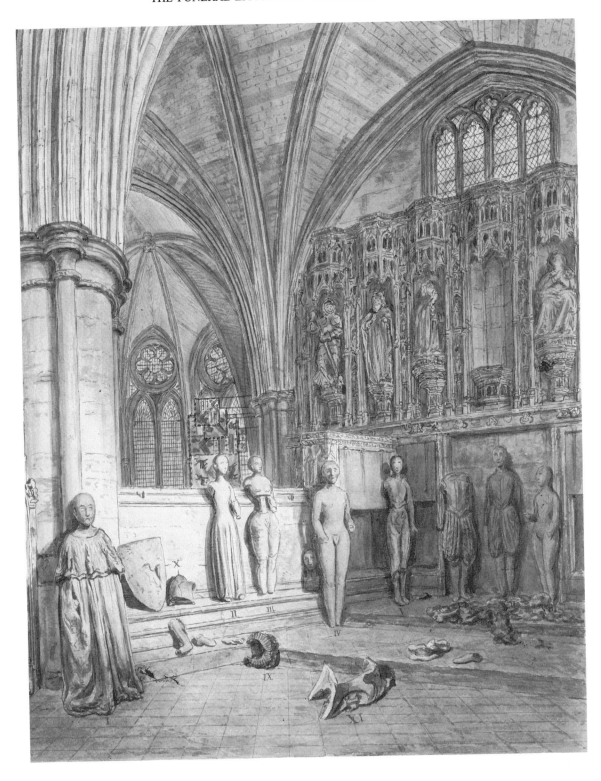

2. The funeral effigies in Henry V's Chantry, 1786
 (drawing by John Carter, Westminster Abbey Library, Langley Collection IX.1 (1))

fifth and his Queene' and Queen Elizabeth were 'repayred, robed and furnished at the King's Majestie his charge', of £70. Another item was 'the making of the presse of wainscott in which the statues do stand', £5 3s 9d.[6] The occasion of the rehousing and refurbishment was the visit of King Christian of Denmark and King James to the Abbey in 1606. Given that the identification of the medieval figures was the same in 1606 and 1683, that a press to contain them was made in 1606, and that the effigies were in Upper Islip in 1658 and 1683, the most likely theory is that they were all together in Upper Islip already in 1606. The size of the larger press would discourage moving it. This would make it easier to understand their survival during the Commonwealth period, Upper Islip being out of the way of events on the floor of the Abbey and easily lockable.

Their history before 1606 is more mysterious. After the funeral of Elizabeth of York in 1503 her effigy was 'had to a secret place by St Edward's shrine', though where this was and how long the effigy remained there are not known.[7] In 1561 the chief verger had oversight of 'the pictures of kings and queens within all the said church remaynyng', which may imply that they were kept in the vicinity of the royal tombs, as were some of the later ones, or that they were in a separate chapel; but their history before 1606 is all speculation.[8]

In 1683 the medieval royal effigies were kept together with the group of early seventeenth century ones – Elizabeth I (d.1603), Henry Frederick, Prince of Wales (d.1612), Anne of Denmark (d.1619) and James I (d.1625). Henry Frederick was then in the same press as the older ones. Stanley's 1658 quotation shows that these later figures were in Upper Islip by then, though when before 1683 the second press, containing Elizabeth, Anne and James, was made is not known.

Two effigies were made in the first half of the seventeenth century which no longer survive – those of Ludovic Stuart, Duke of Richmond (d.1624), cousin of James I, and his wife Frances (d.1639). Keepe saw them in a press near their large monument in Henry VII's chapel in 1683; in 1723 Dart noted 'in an old Wainscot-Press . . . were the Effigies or Hearse-statues of the Duke and Duchess of Richmond before mentioned, but (being decayd) a Batton is nail'd a-cross the Foldings and has been for some years'. Shortly afterwards they must have been removed to Upper Islip, where George Vertue saw them in 1725, the Duke 'a very tall fine figure in his robes'. In 1754 it seems they were back in their old place. Then they disappear, and I have found no trace of them subsequently.[9]

The first effigies after the Restoration, those of General Monck (d.1670), Charles II (d.1685), and Frances, Duchess of Richmond (d.1702), were all kept in individual cases near their graves in Henry VII's chapel. Monck, in armour with robes, baton and coronet, was at the west end of the north aisle in 1723, and was there still in 1815.[10] The effigy of Charles II led an unusually stable existence: it was at the east end of the south aisle of Henry VII's chapel by 1723 at the

6 WAM 33659, fo 6ᵛ. Robinson read 'presse(s)', but the plural is his editorial emendation, for which I see no reason. WAM Muniment Book 7, fo 3r, an account of 'sundrie thinges performed in five years by the Deane and Chapter of Westminster' in Dean Neile's time, adds that they were 'roabed with roabes of crimson vellvett and satten'. For the identification of Philippa of Hainault and Henry V, see below, 25–6.

7 See below, 45.

8 WAM Lease Book IV, fo 33r, cited by Robinson in Hope, 52.

9 Keepe, 102; Dart i, 161; Vertue, 158 (I am indebted to Phillip Lindley for drawing Vertue's notebooks to my attention); *Historical Description* 1754, 43; see below, 69.

10 Dart i, 154 (the engraving cannot represent the arrangement of the presses). See also Keepe, 95; *Historical Description* 1754, 54; *A View*, 9; Joseph Nightingale, *London and Middlesex* (1815) iii part ii, 79.

latest, and was still there in 1836.[11] The Duchess of Richmond was placed at the east end of the chapel near the Richmond tombs; she was mis-identified by some writers as her husband's cousin Mary, who however was never Duchess of Richmond.[12] The last two effigies made to be associated with the funeral of the person represented, those of Edmund, Duke of Buckingham (d.1723) and his mother Catharine, Duchess of Buckingham (d.1743) were also placed on the floor of the Abbey, the Duchess in Henry VII's chapel near the Duchess of Richmond, and the Duke, for some reason, in the chapel of Edward the Confessor.[13] When the effigy of the three-year-old Marquess of Normanby, the Duchess of Buckingham's son, was made is not known exactly: he died in 1715, was buried in St Margaret's church, and reburied in the Abbey in 1721. His effigy always seems to have been associated with that of his mother, which Tanner and Nevinson thought was probably made at the time of her other son's death in 1735.[14]

The early eighteenth century effigies that were made for show, those of William III, Mary II and Anne, were originally housed in the south aisle of Henry VII's Chapel, as was the Queen Elizabeth figure remade in 1760, but all these were in Upper Islip by 1767. William Pitt's effigy was placed in Upper Islip from the first.[15] The effigy of Nelson made in 1806 was placed 'within a large glass case against the west wall' of St Andrew's chapel, near the north transept entrance: 'Victory or Westminster Abbey' was engraved on the glass.[16]

In 1786 the early royal effigies were removed from the Upper Islip chapel and put into Henry V's chantry chapel, where a careful drawing and brief description of them were made by John Carter.[17] This is the earliest visual evidence known on the state of preservation of the earlier effigies, and it is worth examining it in some detail; it can be checked against the brief notes made by George Vertue in 1724–5.[18] The effigies can be identified by comparison with the photographs of them published by Hope in 1907. Katharine de Valois with her carved dress and missing right arm is leaning against the parapet, and next to her Anne of Denmark is recognisable by the stuffing for the legs.[19] To the right of them stands Henry VII, identified by his height, shape and arms, and in the corner Elizabeth of York, again nearly a complete figure missing only the right arm.[20] On the far right, described as a 'carved body' by Carter, is the short, squat and nearly complete wooden figure of Mary Tudor.[21] To the left of her stand two figures in recognisable early seventeenth century male costume, clearly James I and Henry Frederick: the headless figure is James, whose head Vertue says had been 'lately stole away by the workmen being loose'.[22] By 1907 both these figures were headless, the prince reduced to the armature and all the costume gone.[23] Behind Henry VII on the steps the head of Anne of Bohemia is just visible. The figure on the far left by the door must by a process of elimination

11 Dart i, 151; *Historical Description* 1836, 26. See also Crull, 107; *A View*, 5; Neale and Brayley i, 71.

12 *A View*, 21; *Historical Account* 1782, 31; *Historical Description* 1754, 14, 54 is confused, and implies the existence of a further effigy for which there is no other evidence.

13 *Historical Description* 1754, 54, 96; *Historical Account* 1782, 31, 47.

14 T and N, 180, 183; *Historical Description* 1754, 54; see below, 105.

15 T and N, 188, 191, 195; *Historical Account* 1755, 53; *Historical Description* 1767, 75; *Historical Account* 1782, 51.

16 Neale and Brayley ii, 200.

17 Smith, *Nollekens*, 86 (I owe this refence to Dr P. Lindley); WAM Langley Collection, Box IX, 1(1). See plate 2. Though doubted by R.P. Howgrave-Graham, 'The earlier royal funeral effigies', *Archaeologia* xcviii 1961, 159, their presence there is confirmed by Neale and Brayley ii, 96, and John Wallis, *London: Being a Complete Guide to the British Capital . . .* (1814), 85.

18 Vertue, 157–8.

19 Hope, pl. LXIV no. 3, LIX; see below, pls. III, VII.

20 Hope, pls. LXI, LX; see below, pls. 4, 5.

21 Hope, pl. LXIV no. 1; see below, pl. VI.

22 Vertue, 158.

23 Hope, pl. LXV nos. 1, 2.

be Edward III, with robes to suit the period; he was described by Vertue as 'his head plaster some of his hair black, and long beard still on. His nose long. On his shoulders ermine.'[24] The fragments which Carter shows on the floor include the shield, helmet and saddle of Henry V, in front of the shield 'part of an arm, a foot, a hand and a contrivance for hipps'. 'On the ground beyond the saddle is part of a cap and a foot'. At the feet of James and Prince Henry 'is a heap of dresses that once covered these figures.'[25]

So far we have compared the eight standing figures and one head of 1786 with the collection in 1907, using the 1907 identifications. The collection had not altered significantly between those dates, and there had been little deterioration except to James and Prince Henry, and to Edward III's costume. But how do these identifications compare with the seventeenth century lists?

1606 account	Keepe 1683	1786 and 1907
Edward III	Edward III	Edward III
Philippa of Hainault	Philippa of Hainault	
		Anne of Bohemia
Henry V	Henry V	
Katharine de Valois	Katharine de Valois	Katharine de Valois
Elizabeth of York	Elizabeth of York	Elizabeth of York
Henry VII	Henry VII	Henry VII
		Mary Tudor
	Henry Frederick	Henry Frederick
	Anne of Denmark	Anne of Denmark
	James I	James I

Thus we appear to have lost Henry V and Philippa of Hainault, but gained Anne of Bohemia and Mary Tudor. Could they be different identifications for the same two objects? A glance at Hope's picture of Mary will show how easily she could be held to resemble the portly, square-faced figure of Philippa as depicted on her tomb.[26] The effigy was identified as that of Mary Tudor by Hope because of its construction and 'Renaissance' character, and this view has been adopted in this volume. The implication is that between her death in 1558 and 1606 Mary's effigy had been mis-identified as that of a queen some 200 years older. Even bolder than that would be a similar attempt to solve the other problem – that the head of Anne of Bohemia really represented Henry V, or was thought to do so by 1606. According to a contemporary chronicler the funeral effigy of Henry V was of 'boiled leather' (cuyr bouilly); John Dart was aware of this, saying 'I can't suppose it was that carried at his Funeral; for that was made of tanned leather, but this is of Wood, as are all the old ones'.[27] Vertue, on the other hand, describes the Henry V effigy as having a head of plaster, 'his nose the end broke off, just the tip only, a little thinn his cheeks . . .', terms which fit well with the head of Anne, which is

24 Vertue, 157. The clothes could well be those supplied in 1606.
25 Notes to drawing, WAM Langley Collection, Box IX, 1(1); Sir Joseph Ayloffe, 'An account of the body of King Edward the First, as it appeared on opening his tomb in the year 1774', *Archaeologia* iii, 1775, 376–413, describes an effigy of Edward I (p. 386), six feet five inches high. It is tempting to identify this with that of Edward III, though the mis-measurement seems rather great. (I owe this reference to Dr P. Lindley.)
26 Hope, 33 and pl. LXIV no. 1; see above, pl. VI.
27 Enguerrand de Monstrelet cited in Hope, 20; Dart i, 195.

made of wood covered with gesso.[28] Henry V had gone by the time of Carter's drawing, though the helm, saddle and shield associated with the funeral are still preserved, and exhibited in the Museum. We are presented with two possibilities. Either an effigy representing Henry V, but not his real funeral effigy, disappeared between 1725 and 1786; and Anne of Bohemia's head survived separately, unnoticed by the writers, which is not impossible as it is not a very prominent object. Alternatively the wooden head is a survival from Anne of Bohemia's effigy which by 1606 had been redesigned to represent Henry V. Vertue's description of the head makes the latter perhaps the more likely.

In 1769 engravings of Charles II, Monck, William and Mary, Anne, the Duchesses of Richmond and Buckingham, the Marquess of Normanby and the Duke of Buckingham were published in *A View of the Wax Work Figures in King Henry the 7th's Chapel*, drawn and engraved by James and Henry Roberts. In Upper Islip Chapel were 'two large presses, filled with the mutilated effigies of Princes, and other persons of high quality . . . some of them stripped, and others in tattered robes'. One of them was described as that of Edward VI: the eighteenth century writers are sometimes creative in their identifications. His robes 'were of crimson velvet, but now rather resemble leather'. This was probably Edward III.

By the time of Brayley's great monograph on the Abbey published with Neale's engravings in 1823, the early effigies had been returned to Upper Islip; Charles II was still in Henry VII's chapel and Buckingham in the Confessor's chapel; Monck is not mentioned; the Duchesses of Richmond and Buckingham, perhaps with Normanby, had 'recently been placed' in the north transept by the door, not far from Nelson.[29] But the drift into Upper Islip continued, the Duchesses and Nelson having been moved there by 1827.[30] The last effigies on the Abbey floor were thus those of Charles II and the Duke of Buckingham, which were still in their old places in 1836.[31] But their removal was not long delayed. A report on admission to the Abbey and the 'showing of tombs' approved by the Dean and Chapter on 26 May 1841 recommended 'that all the waxworks be removed into the Consistory Court, also the Chest with Heads etc. and not shown to the Public'; and also 'that Islip's Chapel and the Floor above be locked up'. The consistory court was what is now St George's chapel below the south-west tower. Though the effigies appear to have remained in Upper Islip, they were locked up. The first edition of the *Bell's Guide*, published in 1842, states that 'the wax and wooden figures of our kings and queens' were in Upper Islip: 'they are no longer shewn'.[32]

The reason for locking them away was probably a growing feeling of inappropriateness heightened by a current of public criticism traceable in the eighteenth century, which period was also the heyday of their career as exhibition objects. In the late seventeenth century the 'Gentlemen of the Choir' were assigned the fees from showing the monuments, and it was the men of the choir, the minor canons and the vergers who thereafter depended on the admission money for their livelihood. It was they who paid for the refurbishment of Queen Elizabeth's effigy, and the creation of the other ones made for display; this is the reason why detailed documentation of the history and restorations is not to be found among the formal records of the

28 Vertue, 157.
29 Neale and Brayley ii, 29; i, 61 (Buckingham), 71 (Charles), ii, 109–1 (Islip), 200 (Nelson). The duchesses were still in Henry VII's chapel in 1815: Nightingale, *London and Middlesex*, 77.
30 *Historical Description* 1827, 61.
31 *Historical Description* 1836, 26, 44–5.

32 Felix Summerly, *A Hand-Book for the Architecture, Sculptures, Tombs and Decoration of Westminster Abbey* (Geo. Bell, 1842), 98. Public access was apparently not continuous in the eighteenth century: Vertue, 157, says the effigies in Upper Islip were 'of late years nailld up and not shown'.

Dean and Chapter, but only in the more haphazard records of the Precentor and the choir.[33] The end of this aspect of the old régime came when the Dean and Chapter introduced a new scheme for paying the minor canons, choir men and sacrists in 1826, the admission money going into a fund for cleaning the monuments and paying 'Shewers'.[34] This is surely the reason behind the removal of the effigies from the north transept at about that date. The criticism goes back at least to Horace Walpole ('the Abbey would still preserve its general customers by new recruits of waxen puppets'), and was forcibly expressed by the sculptor Nollekens: 'I wonder they keep such stuff . . . Oh dear, you should not have such rubbish in the Abbey!'[35] It seems to have been in the eighteenth century that the early effigies came to be called the 'ragged regiment', the phrase being used by Vertue and Carter.[36] Later, Dean Stanley was well aware of the historical interest of the genuine funeral effigies, but felt that making waxworks to attract visitors was 'ludicrous and discreditable'.[37]

It is worth pausing to note that the top of the large press containing the 'ragged regiment' was formed by the thirteenth century panel painting known as the Westminster Retable. It was first recognised as an object of interest by George Vertue in 1725, who described it as part of 'one large press made in Q. Elis time not earlyer.'[38] It seems likely that this was the press made in 1606, which was still standing there with more or less its original contents. In this way what was left of the retable, like the effigies, escaped the iconoclasm of the Cromwellian period. But during the eighteenth century it fell victim to its new role, the display being changed as more new effigies were made for exhibition. In 1778 that of William Pitt was installed at one end of the old press, perhaps with a partition, and his part of the press painted white. By 1786 the 'ragged regiment' had been moved to Henry V's chantry, part of the case was empty, and part still occupied by Pitt.[39] The press was finally broken up and the retable rescued by Edward Blore in 1827.

Though locked in Upper Islip by 1842 the effigies nevertheless appear to have been accessible to at least some visitors during the later nineteenth century, but it was certainly a quiet period in their history. More interest began to be taken in them during the time when Armitage Robinson was Dean (1902–11). In 1905 the earlier effigies were photographed by Sir Benjamin Stone, and the work begun by a committee appointed by the Society of Antiquaries which resulted in Sir William St John Hope's article of 1907, published with a note on the tradition of identification by the Dean. The Dean was already planning the foundation of the museum, which was installed in the undercroft with the aid of a benefaction in memory of J.T. Micklethwaite, formerly Surveyor of the Fabric of the Abbey. The new museum was opened in 1908. Some of the early effigies were displayed there, but the wax effigies remained in Upper Islip.[40] In 1933–6 the wax effigies were cleaned under the supervision of the Victoria and Albert Museum, giving the opportunity for research on them which resulted in Tanner and Nevinson's

33 T and N, 189, 190, 194.
34 WAM Chapter Minute of 24 June 1826; see also 9 May 1823 for a copy of a paper produced by the Dean for the Treasury on the history of the arrangements.
35 For Walpole see Stanley, 325 note 4; Smith, *Nollekens*, 86. See also Goldsmith's comments cited in Stanley, 323–4, and see below, 138–9.
36 Vertue, 157; Carter notes, as in note 25 above.
37 Stanley, 325.
38 Vertue, 157.
39 Pearson Marvin Macek, 'The Westminster Retable: a Study in English Gothic Panel Painting', Ph.D. dissertation, University of Michigan 1986, 21.
40 See e.g. Francis Bond, *Visitors' Guide to Westminster Abbey*, 1916 and 1929 edns, 56, 75; H.F. Westlake, *The New Guide to Westminster Abbey*, 1934 edn, 41.

article of 1934, and a series of articles in *The Times* and *The Illustrated London News*.[41] They were then returned to the Upper Islip chapel in 'dust-proof' cases.[42]

There, it would seem, the Second World War found them. The wax effigies remained in Upper Islip until in December 1941 they were disrobed and sent for safekeeping to Piccadilly Circus underground station, the clothes being stored 'separately'. The costumes of Elizabeth, William III, Mary and Pitt were found to have been attacked by moth, and were treated at the Victoria and Albert Museum in 1942.[43] Those on display in the undercroft remained there, it being believed to be a safe place. On the night of 10–11 May 1941 the Abbey and precincts were hit by two separate showers of incendiary bombs. The second shower caused fires which spread to the hall of Westminster School, directly above the museum. The Abbey staff were unable to control it, hampered by a shortage of water due to dealing with the fires started by the earlier shower of bombs. The fire brigade arrived at about 2 am, and ran a hosepipe down to the Thames. By 5.30 am, when the 'all clear' sounded, all the fires at the Abbey were under control, 'though the smouldering ruins continued to emit smoke for many hours to come.'[44] Photographs show the ruin of 'School' to have been almost complete; somehow the undercroft vaults held, but the water penetrating caused severe damage to the effigies below. They then remained in the saturated undercroft until the autumn of 1949. Lawrence Tanner later recalled 'they were in a desperate and apparently almost hopeless condition' when R.P. Howgrave-Graham 'undertook to do what he could to salvage them'.[45] 'Glued joints had separated, limbs were detached, plaster was falling off almost daily and the hay of which two bodies were partly made was wet and rotten, and contained wood-lice and maggotts.'[46] We have to thank Howgrave-Graham that we still possess so much of the earlier effigies, though a great deal was lost, notably the bodies of Henry VII and Elizabeth of York. He laboured devotedly and incessantly for two years to repair the effects of the worst single disaster the effigies had suffered.

Meanwhile the wax effigies returned in 1951, and were dressed with the aid of pre-war photographs.[47] They were put into the redesigned undercroft museum, where such as could be exhibited of the restored wooden effigies had joined them by 1953. The museum was redesigned for the Abbey's ninth centenary in 1966, and again in 1987. The remains of the effigies of James I, Prince Henry and Mary Tudor are not on exhibition, and some other fragments retained after the war are kept in the reserve collection.

41 See also Lawrence Tanner's account in *Recollections of a Westminster Antiquary* (London, 1969), 130–9.

42 Article in *The Sphere*, 26 May 1951, 307.

43 Tanner, *Recollections*, 137; WAM, schedule of war removals, December 1942; Sir C. Peers, surveyor's report, 1942.

44 'An account of the Air Raid on May 10–11th, 1941', by Canon (later Dean) A.C. Don, WAM DF.1.

45 *Recollections*, 138; R.P. Howgrave-Graham, 'Royal Portraits in Effigy: Some New Discoveries in Westminster Abbey', *Journal of the Royal Society of Arts*, 29 May 1953, 465–474, and 'The Earlier Royal Funeral Effigies: New Light on Portraiture in Westminster Abbey', *Archaeologia* 98 (1961), 159–69, outline his restoration. His detailed notebook is WAM 64922.

46 Howgrave-Graham, 'Royal Portraits', 466.

47 Tanner, *Recollections*, 137–8.

CATALOGUE

OF THE

EFFIGIES

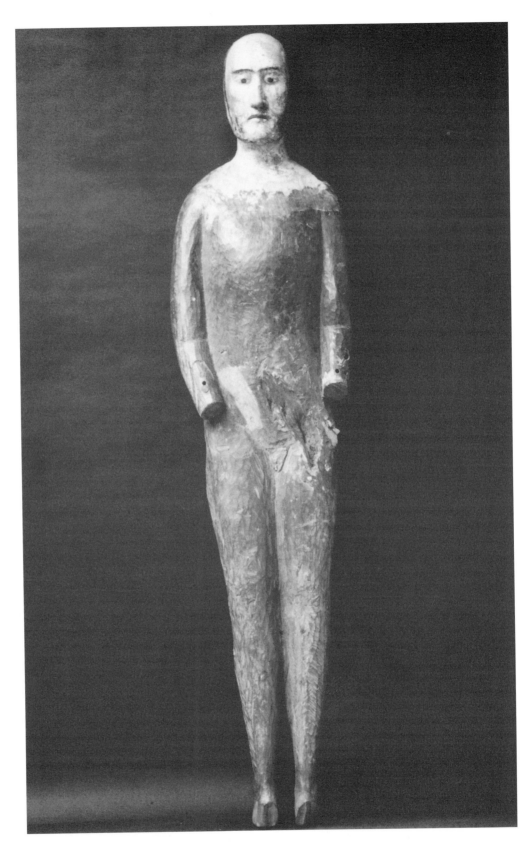

3. Edward III

I. EDWARD III

King Edward III died at his palace of Sheen on 21 June 1377.[1] It is unfortunate that there appears to be no detailed contemporary description of his funeral ceremonies, because Edward's funeral effigy is the first that survives to us from the middle ages.[2] The expenses for the funeral are, however, listed in a Wardrobe account now in the Public Record Office, and they show that the substantial sum of £21 was paid to one Roger Chaundeler, citizen of London, for embalming the defunct monarch's corpse.[3] A torch-lit procession of poorfolk bearing torches accompanied the coffin on its journey to St Paul's, where a hearse costing £11 had been prepared. A far larger sum (£59 16s 8d) was expended on what must have been a bigger and more splendid hearse at Westminster Abbey, where the funeral took place on 5 July. A further £22 4s 11d were paid to Stephen Hadley:

> for making an image in the likeness of the king, a sceptre, an orb, a cross with a crucifix of silver gilt, and various other work done by him about the preparation of the lord king's body before the day of burial.[4]

As Lawrence Stone remarks, the Stephen Hadley to whom the money for Edward III's effigy was paid was not the actual sculptor but the member of the king's household who paid the unknown artist.[5]

Although this account does not specify the material of which the funeral effigy was to be constructed, there can be little doubt that the latter is to be identified with the surviving effigy of a man 5ft 10½ inches high, cut out of one piece of wood, apparently walnut, and very much hollowed out at the back. The traditional identification of the image as the funeral effigy of Edward III is supported by the strong resemblance between the face of the figure and that of the gilt-bronze effigy on the king's tomb.[6] The lost funeral effigy of the king's murdered father,

1 *Calendar of Close Rolls 1377–81*, 74
2 See P.G. Lindley, 'Ritual, regicide and representation: the murder of Edward II and the origin of the royal funeral effigy in England', in idem, *Gothic to Renaissance: Essays on Sculpture in England* (Stamford 1995), 97–112.
3 'Compotus Ricardi de Beverlee', PRO, E101/398/9, fos 27v–28r; E101/495/1, mm 1–2 mentioned in *HKW* ii, 997 n9 is part of a separate account, of the keeper of the king's works at Sheen, Eltham and Rotherhithe, Robert Sibthorpe, and provides extra information. See also W.M. Ormrod, 'The personal religion of Edward III', *Speculum* 64 (1989), 877
4 PRO E/101/398/9, fo 27v. Stephano Hadle pro factura unius ymaginis ad similitudinem Regis, uno sceptro, una pila, una cruce cum cruxifixo argentea deaurata et aliis diversis custubus per ipsum factis circa preparacionem corporis ejusdem domini Regis ante diem sepulture.
5 Stone, 264 n59. Hadley turns up as a valet of the household in various administrative sources including the issue roll concerning the payment to John Orchard for the additions to Queen Philippa's tomb in 1376; as Prof. Mark Ormrod remarks (personal communication 9 May 1990), the fact that he occurs again in relation to an artist suggests that he might have had special responsibilities for such matters.
6 The artist responsible for the latter is also unknown although a strong candidate is the London-based coppersmith, John Orchard. For the wood of the funeral effigy see Howgrave-Graham, 'Royal portraits', 474 and WAM 64922, fo 4v.

Edward II, had also been carved from wood, as is proved by a reference in the surviving accounts for his funeral.[7]

The head and neck of Edward III's funeral effigy are covered with gesso, which retains traces of polychromy, possibly the original paintwork.[8] (St John Hope believed that the funeral effigy was repainted in 1395, but the account which he quotes could refer instead to the famous painted portrait of Richard II in the Abbey: it is difficult to see why the funeral effigy should have been repainted.[9]) There are marks where a beard has been attached by some adhesive, and the head was once covered by a wig and crown; this explains why no ears were carved for they would not have been visible. The few surviving eyebrow hairs were analysed by Dr H.S. Holden, of the Metropolitan Police Laboratory, who reported that they were those of a small dog. The arms and legs are carved integrally with the trunk, but the (separately carved) hands are gone and the feet are broken. Overall, the carving of the figure is rather crude because it was to be covered with clothing and other accessories. Indeed, in 1907 there still remained the canvas foundation of a mantle of red velvet and the remains of a tippet of miniver.[10] Unfortunately, none of the other accessories mentioned in the accounts survived.

During its slow drying out after saturation in the Second World War, the paint and plaster peeled off and blistered. Howgrave-Graham, whose conservation and restoration work preserved the early effigies, stated that the deterioration of the polychromy of the head was more serious than with any other effigy. During conservation work he made the discovery that a plaster mask of the king's face had been fixed to the wooden core of the head.[11] The oddity of this construction is perhaps the strongest argument in favour of the belief that this mask is in fact

7 E101/383/3 m6: 'Item cuidam Magistro cindenti et formanti quamdam ymaginem de ligno ad similitudinem dicti domini Regis Edwardi deffuncti ex convencione in grosso xls'. See also S.A. Moore, 'Documents relating to the death and burial of King Edward II', *Archaeologia* 50 (1887), 215–26.

8 The polychromy has not been examined scientifically and it is possible that original paintwork is covered by a later retouching such as that recorded in 1606 (there is no evidence, though, that this image was one of those retouched).

9 Hope believed that the image 'ad similitudinem unius Regis' referred to in 1395 was identical with the image 'ad similitudinem Regis' made in 1377. He therefore took both references to apply to the funeral effigy of Edward III (Hope, 533). Quite why Richard should have wanted his grandfather's funeral effigy repainted is extremely unclear unless the funeral effigy had been placed on a temporary tomb for Edward III (the present tomb-chest was only constructed in 1386), an arrangement, Prof. Ormrod suggests, which could possibly be depicted in the Litlyngton Missal of 1383–4 (Westminster Abbey Library, MS 37). Hope, 564, indeed suggests that funeral effigies may have been laid on graves after the funeral until permanent monuments were constructed. E.W. Tristram, *English Wall Painting of the Fourteenth Century* (London

1955), 197, took the 1395 reference to apply to Richard II's Abbey portrait. This has been disputed by A. Simpson, *The Connections between English and Bohemian Painting during the Second Half of the Fourteenth Century* (New York 1984), 175, (who follows the, certainly wrong, translation in F. Devon, *Issues of the Exchequer* (London 1837), 262), and implies that the portrait of Richard II antedates December 1395, and by F. Hepburn, *Portraits of the Later Plantagenets* (Woodbridge 1986), 20 n29. The curious fact that the old formula specified that the image was made 'ad similitudinem *unius* regis,' might suggest that neither the funeral effigy of Edward nor the painted portrait of Richard II is intended, though imitation of living reality seems to be implied by the use of the verb 'contrafacere' in the 1395 account and on balance I favour Tristram's suggestion (actually first advanced by William Burges). Binski, *Westminster*, 197, suggests that the effigy was used at anniversaries of the king's death.

10 The draperies, which were 'of special value for their rarity', had, so far as knowledge of their history goes back, always been attached to this figure: they must be those shown in Carter's drawing, where the effigy is readily recognisable on the left.

11 George Vertue mistakenly thought the whole head was made of plaster: Vertue, 157.

a cast taken from a death mask of Edward III.[12] The distortion on the left side of the mouth may actually reveal the effects of the stroke which killed the king. As it dried out, the mask almost completely separated from the rough basis of plaster-on-wood; a large area of the head and part of the cheek had disintegrated, and there was a tear round the chin 'with powdered plaster running out and linen protruding, though the whole vital but fragile death mask was intact'. The conservation work and cleaning which rectified this damage also revealed 'red cheeks and lips, painted eyes and dark colouration round head and face due to some adhesive substance used for the wig and face hair. The lost areas were replaced and painted to agree with their surroundings without being deceptive. One or two tiny remaining hairs were golden brown.'[13] There were fragments of sea-grass on the back of the head, apparently the only remnants of the pillows on which the figure once lay.

What Howgrave-Graham's conservation work revealed, in short, was that the funeral effigy achieved its verisimilitude through the employment of a death mask. The image of the *dead* king, though, is explicitly contradicted by the fact that Edward's eyes are shown open, as if he were alive. This contradiction should doubtless be understood in terms of the English medieval convention of depicting tomb effigies with their eyes open: tomb effigies with the eyes shut, as for instance in the mid-thirteenth century figure of a priest at Little Steeping, Lincolnshire, are very rare.[14] If the effigy of Edward III incorporates a death mask, it has to be understood, in some sense at least, as a deliberate portrait, directly representing the actual appearance of Edward III after his death.[15] Of course, the drive towards a realistic likeness of the king, which the constructional techniques reveal, is partly a direct result of the function of the effigy as a substitute for the actual corpse of the deceased, now contained in the coffin on which the effigy was placed: the wooden funeral image of Edward II, probably the first funeral effigy in medieval England, seems also to have been a deliberate portrait of the deceased rather than a more generalised image of a king.[16] However, the concern to provide a realistic representation results from a confluence of the functional reasons for the effigy with the new attention to naturalistic

[12] R.E. Giesey, *The Royal Funeral Ceremony in Renaissance France* (Geneva 1960), 204, who doubts that Edward III's effigy features a death mask, does not account for this oddity of its construction.

[13] R.P. Howgrave-Graham, 'Royal effigies at Westminster Abbey', *Country Life* (11 January 1952), 82; see also 'Royal portraits', 468, and 'New light', 160–62. Interestingly, Vertue described this effigy as having 'some of his hair black, & long beard still on. his nose long' (Vertue, 157). The hair and beard had disappeared by 1786, when Carter depicted the effigies.

[14] Compare also the effigies of the Saxon bishops at Wells Cathedral, for which see J.A. Robinson, 'Effigies of Saxon bishops at Wells', *Archaeologia* 65 (1914), 95–112, pls. VIII–XI; Stone, pl. 79.

[15] This involves slightly altering the definition of portrait offered by A. Martindale, *Heroes, Ancestors and the Birth of the Portrait* (Maarssen 1988), 30, as 'a life-like charac-

terisation of the face of a living person presented as a self-contained image'. It is clear that the funeral effigy offers a portrait *after* death, but the eyes of the effigy are shown open, as if Edward III were still alive.

[16] Hope suggested (p. 527) that the corpse of Henry III was the first to be borne to the grave in a coffin with a funeral effigy above it. However, the document of 20 January 1276, which records the purchase of 300 lbs of wax from which Robert of Beverley was paid £3 6s 8d for making an image, probably refers to a votive figure: there is no evidence whatsoever that this was even an image of the king, let alone a funeral effigy. Edward I would have been a better candidate, but there is no unequivocal evidence for his having had a funeral effigy. The first such effigy was, very probably, that of Edward II, who died on 21 September 1327 at Berkeley Castle, but who was not actually buried in Gloucester Cathedral until 20 December 1327. See note 2 above.

representation which characterised mid- and later thirteenth century art.[17] Such copying from life lies behind the emergent interest in portraiture in the early fourteenth century.

A good deal has been written on the emergence of portraiture in thirteenth century art, but a major problem has been the lack of multiple images of an individual with which individual works could be compared, to ascertain if they really are portraits.[18] The Sienese painter Simone Martini produced what is generally taken to be the first independent portrait in the modern sense, in 1336 (a portrait of Laura for Petrarch), and the earliest extant painted portraits of medieval rulers date from mid-century.[19] In 1380, Charles V of France actually owned a painted portrait of Edward III[20] and this concern with the physical appearance of specific individuals is also revealed in the much remarked realism of Jean de Liège's alabaster tomb effigy of Queen Philippa of Hainault, for which the sculptor was paid the substantial sum of £133 6s 8d in 1367.[21] Such interests are, however, much less evident in the gilt-bronze tomb effigy of Edward III. Here, the head of the funeral effigy has been idealised, and the features of the tomb effigy's head, although recognisably similar to the death mask, have been smoothed out. A similar modification, albeit at a much more sophisticated level, is discernible in the changes made by the Florentine sculptor Pietro Torrigiano to his funeral effigy of Henry VII, which also features a death mask, in producing the blander and idealised tomb effigy of the Tudor monarch.[22] This suggests that a highly developed realism, which would anyway have been difficult to render in gilt-bronze, may have been considered undesirable for such tomb-effigies. Their public, long-term, propagandistic functions tended to exclude the detailed portraiture which some of the funeral effigies undoubtedly reveal.

PL

CONSTRUCTION

This is a hollow wooden effigy in remarkably good condition and shows little sign of insect attack. Howgrave-Graham states the wood is walnut, identified by the Forest Products Research Laboratory at Princes Risborough.

The head and neck are the only areas to retain pigment. This is much restored though there is clearly a substantial amount of original paint remaining.

There is a joint around the face and the front of the ears. There are substantial fillings in the forehead and front crown. There are holes drilled in the wrists possibly for the attachment of hands.

JL

17 Martindale, *Heroes*, 24; Camille, 211–13.
18 This objection must be raised, for instance, to the interesting study of S. Whittingham, *A Thirteenth Century Portrait Gallery at Salisbury Cathedral* (Salisbury 1979).
19 Martindale, *Heroes*, 31.
20 J. Labarte, *Inventaire du Mobilier de Charles V, Roi de France* (Paris 1879), 242.
21 The queen, in whose lifetime the effigy was carved, is shown not so much as an idealised woman in the prime of life, as Edward I's wife

Eleanor of Castile had been in her gilt-bronze tomb effigy, but rather as a middle-aged woman. See J.G. Noppen, 'A tomb and effigy by Hennequin of Liège', *Burlington Magazine* 59 (1931), 114–17 and Stone, 192. For Jean de Liège see also *Les Fastes du Gothique: le Siècle de Charles V*, Exhibition catalogue, Paris 1981, nos. 65–7, 70, 78.
22 C. Galvin and P.G. Lindley, 'Pietro Torrigiano's portrait bust of King Henry VII', *Burlington Magazine* 130 (1988), 892–902.

CONSERVATION

1949–50 Plaster reattached to wooden core of head by injection with synthetic resin and shellac; paint stabilised and cleaned; parts of right cheek, left eyeball and nose filled with plastic wood and coloured (Howgrave-Graham). RM

II. QUEEN ANNE OF BOHEMIA

Richard II's first wife, sister of the Emperor Wenceslas, died at Sheen on 7 June 1394, but her funeral did not take place until 3 August, apparently to give time for the preparations for the splendid and expensive ceremony.[1] The funeral itself was marred by Richard's striking the Earl of Arundel across the face for showing insufficient respect for the corpse, an incident which has been used to indicate Richard's violently distraught temperament.[2] Of a piece with this behaviour is the king's 'romantically morbid' gesture of ordering the palace at Sheen in which Anne had died, a house which had been one of his favourite residences and which had been extensively rebuilt by Edward III, to be demolished.[3]

There can be no doubt that an effigy was carried in the funeral procession, as is proved by an entry in the Issue Roll for Easter, 17 Richard II:

> In denariis solutis pro batilagio et cariagio ymaginis ad similitudinem Anne nuper Regine Anglie facte videlicet de London usque Shene per consideracionem Thesaurarii et Camerariorum, iiis.[4]

Dr John Harvey discovered, in a Foreign Account roll, a reference to Roger Elys which indicates that the latter supplied the funeral effigy of the queen:[5]

> Idem computat in una cista xx ulnis panni lin' et xxxlb cere pro eisdem incerandis ac aliis expensis necessariis per ipsum factis circa corpus dicte nuper Regine sepeliendum prout moris est pro huius persona facienda una cum cariagio earum rerum de London usque manerium de Shene £xv viijs iiijd.

Howgrave-Graham interpreted the 'persona' as a wax death-mask.[6] Its inclusion in payments to Elys, a London tallow-chandler, need not, however, necessarily indicate that the 'persona' was made of wax; nor is it at all clear that the 'persona' should be interpreted as a death mask (although, as examination of Edward III's effigy has revealed, death masks could be employed for funeral effigies.)[7] More probably, the 'persona' may indicate the whole funeral effigy, which Elys may well have supplied but need not have fabricated himself. Even if the 'persona' was a wax death mask, it was not itself incorporated into an effigy's head and could only have served as a model for the sculptor.[8] This is evident because a head, generally identified as that of Queen Anne's funeral effigy, still survives. It is made of oak, not wax, and has been broken off a

1. F. Devon, *Issues of the Exchequer* (London 1877), 255.
2. For this incident see H.T. Riley (ed.), *Johannis de Trokelowe et Henrici de Blaneforde, Monachorum S Albani, necnon quorundam anonymorum, Chronica et Annales* (Rolls Series, London 1866), 168–9, 424.
3. *HKW* ii, 998.
4. PRO E 403/548, m11.
5. I am indebted to Dr Harvey for this reference (personal communication 9 May 1990). His discovery is mentioned by Howgrave-Graham, 'New Light', 162. For Elys, see M.F. Monier Williams (ed.), *Records of the Worshipful Company of Tallow Chandlers, London* (London 1897), 98.
6. Howgrave-Graham, 'New Light', 162.
7. See the essay on Edward III's effigy, above 30–32.
8. Howgrave-Graham, 'Royal Portraits', 468.

hollowed trunk, like that of Edward III's figure.[9] The head has well modelled ears, and is covered with gesso and painted. The tip of the nose, which was already missing in the eighteenth century, was renewed during the conservation work by Howgrave-Graham. On either side behind the ears are the remains of carved hanging plaits of hair. On the top is fixed a large nail, around which dark brown human hair used for the wig was discovered (evidently a combination of carved and real hair was used) and there is also a large round hole for hollowing out the head.[10]

Anne of Bohemia's head is described by Howgrave-Graham as 'the least precise portrait' of those which survive, perhaps because the stylised oval shape of the head struck him as 'unrealistic'.[11] However, within the stylistic canons of the period, it appears to be an attempt to reproduce the actual appearance of a young woman (Anne was twenty-eight when she died) in death. The face is long and narrow, and this may be partly the result of sculptural convention, but it also powerfully conveys the impression of a corpse even though the eyes are carved open; additionally, the carved plaits of hair were evidently supplemented by a wig and this may have framed the face, lessening its narrowness. By the late fourteenth century portraiture in the modern sense was increasingly common, and it is difficult to believe that Richard, whose interest in portraiture is well documented, would have been content with only a vague resemblance to his deceased wife.[12] Anne of Bohemia seems, indeed, to have been the first queen consort to have been commemorated with a funeral effigy carried at her funeral, and the extension of this custom to his late queen must have been a decision of Richard's. It is probable that her effigy was deliberately modelled on her appearance.[13]

The style of this head has been compared by St John Hope with that of the gilt-bronze tomb effigy in the Abbey ordered by Richard II from the London coppersmiths Nicholas Broker and

9 The head is evidently that mistakenly identified by Vertue as that of Henry V (Vertue, 157): 'King henry 5. his head bald (of. plaister) – his nose the end broke off. just the tip only. a little thinn his cheeks as taken from a face some what wasted by sickness'. Vertue mistook the material of which the head was made – easy enough to do in view of the light-coloured paint with which it is covered – but his description otherwise suits Anne's head, as seen in 1907, so closely that it must be presumed that this is the head he was describing (the carved plaits of hair at the back of her head are easily overlooked). Presumably, this also explains the occasional references in antiquarian sources to a wooden image of Henry V, whose funeral effigy was, in fact, of boiled leather (the Abbey account of 1606 also mentions an effigy of Henry V): see Katharine de Valois, note 2 below.

10 Howgrave-Graham, 'New Light', 164 for the wig hair.

11 Howgrave-Graham, 'Royal effigies at Westminster Abbey', *Country Life* (11 January 1952), 83.

12 The gilt-bronze tomb effigies of Richard and Anne furnished by Nicholas Broker and Godfrey Prest were specifically made in the

likeness of the king and queen: 'l'une Ymage conterfait le corps de nostre dit Seignur le Roy, et l'autre conterfait le Corps del tresexcellent et tresnoble Dame Anne.' (T. Rymer, *Foedera* (London 1709), vii, 797). For the larger context of Richard's interest in portraiture, see *The Age of Chivalry: Art in Plantagenet England*, Exhibition Catalogue, London 1987; J.H. Harvey, 'The Wilton Diptych – a re-examination', *Archaeologia* 98 (1961), 1–28; G. Mathew, *The Court of Richard II* (London 1968); F. Hepburn, *Portraits of the Later Plantagenets* (Woodbridge 1986).

13 It must be admitted, though, that the effigy head fits the description of Philippa of Hainault given by Bishop Stapeldon remarkably well: he reported to Edward II that 'her head is clean-shaped; her forehead high and broad, and standing somewhat forward. Her face narrows between the eyes, and the lower part of her face is still more narrow and slender than her forehead' (Stapeldon's register quoted by G.G. Coulton, *Medieval Panorama* (Cambridge 1949), 644). However this description of her as a young woman differs from the matronly image produced for her tomb effigy by Jean de Liège and there is no evidence anyway that she had a funeral effigy.

Godfrey Prest.[14] It has a similarly oval-shaped head, narrow mouth and almond-shaped eyes, though the handling of the eyes and the narrowness of the lower face are rather different from the tomb effigy. It seems unlikely, therefore, that the sculptor of the funeral effigy was responsible for the 'patron' (possibly a painted or drawn design rather than a wooden three-dimensional model) employed by Broker and Prest for the tomb effigy.[15]

PL

CONSTRUCTION

The head and a fragment of neck remain. It is painted wood, probably oak. The head is carved hollow and there is a round hole approximately one inch in diameter in the top of the cranium.

Much of the original polychromy remains on the head and face. However it is much abraded and in many places only the gesso remains. The eyes and lips are painted, but this may not be original. Traces of eyebrows also remain.

There is a large iron nail-head in the upper forehead which may have been part of the fixing for a wig or crown. Some hair is carved into the wood at the back of the head and the wig would have been laid over this. There is very little evidence of any insect damage.

JL

CONSERVATION

1949	Cleaned and waxed; tip of nose made up with dowel and plastic wood, and coloured (Howgrave-Graham).

RM

[14] Hope, 549.

[15] Howgrave-Graham, 'New Light', 164 states that Broker and Prest's work is inferior, pointing out that Richard and Anne's heads 'are very large indeed, and out of proportion to the heights of the figures unless he was very short'. He conjectures, however, that the funeral effigy head was probably the model for the later sculptors. For the tomb, see now Binski, 200–2, and Lindley, 'Absolutism'.

III. QUEEN KATHARINE DE VALOIS

The third extant funeral effigy is the one traditionally identified as that borne at the funeral in February 1437 of Henry V's Queen, Katharine de Valois. As yet no accounts for its construction have been discovered. Although four other monarchs or their consorts had died since the funeral of Anne of Bohemia, only Henry V was also certainly commemorated with a funeral effigy. The circumstances of King Richard II's death were such that no effigy was required for his funeral for, according to the chronicler Thomas of Otterbourne, Richard's corpse was exhibited from Pontefract to London with the face bare 'from the lowest part of the forehead to the throat' and the rest of the body encased in lead.[1] There are no accounts of the funerals of Henry IV and Queen Joan of Navarre at Canterbury, but at King Henry V's funeral in 1422 a funeral effigy was employed.[2]

The 5ft 4ins high funeral figure of Queen Katharine is carved from a single piece of wood, apparently oak, and is hollowed out at the back in a manner similar to that of Edward III's funeral figure. This technique is generally employed in wood sculpture to help minimise warping and cracking, but in view of the function of this image there can be little doubt that its primary purpose was to make the effigy less heavy to carry. The head and neck are well modelled, and the ears are carved; round the skull is a groove for a wig and crown to be added. Uniquely, the body is shown covered by a tight-fitting dress, cut square at the neck, and painted throughout a bright vermilion. The right arm is broken away below the shoulder and though the left arm is slightly raised, at her side, the separately carved hand is gone. The shoes protrude from under the dress and bear traces of gold and colour although the leading surfaces have been broken off. The tip of the nose has been replaced.[3]

After the effigy's saturation in World War II, paint started to peel off in strips as the wood dried, but the losses were arrested by Howgrave-Graham's conservation work. The latter's opinion of the effigy seems to have changed somewhat. In 1952 he wrote, 'of the determined efforts to produce life-like portraits, Katharine's effigy was the least successful',[4] but nine years later he was to state that 'Katharine's pathetic face shows clearer signs of derivation from a death-mask than do the other carved heads. The mouth is small and the eyelids are heavy. Apart from the artist's poor success in escaping from post-mortem appearances, the dead face has beauty as well as pathos'.[5] Perhaps these two accounts can be reconciled by emphasising that the figure is intended to represent the queen's corpse, although the eyes, as is the case with all the

[1] T. Hearne (ed.), *Chronica Regum Angliae, per Thomam Otterbourne* (Oxford 1732) i, 229.

[2] H.T. Riley (ed.), *Thomae Walsingham, quondam monachi S. Albani, Historia Anglicana* (Rolls Series, London 1864) ii, 345–6. This lost figure is described by the contemporary French chronicler Enguerrand de Monstrelet, as made of boiled leather: 'une resemblance, et representation de cuyr bouilly painct moult gentillement, portant en son chief couronne d'or moult precieuse, et tenoit en sa main dextre le sceptre ou verge Royalle, et en sa main senestre avoit une pomme d'or' (*Chroniques d'Enguerran de Monstrelet* (Paris 1596) i, 325b). This material rules out the possibility of its having been reused for the surviving core of Henry V's silver-gilt tomb effigy.

[3] Howgrave-Graham, 'New Light', pl. xlix for photographs during and after conservation.

[4] Howgrave-Graham, 'Royal effigies at Westminster Abbey', *Country Life* (11 January 1952), 83.

[5] Howgrave-Graham, 'New Light', 164.

medieval funeral effigies, are shown open. In December 1418, at a conference held at Pont de l'Arche, a portrait of Katharine was brought by a French embassy to Henry V, 'la figure painte au vif de Madame Katherine, la noble fille royalle, laquele fut presentee au roy Henry et luy pleut moult bien.'[6] Sadly neither this nor any other authentic portrait of the queen survives, so it is impossible to judge the accuracy of the funeral effigy's portrayal.

The sculpted clothing of this effigy is somewhat surprising, since there is no doubt that it was to be covered in the queen's own garments: indeed, the heads of the nails used to attach this clothing can still be seen, round the edge of the dress. This feature does, however, permit a comparison with the sculptures of Henry V's chantry chapel in the Abbey; the proportions of the figure, the turn of the head with its broad forehead, rather severe features and long neck, together with the long straight folds of the heavy cloth turned over the feet, can be paralleled in some of the chapel's most simply draped imagery.[7] This suggests that the effigy can be attributed to one of the sculptors who was later responsible for the stone imagery of Henry V's chantry chapel and perhaps also for the wooden core of Henry V's tomb effigy.[8]

A further consideration which is suggested by a comparison of Katharine's funeral effigy with the two previous ones, and with the next two which survive, is that the techniques for the manufacture of these early effigies varied remarkably. Each sculptor or team of artists responsible for an effigy evidently adopted a different technique, and this highlights the fact that these were in every sense extraordinary figures for unique and infrequent occasions. In this case, the sculptor had produced an image of a type familiar to him from the carving of female saints to stand in architectural niches. There is often a tension in Northern Gothic funerary sculpture between the recumbency of the effigy and the verticality generally implied by the manner in which the figure is carved.[9] It can be readily seen that the funeral effigy of Katharine de Valois would be suitable to stand in a niche; there is little to distinguish it from conventional niche statuary, although almost all comparable images in wood were destroyed at the Reformation.

PL

CONSTRUCTION

The effigy is of a full figure and head with the right arm missing and damaged feet. The whole figure is carved from one piece of wood (probably oak) and the marks of wood gouges can still be seen in the back. The wood is hollowed to an average thickness of about one inch.

There appears to be no evidence of insect attack and apart from some longitudinal cracking the wood is in excellent condition. The top of the head has a deep encircling groove in the wood which probably held a crown or wig band in place.

The paint on the face and neck appears to be mainly original. However it has flaked a great deal and has been restored in places. The figure wears a red garment (the red is painted over a gesso).

6 W. Hardy (ed.), *Recueil des Croniques et Anchiennes Istories de la Grant Bretaigne, par Jehan de Waurin* (Rolls Series, London 1868) ii, 252.

7 E.g. A. Gardner, *English Medieval Sculpture* (Cambridge 1951), fig. 472.

8 For the dating of this chapel's imagery see

W.H. St John Hope, 'The funeral, monument and chantry chapel of King Henry the Fifth', *Archaeologia* 65 (1914), 130–86; *HKW* i, 489; Stone, 205.

9 E. Panofsky, *Tomb Sculpture* (London 1964), 55–7.

There are many nail-heads visible on parts of the shift and these indicate the attachment of other items of costume made of metal.

JL

CONSERVATION

1950–1 Cleaned; paint consolidated and retouched in places; nose added (Howgrave-Graham).

RM

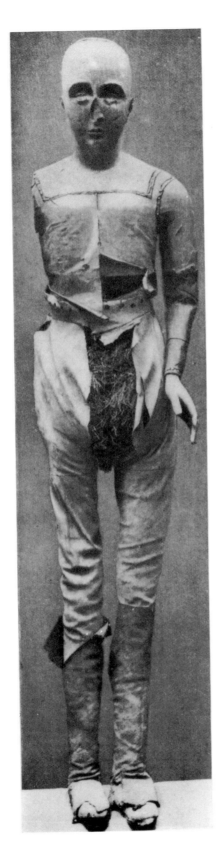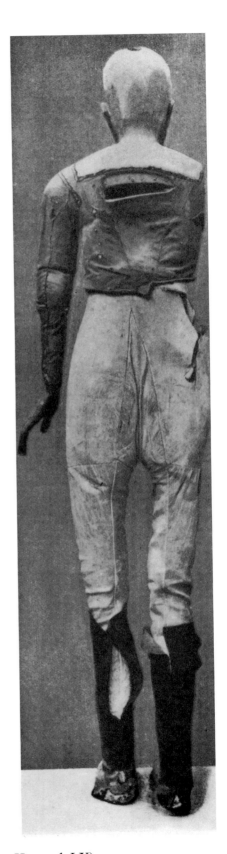

4. Elizabeth of York, body before destruction (from Hope, pl. LX)

IV. QUEEN ELIZABETH OF YORK

The fourth surviving figure is that of Henry VII's wife, Elizabeth of York, who died on 11 February 1503. The only king or queen whose funeral featured an effigy between that of Katharine de Valois and Elizabeth was Edward IV, who died in the palace of Westminster on 5 April 1483 and was buried at Windsor in the splendid new chapel he had constructed.[1] His funeral image has, however, unfortunately disappeared without trace, and there is no known record of the expenses for its construction.

When St John Hope described Queen Elizabeth's effigy, it consisted of a nearly complete figure of a woman, 5ft 11½in tall. Its construction differed markedly from the three effigies previously described, comprising a wooden head and bust with wooden arms jointed at the elbow, and the rest of the body formed partly of hoops, partly of a covering of leather stuffed with hay, and extending from the bust, round the lower edge of which it was nailed, to the feet. The legs, cased in dark cloth stockings up to the knees, were formed around two long pieces of fir, passing up into the bust. The feet were damaged, though still attached to the legs, but the shoes were missing. Except for the shoes, clothing and other accessories and the loss of the right arm, the effigy, although very battered, was essentially complete. However, in 1949, after saturation during World War II, it had dramatically deteriorated. It was so discoloured as to be nearly black;[2] 'the "wainscot" boards of which it was built were separated except in rather small areas, the saucer-like disc forming the back of the head being entirely detached . . . The rough hoop below the bust remained intact, but the hay stuffed lower body and legs had completely disintegrated . . .'[3] The fir poles which formed the legs had to be cut off during conservation work and the hay-stuffed body was entirely lost, although the left arm survived.[4] Today only the head, bust, arm and hand (half the forefinger had already been lost by 1907) are exhibited.

The head has two holes, a peg hole (to fix the wig?) and another for hollowing it out. The face was carefully modelled and painted. Holes for ear-rings were bored in the ears: one hole, which had been made a little too large, was packed out with wax. As Howgrave-Graham's comments reveal, the bust and the head were constructed of laminated planks which had started to separate after their prolonged saturation. The bust had been covered with white or

1 The account of the funeral, in College of Arms MS I.11, fo 85, relates how the coffin was taken to Westminster Abbey and laid within a hearse 'and in the herce above the corps was upon the cloth of golde abovesaid a personage lyke to the symilitude of the Kinge in habit Royall crowned with a crown on his heed, holding in one hand a scepter and in the other hand a ball of sylver and gylt with a cross paty'. After the service ended 'the corps with the personage' was conveyed in a chariot covered with black velvet first to Charing Cross and then to Syon, 'where at the cherche dore the bushops sensed hym and the corps with the Image as before was borne into the quere of the same churche and the bushop of

Duresme dyd the service. And on the morrow in lyke order as above was conveyd to the chariet and from thence to Wyndesor . . . and so proceeded to the new cherche wher in was ordered a marvelous well wroght herce.'

2 The nose was already missing in 1907 when St John Hope published an illustration of the figure. The nose was restored by Howgrave-Graham on the basis of those shown in painted portraits of the queen: see H. Dow, 'Lawrence Emler', *Gazette des Beaux Arts* 64 (1964), 155.

3 Howgrave-Graham, 'New Light', 165.

4 According to Dr Mortimer, the legs do not survive.

gold coloured satin, seamed and edged with red velvet and cut square across the breast and back. The left forearm was suspended from the bust and had a loose joint at the elbow; like the bust, it was covered with satin. The movable joint must have been intended to facilitate the dressing of the effigy and is the first such joint in any of the Westminster effigies. The surviving left hand is beautifully modelled but does not seem to have held anything securely, probably indicating that the sceptre mentioned below was borne in the right hand. Analysis of a small sample taken from the hand revealed that it had been carved from the pear-tree timber mentioned in the accounts below.

The remarkable interest of this effigy, aside from constructional novelties such as the jointed arms and the use of stuffed leather for most of the body, lies in the fact that it is so well documented. There are, first of all, detailed accounts of Queen Elizabeth's funeral in a College of Arms manuscript and in one of the Wriothesley manuscripts in the British Library.[5] This is the first surviving effigy for which an official account of the funeral survives. The manuscript gives details of the hearse in the Tower, where she died, and relates how on the tenth day following her death, there was a service after which

> the corps was conveyed into the chayre which was new pareled as foloeth. Furst all the baylles sydes and coffres covered with black velvet and over all along of a pretty depnes a cloth of black velvet with a crosse of cloth of sylver well frynged drawen with vj horsses traped with blak velvet and all the draught with the same and when the corps was in the same there was ordened a holly chest over yt wheron was a ymage or personage lyke a quene clothed in the very robes of estate of the quene having her very ryche crowne on her hed her here about her shoulder hir scepter in her right hand and her fyngers well garneshed with rynges of golde and presyous stones and on every end of the chayre on the cofres kneled a gentleman hussher by all the way to Westminster.

The still unpublished early sixteenth-century drawing records the appearance of the funeral car and the banners of Our Lady which accompanied it, but does not, unfortunately, show the kneeling gentlemen ushers: instead, there are small figures holding candles.[6] At Westminster

> the corps was sensed and taken out of the chare borne by soch persons as were apoynted (the) ymage and all tht aperteyneth with the foresaid banners of Our Lady and the greatest estates layinge their hands to yt was with the procession conveyd to the herce[7] and thene beganne dyrge.

After services, various palls having been offered in honour of the deceased, there followed the sermon, following which the palls were removed:

> Then the Ladyes departed after whos departyng the Image with the crowne and the riche robes were had to a secret place by St Edwardes Shryne.

5 College of Arms ms I. 11, fos 27r–32r, cited by Hope, 545–6 (his transcription is used here). See also the account in BL Add. 45131, fos 41v–47, one of the mss from the collection of Sir Thomas Wriothesley, Garter King of Arms, 1505–34.

6 BL Add 45131, ff 41v–42. I am indebted to Dr Lisa Monnas for information about this drawing.

7 The hearse 'which was curiously wrought with Imageri well garnisshed with banners and banerolles pencelles cloth of majeste with the valance ffrengid accordyng on the which was writen her words humble and tenerense garnysshid with hir armes and other hir bages' (BL Add. 45131, fo 46).

Finally the queen's body was solemnly buried, her chamberlain and her gentleman ushers breaking their rods of office and casting them onto the coffin.

In addition to this detailed account, which provides the first, albeit infuriatingly vague, information as to what was done with a funeral effigy after the funeral service, the Public Record Office houses accounts for the manufacture of Queen Elizabeth's effigy. They provide the fullest evidence we possess for the construction of a surviving pre-Reformation effigy:[8]

For the pikture	
Richard Gibson for ij waynscottes called Regall	ijs iiijd
Item for oon waynscot borde price	xd
Item for ij peces of peretre tymbre price	viijd
Item for iij Joyners for half a day and an hole night, ich of them iiijd the half day and viijd the hole night for joynyng of the waynscot to gedr	iijs
Item for glewe for the same worke price	iiijd
Item to Master Lawrence for kerving of the hedde with Fedrik his mate	xiijs iiiid
Item to Wechon Kerver and hans van hoof for kerving of the twoo hanndes	iiijs
Item for ij Joyners on friday at night to frame the body	xvjd
Item for vij small shepe skynnes for the body	ijs iiijd
Item for naylles	iijd
Item for a paire of hosen for the same	xd
Item for oon hole pece of Sipers price[9]	ijs iiijd
Item for hire of the here	vs[10]
Item for laying of the first pryme coler	iiijd
Item to Master henry for painting of the Image	iiijs
Item for making of the garmentes for laten naill	ijs iiijd
Item to John Scot for watching in the tower a night	viijd
Item to ij porters for feching of the Coffyn frome the princes warderobe	ijd
Item for ij porters to bere ye piktur to ye Tower	iijd
Item for blewe lior to bynde ye figure to ye coffyn	iijd
Item for the lior that drewe the cofyn oute of the chare price	vjd
Item for my labor and John Englissh labor	xvd [xd cancelled]
	Summa lxs
William Botry for ix yerdes crymsyn saten for a garment for the said pikture at xd a yerde	
	£iiij xs
Item a yerde i quarter blue velvett to bordure ye same garment price the yerde xs	
	xijs vid

In addition, the Heralds' College manuscript cited by Hope lists:[11]

To Richard Gybson for her pyctur makinge	£iii
To William Bottres for ix yerdes crymoysen saten & a yerd quarter of black velvet for garment to ye said pyctur	£vi ijs vjd

8 PRO LC/1/2, fos 46v–48v.
9 The 'hole piece of Sipers' may well relate to the 'unpleasant-looking fabric of dirty grey with a shimmer of yellow' which 'when cleaned, was found to be exquisite gold satin' (Howgrave-Graham, 'New Light', 165).
10 Not '10d' pace Dow, 156.
11 Hope, 551.

Richard Gibson was evidently the head of the workshop making the effigy, but the most important sculpted details – the head, bust and hands – were carved by a group of sculptors who were undoubtedly of continental origin. (The evidence that day and night work are mentioned indicates the expedition with which the whole work was undertaken.) Master Lawrence is probably to be identified with the Swabian sculptor Lawrence Emler, who tendered an estimate in 1505–6 for sculpture in connection with a tomb-project for Henry VII designed by the Italian sculptor Guido Mazzoni. Emler took out letters of denization in 1506 and had been working in London since 1492 at least.[12] Neither his mate Frederick, probably another German, nor 'Wechon' and Hans van Hoof have yet been discovered in other accounts. The last two may well have been Netherlandish artists, large numbers of whom were working in London in the late fifteenth century.[13]

The subtle and realistic portrait of the queen which the sculptors produced testifies to the burgeoning desire for portraiture in the late fifteenth century and the impact of canons of realism derived from early Netherlandish art. The face of the gilt-bronze tomb effigy by Torrigiano is clearly an idealised version of this head. Sir Roy Strong has shown that all the surviving painted portraits of Elizabeth are of one type, based on a lost original painted in the last years of her life and also employed by Holbein for his Privy Chamber wall-painting at Whitehall.[14] They show a strong facial likeness to the funeral effigy and tend to confirm its status as an extremely accurate portrait. PL

CONSTRUCTION

All that now remains of the effigy is the head and bust (to below the breasts) with arms articulated from the elbow and the left hand.

The figure is made of four planks of wood, said to be pear wood, joined together from front to back, i.e. the face is a mask; behind that is another plank part way through the ear; the back of the head is another, and another forms the back of the cranium. These divisions continue down through the neck, shoulders and torso and are clearly visible at the side of the figure. At the top of the head is a large round cavity 5–6 inches across. There are traces of nails on the top of the head which could be associated with wig fixing.

The paint on the head, neck and arms appears to be mainly original, although it has been

12 Dow, 153–60; I cannot accept Dow's dating of two images at Winchester to c.1500, nor her attribution of them to Emler. See P.G. Lindley, 'The great screen of Winchester Cathedral', *Burlington Magazine* 131 (1988), 604–15. For Mazzoni see also T. Verdon, *The Art of Guido Mazzoni* (New York 1978).

13 See S.L. Thrupp, 'Aliens in and around London in the fifteenth century', in A.E.J. Hollaender and W. Kellaway (eds.), *Studies in London History presented to P.E. Jones* (London 1969), 251–72. For some works by alien artists see M.R. James and E.W. Tristram, 'The wall paintings in Eton College Chapel and in the Lady Chapel of Winchester Cathedral', *Walpole Society* 17 (1928–9), 1–44; M. Rickert, *Painting in Britain: the Middle Ages* (Harmondsworth 1954), 201, 206–7.

M. Campbell, 'English goldsmiths in the fifteenth century', in D. Williams (ed.), *England in the Fifteenth Century* (Woodbridge 1987), 43–52, shows (44–5) that in 1469 at least 113 alien goldsmiths, of whom the vast majority were Flemish, were resident in London; between 1470 and 1477 another 94 are recorded and from 1479 to 1510 a further 319. D.R. Ransome, 'The struggle of the Glaziers' Company with the foreign glaziers, 1500–1550', *Guildhall Miscellany* 2 (1960), 12–20 for the friction caused by large numbers of alien craftsmen.

14 R. Strong, *Tudor and Jacobean Portraits* (London 1969) i, 97–8. The votive picture at Windsor is too conventionalised to have much value as portraiture (see Strong, i, 151).

much abraded and there is still some evidence of flaking. Where the bare wood is exposed, one can see that the wood was shaped with a rasp.

There are traces of material attached to the right shoulder with rivets and around the neck there are rivets and material from original dress fabrics. JL

Framed piece of satin. This is not a satin of 8 but it is difficult to see in the Museum without a twin lens microscope and a better light. It may be a satin of 5 or a slightly more irregular satin. Either way it is unlikely to be as late as 1700 but could date from either 1503 or 1603. The change in the normal satins used came in the eighteenth century. NR

CONSERVATION

1950 Remains of stuffed body discarded; head re-glued and screwed; upper arms reattached; nose added; varnish removed, paintwork cleaned and consolidated, pupils blackened; textile material taken off, cleaned and that from shoulder replaced (Howgrave-Graham). RM

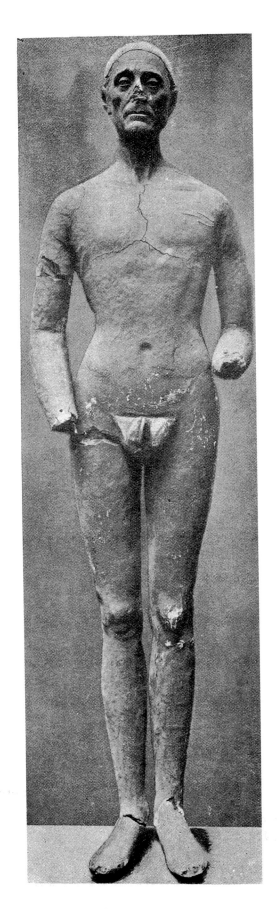

5. Henry VII, body before destruction
 (from Hope, pl. LXI)

V. HENRY VII

A manuscript account of Henry VII's funeral by Thomas Wriothesley relates how the king died on 21 April 1509 at Richmond.[1] Another manuscript describes how, on Wednesday, 9th May, the encoffined corse was taken to St Paul's, on a chariot 'covered with blacke cloth of golde. . . . Over the corps was an Image or Representacion of the late king layd on quissions of golde aparelled in his Ryche robes of astate with (the) crowne on his hed, ball and sceptre in his handes'. At the corners of the chariot walked four barons, each carrying a banner of the king's patrons – the Trinity, Virgin Mary, St George and Mary Magdalene. The coffin and effigy were placed under a great hearse at St Paul's where Bishop Fisher preached the sermon. Then they were brought to Westminster Abbey, where the funeral effigy lay on the coffin on a cloth of gold pall under a great hearse, ablaze with candles, for interment after the final ceremonies.[2] The same manuscript has a list of costs for the funeral, including an entry for

The Kinges Pyctour £vj xijs viijd

At first sight this payment appears to refer to the funeral effigy itself, but another set of accounts lists under the heading 'The Kynges pycture'

Item of Thomas Mountey ix yerdes perpill satyn for a gown for to ley upon the same pycture at xiiijs the yerde
 £vj vjs
Item to Stephen Jasper for makyng of the same gown
 vjs viijd
Summa
 £vj xiis viijd[3]

Since this cost corresponds exactly to the entry in the College of Arms manuscript for the king's 'pyctour' or funeral effigy, and because most of the other accounts for the interment of Henry VII in that manuscript relate only to fabrics (or to their making up into robes), it seems very likely that the entry relating to the effigy there also applies solely to the cost of the gown.[4] There seems, in short, to be no information about the cost of the king's effigy itself, nor of the name of the artist or artists responsible for its production. This is doubly unfortunate because the exceptionally important effigy is shown in a contemporary woodcut accompanying Bishop Fisher's funeral sermon and because it survived in very good condition up until the Second World War. The effigy's clothing (the parliament robes, as in the case of Henry V's figure, and not the coronation garments) had been lost by 1907. In that year, when St John Hope described the figure which is incontestably to be identified with that employed at Henry VII's funeral, it consisted of 'a well-modelled complete figure of a man, 6ft 1 inch high'.[5] The body was constructed on a crude wooden core, surrounded with hay padding and then covered with canvas, soaked in plaster. The head was finely modelled and painted, the skull left bare for a wig; the body too had been painted and was of a greyish colour. The left hand, which was loose, was modelled on a

1 S.J. Gunn, 'The accession of Henry VII', *Historical Research* 64 (1991), 278–88. BL MS Additional 45131, ff. 52v–53r. For details of the funeral ceremonial see Fritz, 61–79.
2 College of Arms MS I 11, fo 86b; see also Fritz, 61–79 and S. Anglo, *Images of Tudor Kingship* (London 1992), 100–4.
3 PRO LC 2/1 pt 1, fo 97r.
4 Howgrave-Graham, 'New Light', 166, seems to have believed that the image and robes cost exactly the same amount.
5 Hope, 551.

wire foundation, and was hollowed as if to support the orb. The right hand, which presumably held the sceptre, was already broken off and lost. The feet, too, were broken off but still survived. As St John Hope justly observed, 'the work is Renaissance and that of a master, most likely an Italian.'[6]

This effigy, like that of Henry's consort, suffered particularly badly from the effects of saturation in the Second World War and Howgrave-Graham was able only to salvage the wooden armature, head and feet from the decaying mass: 'the body had entirely disintegrated into a mere confused heap of plaster, canvas, hay and wood',[7] It could now be seen that the hay which formed the bulk of the figure had been wrapped around large nails protruding from the armature, and that layers of canvas, linen and plaster had been used to model the exterior form 'in a better style than was essential for the subsequent dressing'.[8] This is to understate the extraordinary sophistication of this effigy which, before its damage, must have possessed a remarkable realism, comparable in effect to late fifteenth century Italian votive figures, which were constructed with closely comparable techniques.[9] It is regrettable that today, besides the bust (which remains in very good condition), only the legs, backplate, cross-member and iron wire armature of the right arm, and one foot (the other appears to have been mislaid since the 1950s) survive.

Both Howgrave-Graham's conservation work and recent study at the Victoria and Albert Museum have revealed a great deal about the construction of the effigy head.[10] X-radiographs showed that a central wooden core, consisting of a post with another two pieces of wood nailed to it, formed the armature of the head and neck. Other nails were used as 'markers' to help key the plaster face to the core. Two nail heads can be seen in the upper part of each ear and others are positioned at nose and chin level. A neat row of about twenty one-inch nails runs round the back of the head, two of which are actually visible on the exterior of the head, just above each ear, where they secure the ends of a linen band. Fragments of hair wrapped round this band are still visible, and it doubtless formed the lower part of the wig. A pre-formed plaster cap, upon which the major part of the wig sat, was fixed to the top of the head. In one of Howgrave-Graham's photographs the lines left by linen bands, around which the rest of the wig must have been made, can still be seen running across the crown of the head from front to back: these lines were subsequently painted out. The plaster cap must have been used as a 'former' by the wigmaker, to enable him to produce the wig independently of the effigy within the space between Henry's death and his funeral. The cap with the wig, completing the head, was probably one of the last additions to the effigy.

The face of Henry VII is, like that of Edward III (but at a much more sophisticated technical level) based on a death-mask. The outer edge of the original mask can, in fact, be traced on the effigy head, from the top of the forehead, down the side of the head and neck, incorporating part of the ears, and so down to the base of the throat. As shown on the x-rays, the preformed cast from the death-mask was keyed and fixed with plaster, bulked out with fibres of wool, onto the nails protruding from the wooden core. The back of the neck was very crudely modelled to meet the edges of the mask and no attempt was made to conceal the join which would have been hidden by the wig. Finally the eyes were 'opened' by carving into the closed lids. There is no doubt, therefore, that the features of the effigy head directly reflect those of Henry's corpse.

6 Hope, 551.
7 Howgrave-Graham, 'New Light', 166.
8 Howgrave-Graham, 'Royal effigies at Westminster Abbey', *Country Life* (11 January 1952), 84.
9 D. Freedberg, *The Power of Images* (Chicago 1989), 225–6.

10 For the relationship between the two works, see C. Galvin and P.G. Lindley, 'Pietro Torrigiano's portrait bust of King Henry VII', *Burlington Magazine* 130 (1988), 892–902 (revised in Lindley, *From Gothic to Renaissance*, 170–87).

The sunken upper lip, the lop-sided mouth, the hollow cheeks and tightly set jaw, and the asymmetry of the whole face, are all the features of a cadaver. The only feature which does not belong to the deathmask is the nose, which had already been broken off by 1907; Howgrave Graham restored this, using as a model the terracotta portrait bust of the king in the Victoria and Albert Museum.[11] Recent study has shown that the face of the terracotta bust and that of the effigy are nearly identical and that the bust itself was based on a cast from Henry VII's face. Very probably, the Florentine sculptor Pietro Torrigiano, to whom the Victoria and Albert Museum bust is almost universally attributed, was also responsible for the funeral effigy of Henry VII.[12] He seems to have employed a cast from Henry's death-mask as the basis for the terracotta bust, slightly fleshing out the features and smoothing away the signs of death, but also investing the portrait with a sense of dynamism and authority which lesser sculptors would have failed to produce. For the tomb effigy of Henry VII the idealising process has been taken a stage further.

Pigment samples taken from the face of the funeral effigy revealed two distinct layers of polychromy. The earlier was a single layer of paint applied directly to the plaster; it consisted of lead white with small traces of vermilion, crimson lake, an orange ochre, carbon black, azurite and yellow (probably tin yellow). The resulting colour would have given a death-like pallor to the whole face. On the temple, a small area containing a high proportion of azurite suggests that a blue vein may have been painted here. The blue paint was applied whilst the flesh-coloured layer was still wet. (The lips have a second slightly warmer layer with more vermilion and crimson lake added, but without any trace of azurite.) The final layer of paint features warmer flesh tones with lead white and vermilion and the lips painted deep pink; this paint was probably applied at a much later date. It seems that Henry's funeral effigy was originally painted to represent a corpse, although this seems to conflict with the fact that the eyes were shown open, in the traditional manner, as if the king were alive. This shows the strength of the convention that funeral effigies should be shown, like the vast majority of English tomb effigies, as if in life.[13]

The only surviving portrait painting of any evidential value known to exist of Henry VII is the 1505 panel by Michel Sittow, painted at the order of Herman Rinck, the agent of Maximilian I, to be sent to Margaret of Savoy during the projected marriage negotiations. The funeral effigy makes it possible to confirm the accurate portraiture of the panel painting. Other portraits of Henry seem to stem from a lost exemplar presumably close in date to the lost companion portrait of Elizabeth of York.[14]

PL

CONSTRUCTION

All that remains of the effigy is the head, the armature and one of the feet. The remains of the armature consist of a flat back plate, two poles for the legs and a cross-bar for the arms. There are traces of iron wire suspended from one side of the bar which would originally have supported the arm. The foot is plaster.

While under examination in 1986 as part of the investigation done by the Victoria and Albert Museum into the terracotta bust of Henry VII, the hollow plaster at the base was filled. JL

[11] Howgrave-Graham, 'New Light', 167.
[12] For Torrigiano, who also executed the tombs of Lady Margaret Beaufort and Henry VII and Elizabeth of York, see the literature cited in note 10 above.
[13] See the entry on Edward III above, 33–4. One

must, of course, exclude 'transi' effigies from this generalisation.
[14] Strong, *Tudor and Jacobean Portraits* i, 149–52. See also S.B. Chrimes, *Henry VII* (London 1984), appendix F.

CONSERVATION

1950–1 Body stuffing discarded; head, scalp and neck area solidified with shellac solution, beeswax and turpentine, and some gaps filled; nose added; cleaned, and colour slightly retouched in some places (Howgrave-Graham).

1986 See above, and pp. 50–51.

In 1950 samples from the stuffing of the discarded body of Henry VII were examined by Dr Margaret Brett. There were specimens of penny cress, vetch, hairy tare, white bent grass, knapweed, soft brome grass, crested dogstail grass, selfheal, broadleaved dock, bulbous buttercup, hogweed and cereal straw.[15]

RM

15 WAM 64922, fos 45–7.

VI. QUEEN MARY TUDOR

Queen Mary died, aged 42, at St James's Palace, on 17 November 1558.[1] A contemporary description of her funeral, nearly a month later on 14 December, describes the extremely elaborate hearse provided at Westminster Abbey (another was provided at St James's):

> All the eight square of the hersse was garneshed and sett with Angelles morners and Qwenes in their Robes of Estate maid of waxe, under the hersse was a great majestie of Taffata Lyned with bokeram and in the same was maid a great Dome of paynters works with foure evangelystes of fyne gold . . .[2]

There are two series of accounts relating to the funeral's costs in the Public Record Office.[3] From the Great Wardrobe accounts, we learn that over 18 yards of 'yellowe clothe of gold tisshew for part of a paule to laye upon the coffin' at Westminster came from store, as did a yard of cloth of gold for one pair of sabatons 'for the Quenes Picture'.[4] Nicholas Lizard, the Serjeant Painter, was responsible for 'gildinge of a large majestie of taffata ffor the hearse at Westminster with a dome and the iiij evaungelistes' at a cost of £8, and was supplied with 12 yards of black taffeta out of the store of the Great Wardrobe 'for a Maiestie for the Chariott wherin the Corpes and Presentacion was carried'.[5] Amongst many other payments to Lizard is one, for £6 13s 4d, 'for the Presentacion'.[6] A diagram in a manuscript account of her interment, still unpublished, shows the layout of the funeral procession, and reveals that the 'presentacion', or funeral effigy, was 'appareled in robes of Estate with a crowne on her hed the ball and scepter in her hand as her fingers being richly sett with ringes and in the same riche stones the septer and crowne garneshed in lyke maner'.[7]

St John Hope identified the 'well-modelled complete figure of a woman, 5ft 5in high', with this 'presentacion', Queen Mary's funeral effigy. It has sometimes mistakenly been thought to represent Queen Philippa of Hainault, owing to its supposed resemblance to the rather portly tomb effigy by Jean de Liège.[8] The body of the effigy, which is not on exhibition, is, like the earlier figures, carved from wood, but its construction is very different. The body is solid and was apparently carved from wainscot oak, while the legs (both feet are broken) seem to be of pine.[9] The arms are jointed at the shoulder with large iron screws, and the elbows are attached by hinges; the legs are also jointed at the knees. These features were probably provided to facilitate dressing the figure: it should be emphasized that there is no record, in the English context, of the

1 See the biography by D. Loades, *Mary Tudor: A Life* (Oxford 1989) and Sandford, 506–7, for the background.
2 SP 12/1 fo. 75v (also quoted by E. Auerbach, *Tudor Artists* (London 1954) 95, though her references have sometimes to be treated with caution). This was the last time in English royal funeral ceremonial that the four religious banners – the Trinity, Our Lady, St George and St Mary Magdalen – were displayed (see Fritz, 63).
3 The full set of Lord Chamberlain's Office accounts (on paper) referred to by Hope as Series 1, vol. 553, are now PRO LC 2/4 (2) and the others referred to by him as Declared Accounts, Pipe Office, Great Wardrobe, 3142 are now PRO E 351/3142 (these are the set on parchment, abridged by the Clerk of the Pipe).
4 LC 2/4 (2), fos 5v, 7r.
5 LC 2/4 (2), fos 6v, 5v.
6 LC 2/4 (2), fo 6v.
7 PRO SP 12/1, fos 69–80 (fo 74r).
8 Hope, 552; Vertue, 157.
9 I have been unable to see the body of this figure which is in store.

extraordinary obsequies which, in contemporary France, led to the funeral effigy being treated exactly as if it were the living monarch (including the service of meals to it) until the burial service.[10] The joints in this effigy, besides easing its dressing (presumably in the queen's own robes), may also suggest that after the funeral ceremony the figure could be stood upright and exhibited. There is no record of any such function until the early seventeenth century, but the technical construction of this effigy, coupled with the explosion of demand for portraiture in the sixteenth century, is suggestive. Both it and the earlier Westminster effigies may have possessed two functions: first within the funeral service, as a recumbent representation of the dead monarch and then, after the service, as a memorial figure. The representation of the figure with the eyes open would, of course, have aided this putative transformation of function, which would help to explain the survival of the effigies after their use in the funeral ceremonies. The broken right hand was modelled in gesso and evidently once held a sceptre. The left arm is broken off at the elbow. The head and ears have been modelled in the same material, but the features are damaged.

It is unlikely that Nicholas Lizard was himself responsible for the effigy's manufacture, since he is recorded only as a painter. The Italian artist Nicholas Bellin of Modena provided King Edward VI's funeral effigy in 1553, when he is called the 'Maker of the kinges picture',[11] and he is known to have been a 'kerver' or sculptor.[12] Nicholas was described in February 1559 as 'Image graver to the Quenes [Elizabeth's] majestie' ('graver' also meant, in sixteenth century English, 'sculptor') and received payments under Mary too.[13] It is unfortunate that Edward's funeral effigy is no longer extant to provide a comparison with that of Queen Mary. It seems clear that the rather crude wooden body of Mary's funeral effigy required little technical expertise. The head, the only part of the figure on exhibition, is made of plaster and would doubtless have been produced separately from the body, by a different artist. Nicholas's extensive experience as the master of sculptural workshops and as a moulder of plaster and stucco-duro would all have ideally fitted him for the task. It is unfortunate that the chin, cheeks, nose and other features were rather ineptly restored between 1907 and the Second World War, since this has made it rather difficult to evaluate the head. It has therefore to be judged on the basis of the photograph accompanying St John Hope's article in 1907. Even from this, though, the head appears to be of such low quality that it is difficult to believe that an artist of Nicholas Bellin's calibre could have been responsible for it.

By comparison with the monarchs represented by the five previously discussed funeral effigies, there are many more extant painted portraits from Mary's reign and, owing to the residence of the Venetian ambassadors in England throughout much of her reign, there are also numerous descriptions of her.[14] Giovanni Michieli provides a record of the queen a year before her death, on 13 May 1557:

10 R.E. Giesey, *The Royal Funeral Ceremony in Renaissance France* (Geneva 1960).
11 C. Ord, 'The Accompte of Sir Edward Waldegrave, Knighte . . .', *Archaeologia* 12 (1796), 381, 391.
12 M. Biddle, 'Nicholas Bellin of Modena: an Italian artificer at the courts of Francis I and Henry VIII', *Journal of the British Archaeological Association* 29 (1966), 106–21, interprets Nicholas's task as only 'painting the likeness of the king on the effigy' but it seems more probable that he was responsible, as the documents seem to indicate, for the sculpting and modelling as well as the painting.
13 Auerbach, 92, records a large payment to Modena in 1557.
14 Strong, *Tudor and Jacobean Portraits*, 210.

She is of low rather than of middling stature, but, although short (*piccola*), she has no personal defect in her limbs, nor is any part of her body deformed (*offesa*). She is of spare (*magra*) and delicate frame, quite unlike her father, who was tall and stout; nor does she resemble her mother, who if not tall, was nevertheless bulky (*masiccia*). Her face is well formed, as shown by her features and lineaments, and as seen by her portraits. When younger she was considered not merely tolerably handsome, but of beauty exceeding mediocrity (*non pur tenuta honesta, ma piu che mediocremente bella*). At present, with the exception of some wrinkles, caused more by anxieties than by age, which make her appear some years older, her aspect, for the rest, is very grave. Her eyes are so piercing that they inspire, not only respect, but fear . . . In short she is a seemly woman (*una donna honesta*) and never to be loathed for ugliness, even at her present age, without considering her degree of queen.[15]

The effigy's height, at 5ft 5ins, may be an exaggeration of Mary's stature and its girth certainly contradicts Michieli's description of her. The plaster head was rather awkwardly located on the wooden torso but this seems a consequence of the low quality of workmanship rather than an indication that the head and figure do not belong together. The head can certainly be identified as a portrait of the deceased queen. The sub-Holbein portrait of 1544 by 'Master John', painted when Mary was 28, is the earliest certainly identified painting of her,[16] but all the portraits produced during her reign and after derive from portraits by Antonio Mor and Hans Eworth.[17] Mor's penetrating portrait confirms the correct identity of the funeral image but also underlines the latter's low quality.

<div align="right">PL</div>

CONSTRUCTION AND CONSERVATION

The painted head and neck are made in plaster. The paint would seem to be much restored. The eyes, lips and eyebrows have been repainted and the nose has been rebuilt.

A shaved head has been suggested using brown paint, but there is no trace of nails for the attachment of a wig. At the back of the skull there are several deep inscribed lines, which may have been made by the wig maker. Generally the head is in a sound condition. The torso is carved from a solid piece of wood, probably oak.

In 1987 it was conserved by John Larson. There was some insect damage in the feet of the figure which was treated with a fungicide (Rentokil) and consolidated with Paraloid B. 72. The wood was dirty and stained and it was carefully cleaned using hot water compresses. Some cleaning was also done using acetone and white spirit.

<div align="right">JL</div>

1950	Head cleaned (Howgrave-Graham).
1954	New nose; mouth repaired (Howgrave-Graham).
1987	See above (John Larson).

<div align="right">RM</div>

[15] *Calendar of State Papers Venetian, 1556–7,* 1054.

[16] Strong, 207–13, pls. 412–13.

[17] Strong, 212–13; pls. 415–24. See also J. Woodall, 'An exemplary consort: Antonis Mor's portrait of Mary Tudor', *Art History* 14 (1990), 192–224, for an excellent study of royal portraits.

VII. HENRY, PRINCE OF WALES

The funeral procession on 7 December 1612 of Prince Henry, the eldest son of King James I and Queen Anne of Denmark, who had died on 6 November, is described in a letter sent by Isaac Wake, secretary to Ambassador Carleton, to the latter's wife. Under a canopy,

> laye the goodly image of that lovely prince clothed with the ritchest garments he had, which did so liuely represent his person, as that it did not onely draw teares from the severest beholder, but cawsed a fearefull outcrie among the people as if they felt at the present their owne ruine in that loss.[1]

When St John Hope came to describe the early funeral effigies at the beginning of this century, he identified as the remains of Henry's figure a 'headless and massive framework of fir, with a cross-piece for the shoulders, pinned on to a vertical body post, which is jointed in the middle. To the ends of the cross-piece are fixed iron loops and pointed screws for suspending the arms. The arms themselves are lost.' The legs are carved from a single piece of timber, attached to a separate thigh joint and jointed on to the lower end of the body post with wooden pegs; the left leg has now lost part of its upper section and is detached from the figure. The pegs may have been intended as retaining pins to hold the legs in position; when they were withdrawn, the legs could be removed, fitted with clothing, and then replaced. The feet were jointed at the toes, which are broken off. From the knees downwards the legs are well modelled and, in Hope's day, were 'covered with white stockings with fine clocks'.[2] These sad remains, which are not on exhibition, are those of the figure mentioned in the surviving accounts for the manufacture of Prince Henry's funeral effigy:

Richard Norris. The Coffin and Representation vizt.
Paied to the said Richard Norrice Joyner for making a coffin of strong elme plankes and Setting on the Ironworke to the said coffin and incoffering the bodie of his highness in the same coffin and for his attendaunce about the same business £vj
Item for makinge the bodie for the representation with severall joynts, in the Armes leggs and bodie to be moved to sonderie attions and for settinge up the same in the Abbie and for his attendance there £ix

Abraham Vanderdort for the face and hands of the the Representaton
Paied to the said Abraham Vanderdort for the face and hands of the Princes representacion being verie curiouslie wrought price £x.
William Peake one staff guilt viz
Paied to the said William Peake for one staffe all guilt and burnished with fine gold for the Representacion of the body xxxs.[3]

[1] R. Strong, *Henry, Prince of Wales and England's Lost Renaissance* (London 1986), 7; M.A.E. Green (ed.), *Calendar of State Papers, Domestic Series, 1611–1618* (London 1858), 162; Llewellyn, 'Royal body', 229.

[2] Hope, 554.

[3] The Lord Chamberlain's Records, Series 1, vol. 555, referred to by Hope and rather inaccurately quoted by him, are now PRO LC 2/4 (6). The references here are to fos 5r–v.

Amongst the same accounts are, *inter alia*, references to the carpenter, William Portington, making and setting up the hearse in Westminster Abbey and to the smith, Thomas Larkin, for ironwork including the following:

> Item for a great skrew with a nutt and a turned necke of iiij foote long and a cross foote of a foote square with nutts and skrewes for the foote of the same skrew for the Princes Representacion xs.
>
> Item for ij skrewes with nutts of a foote long a peece for the presentacion of the upper part of the Princes bodie vs.
>
> Item for one dozin of Revetts and xx forged nailes to sett on the same Ironworke iijs.[4]

Amongst the payments to John Hull appears the following:

> . . . for ij yards of crimsin velvet for a quishion used in the chariott for the Representacion at xxxvs lxxs.[5]

In another set of accounts, generally more concise, John Bankes is listed as receiving £20 for 'a newe chariotte of Tymber worke and Ironwoorke with wheeles carriadges etc and for altering the same after it was made diverse tymes according to the harralldes direttions.'[6]

In the accounts for Henry's funeral, the design of the effigy is for the first time explicitly related to its function during and after the funeral ceremony. The effigy, which had to be recumbent during the funeral obsequies, seems to have been designed not only so that it could be easily dressed but also so that it could be arranged in different postures. There is incidental evidence that it was also designed for exhibition after the funeral ceremony, thus foreshadowing the well documented function of some of the later effigies. A letter from Edward Shirburn to Sir Dudley Carleton, of 9 April 1616, mentions that the robes of the Prince's effigy had been stolen from the Abbey, less than four years after Henry's death, and this tends to indicate that the figure had been on public display.[7] On 4 August 1606, King James I had brought King Christian IV of Denmark to see the Abbey and in preparation for this visit the effigies of seven kings and queens were repaired, rerobed and furnished with new accoutrements; a wainscot press, incorporating the thirteenth-century Westminster Retable was provided for their display.[8] This exhibition of the effigies may well reflect a longer established tradition at the Abbey for which there is now little documentary evidence. However, a patent of 1561 allowing the chief verger 'to have the custodie and oversight of the Tombes and monimentes and of the pictures (funeral effigies) of kings and quenes within all the saide church remaynyng',[9] strongly suggests that the tradition went back at least to the middle of the sixteenth century.

The selection of Abraham van der Doort as the sculptor of the funeral effigy's head and hand is slightly surprising since either John Colt, who had been employed to carve the (lost) effigy of Queen Elizabeth I in 1603, or his brother Maximilian, who became Master Sculptor to the Crown in 1608, and who carved the effigy for Henry's mother, Anne of Denmark, in 1619 and for James I himself in 1625, would have seemed more obvious choices.[10] However, the Dutch numismatist and sculptor, today best known as the cataloguer of Charles I's picture collections,

4 LC 2/4 (6), fos 12r–13r.
5 LC 2/4 (6), fo 16r.
6 PRO E 351/3145, fo 50r.
7 *State Papers, Domestic*, 361, 9 April 1616; J.A. Robinson in Hope, 568.

8 See above, 23.
9 J.A. Robinson in Hope, 568, citing Register E, fo 33.
10 For the Colts see Whinney, 19–21. See also the essay on Queen Elizabeth.

had been in Henry's service and would have known the prince extremely well.[11] It is presumably this personal connection which accounts for his selection as sculptor.

This is the first (partially) surviving effigy in England of anyone other than a king or queen; it is also the first survivor for which there exists an engraving of the hearse used for the funeral ceremonies.[12] The hearse set up in Westminster Abbey is depicted in a William Hole engraving accompanying George Chapman's *Epicede or Funerall Song: on the Death of Henry Prince of Wales* (1612 and 1613) and in an engraving in Francis Sandford's *Genealogical History of England* (p. 563).[13] The classicising hearse, which in some respects resembles the most splendid contemporary tombs, had a base section supporting the coffin, covered in purple velvet adorned with black lace, above which lay the effigy of the prince, dressed in a superb velvet and ermine-lined mantle with the chain of the Order of the Garter encircling his shoulders. The canopy of black velvet with fringes of black silk, and bedecked with armorial insignia, mottoes and banners, was borne on six ionic pillars. At the apex of the pyramidal structure stood the royal arms encircled with the motto of the Prince of Wales.[14]

In 1786, when John Carter depicted the effigy in the upper part of Henry V's chantry chapel together with other members of the 'ragged regiment', it was in a much better state of repair than when St John Hope described it in 1907. The damage occurred between 1786 and 1872, for an engraving of the latter year shows it stuffed in a cupboard above the Islip chapel; it had come in half, the hips and legs being thrust in horizontally over the heads of its companions, and the clothing apparently lost.[15] In the early eighteenth century, when the antiquary and artist George Vertue visited Westminster Abbey, he drew and made notes upon the 'ragged regiment'.[16] Vertue remarked that the head of King James I's effigy, which he remembered as 'curiously done and very like him' had recently been stolen in 1724/5, but described the effigy of Prince Henry in the following terms:

Prince Henry. his Effigie was finely done especially the head is repaird in plaister. in a very good taste.

Henry's head, visible in Carter's watercolour, had in all probability disappeared by 1872. Sir Thomas Cornwallis described Henry as:

of a comely tall middle stature, about five foot and eight inches high, of a strong, streight, well-made Body (as if nature in him had shewed all her cunning) with somewhat broad shoulders, and a small waist, of an amiable Majestick Countenance, his hair of an Auborne colour, long faced and broad forehead, a piercing, grave eye, a most gracious smile with a terrible frowne, courteous, loving.[17]

The surviving portraiture of Prince Henry largely derives from the portraits by Robert Peake the

11 See Strong, *Henry*, 198–9.
12 For depictions of earlier funeral processions, see the Litlyngton Missal (Westminster Abbey Library MS 37) and the essay on Elizabeth of York, above, 46. See also the much-reproduced representation of Abbot Islip's funeral in the Islip Roll for the appearance of a sixteenth-century hearse.
13 Strong, *Henry*, 130.
14 Although Inigo Jones was the prince's Sur-

veyor of the Works, and walked in his funeral procession, he does not seem to have been directly responsible for the design of the hearse, which owes something to Colt's tomb for Queen Elizabeth I in Westminster Abbey.
15 Howgrave-Graham, 'New Light', pl. xlvii a.
16 Vertue, 158.
17 Sir Charles Cornwallis, *The Life of Henry Prince of Wales* (London 1641), 93.

Elder, Henry's personal painter, or by Isaac Oliver, who worked for Henry later in his life.[18] The fine profile miniature in a classical manner by Oliver or the incomparable 1612 large miniature in the Royal Collection give us our finest representations of the prince before his death. Oliver supplied William Hole with the drawing for his famous engraving of the prince exercising with the pike, and we can recognise exactly the same profile – of a somewhat long face with a distinctive, rather aquiline nose, and tall forehead – that we see in Hole's depiction of the funeral effigy.[19]

PL

NOTE

In 1986 Mr Martin Holmes presented to the Dean and Chapter a life-size wooden head, carved and painted, but with a flat back that allows for no tapering of the rear part of the head or modelling of the neck. The eyes were painted and drilled. Two nail holes show where a moustache was crudely attached, probably at a later date.

In a paper read to the Society of Antiquaries in 1986 Martin Holmes argued that the head was that carved by Abraham Vanderdoort for the effigy of the prince, whose funeral took place in Westminster Abbey in December 1612. Since at least the early nineteenth century it had been screwed to a plank as part of an armour stand. But the shape of the head makes it quite unsuitable to support any known type of helmet, and indeed it is difficult to think of any possible use for it other than as part of a clothed supine effigy such as is illustrated in Sandford's *Genealogical History of the Kings of England*. On the other hand, the surviving body of the prince's funeral effigy has a hole in the shoulder piece to take a peg on which the head was to be fitted, whereas this head has the curved jaw carried all the way to the back of the head, providing no simple means of attaching it to a body. This feature alone appears to rule it out from having belonged to an effigy. Moreover it is carved from wood, whereas, if James I's effigy provides a relevant comparison, the effigy head was probably made from plaster, and there is no trace on the wood of the repairs 'in plaister' described by Vertue.

The head may be compared with the eighteenth century heads in the Tower Armouries. Some of these are also flattened at the back, but none is without any tapering towards the rear of the head, and all (unlike this one) have some means of support. None has the eyes drilled. Tests on samples of the pigment have failed to show whether this head is seventeenth or eighteenth century.

The identification of the head as that of the prince (who was 18 when he died) remains doubtful.

PL and AEH

CONSTRUCTION AND CONSERVATION

The effigy is constructed of several articulated sections (possibly pine, though Hope says fir) with several longitudinal splits. There is no head and only a fragment of one arm remains. Both legs survive, joined by a system of round wooden dowels and iron nails. The figure is much decayed with signs of active woodworm.

JL

The effigy appears not to have been conserved.

RM

18 Strong, *Tudor and Stuart Portraits*, 161–5. 19 Strong, *Henry*, 130.

VIII. QUEEN ANNE OF DENMARK

The figure on exhibition in the museum comprises a wooden head and bust of a woman, with a well-carved face. In 1907 this was still fixed onto a worm-eaten wooden post and a separate lower body, consisting of a canvas bag filled with tow, forming the hips, to which were attached the wooden legs. Like the bust, these were well-modelled but much damaged by woodworm infestation. The arms were suspended, as were those of Prince Henry's effigy, by iron loops at the shoulder and elbows, but only the upper part of the left arm remained.[1] The feet are lost. St John Hope notes that the body seems to have been attached to the trunk post by a large iron pin through the hips and reports that, according to the late Sir George Scharf, the effigy's height was originally 5ft 8ins.[2] It is shown by John Carter in his 1786 watercolour in very much the same condition as that in which St John Hope published it.

This effigy is to be identified as that made for the funeral of Queen Anne of Denmark in 1619, by Maximilian Colt, a sculptor from Arras who accompanied his elder brother, John, to England in the mid-1590s as a refugee from the Wars of Religion.[3] Maximilian Colt is a puzzling sculptor, whose tomb of the first Earl of Salisbury (1614), at Hatfield, is an extremely distinguished work which stands out from the run of Anglo-Netherlandish 'Southwark school' tombs. Stylistically, the bare-breasted Virtue at one of the corners of the tomb has much in common with the bust of Anne of Denmark: the firm modelling, tubular neck, round breasts with prominent nipples and the classical sense of *gravitas* temper the realism which can be seen in Colt's tomb-effigy of Queen Elizabeth or in the tombs of James's two infant children, Mary and Sophia.[4] In 1608, Colt had become Master-Sculptor to the Crown and he was the natural candidate to execute the funeral effigy of Queen Anne of Denmark. The surviving accounts mention his name in connection with the provision of the 'representation' or funeral image:

Abraham Greene for inclosing of ye Corpse in leade and for makinge the Armes and Crownes etc viz

Paied to Abraham Greene Serjeant Plumber for the intombinge of the Royall Body of our late Soveraygne Lady Queene deceased with lead and soder and for his travailes and attendance of himselfe and servants for certaine daies at his Majesties honor of Hampton Courte and for one great vessell to putt in the Bowells and inwarde parts which were sent to Westminster Abbey. And for castinge of the Armes and Crowne of the late Queene deceased and her progenie and for guildinge and paynting of the Armes Crowne and letters and for makeinge and Carvinge of the Mould for the Armes Crowne and lettres of the same late Queene deceased and for stone and workmanship preisse in gross £xx

[1] This is still detached.
[2] Hope, 555–6.
[3] For the background see Whinney, chap. 3.
[4] The Hatfield tomb is illustrated in Whinney, pls. 12b and 13; the tomb of Queen Elizabeth is shown in Wilson, *Westminster*, 153. The latter was completed by December 1606: see A. White, 'Westminster Abbey in the early seven-

teenth century: a powerhouse of ideas', *Church Monuments* 4 (1989), 43 n24. For the tombs of Mary and Sophia, the last royal children provided with tombs in the Abbey, see J.D. Tanner, 'Tombs of royal babies in Westminster Abbey', *Journal of the British Archaeological Association* 16 (1953), 25–40. See also Llewellyn, 'Royal body', 276 n13.

Maximilian Coulte for makeinge a Representacon and dyverse other things viz
Paied to Maximilian Coute Carver for makeing the representacion, for Ironworke for the Joynts for a paire of Bodyes a paire of draweinge hose and for bombast to fill them, for a cheste to carry the picture to Denmarke House and for Carriag of it and for makeinge a copper plate with writeing graven uppon it to be fastened uppon the Coffin and allsoe for makeinge of a mould to mould divers sheilds with the Kings and Queenes Armes in them which hath been employed about the hearse preisse in gross £xvj.[5]

Further on in the accounts are details of the cost of a new funeral car (£20) and the manufacture of a hearse at Denmark House. There are also payments for the Westminster hearse, amongst which are included the following:

John Decrits
Paied to John Derwitts for guilding and silvering a great Lyon a unicorne and ij wild men to stand on the iiijor Collumns of the hearse, the Lyon at Ls the Unicorne and ij wild men at xxxs the peece £vij[6]

There follow further payments to him for painting banners and escutcheons and then a number of entries including

Item for dyvers tymes painting the Royall Representacon	xxxs
Item for a Crowne to sett on topp of the hearse	lxxvis
Item for a greate crowne about the hearse	cs
Item for the beasts and capitalls of the hearse	£iiij
Item more for the crowne and septer	£x.

and then a payment to John Smith:

Paid to John Smith for performing a Roabe for the Royall Representacon	£vj

John Hobson was paid for 'crimson sattin for the Royall representaton'.

Item for xiij yards of crimson satten delivered to Mr Duncombe one of her Majesties Roabes to bottome a quishion and to make a petticoat for the Royall representation of Queen Anne at xiiijs ixd the yard	£x xjs ixd.

Robert Austin and William Hainwood were paid for eleven and a half yards of crimson velvet 'to make a gowne for the Representacion' at a cost of £12 13s and a yard of crimson velvet was delivered for the cushion to place beneath the effigy's head.[7]

In another set of more summary accounts, there are abstracts of payments to:

Benjamin Henshawe silkeman for golde ffringes Tassells Ribbons and Silkes ymploied as followeth videlicet about a velvett crimsin Cushion to lay under the Representacion xlixs ijd about garnishinge the the [sic] hearse in the abby £xlii vs id ob[8]

5 PRO LC 2/5, fo 3r.
6 For John de Critz the elder, Serjeant Painter 1605–42, see Auerbach, *Tudor Artists*, 134–5, 148. LC 2/5, fo 12v.
7 LC 2/5, fos 13r–19v.

8 PRO E 351/2145 fo 56r. In these same accounts, Maximilian Colt is paid 'for makeinge the representation with Iron worke and other charges incident thereunto in full of £xx xvs viijd demaunded £xvj'.

The reference in the accounts to a 'paire of Bodyes' needs clarification. It does not imply that two entirely separate figures were made, as was the case in the exequies of King James I: on that occasion the commissioning of a second effigy has the appearance of an *ad hoc* decision, made at short notice. Throughout these accounts, by contrast, there is reference to a single representation. The 'paire of Bodyes' are instead, as Janet Arnold suggested, a pair of stays.

A coloured drawing in a manuscript in the College of Arms represents the hearse of Queen Anne in 1619.[9] A proclamation by the Earl Marshal in November 1618 ordered that owing to the 'sinister' activities of pretenders to the science of heraldry, all carvers, masons and tomb-makers were henceforth to send in copies of their designs to the College of Arms, there to have their arms and epitaphs checked. The drawing of the hearse, with the funeral effigy shown within it, is ascribed by Katharine Esdaile to Maximilian Colt. It shows a square enclosure with classicizing columns at the angles supporting the lion, unicorn and the two wild men gilt and silvered by John Derwitts at the corners (a format much employed by the Tudors) and, in the centre, an octagonal structure. The base supports classical columns surrounding the funeral effigy. The elaborate black superstructure is covered with heraldry and from it are suspended heraldic banners. Shields of arms and royal badges decorate the structure. The design of the hearse, which draws from a wide range of sources, even has echoes of Inigo Jones's masque sets, and is particularly appropriate for a queen who personally appeared in masques by Jonson and Daniel.[10]

Colt's effigy bust of Anne of Denmark is closely comparable to the portrait of the queen in the National Portrait Gallery, attributed by Sir Roy Strong to William Larkin, and datable to c.1612, for it shows her in mourning for Prince Henry.[11] The long nose, broad at the bridge, high forehead, marked underlip, and strong neck are closely similar, though the sculpture's classicising feel finds no real antecedent in the painting. Other paintings, by Marcus Gheeraerts the Younger, who took part in Anne's funeral procession,[12] and Paul van Somer, as well as miniatures by Nicholas Hilliard and Isaac Oliver, provide clear evidence of the accuracy of Colt's portraiture.[13]

Howgrave Graham had the bust immersed in a gas-chamber against further worm infestation; 'more than 250 worm holes . . . were filled and the filling touched out with paint.'[14] 'The cleaning revealed a finish of utmost delicacy and beauty in colour and texture . . . the craftsman has shown with subtle skill the blue veins in the temples, near the eyes, and on the breast, and has even carved a pimple on the left cheek.'[15] Two cut-away sections, running diagonally from the neck to the back of the head, must be for the tall ruffs still worn in this period.　　　　PL

9　College of Arms MS I.1, 'The Booke of Monuments, 1619', p. 1. K. Esdaile, 'By a tomb-maker who bowed to authority: newly-found Colt designs', *Illustrated London News* 18 August 1934, 242.

10　There is remarkable confusion in the literature about a design ascribed to Inigo Jones and claimed to represent his project for Anne's funeral catafalque (e.g. J. Harris, S. Orgel and R. Strong, *The King's Arcadia: Inigo Jones and the Stuart Court* (London 1973), 99, item 178). The design needs further study.

11　R. Strong, *The English Icon: Elizabethan and Jacobean Portraiture* (London 1969), 323. See also Strong, *Tudor and Jacobean Portraits* i, Appendix 2, 363.

12　LC 2/5, fo 38v, as 'Marcus Garrett'. He was accompanied by Peter Oliver and Abraham Vanderdoort.

13　Strong, *Tudor and Jacobean Portraits* i, 7–11, pls. 13–18.

14　Howgrave Graham, 'New Light', 167.

15　Ibid.

CONSTRUCTION

All that remains of this effigy is a head and bust. They are wooden, probably pine. The bust appears to be solid, but is constructed of several pieces of wood. The breasts have been added to the chest and the head and neck are separate from the shoulders. There is clear evidence of insect attack on much of the surface, which now appears to be more widespread than was suggested by the Hope photograph.

On the right hand side of the neck a slice of wood is missing and this, like the piece on the other side is probably a repair made after insect damage had caused structural breakdown.

On the face, paint layers disguise any evidence of insect attack. The head appears to retain much of its original flesh colour on a gesso ground; traces of brown still appear on the eyebrows and the eyes are also brown. The lips are red and the cheeks are painted a deep pink. Remains of paint on the chest and breast indicate that the figure originally would have worn a dress which revealed much of the breast.

Several ferrous nails can be seen at the top of the head, presumably as attachments for the wig. Below the shoulders are two metal rings which were attachment points for the wooden articulated arms of the effigy.

Although there are splits in the shoulders and chest, the wood generally appears to be stable.

JL

CONSERVATION

1905	Head immersed in paraffin 'to kill the insects'.
1952	Gaps and cracks closed with plastic wood; treated in gas-chamber against worm; more than 250 worm-holes filled (Howgrave-Graham). RM

IX. JAMES I

Details of the manufacture of the funeral effigy of James I, who died on 27 March 1625 at Theobalds, and of many of the arrangements made for his funeral are provided in surviving accounts:

> Abraham Greene. For vessells of lead for Entombeinge of his Royall Corps and bowells. Abraham Greene for the Entombing of the Royall corps of our late soveraigne King James with lead sodder and workemanship being done at Theobalds. Item more for one vessell of lead to putt in the bowells of his Ryall Majestie with sodder and workemanship
>
> £xxv.[1]

Maximilian Colt was paid 'for two representatcions with divers other necessaries':

> Paid to Maximilian Coult for making the body of the representacion with severall joynts in the armes leggs and body to be moved to severall postures and for setting up the same in Westminster Abbey and for his attendances there £x
> Item for the face and hands of the said representacion being curiously wrought £x
> Item for the labour paines and expences of himself and his servants and for stuff by him imployed in and about the said service and his Journey to Theobalds for the moulding of the Kings face for the better makeinge of the premisses being upon special command
>
> lxvjs viijd
>
> Item for making a representation suddenly to serve only at Denmarke house untill the funerall and for his attendance theire att divers times £x
> Item for a plate of copper with an inscription fastened upon the breast of the leaden coffin
>
> xls
>
> Item for a crowne of wood and a Lyon upon it for his majesties creast xls
> Item for a sheild with his Majesties armes a garter comptment and a Crowne upon it xxxs
> Item for a scepter and a gloabe for the Representation xxvjs viijd
> Item for making a Crowne with Divers counterffitt stoans on it cs
> Item for painting the face and hands of the last representation xls
> Item for the makeing of a better crowne the former being broaken by the often removeing of the representation and for the guilding of the same being sett with divers stones £x

> Daniel Parkes For two Periwiggs
> Paid to Daniel Parkes for makeing of one periwigg beard and eyebrows for the body at Denmark house £x
> Item for one other periwigg and other beard and eyebrowes for the body which remaines in the Abbey att Westminster £x.[2]
> Sum £20.

[1] PRO LC 2/6, fo 3v. PRO E 351/3145, fo 61r, reveals that the urn for the bowels cost £5 of this total.

[2] LC 2/6, fo 5v.

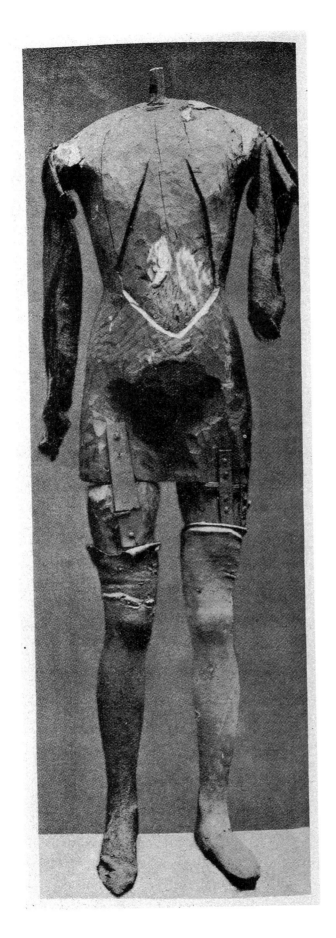

6. James I
(from Hope, pl. LXV)

John Lewgarr was paid £5 10s for

> . . . the covering of a close chariott with black cloth and for lyneing it within with the same and for covering of the carriadg and the Coachmans seat att Whitehall to goe to Theobalds and for covering the same againe at Theobalds with black velvett and for garnishing the same within and without . . .,[3]

whilst Richard Miller received payments for cloth:

> Item for xxxiiij yards of vellvett to make a large Cannopie to carry the figure from Denmark house to Westminster att xxvjs viijd £xlvj vjs viijd'

A little further on in the accounts, he is paid for

> Item for xvj yards of Crimson vellvet to make a roabe for his late majesties statue at xxxs
> £xxiiij
> Item for a yard of rich crimson vellvett to make a capp for the said statue at xxxs xxxs.[4]

The Sergeant Painter, John de Critz, was paid for painting and gilding banners and amongst later payments to him are the following:

> Item more for painting the face and hands of the Royall Representacion xls
> Item more for the Crowne scepter and Globe of the Representacion £xi xs
> Item more for the Lyon and Crowne £iiij
> Item more for painting and guilding of vj dozen of large pendaunts for the hearse at £iiij p.d. £xviij
> Item for colouring blew xij stands for the Canopie fflower Deluces being wrought thereon in gould at xs a peice £vj.[5]

Oliver Browne and John Baker received payments for making the hearse at Denmark House of black velvet, for the quilt on which the representation lay, and

> Item for covering the great hearse in Westminster and for covering and arming all the Pillars and pilasters that suppoerted it: and the others that stood without the hearse all being covered with vellvet and garnished with fringes and lace of black silke and also for covering all the rayles round about and downe to the ground on both sides £xx.[6]

A number of important points emerge from these accounts. The first is that for King James's obsequies there were two funeral effigies, one at Westminster Abbey and the second only for Denmark House, to which the corpse was moved from Theobalds. Evidently at short notice, a second, entirely separate, effigy was produced. No less a sculptor than Maximilian Colt was given the job of making the effigies. The commissioning of two effigies was doubtless intended to facilitate the funeral ceremony arrangements and was decided after a change of plan: in other words it did not directly reflect funeral precedents but was a response to the exigencies of the particular situation. The longer-term consequences of constructing the second effigy are unclear. It could be argued that it entailed a conceptual separation of the corpse from the effigy, and thus indirectly facilitated the evolution of the funeral effigy into a memorial figure, from its

3 LC 2/6, fo 8r.
4 LC 2/6, fos 9v–10v.
5 LC 2/6, fos 14r–15r.
6 LC 2/6, fo 18r.

role as a visible substitute for the encoffined corpse. Thus it could be said to adumbrate the later functions of effigies, and mark a point of transition in the emergence of the memorial waxwork from the funeral effigy tradition. A third point of importance is that Colt and his servants actually went to Theobalds (Lord Burghley's great house, given to the Crown in 1607, where James was having a new banqueting house erected at the time of his death)[7] after James's death on 27 March, to take a death mask from the corpse 'for the better makeing' of the effigy. Here we can find documentary evidence which is clearly relevant to the earlier effigies – those of Edward III and Henry VII – which also feature death masks: in neither of the earlier cases is there documentary evidence for the employment of death masks, although such evidence does survive in medieval French accounts.[8] Fourthly, there is more evidence for the purchase of wigs and beards for the effigies, such as we have already found recorded in the case of Elizabeth of York's effigy, and inferred in the case of the others. These accoutrements enabled the 'statue' or 'representation' or 'body' as it is termed indifferently in the accounts (a fact itself of some interest) to portray the individual as accurately as possible. Finally, there is a reference here to the moving of the effigy into different postures (as was the case with Prince Henry's effigy), during which some damage was done. These movements are surprising (if they are unconnected with dressing the effigy) since the evidence from the accounts indicates that the effigy was still always shown recumbent.

Amongst the funeral effigies remaining at Westminster (but not exhibited) is one which may have been that of James I. It received its only analysis in the description provided by St John Hope in 1907.[9] It consists of the headless figure of a man, 5ft 7in high, of fir wood, hollowed out at the back like the earlier effigies. A wooden peg for the head is fixed in the top. The body is extremely roughly carved and has a piece cut out at the front, which Hope interpreted as space for the point of the doublet. The traces of plaster padding which he could see have now all but disappeared. The arms were lost already in 1907 but the canvas sockets, which were still extant then, have also now disappeared. The legs are held in place by iron straps: they fit the body extremely badly. The pairs of stockings, of wool and silk, have also disappeared since 1907. There is a good deal of gesso left over the wooden stumps at the base of the legs; these must be the remains of the feet which were modelled in gesso. St John Hope noted around the left leg very faint traces of the Garter. He confidently identified these sad remains, which can be seen in Carter's drawing, still fully clothed, as those of James I's effigy, a figure which had retained its head when Vertue first saw it.[10] However, the legs of the surviving effigy could not be moved, which indicates either that these are not the remains of James I's Westminster effigy or, much more probably, that the iron straps (or the legs) are replacements for the original ones, which may have been damaged.

The funeral took place on 7 May and was described by John Chamberlain as 'the greatest ever known in England; blacks (mourning cloths) were given to 9,000 persons. Inigo Jones did his part in fashioning the hearse'.[11] There is, indeed, clear evidence that the Westminster hearse was designed by Inigo Jones. His designs for it remain at Worcester College, Oxford, and the hearse as erected is engraved in Francis Sandford's *Genealogical History* (p. 561).[12] A strongly

7 *HKW* iv, 277.
8 See R. Giesey, *The Royal Funeral Ceremony in Renaissance France* (Geneva 1960), 100–2.
9 Hope, 557–9. He conjectured that this is the Denmark House effigy, the other having been broken.
10 See above, 61.
11 J. Bruce (ed.), *Calendar of State Papers, Domestic Series, 1625–6* (London 1858), 22. For

the funeral arrangements see pp. 14–15, 19–20, 22. C. Gittings, *Death, Burial and the Individual in Early Modern England* (London 1984), 221–3, 228.
12 J. Harris and G. Higgott, *Inigo Jones: Complete Architectural Drawings* (London 1989), 186–7. See also J. Peacock, 'Inigo Jones's catafalque for James I', *Architectural History* 25 (1982), 1–5.

classicising construction which draws on the recent Italian tradition of tempietto-catafalques and on that of Anne of Denmark's hearse, it featured an octagonal structure raised on a podium ascended by three steps (plate 1). Standing female figures representing Religion, Justice, War and Peace, were placed on short pillars in a position analogous to that occupied by wild men and royal beasts in Anne's hearse. The king's funeral effigy reclined under a dome supported on an entablature decorated with the royal arms and seated female allegorical figures of virtues in mourning. The dome, surmounted by a crown, was hung with heraldic pennants. The allegorical figures were executed by Hubert Le Sueur, a sculptor who had recently arrived from France.[13] He was paid for 'moulding, making and fashioning' the figures which were probably made of plaster of Paris. Aubrey notes the draperies 'of white callico, which was very handsome and very cheap, and shewed as well as if they had been cutt out of white marble'.[14]

There is no reliable evidence for the appearance of the head of the effigy of James I but it would presumably have resembled the National Portrait Gallery portrait by Daniel Mytens c.1621. Colt's statue of the king at Hatfield House may provide a good indication of the general appearance of the effigy.[15] However, the lost funeral effigy head, based on a death mask and 'curiously wrought', would have provided a portrait whose verisimilitude would be unchallenged.[16]

PL

CONSTRUCTION AND CONSERVATION

This effigy has no head (though a dowel remains) and no arms. The torso is made of one piece of wood with longitudinal splits. The wood, which could be pine, has active woodworm. The legs are attached by a number of corroded ferrous brackets and iron nails.

JL

The effigy does not appear to have been conserved.

RM

[13] For Le Sueur see Whinney, chap. 5. She cites (p. 242 n4) PRO Declared Accounts, A.O.I. 2425/57. See also C. Avery, 'Hubert Lesueur, the "Unworthy Praxiteles" of King Charles I', *Walpole Society* 48 (1982), 41. (Neither Le Sueur nor Jones receive detailed payments in LC 2/6 or E 351/3145.)

[14] Aubrey, 115.

[15] Strong, *Tudor and Jacobean Portraits*, pls. 354–6.

[16] It is just possible that Vanderdoort's head for Prince Henry's effigy also featured a death mask, though there is no documentary evidence for this.

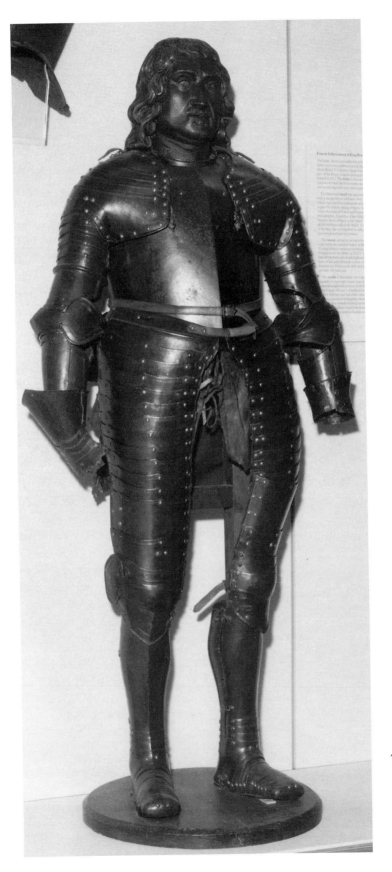

7. George Monck, Duke of
 Albemarle, funeral armour;
 limewood head carved in
 1964

X. GEORGE MONCK, DUKE OF ALBEMARLE

In addition to the royal effigies, there remains one other from the seventeenth century, that made for the state funeral of General George Monck in 1670, well illustrated in Sandford's account of it, and also engraved in Dart's *Westmonasterium*.[1] Two earlier effigies are also documented, those of Ludovic Stuart, Duke of Richmond (d.1624), and his wife Frances (d.1639); the press in which they were contained was nailed up by 1723, according to Dart, and Vertue records them in a second press in the Islip chapel: he describes the duke's figure as 'a very tall fine figure in his robes. his h[ea]d plaister of Paris. his hair beard & face well done'.[2] Subsequently they disappeared, apparently without any visual record. In addition, there was an official funeral effigy at the funeral of Oliver Cromwell (d.1658): the bust in the Museo Nazionale in Florence is 'likely to be a version of the head' of this figure (the wax head by Thomas Simon and the body of wood carved by Phillips), which Christian Huygens was shown by the Keeper of Charles II's closet in July 1663: he described it as 'une teste de Cromwel, moulée sur la siene propre après sa mort, et peinte de couleurs avec des yeux de verre fort bien faits, de sorte qu'il semble qu'on le voit tout vivant'.[3] According to David Piper, Cromwell's effigy was first shown at Somerset House, recumbent: the figure was shown 'apparelled in a rich suit of uncut Velvet being robed first in a little Robe of Purple Velvet, laced with a rich Gold Lace, and furr'd with Ermins'. A sword hung by the figure's side; a sceptre was placed in the figure's right hand, an orb in the left. Either this effigy or a second one (again following earlier royal precedent) was then shown for several days in another room, on a low dais, standing upright, in a rich cloth of state, vested in royal robes, with a sceptre in one hand and an orb in the other, an imperial crown on the figure's head and armour at his feet. Cromwell's effigy is shown standing upright in an engraving in the British Museum and this may be the earliest depiction of this second function of the funeral effigy although the deliberate desire to follow royal precedent suggests that it reflects previous usage.[4]

Sandford relates how Charles II 'resolved to pay all the Honours and respects imaginable' to the memory of General Monck and commanded some of the Lords of the Council to consider fitting solemnities.[5] These included hanging three rooms at Somerset House 'for the placing the Effigies there in State' in mourning, and providing a hearse at Westminster, a funeral car and escutcheons, mourning apparel and so forth. Sandford provides a detailed account of the appearance of the three rooms at Somerset House and a mass of other information. On the Bed of State in the third room was placed a coffin covered with a pall of black velvet and 'therupon the

[1] F. Sandford, *The Order and Ceremonies Used for and at the Solemn Interment of the most High, Mighty and Most Noble Prince George Duke of Albemarle* (London 1670). A warrant for the delivery of the 20 copper plates to Sandford is in PRO LC 2/10 (1), 13, and for his bill LC 2/10 (1), 97. Dart i, 153. For an account of the funeral see also Aubrey, 351. For costs, see W.A. Shaw (ed.), *Calendar of Treasury Books 1669–72* (London 1908), iii/1, 525, 542, 560 and iii/2, 893.

[2] See above, 23; Vertue, 158.

[3] *Oeuvres Complètes de Christian Huygens*, iv,

Correspondence 1662–3 (Société Hollandaise des Sciences, 1891), 369.

[4] D. Piper, 'The contemporary portraits of Oliver Cromwell', *Walpole Society* 34 (1952–4), 27–41. Gittings, *Death, Burial*, 229–30. A plaster head, sold in New York in 1995, has been claimed to be a cast after the wax head by Simon: see *The Cyril Humphris Collection of European Sculpture and Works of Art*, part 1, Sotheby's, New York, 10 January 1995, lot 67, 'A plaster head of Oliver Cromwell'.

[5] Sandford, *Order and Ceremonies* (not paginated).

Effigies of the Duke in a Buff coat, and over that compleat Azure Armour with Guilt Nails, a Cravat about his Neck; his Ducal Coronet and Cap turned up with Ermine on his Head, Invested in his Ducal Robes of Crimson Velvet, about his neck a Coller (*sic*) of the Order and George, under the Head a Cushion of Crimson Velvet, with Fringe and Tassels of Gold, his Sword guirt about him . . . and a Guilt Truncheon in his right hand.' After the exequies at Somerset House were complete, the coffin was privately conveyed to Westminster by water and was interred in the Abbey. The effigy, on the other hand, was now separated from the coffin and was taken in a long and elaborate funeral procession through the streets to Westminster, where it was placed in a splendid hearse, with the chief mourners placed beside the effigy.[6] The separation of coffin from funeral effigy recorded by Sandford helps to accentuate the division between corpse and representation already discussed in the essay on James I, above.

Henry Keepe, in his *Monumenta Westmonasteriensia*, written a few years after General Monck's funeral, described the funeral effigy as 'in compleat Armour, with his Parliament Robes as a Mantle covering them, with the Collar of the Order of St George round his neck, a Battoon in his hand and a Coronet on his head . . . placed in a Press of Wainscot further to remember him'.[7] In the early twentieth century, the figure was taken to pieces and remounted at the Tower of London, under the direction of Viscount Dillon.[8] By then it consisted only of sticks wrapped with straw and a head formed from a rough block of plaster, painted black. (The present limewood head was made in 1964.) The figure wore a full suit of armour but the gauntlets are mutilated. Underneath was an old leather undress buff coat with leather ties, the sleeves lost. On the head was a gilt metal ducal coronet encircling a black cap of estate edged with dark brown fur.[9] To this figure also, apparently, belonged an ermine cap, a wig and a red leather belt with gilt buckles, all now lost. The effigy must have suffered from the fact that its case had no glass front, and was therefore vulnerable to pilferers, and by the late nineteenth century it was in too dilapidated a condition to be shown.[10]

A surviving warrant for the manufacture of the effigy was issued to the Master of the King's Great Wardrobe:

These are to signifie unto your Lordshipp his Majesties pleasure that you provide and deliver or cause to be provided and delivered, unto Sir Edward Walker Knight Garter principall Kinge of Armes these particulars followinge for the laying in state of his grace the duke of Albemarle at Denmarke House (videlicet) a Pall of Velvett of eight yards long and eight breadths lined with a sheete of fine holland of eight breadths and eight ells long which is to be turned over the velvett halfe a yarde or more to Lye upon the Bedd where the Corps are (*sic*) to be Layd. And thereupon the Representation to be laid. The bed to be Compassed about with an outer Rayle about five foot distant all the posts and Railes to be covered with Velvett. And also that your Lordshipp give order for the prepareinge of the Effigies to be in Complete Armour azured with guilt Nayles and guirt with a Girdle of Crymson of velvett with gold Lace the sword appendant thereat to have a Crosse hilt Guilt and a guilt Chape. This Representation to hold (a) Guilt Baston of Copper in the Right hand and to be invested in a Ducall Roabe of Crymson velvett, lyned with Ermines, about the Necke a Collar and

6 Ibid.
7 Keepe, 95.
8 Hope, 559.

9 This description is taken from Hope, 559.
10 Stanley, 323.

George of the Order of the Garter of Copper Gilt, and under the head a Cushion of Crymson velvett with Gold fringe and Tassells and upon the head a Capp of Crymson Velvett turned up with Ermins with a Ducall Cornett of Copper Gilt, about the left Legg a Garter of blew velvett the buckles and Letters of Copper Gilt, A Velvett Carpett to Cover a Narrow table on which the Helmett Crest etc are to stand. And this with his hand for the Receipt thereof shall be your Lordshipps Warrant. Given under my Hand this Eliaventh day of January, 1669 in the 21 yeare of his Majesties Rayne. MANCHESTER.[11]

The accounts, some of which are gathered together with the warrant, give very full details of the costs of the effigy, its clothing and accessories. They reveal that Joseph Worwood supplied the armour for £20: although, by the Civil War, armour was almost obsolete, military commanders were still generally portrayed wearing it, to invest them with an appropriately martial character. The goldsmith Francis Walton supplied the coronet, collar, baton and badge of St George for £23, and the acounts give full details of the costs of the hearse, mourning clothing and other accessories.

The haughty and eccentric sculptor John Bushnell, who had recently returned from Venice where he had carved the Alviso Mocenigo monument in S. Lazaro dei Mendicanti, sent in a bill of £35 on 5 April:

for making the head and hands in wax; for paintinge the same. A Perriwigge of Hayre to it, And modelling the whole body in Stucke and for my paines and servants and alsoe (for) attendence in dressing and setting up the same in Westminster Abbey.[12]

'As a statuary,' Rupert Gunnis writes, 'Bushnell could either be extremely good or maddeningly bad'.[13] His best known works are perhaps the great baroque group of William Ashburnham and his wife, of 1675, at Ashburnham in Sussex and the simple wall-monument to Abraham Cowley in Westminster Abbey. He was certainly the best sculptor in the immediate post-Restoration years.[14] Besides Loggan's *ad vivum* engraving of 1661, paintings from the studio of Sir Peter Lely dating from c.1665–6 give perhaps the best impression of Monck's appearance and, therefore, an indication of the physiognomy exhibited by Bushnell's lost effigy head.[15]

This was the first effigy (besides Cromwell's) for which wax was certainly employed to make the head and hand: it marks the beginning of a long tradition, which lasts until the early nineteenth century at Westminster. More importantly, it also highlights the intersection between funeral effigies and the popular waxworks, which developed in the late seventeenth century.[16] In France in 1667, Abraham Bosse praised Antoine Benoist, 'ecuyer, peintre du roy et son unique sculpteur en cire colorée'.[17] The following year Benoist received a royal privilege to make wax portraits of high-ranking people in Paris and elsewhere and to display them publicly. Already by 1688, however, La Bruyère could disdainfully refer to him as a 'montreur des marionettes'. As

11 PRO LC 2/10 (1) includes various loose sheets grouped together, ranging from transcriptions from the Gazette of 25 and 28 April 1670 about the ordering of the funeral procession to documents concerning the hearse, false coffin and hearse trappings. Hope, or whoever transcribed the documents for him, worked not from these documents but from the book of abstracts of the warrants and names of the suppliers and costs, also included in LC 2/10 (1).

12 PRO LC 2/10 (1) (Book of abstracts). The Mocenigo monument is illustrated in Whinney, pl. 30.

13 Gunnis, 72–3.

14 John Physick in Wilson, *Westminster*, 157.

15 Piper, *Catalogue*, 2–4, pl. 8f.

16 Freedberg, chapter 9.

17 Freedberg, 224.

Professor Freedberg has perceptively indicated, we can see here the moment when praise for naturalistic representation turns to denigration of a realism which is less than art.[18] In England too, similar judgements were increasingly to be made, particularly after a change in the function of the effigy, a change which saw it become exclusively a memorial figure, and the loss of its role as a ritual object. Classicising, idealising, unpainted sculpture was increasingly in opposition to highly realistic painted figures made of wax, and equipped with wigs and accessories.

<div align="right">PL</div>

DESCRIPTION

1. ARMOUR

A cap-à-pie armour composed of parts from at least three armours. The surface is now rusted to a russet colour, but the instructions in the official order for supplying it, that it was to be 'azured', indicate that it was originally fire-blued throughout.[19] There is no helmet, and it is unlikely that one was supplied with it in addition to the funerary 'Helmett Crest etc' that were to stand on a table adjacent to Monck's effigy.[20]

CUIRASS, comprising a breastplate of flattened form, slightly convex in profile, with a low medial ridge drawn down to a blunt point at the bottom, and a short backplate shaped to the back; it fits closely to the neck, where there is a narrow upstanding flange, while a deeper flange encircles the bottom; the edges of both of these, and of the arm-holes, have plain inward turns. The two parts are secured together by a leather waist-belt, made in two halves, and leather shoulder-straps, all riveted to the backplate. The belt, which is plain, has an iron buckle; the shoulder-straps are decorated with small riveted, bow-tie shaped plaques of gilt brass (?), and terminate in long iron straps, each pierced with two keyhole-slots, either of which engages over a corresponding stud on the breastplate (giving alternative positions), and with ornamentally shaped and pierced ends. Riveted to each shoulder of the backplate is a strap for the attachment of the corresponding pauldron, while the breastplate and backplate each carry a pair of studs on the bottom flange for the attachments of the tassets and culet respectively.

Two holes, now filled with rivets, set one on each side of the top of the breastplate, probably originally held studs for the attachment of a separate reinforcing-breastplate (*plackart*).

LONG TASSETS, articulated on internal leathers, and composed of pieces from two different, but similar, armours. The upper part of each, extending almost to the knees, comprises a wide top plate and twelve narrower upward-lapping lames; the top plate is boxed, embossed with a transverse hollow rib, and pierced with a horizontal keyhole-shaped slot near its outer edge, all to fit the bottom flange of the breastplate, its turned edge, and appropriate stud. The top plates are secured together at the front by a strap and a buckle riveted respectively to each. A pair of knee-pieces (*poleyns*) from the long tassets (or cuisses) of a different armour are riveted to the bottoms. Each retains one lame from its original tassets, and consists of a main plate with a heart-shaped side-wing and two narrow articulated lames above, and a narrow lame and a

[18] Freedberg, 224. See also the fundamental study by Julius Schlosser, 'Geschichte der Porträtbildnerei in Wachs', *Jahrbuch der kunsthistorischen Sammlung des allerhöchsten* *Kaiserhauses (Wien)* 29 (1910), 161–258.

[19] See above, 70.

[20] See above, 71.

deep pointed plate below: the last-named is pierced and fitted with a pivot-hook near its inner edge for the attachment of the corresponding greave.

CULET, of four upward-lapping lames, the top and bottom ones wider than the others. The top lame is boxed and embossed with a transverse hollow rib – as on the tassets – to fit the bottom flange on the backplate and its turned edge; it is pierced with two keyhole-shaped slots which are sprung over the studs on the flange. The edge of the bottom lame has a plain inward turn.

PAULDRONS, extending well over the front and back, where they are of rectangular shape with rounded corners, and with flanges over the armpits at front and rear. Each comprises a large plate at top and bottom with three narrow upward-lapping lames between, and four downward-lapping ones below, the lowest riveted to a turning-joint linking it to the corresponding vambrace.

VAMBRACES attached permanently to the pauldrons. Each comprises closed upper- and lower-cannons linked by a bracelet cowter with two articulated cusped lames above and below (repaired with new riveted plates on the left). The lower-cannon is in two halves joined by a single internal hinge on the inner side, and secured by a hole and pin fastening on the outside.

Fingered GAUNTLETS, roughly made, of thin metal, for funerary purposes only. Only the cuff of the left one survives. The other comprises a pointed one-piece cuff, four metacarpal lames, and a lame shaped to the bases of the fingers to which a few surviving finger plates are riveted.

On all the pieces described so far the main edges are bordered by plain turns and, other than on the cuirass, the edges of all the plates also by pairs of engraved lines.

GREAVES and SABATONS, from another armour. Each greave comprises two main plates and three upward-lapping laminations at the ankle, the former shaped to the shin and calf and joined by two internal hinges on the outer side. The whole is secured when closed round the leg by a pin and swivel-hook on each side of the foot, and two similar fastenings up the inside of the greave; it is attached to the corresponding poleyn by another fastening of the same kind. The sabatons are riveted permanently to the greaves, and each comprises four narrow articulated plates respectively above and below and a square, slightly pinched toe-cap. A pair of holes, now filled with rivets, over each heel indicate where spurs were formerly riveted.

The rivets (nails) throughout have domed heads of brass or iron and, together with the various metal fastenings retain considerable traces of gilding. Many are later replacements, as are all the leathers.

Under the armour is a somewhat dilapidated buff-coat with leather laces.

By the beginning of the English Civil Wars in 1642, the heaviest cavalry were the cuirassiers, armed with sword and pistols, who wore three-quarter armours, that is, armours which extended to the knees only. In the early years of the wars, the wearing of these was generally discontinued in England in favour of, at the most, a cuirass, an open helmet and an elbow-length gauntlet on the left (bridle) arm. It would therefore clearly have been easier for Joseph Worwood, who supplied it, to make up the 'Complete Armour' required for Monck's funeral from old pieces than to acquire a new one. What he did was to use a cuirassier armour of about 1630–40,[21] with

[21] It is possible that the cuirass was made for use by itself at a later date than the other pieces. The way in which the top plates of the tassets fit its lower flange would, however, seem to be against this.

which he associated an earlier pair of greaves and sabatons. In order to make these appear to fit he had to extend the tassets so that they would meet the greaves, which he did with some plates incorporating a pair of poleyns from yet another armour of approximately the same period as the main one.

Cuirassier armours of this kind are, in general, international in style, but the double engraved line borders and, of course, the context of this one are very much in favour of the view that it was made in England, and not imported from the continent. The greaves and sabatons, with their laminated ankles, pinched toes, and pivot-hook fastenings at the ankles are characteristic products of the English Royal Almain Armoury. This was founded at Greenwich Palace by Henry VIII in 1515 and remained there until 1642, when the workshop was closed. It was reconstituted at the Tower of London in 1660, only to be closed permanently in March 1668.[22] The general form of the greaves, and the presence of a pivot-hook fastening on the outside of the foot, instead of a hinge, suggests that they were made very late in the workshop's first period. CB

2. BREECHES

Crimson cut velvet 23in wide, an odd width. Silver-gilt braid, coarse and rather coppery in colour. Could perhaps date from the seventeenth century but could also be much later.

NR

[22] See Tower of London Armouries, Catalogue *Exhibition of Armour made in the Royal Workshops at Greenwich*, 22 May – 29 September, 1951; H.L. Blackmore and C. Blair, 'King James II's harquebus armours and Richard Holden of London', *Journal of the Arms and Armour Society* 13 no. 5 (September 1991), 318.

XI. CHARLES II

In a striking breach with precedent, no effigy was apparently exhibited during the funeral obsequies of Charles II. Instead, in spite of opposition from the office of arms, Privy Council, after consulting with James II, decided on a funeral after 'the private manner'.[1] The king's body lay in state in the Painted Chamber at Westminster between his death on 6 and burial on 14 February 1685. Evelyn records that 'the King was this night very obscurely buried in a Vault under Hen: 7th's Chapell in Westminster, without any manner of pomp and soone forgotten after all this vainity . . . All the Greate Officers broke their white-Staves over the grave & c: according to forme.'[2]

The Lord Chamberlain had issued orders on 11 February to arrange for the materials for the funeral to be delivered to Sir William Dugdale, Garter King at Arms.[3] The materials provided included a canopy of black velvet, escutcheons of the arms of England and Portugal, ten candlesticks to stand around the body and an imperial crown to stand on a purple cushion on the coffin. Luttrell's *Brief Historical Relation* relates how

> The 14th was solemnized, privately, the funeral of his late majestie, from the painted chamber in Westminster to the abby there: the body was carried under a velvet canopy, attended by the servants of the nobility, their royal highnesses, their present majesties, the queen dowagers and the late king's servants; then followed the nobility, with the great officers.[4]

The reason for the low-key funeral and for the absence of an effigy may well be the king's conversion to Catholicism. Charles's successor, James II, also a Catholic, wrote that Charles took the *viaticum* from Father Huddleston, who had risked his life long before to help Charles escape from Worcester;[5] King James was not present at the funeral, it being 'a difficult matter to reconcile the greater ceremonies which must have been performed according to the rites of the Church of England with the obligation of not communicating with it in spiritual things'.[6]

The precise date when the extant wax memorial figure of Charles II was executed is unknown, but on 8 June 1686, Henry Guy, Secretary to the Treasury, authorized the payment of £18 10s to Philip Packer, Paymaster of the Works, for a 'Press for the late Kings Effigies', indicating that the figure was by then ready for exhibition.[7] The display case still survives, but is not on show. No accounts have yet been located to identify the artist responsible for the effigy. As Tanner notes, 'the modelling of the face is so remarkable and the effect is so lifelike, that it could only have been done by an artist of exceptional powers'.[8] John Bushnell, who is documented as having made the (destroyed) wax head and hands of General Monck's effigy some fifteen years earlier, and who is known to have produced portrait busts of Charles II (the terracotta portrait

1 T and N, 171. It is a pleasure to acknowledge the great debt which this author owes to Tanner and Nevinson's path-breaking article for this and all the succeeding entries. For the background see Fritz, 69–70.
2 Evelyn iv, 415. T and N have 10 February. See also *London Gazette* 16 February.
3 *Calendar of State Papers, Domestic, James II*, Feb.–Dec. 1685 (London 1960), 9–10, 17.
4 N. Luttrell, *A Brief Historical Relation of the State of Affairs from September 1678 to April 1714* (Oxford 1857) i, 330.
5 G.N. Clark, *The Later Stuarts 1660–1714* (Oxford 1934), 110.
6 W. Bray, *The Diary and Correspondence of John Evelyn FRS* (London n.d.), 423 note b.
7 W.A. Shaw (ed.), *Calendar of Treasury Books 1685–9* (London 1923) viii/2, 769.
8 T and N, 171.

bust in the Fitzwilliam Museum is ascribed to him) is perhaps the most obvious candidate.[9] However, there was a considerable output of statues of Charles II during his reign including Honoré Pellé's busts in the Victoria and Albert Museum and at Burghley House and it may be that another sculptor was responsible for the effigy.[10]

The wax effigy perhaps provides the most accurate representation of the king's face and may be based on a cast. The large nose and rather coarse features, the prominent lower lip and thick eyebrows are very close indeed to Pellé's 1682 marble bust at Burghley House. Characteristic of both works is the fierce countenance noted by Evelyn.[11] The wax figure perfectly illustrates Marvell's famous description of Charles as 'of tall stature and sable hue'.[12] The second half of the seventeenth century witnessed a huge expansion in the popularity of portraiture, usually in the form of easel paintings, but from c.1660–70 there also developed a fashion for taking life-masks.[13] It is to the development of this fashion that we owe Pepys's account of a visit to 'the Plasterer's at Charing-cross that casts heads and bodies in plaster' on 10 February 1669. He gives an account of the process of making a life cast which may be relevant to King Charles's effigy head, if it is derived from a life mask:

> I had my whole face done; but I was vexed first to be forced to daub all my face over with Pomatum; but it was pretty to feel how soft and easily it is done on the face, and by and by, by degrees, how hard it becomes, that you cannot break it, and sits so close that you cannot pull it off, and yet so easy, that it is as soft as a pillow.[14]

The dressing of the effigy in Garter robes (as he was frequently shown in painted portraits) is based on the frontispiece representing Charles II in Ashmole's *Institution . . . of the Order of the Garter*, published in 1672.[15] The rhetorical pose of the figure, with the rather awkwardly placed foot, is contemporary. Here, for the first time, Baroque portraiture has affected the Westminster royal effigies. Charles's figure appears to be depicted almost in the act of movement, as if he were barely confined by the display case. The diagonal pose, haughty expression and sumptuous robes contribute to the theatricality of the image.

The effigy is 6ft 2ins in height, and this is consistent with the official description of Charles issued after the battle of Worcester which stated that Charles was 'a tall man, above two yards high'.[16] It is dressed in the robes of the Order of the Garter, as described by Ashmole, and there is no reason therefore to doubt that these are genuine Garter robes, probably even those of Charles II himself. The wig was renewed in 1729.[17]

The intentions behind, and the significance of, the commissioning of this effigy are obscured by the absence of any surviving accounts. However, it seems clear that this was the first extant 'effigy' which was not actually carried in a funeral service. Although it was apparently positioned over the king's grave,[18] the portrait figure marks a significant departure from the

9 See essay on Monck, above, 75; see also Gunnis, 72–4.
10 Piper, *Catalogue*, 69. For information on the marble bust by Honoré Pellé at Burghley House I am indebted to Carol Galvin's conservation report of October 1991.
11 Evelyn, 409.
12 DNB, qv.
13 Piper, *Catalogue*, xxii.
14 Pepys ix, 442 (for his appreciative judgement of the cast see 449). The artist has been identi-

fied by K.A. Esdaile as William Larson junior, modeller and caster: see *Times Literary Supplement*, 2 October 1943, 480. The cast does not survive.
15 T and N, 172.
16 M.A.E. Green (ed.), *Calendar of State Papers, Domestic Series 1651* (London 1877), 476.
17 See below, 92.
18 Dart, *Westmonasterium*, i, 151. It is engraved on p. 153.

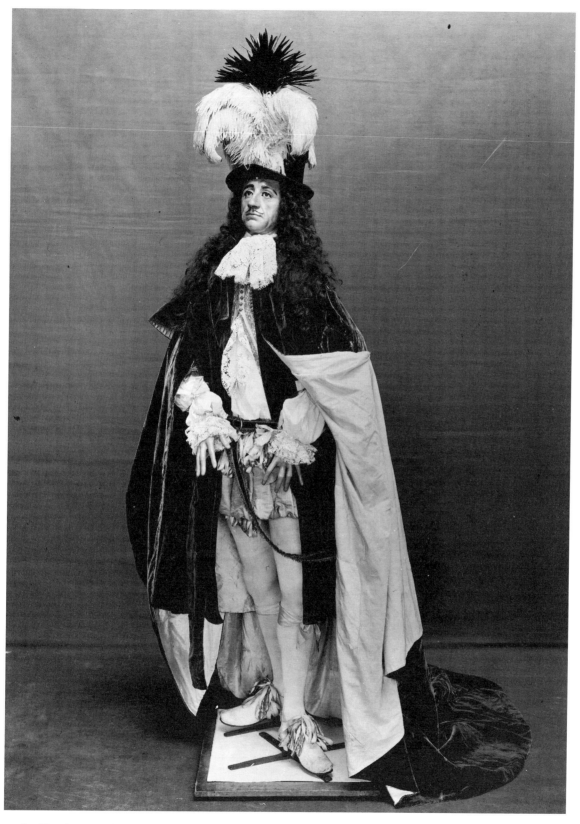

8. Charles II: whole effigy after restoration of 1933–4

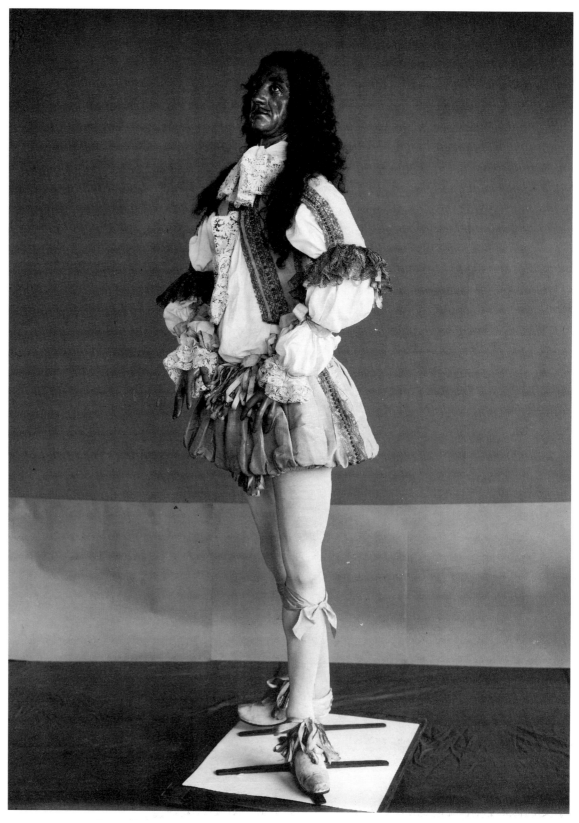

9. Charles II: effigy with hat, mantle and surcoat removed

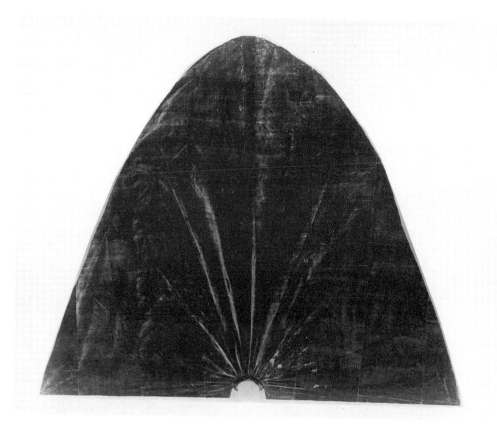

10. Charles II: mantle (catalogue no. 1)

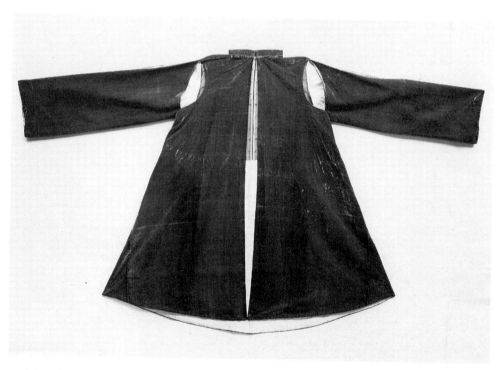

11. Charles II: surcoat (catalogue no. 2)

Westminster tradition and an important stage in the divorce of the figure from its original ritual role in the funeral ceremonies. Here, already, the figure's memorial function has, to some considerable extent, superseded the former liturgical one. The movemented pose underlines the fact that this figure's function has changed. It is not a funeral effigy with a subsequent role as a portrait figure: it was a portrait memorial figure from the outset.

PL

DESCRIPTION

The figure consists of a wax head and hands, a stuffed body stiffened with wood, and iron and wooden legs, held upright by two cross-shaped pieces of iron which support vertical staples passing through the soles of the shoes. The eyebrows are painted, the eyelashes and small moustache are of hair; the eyes of glass. The body is stuffed with hay and tow, and covered with coarse canvas; there was more stuffing between shirt and doublet. The arms are padded about an iron wire; the wooden legs are carved from single blocks to mid-thigh, above which there are cylindrical pieces which, in their turn, are glued to a cross-piece; from this rises an iron socket into which the central wooden post of the bust fits. The feet are similarly carved, and have been glued to the legs.

T and N

1. MANTLE

Length (front) 63in, (train) 108in; hem (from front to centre seam of train) 144in. Made from six widths of blue silk velvet with cut pile 20ins wide and two part widths, lined with white silk taffeta. Loom width of taffeta is 41in. There is a standing band collar (19½in), with two large worked buttonholes surrounded with silk. The skirts on the right are looped to the shoulder with a white silk ribbon bow; on the left shoulder are the tears where the badge (Garter gross) has been removed. It would appear to have been a pearled cross enclosed by the garter, without a glory, of the dimensions given by Ashmole (height 10in, width 7in). The mantle is without facings and the cords and tassels for fastening no longer remain.

T and N

2. SURCOAT

Length (front and back) 46in, width (shoulders) 19in; skirts (lower edge) 106in; sleeves, length 32½in, width 9½in. Red silk velvet, lined with white silk taffeta. There is a band collar (18 in) without fastenings. The body is cut full and straight. The sleeves, though lined and open at the wrist, are false, and the arms pass through a slit in front of the shoulder. The upper seam of the sleeves is also slit from shoulder to elbow.

T and N

3. HOOD

Diameter of ring, 4½in, length (band) 53½in; width 6in. Red silk velvet, lined with white silk taffeta. The hood consists of a stiff padded ring covered with velvet, to which a cape-like flounce 10½in deep is attached. From the ring hangs a long band of the same materials. This represents the medieval hood and the streamer which fell from it, and was often wrapped about the neck. The hood is worn on the right shoulder, resting on the mantle; on this effigy it was found placed on the left shoulder to hide the place where the star had been, and the band had been tucked in under the sword belt.

T and N

4. DOUBLET

Length (front) 16in, width (shoulders) about 17½in.

T and N

Cloth of silver woven in tabby of silk and silver thread.

NR

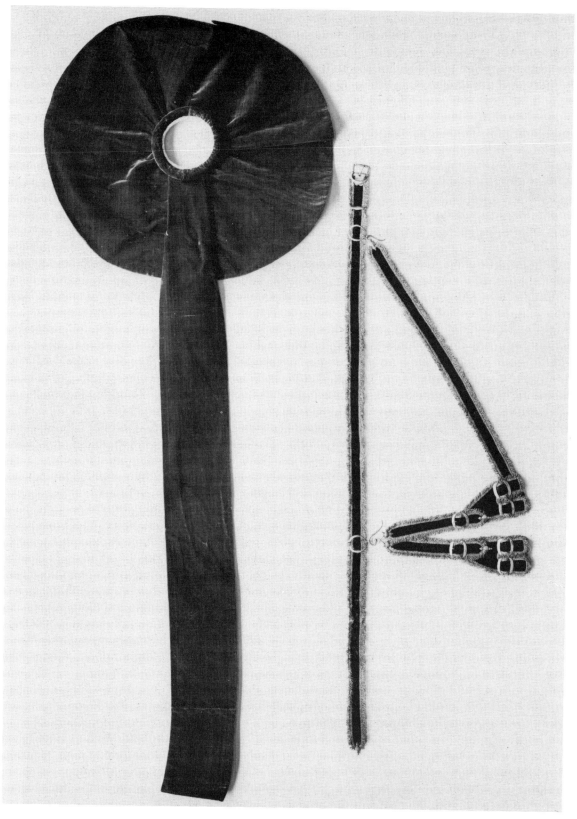

12. Charles II: hood and sword belt (catalogue nos. 3 and 14)

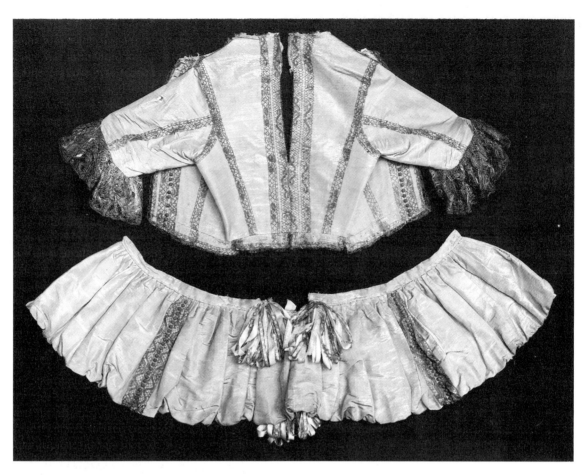

13. Charles II: doublet and breeches (catalogue nos. 4 and 5)

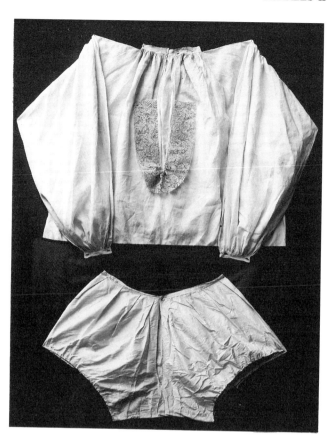

14. Charles II: drawers and shirt
(catalogue nos. 6 and 8)

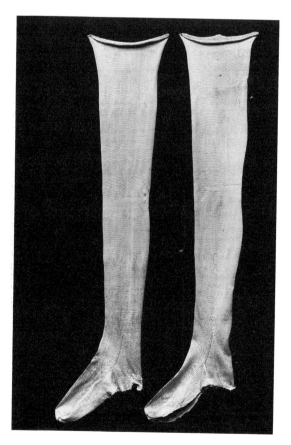

15. Charles II: stockings
(catalogue no. 7)

Trimmed with silver bobbin lace. The collar is missing, and the front meets over the top of the chest, where there are seven small buttons; below, the doublet falls apart, leaving an opening in the form of an inverted V, in which the ruffles of the shirt show. The front is decorated on either side with a vertical row of small buttons and braiding; the latter is continued up over the shoulders and down the back, which has an 8½in slit in the centre, to secure freedom for the shoulders while keeping a tight fit. The doublet has been cut from here to the neck when it was fitted to the effigy. The waist is cut square, and about it are six wide, shallow (½in) tabs, edged with silver lace; about these is a row of false eyelet holes set close, a survival of the period (before 1630) when the breeches were attached by points. The sleeves are short and full (13in) and have an ornamented slit down the front seam and braid on the outside. The doublet is stiffened with canvas and lined with white silk. This doublet would be of the form prescribed by Charles II in April 1661, and shows the attenuated form which the Elizabethan doublet had assumed by that date. The waist had shortened until a roll of shirt appeared between doublet and breeches, the sleeves had shortened to the elbow, and the two sides barely met across the chest. Clearly the doublet is of the early Restoration period; the collar, now cut away, would have been, on the analogy of the doublet at Lennoxlove, a plain band of silk braid. T and N

The sleeves are decorated down the back seam and either side of the 'slashed' openings with bands of metallic bobbin lace. Deeper borders of metallic bobbin lace with a bold Baroque pattern trim the lower edges of the sleeves. The lace was probably made in London. Both laces are badly tarnished; they appear to have been made of silver and, in the case of the wider border, of poor quality silver-gilt on a copper base. SL

5. BREECHES

Waist 32in, length 11in. These are of the same material as the doublet, in the form of a short petticoat, and have no division for the legs; they button from top to bottom at the back, and have a single button in front. The material is not paned, but set in very full pleats, which pouch and hand over along the lower edge; there is an inner stiffening of buckram. At the waist in front there are two bunches of white and silver figured ribbon, and there are three similar bunches under the pleats on the lower edge. At the sides are two vertical bands of silver braid and ornamental buttons which mask the openings of two silk-lined pockets. The pair at Lennoxlove has a division for the legs, and it is possible that the Westminster garment was mutilated when the effigy was mounted. T and N

6. DRAWERS

Waist about 37in, length about 13in. White silk. These are cut full and square; they fasten with ribbons in front, and have a small slit and ties behind; the stockings are sewn to the legs.

T and N

7. STOCKINGS

Length 31in, foot 10in. Bluish-white silk, knitted. The legs, heels, and upper part of the feet are made in one piece, and the soles, with narrow gores running up to a point on the ankle, are sewn in. Above the points of the gores there are small figured flowers. The feet have been slit for mounting, and the tops are sewn to the drawers. The silk is much faded. On the right leg below the knee is tied a small garter of white silk ribbon; on the left a broader bright blue ribbon to represent the Garter itself. T and N

8. SHIRT

Length 43in; neck about 16in. White linen. It is cut very full, both in the body and the sleeves, and is finely gathered to neck and wrists. The neck has been cut out and mutilated – the narrow

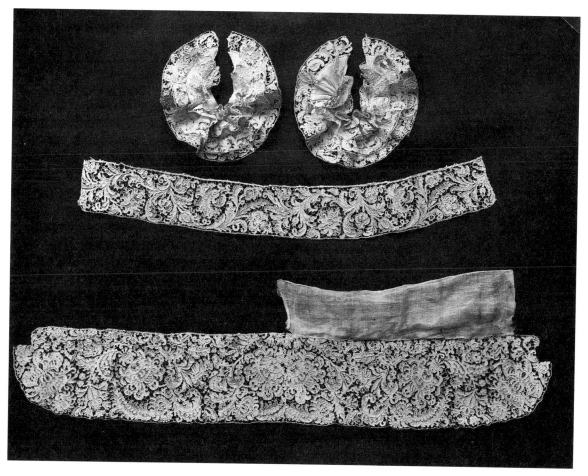

16. Charles II: lace of shirt, sleeve ruffles and cravat (catalogue nos. 8 and 9)

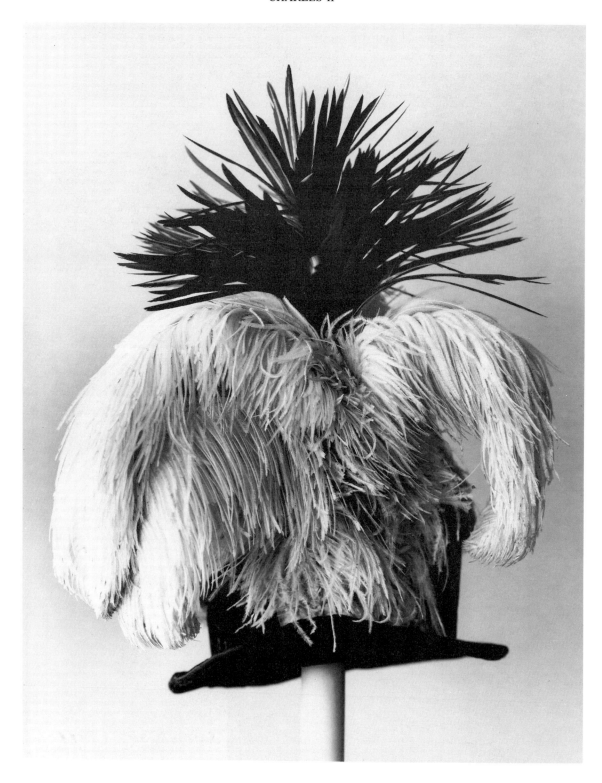

17. Charles II: hat (catalogue no. 10)

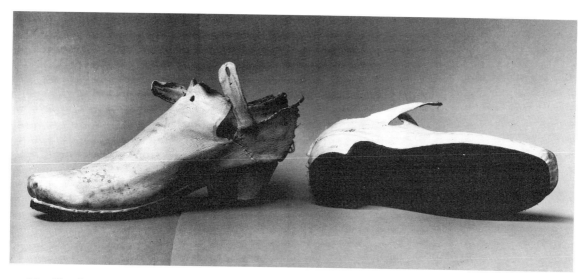

18. Charles II: shoes (catalogue no. 12)

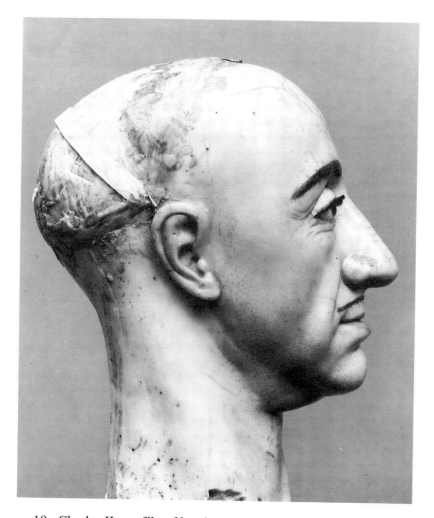

19. Charles II: profile of head

band has two buttonholes on the left – and the sleeves cut off in two places. The latter are gathered in two full puffs by white silk ribbons at the elbow and on the forearm. To the wristbands, which have four buttonholes, are attached the ruffles of lace, and strips of similar lace edge the opening down the front of the shirt. The shirt has been underlaid and repaired. T and N

The lace on the shirt and cravat is raised needle lace, Venetian in style but possibly made in London. SL

9. CRAVAT

The lace is gathered about three sides of a narrow oblong strip of cotton. This is drawn together lengthways so that the lace forms a knot at the throat. The cravat had been loosely refixed to the head by a strip of loosely woven cotton, and might seem to be a later arrangement. The engraving in Ashmole shows a broad falling collar of similar lace, and this cravat may have been made up from a collar of this sort. On the other hand the cravat was being worn by 1680, especially by soldiers. T and N

The cravat is a twentieth-century restoration using old lace. NR

10. HAT

Height 6in, diameter 11½in. Black velvet, lined with black silk. The shape is cylindrical, with a flat top and close pleating down the sides; there is a small brim, which has been sewn up where the plume is fixed. The plume consists of ten white ostrich feathers attached in fan shape to a piece of card, and there is an aigrette of narrow black and white heron's feathers. The band – no doubt of gold or jewelled – is missing (the marks of the stitches are visible), and the brim was probably caught up to secure the plume when the band was removed.

T and N

11. WIG

Length about 20in. Human hair, chestnut brown. A full wig rather lightly curled, made of human hair made up in long `tresses' and attached to the corded foundation, which is partly lined with pink silk. It is slightly moth-eaten, and is certainly the 1729 restoration. A contemporary wig of Charles II would undoubtedly have been black, since he is known to have been a very dark man. T and N

12. SHOES[19]

Pair of white leather tie shoes, made grain out.
Toe 1¾in square, rounded at the sole, with the upper forward jutting, roughly gathered onto it. The toe puff is about 1½in to 1⅝in long.
Heel 1⅜in high, covered in white leather, with red top piece.
Sole is also of red leather, flesh out, made straights, and continuous through an acute angle down the heel breast, and held there with a wooden peg. No channel was cut for the stitches and it is as well that the shoes are unworn for the stitches would have abraded very quickly. The construction is a rolled rand ending well forward of the heel breast, with no stitches visible on the edge, though there are impressions of a rather irregular and coarse 2½ stitches to the inch.

19　It was not practical to remove the shoes of most of the effigies for examination. While possible to make assumptions about the amount of wear, construction and interior details from what is visible, it should be pointed out that more detailed examination might prove some of the assumptions to be incorrect. (JS).

Length 11in, width almost 3in at the tread, a generous size over the 10in stockings (stocking size given by Tanner and Nevinson).

Upper consists of vamp and pair of quarters joined by an oblique, straight side seam, 2in long, which starts 2½in along the seat from the back seam. Vamp and quarters are cut to leave small open sides about 1in across, the last relics of the fashion which had been exaggerated in the first half of the century and which died out in the new reign of Charles II. The back seam is broken and has been cross-stitch repaired. It measures 2¾in and was probably cut with a V-dip at the top, to relieve strain.

The vamp extends to a fairly high tongue on one shoe, irregularly cut and damaged, probably originally square with cut corners. The quarters' top edge is also irregular (damage), with impressions of a reinforcing cord, whipstitch attached here and round the side opening, though the damage indicates it was not very efficient. The lace holes are unworked (one latchet is broken), and the laces, which would have tied over and through the pair of lace holes (also unworked) in the tongue, are missing.

Inside It was not possible to examine this, but the shoes seem to be unlined apart from an impression of a side lining whipstitched along its top edge at about 3 stitches to the inch on both vamp and quarters.

The 1723 print in Dart's *Westmonasterium*[20] shows the shoes tied with comparatively narrow ribbons and an almost circular buckle in the centre of them. Some of the breeches ribbons which had been transferred to tie the shoes sometime before 1893 were restored to their original place in the 1986 conservation.

The coarseness of the workmanship suggests that these were cheap shoes, adequate for being pierced through the heel for the effigy support, but unlikely to have belonged to Charles, though the rarity of surviving men's shoes of this date means there is insufficient evidence to confirm this. It is a little surprising to find that they appear to be tie shoes, when Charles had worn the new fashion of buckles, which were to become the major fastening in the reign of William and Mary, as early as the Coronation portrait of 1661. The 1723 print with the small buckle is acceptable as the original: the buckle would then have been attached with a stud or anchor type chape through the lace holes.

<div align="right">JS</div>

13. JEWELLERY

The ornaments on this effigy were apparently stolen by robbers who crept into the Abbey during the private burial of one of Princess (later Queen) Anne's infants on 27 January 1700. The only metal articles remaining are two open gilt metal buckles and two hangers on the sword belt.

<div align="right">SB</div>

14. SWORD-GIRDLE AND HANGER

The figure of Charles II has lost its sword, but still retains its girdle and hanger of blue velvet lined with white silk, trimmed with silver-gilt fringe and with plain gilt metal mounts (silver-gilt according to T and N). It comprises a narrow girdle with a buckle and slide at the front end and, to the left, two moveable buckles incorporating rings, of which the rear one is for a suspension-hook on the hanger. The latter comprises two straps joined at the top to form a narrow triangle with the suspension-hook at the apex, and each buckled at the bottom to the apex of a triangular frog. Each frog is itself split vertically at the bottom into two straps which are bent back upon themselves and secured by two buckles, the four together forming a tube through which the scabbard of the sword was passed almost horizontally. Stitched to the front frog is a long restraining strap terminating at the other end in a hook which engages in the ring on the

[20] Dart i, 153.

front movable buckle of the girdle, in order to prevent the hanger and sword from swinging round the wearer's back. Length, 50in, width 1¾in (dimensions given by T & N).

The form of hanger is one that was introduced in the sixteenth century for the civilian sword, the rapier.[21] It had gone out of general use by c.1630, but, as this example shows, was retained much longer for wear with ceremonial robes. The engraving of Charles in Garter robes in Ashmole's *Institutions* shows him wearing a robe-sword very similar to those on the William III and Duke of Buckingham figures here.

CB

CONSERVATION HISTORY

1729	Wig renewed (Precentor's Book).
1933	Clothes cleaned, including plumes.
1934	Right eyelid repaired. 'The wax of the head had dried, and the nose had been broken, and the eyelids were also damaged . . . Some of the fingers of the hands were detached, and had been mended at earlier dates.' (T and N)
1978	Forefinger detached and repaired.
1979	Clothes cleaned.
1987	Full conservation of figure and clothes, Osterley Outside Work Scheme, V and A, with help in realigning the figure from Plowden and Smith.

Head and hands removed, and effigy stripped to wood and canvas base. Stuffing of torso corrected and augmented to fit doublet and waist of breeches, covered with new cotton tightly stitched to hold in place. Torso and legs separated and rejoined to give improved stability. Rough wood of legs covered with new stockings. Shirt, underpants, stockings and lace washed and repaired, doublet and breeches checked and surface cleaned. Silk lining of mantle found to have been repaired with pieces taken from the surcoat, any missing areas made up with new silk. Water damage on silk of mantle treated without complete removal; cut original stitches left in place. Velvet surface cleaned with soft brush; hole repaired with patch of new velvet; steamed. Ribbons from shoes, petticoat, breeches and sleeves removed, washed and mounted on Cremplene with thermoplastic adhesive.

SBL

Wax of head and hands cleaned with damp swabs to remove white bloom produced by wax drying out; discoloured fillings removed from cracks and break across left eyebrow, refilled with colour-matched beeswax; lost bristles from eyelashes and moustache replaced with bristle coloured with watercolour. Two digits from right hand removed and replaced with dowelling; cracks filled. All fillings toned with watercolour coated with layer of paraffin and ceresin wax mix to discourage formation of white bloom. Head and hands previously realigned to add cotton aprons for attachment to body; these reused and figure dressed again.

VK and RM

21 C.R. Beard, 'Girdles, shoulder-belts and scarves', *The Connoisseur*, December 1940, 249–54.

XII. FRANCES, DUCHESS OF RICHMOND AND LENNOX

Frances Stuart, Duchess of Richmond, known as 'La Belle Stuart', was born in 1647.[1] Her father, Walter Stuart, a distant relative of the royal house of Stuart, fled to France with his family in 1649 to the exiled court; his wife, Sophia, was attached to the household of the Queen Dowager, Henrietta Maria. Frances was brought up in France but after the Restoration accompanied her mother to England, with a letter of introduction from the Duchess of Orleans, who described Frances as 'la plus jolie fille du monde'.[2] Early in 1663 she was appointed maid of honour to Charles II's wife, Catherine of Braganza.[3] Barbara Villiers, Countess of Castlemaine, and Charles II's mistress, seems to have brought her to the king's attention with results that should not have been unexpected given the fifteen-year-old Frances's attractions and Charles's 'addiction' to women.[4] By July of 1663 the king seems to have been besotted with her. On the thirteenth of that month Samuel Pepys noted that she was the greatest beauty the diarist had ever seen, 'with her hat cocked and a red plume, with her sweet eye, little Roman nose and excellent *Taille*' and that night he imagined himself 'to sport with [her] with great pleasure'.[5] The Duke of Buckingham, Sir Henry Bennet and others all made advances to her but in spite of the Chevalier de Gramont's caustic comment, 'it is hardly possible for a woman to have less wit or more beauty', she seems to have been perfectly able to resist their addresses.[6] Although the king offered to make her a duchess and in January 1667 was seriously considering divorcing Queen Catherine and marrying her, Frances had already accepted the proposal of Charles Stuart, Duke of Richmond and Lennox and at the end of March eloped with him to a private marriage in Kent, to the king's great fury.[7]

Before she was disfigured by smallpox in 1668 Frances Stuart was considered the greatest beauty at court, and the best known early portraits of her, such as the painting of her as *Diana* among the Lely 'beauties' now at Hampton Court or the 1664 Huysmans portrait at Buckingham Palace, in which she is dressed as a male soldier in a buff doublet, confirm her reputation.[8] In 1667 she was depicted as 'Britannia' on the Peace of Breda and Naval Victories medals. With the exception of the full length portrait at Lennoxlove by William Wissing and Jan van der Vaart of 1687, however, the majority of images of the duchess date from the 1660s: the funeral effigy by contrast gives an extremely accurate image of her as she was in her fifties.

In a codicil to her will, dated 7 October 1702, the duchess ordered her executors:

to have my Effigie as well done in Wax as can bee and set up near the old Duke Lodowick

1 T and N, 176.
2 DNB, q.v.
3 DNB; C.H. Hartmann, *La Belle Stuart* (London 1924).
4 Evelyn iv, 410 for Evelyn's characterisation of the king as 'addicted to women'.
5 Pepys iv, 230.
6 Hartmann, 26.
7 DNB, q.v. Pepys viii, 183–4.
8 R.B. Beckett, *Lely* (London 1951), 19 (pl. 100) dates the Lely 'Windsor Beauty' portrait to c.1666; O. Millar, *Tudor, Stuart and Early Georgian Pictures in the Collection of H.M. the Queen* (London 1963), nos. 257–66, prefers c.1662–5 and thinks the portrait of Frances Stuart was 'painted not later than c.1662'. The Lely portraits were described by Pepys as 'good, but not like' (284). The duchess was also painted in male dress by Samuel Cooper: the fashion of dressing as men seems to have been popular at the time. See also Hartmann, Appendix, for portraits of her.

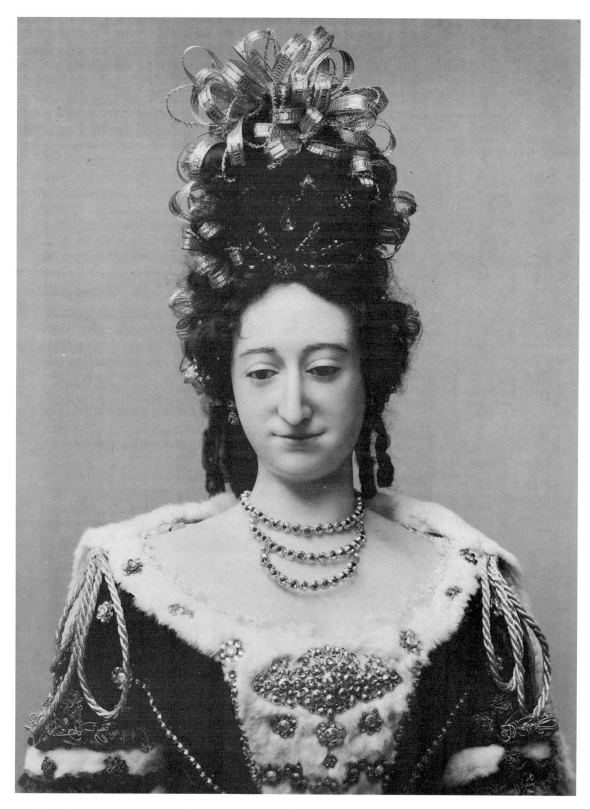

20. Frances, Duchess of Richmond: head and bust after restoration of 1933–4

and Dutchesse Frances of Richmond and Lennox, put in a presse by itselfe distinct from the other with cleare crowne glasse before it and dressed in my Coronation Robes and coronette.[9]

She died on 15 October 1702 and was buried in the Duke of Richmond's vault in Henry VII's chapel on 22 October. The *Daily Courant* for Friday 6 August 1703, describes how 'Mrs Goldsmith, the Famous Woman for Waxwork brought to Westminster Abbey the Effigies of that celebrated Beauty the late Dutchess of Richmond, which is said to be the richest Figure that was ever set up in King Henry's Chappel'.[10] In an account of June 1703, the executors paid 'To Mr (*sic*) Goldsmith for the performing of Her Grace's Effigies, Glass, Jappanning, Bringing home, and setting up in K. Henry 7th Chappell £260'.[11]

On a contemporary bracket by the side of the duchess is perched the stuffed parrot which had lived with her for forty years and died very soon after her. The parrot is a West African grey: John Ray, writing in *Synopsis Avium* in 1694 states that there were many in England at the time.[12] This is apparently the oldest stuffed bird in England.[13] The appearance of the faithful parrot here, beside its owner, highlights a decisive turning point in the evolution of the Westminster effigies. 'La Belle Stuart' had intended her effigy to be a memorial to her, quite divorced from her funeral ceremony, and the addition of the parrot is wholly in keeping with this ambition. Although two later effigies, those of Catherine, Duchess of Buckingham (d.1743) and of her son Edmund, second Duke of Buckingham (d.1735), were carried in funeral ceremonies, these were the last to play such a part, and the future lay with the memorial figure. Charles II's waxwork effigy, made after his funeral, had, perhaps unintentionally, diverted the Westminster tradition in a new direction, and the figure of the duchess of Richmond confirms the new divorce between the waxwork and the funeral ceremony. The portrait-figure is still associated with her burial place, but now stands primarily as an almost entirely secularised memorial representation. The stuffed parrot has become an attribute, a faithful accessory which helps to identify the owner. Ironically, by the late eighteenth century the parrot had become more significant, as a tourist attraction, than the effigy of the duchess.[14]

The duchess's figure, including the shoes, is 5ft 8in high and is dressed in the robes which she wore at the coronation of Queen Anne.[15]

PL

DESCRIPTION

The head, bust, forearms, and legs from above the knee to the ankle are of wax, formerly tinted pink; the ears are only roughly modelled; the eyes of glass with eyelashes of hair. The body is stuffed and covered with canvas, which is sewn along the seams; it is supported on a wooden upright between the legs, so placed that the feet just touch the ground; the square base was covered with white silk, and has four wooden rollers on its under side.

T and N

9 PCC Hern f. 166, quoted by Hartmann, 246.
10 *Daily Courant*, Friday 6 August 1703. See also J. Ashton, *Social Life in the Reign of Queen Anne* (2 vols., London 1882, 1904), 213–14 who believes that Thomas Goldsmith is identical with Mrs Goldsmith. See also E.J. Pyke, *A Biographical Dictionary of Wax Modellers* (Oxford 1973), 55–6 and *Supplement* (London 1981), 18. It seems most likely to me that they were a husband and wife team, with Mrs Goldsmith as the modeller.

11 Hartmann, 247 n1. See the engraving in Dart, *Westmonasterium*, i, 154 (where the effigy is misidentified).
12 T and N, 177.
13 See below, 108.
14 Nollekens' well-known statement about the Westminster effigies testifies to this: see above, 24.
15 T and N, 176.

1. ROBE

Length (front of corsage) 15in, (back) 17½in, length (back, including train) 82in, greatest width (train) 81in; length (sleeves) 12½in. The robe is of plain red silk velvet, the edges trimmed with a 2in band of ermine. The bodice laces behind, and is pointed at back and front; the neck is cut almost horizontal and trimmed with ermine (in which are set pastes in silver mounts) and narrow lace. The skirt is partly pleated to the waist, but most of the fullness is obtained by cutting (gores); the edges are undulating and trimmed with ermine. The short sleeves (which had been separated from the body when the figure was mounted and were loosely pinned) have a double rouleau of ermine trimmed with silver-gilt bobbin lace and galloon bows below the shoulder; they are finished above the elbow with velvet tabs similarly trimmed. The robe is lined with a light weight white silk, and stiffened with cane at the back of the bodice. As worn, the skirt is caught back on the hips, and gives a basque effect below the waist in front. T and N

2. STOMACHER

Length 14¾in, width at top 7in. Ermine mounted on thin card and set with pastes in silver mounts. It is stitched to the bodice of the robe and is of the usual narrow triangular shape. To the top is attached the large silver clasp (below, no. 26(2)), and the bodice of the robe is decorated with a line of pastes on either side. T and N

3. TRAIN

Length 117in, width (shoulders) 16in; greatest width 84in; length of cape 13½in. Red velvet uniform with the robe, but trimmed with a wide band of ermine; the edges are straight; part of the fullness is gathered to the shoulders but much is obtained by the cutting. There is a turn-down ermine cape collar lying flat on the shoulders. The train was sewn to the shoulders of the robe, and has no cords for attaching. It is lined with white silk. Although the above three items are roughly made, they may be actual duchess's robes. T and N

4. PETTICOAT

Length 43in, circumference (hem) 92in, waist 29in. White silk tabby brocaded in silver-gilt thread, now much tarnished, *filé* and *frisé*, and khaki silk. Width of silk 21¼in. Repeat width 7in. Length 9in. Selvage: 2 green and 1 white stripe with outer cords. Woven in twill. Bodice: crimson cut velvet of several dates. Tassels could be original.
The silk is probably French, c.1690, an interesting proto-bizarre design.[16] NR

The petticoat is trimmed with metallic bobbin lace and woven metallic braid: poor quality silver-gilt on a copper base, probably made in London. SL

5. PETTICOAT

Length 42in. Blue and white striped worsted (4 threads white, 3 threads blue). Similar in cut to the preceding; about the hem are attached, very roughly, pieces of blue and white striped silk (length of each about 26in). NR, T and N

6. PETTICOAT

Pale blue silk, very lightweight tabby striped in the warp. NR

[16] Illustrated in Thornton, *Baroque and Rococo Silks*, pl. 27b.

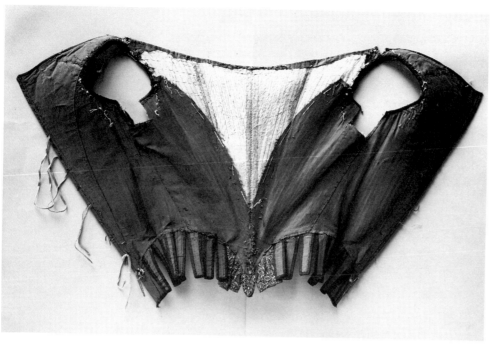

21. Frances, Duchess of Richmond: corset (catalogue no. 9)

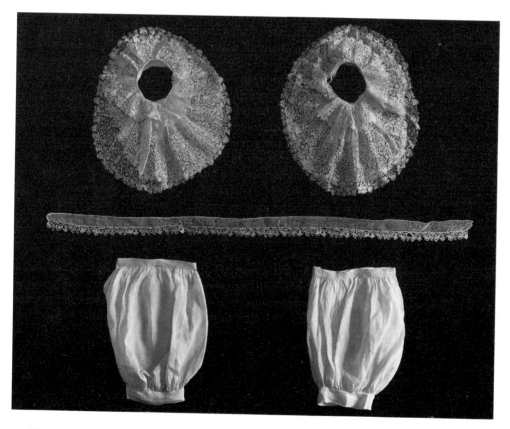

22. Frances, Duchess of Richmond: sleeves, ruffles and shift lace
 (catalogue nos. 10–11)

7. PETTICOAT

Pale blue worsted with a chevron pattern weave, with linen waistband and ties.

NR, T and N

8. UNDER PETTICOAT

Length 43in. White flannel, much stained by dust. Similar in cut to the two preceding.

T and N

9. CORSET

Length (front) 16¾in, (back) 20in. Canvas stiffened with cane, and has been covered with dark blue silk. The front has been embroidered with gilt metal thread, but all the embroidery except the tabs at the peak of the stomacher and small portions on the shoulders has been torn away. The corset laces at the back, where there are two thick canes running up high on to the shoulders; at waist behind are two 2in hooks, now misplaced. About the waist are long narrow basque-tabs, some with pairs of eyelet holes. The shoulder-straps are defective, and the corset has been cut under the arms when fitted to the figure. It is lined with woollen cloth.

T and N

10. PART OF SHIFT(?) AND PAIR OF SLEEVES

Length 34in, circumference (lower hem) 66in, circumference (top) 46in; sleeves, length 11in, diameter 9in. Both are of cambric; the first piece has been hemmed, and may be from the skirt of a shift. The short sleeves are full, and are gathered to bands above and below.

T and N

The neck is trimmed with Brussels bobbin lace, matching that on the wrist ruffles.

SL

11. SLEEVE RUFFLES ('Engageants')

Greatest depth 7in. A triple flounce of lace; the two under strips of lace are mounted on muslin. To the lowest are attached five bows of gilt ribbon.

T and N

Brussels bobbin lace.

SL

12. GIRDLE AND SHOULDER KNOTS

Length of girdle 10ft. Both are made of plaited silver thread; the girdle has large tassels at either end.

T and N

13. CAP

Height (overall) 5½in, diameter (at base) 6½in. The upper part of red velvet pleated at sides; the top nearly flat and with a knot in gilt bullion work; about the base a thick wadded roll covered with ermine to support the coronet. White silk lining.

T and N

14. STOCKINGS

Length (foot) 8in. Knitted green silk, with white striped tops, and no provision for a garter. The foot and gores at the ankle are of a separate piece. There are no clocks.

T and N

15. INNER STOCKINGS

Length 21in. Knitted pale blue wool, and are of the same dimensions and make as the outer pair. They were probably put on in order to prevent the wax of the legs from staining the silk stockings.

T and N

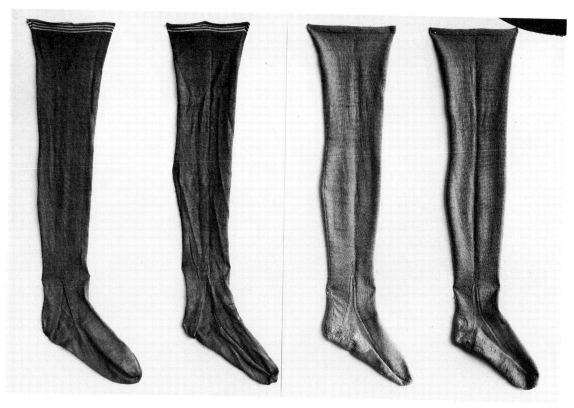

23. Frances, Duchess of Richmond: stockings (catalogue nos. 14–15)

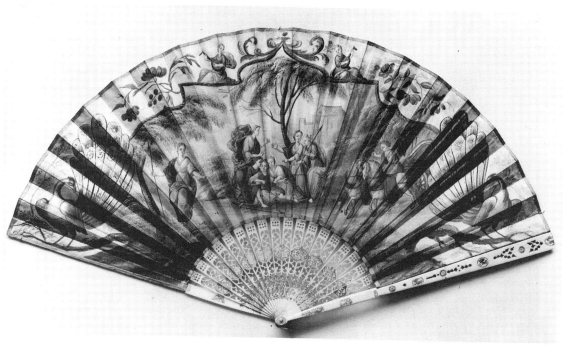

24. Frances, Duchess of Richmond: fan (catalogue no. 17)

16. PAIR OF GLOVES

Length 16in. Plain white kid, made up inside out and resembling suede. Long narrow gauntlets. The gloves were pinned to the right side of the petticoat (no 4). T and N

17. FAN

Length 11in. The nationality and date of the fan are uncertain, but it would appear to be rather later than the effigy. The sticks are of ivory, pierced and gilded; on the paper mount is a classical scene, flanked by peacocks, showing a group surrounding a dying youth (Venus and Adonis?); on the left is a goddess, on the right a chariot. The back of the fan is painted with a bunch of flowers. T and N

18. PAPER FLOWER

Length 7in. A rose with wrapped wire stalk. T and N

19. WIG

Height (from forehead) 7½in; total length 29in. The wig is built up from a wire frame pinned to a cotton skull-cap; among the curls is a large ornament. The curls at the back are held in position with rolls of black paper, and two large hanging curls are similarly fixed, but the four smaller hanging curls are not stiffened. The hair is brown, and has been heavily powdered with white (?) powder. T and N

20. SHOES

Pair of tie shoes of white leather and golden coloured silk braid.

Toe needlepoint, with low toe spring, the upper overhanging.

Heel 3 in high Louis, covered in polished black goatskin, with the fairly straight back line typical of its date. White kid top piece, for indoor wear, to prevent slipping on polished floors.

Sole of brown leather with longitudinal impressions, and brown polished edge finish. It is made straights, and continues down the heel breast. There is a single nail hole at the toe, with two plus one at the waist, used in attaching the sole to the last before stitching. There are no signs of wear (braid is missing from the upper where the joint flexes, but this may be due to handling during removal from the effigy). The construction is a white kid rand, ending at the start of the heel, finely stitched with stitches visible on the side of the rand, which is the usual practice for eighteenth century English shoes. Length 9 in, which fits well over the 8in stockings (stocking size given by Tanner and Nevinson).

Upper consists of vamp and pair of quarters, joined by oblique side seam, leaving a small open side, inevitable with a bound shoe of this pattern. The vamp is cut with a high square-cut, flared tongue, with a broad band of diamond-checked gilt braid from toe almost to the top. The quarters are short and extended into square-cut latchets, with the lace holes probably unworked. A strip of white tawed leather, tapering each end, joins them, and one is overlaid with figured gilt braid, which has left a copper green stain (missing from the pair). This was probably originally stitched to the latchet at one end and used to fasten the shoe through a buckle with stud or anchor chape (now missing), attached through the opposite 'lace' hole. The top edges are bound with bright yellow silk. The rest of the vamp and quarters have rows of narrow golden coloured silk braid appliqued, producing a striped effect. They are meticulously matched at the side seam.

Inside It was not possible to examine this in detail, but the stitches holding the narrow braid appear on the inside, and the tongue is lined with striped silk (according to Tanner and Nevinson).

The quality of the workmanship indicates that the shoes were expensive, and the colour

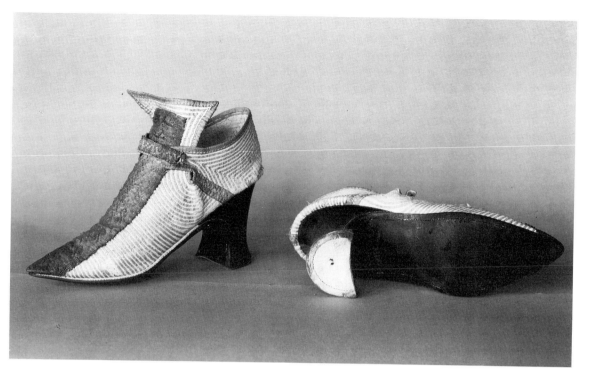

25. Frances, Duchess of Richmond: shoes (catalogue no. 20)

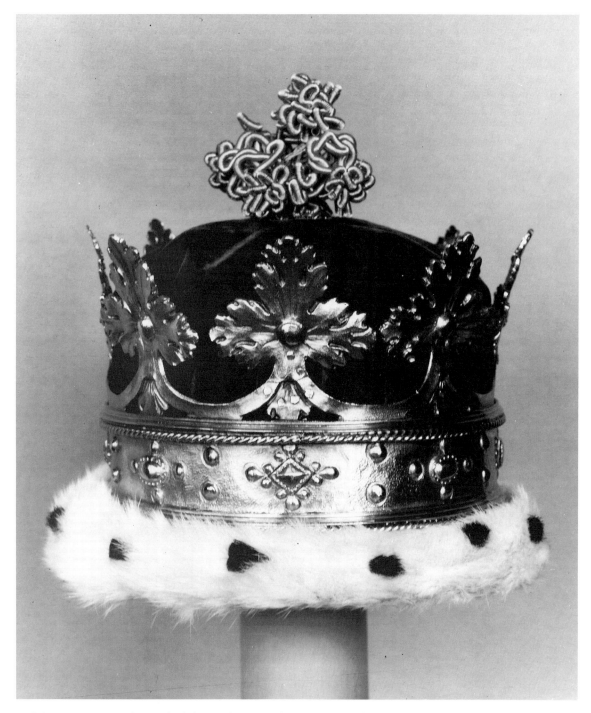

26. Frances, Duchess of Richmond: cap and coronet (catalogue nos. 13 and 21)

suggests they may be associated with the coronation robes and therefore belonged to the duchess.

There are a considerable number of shoes surviving with this type of decoration, the so-called 'laced shoes'. Randle Holme in 1688 describes laced shoes: 'have the over leathers and edges of the shoe laced in orderly courses, with narrow galoon lace of any colour'.[17] But though they range in date from about 1650 to 1750, few are as exquisitely made as this pair. Some were in fact decorated in ugly contrasting colours.

Dart's 1723 print of this effigy clearly shows the shoes visible below the skirt, though contemporary early eighteenth century portraits rarely show more than the toe tip.[18] JS

21–27. JEWELLERY

The jewellery can largely be dated to 1700–1703 and some pieces probably to the latter two years. As the duchess directed in a codicil to her will dated 7 October 1702 that her effigy be made in wax and dressed in the robes and coronet that she wore to the coronation of Queen Anne on 23 April nearly six months earlier, Mrs Goldsmith, who made and dressed the figure, would have wanted to honour so famous a beauty by adding some up-to-date ornaments. The delivery date of 4 August 1703, derived from a report in the *Daily Courant* of two days later, established the terminus. Unhappily most observers were so struck by the naturalism of the rendering and the brilliance of the figure they failed to comment on the jewellery, which is equally notable. Sophie von La Roche, visiting London in 1786, wrote that 'A beautiful Duchess of Richmond seems to come towards one, when the doors of her cupboard have been opened . . .'[19]

21. SMALL CORONET with ducal crest of eight strawberry leaves.

Height 3in, diameter at base 5in. Silver-gilt with the strawberry leaves attached by rivets; repaired. Maker's mark WH and London hallmark. Owing to the disappearance of all the registers of goldsmiths prior to 1797, the identity of the maker, who appears to have been active since 1664, has not been established. The coronet surmounts a red velvet cap with a bullion knot.

22. HEADDRESS ORNAMENT. Height from forehead, 7½in (T and N).

Silver, set with white pastes and one red one, some rose-cut and others table-cut. Designed to be silhouetted against the high coiffure, it comprises five strips of metal fanning out from a bossed base behind a triple bow and a cluster projecting from a spring ('trembler'). The strips are bent forward of their tops to allow for the attachment of front-facing motifs. The central strip holds a red table-cut paste (with side facets) projecting from a rectangular rub-over setting with clipped corners and a row of scallops at the lower edge; halfway down are two arms, probably formerly a bow, each formed of three high table-cut pastes in plain rub-over collets, also rectangular, with clipped corners. They are strung on two wires which are threaded through tubes attached to the back of the collets, a standard method of attachment. The ends of the wire are roughly twisted around a boss on the strip, further evidence that the wings were a bow with a different method of attachment. From the boss falls a rose-cut tear-shaped drop. The upper two flanking strips each terminate in a rosette with a central rose-cut paste in a rub-over collet with a scalloped base set proud of six smaller pastes, also cut as roses, with smaller pastes in the spandrels, some wanting. The two lower strips each end in an open bow

[17] Randle Holme, *The Academie of Armory and Blazon* (Chester 1688), bk 3, 14.

[18] Dart i, 153.

[19] Sophie von La Roche, *Sophie in London, 1786* (1933), 118.

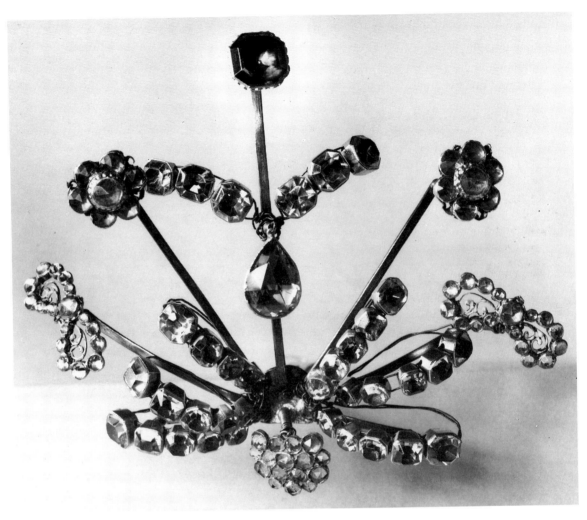

27. Frances, Duchess of Richmond: headdress ornament (catalogue no. 22)

outlined by a row of graduated rose-cut pastes in conjoined collets and filled with scrolling metal filigree; in the centre, a large rose in a scalloped collet. The three loops of the bow at the bottom are like the arms projecting from the central stem. The pastes are cut, mounted in separate collets and strung in the same way, the double wires bent round at the back to form the bow. The trembler is set with small roses.

23. OTHER ORNAMENTS in the coiffure. Strings of rose-cut white pastes in rub-over collets decorated with pellets are entwined through the hair.

24. EARRINGS. Apparently silver, they are of the top and drop variety. The tops are circular, each having a single white rose-cut paste set proud of a border with a lobed outline. The drops are oval but are otherwise constructed in a similar fashion. The convex backs are decorated with black sprigs on an opaque white enamelled ground. Probably en suite with the necklace, they may date to the 1690s.

25. NECKLACE. Length 11½in. Separate rose-cut white pastes mounted in rub-over collets with scalloped decoration at the base, strung on two wires passed through the back of the collets, with two festoons, one above the other. Festoons of this type are rare, but this may simply reflect the paucity of diamond necklaces of this period. The necklace appears much as it is now in 1769.[20] If it pre-dates the effigy, as is possible, it was probably originally strung on silk.

26. BODICE ORNAMENTS

(1) The furred edge of the bodice is dotted with four rosettes of white rose-cut pastes, two of which have central stones in collets with a scalloped base and the other two in plain gold, which are probably later. The first two rosettes appear with the necklace and the large bodice ornament in Plate 20; their backs are enamelled with sprigs. Two units with a rose-cut paste mounted in silver with trefoil ends are interspersed with the rosettes.

(2) Corsage clasp or stomacher. Length 4½in. In three parts, comprising a central openwork rosette with two side wings attached by a hook or clip at the back. The largest of the rose-cut white stones, placed in the centre of the rosette, is mounted in a lobed setting; the majority of the rest are in rub-over collets with scalloped decoration at the base and a few, the smallest, are integrated into an openwork structure of foliated scrolls. The principal pastes in the rosette are set proud of the others, echoing in more complex fashion an arrangement of hired diamonds which temporarily adorned Mary of Modena's diadem at the coronation of James II and his consort on 23 April 1685. The diadem, which has survived, was reset with rose-cut pastes (since exchanged for rock crystals), probably in about 1702. The settings of openwork scrolls and the treatment of the collets are directly comparable with those of the duchess's clasp.[21] The back of the clasp is carefully engraved with foliated decoration, conclusive proof that it is not a funerary ornament.

(3) The engraving of the duchess's effigy in *A View* shows two, possibly three large ornaments, together with small units and clusters, but the larger pieces might have been composed of similar small items grouped together. A set of two or more jewelled pieces of diminishing size, known collectively as a stomacher, were not unknown (see the stomacher

[20] *A View*, opp. 21.
[21] See the comments on the diadem and the sleeve of the queen consort's sceptre with

cross in the writer's forthcoming catalogue raisonné of the Crown Jewels.

on Mary II's effigy), but so were singletons, and on balance it is probable that only one large ornament existed.[22]

(4) Ten rosettes similar to those cited above and eight more clasps with trefoil ends, also set with rose-cut pastes, are disposed over the bodice. In the 1930s these units were placed together to create the impression of two curvilinear bands or straps, one above the other. They are now spaced at intervals.

27. SLEEVE ORNAMENTS. Two further rosettes decorate each sleeve. SB

28. PARROT

A stuffed African grey parrot (*Psittacus erithacus*). Radiography in 1981 revealed that the entire skeleton, the brain and trachea are still present, the complete bird being held on wires simply spiked through the body.[23] There are some traces of paint on the bare skin round the eyes. This very primitive method of mounting the bird would not have been adopted by a taxidermist of the nineteenth or even the late eighteenth century, and strongly suggests that this is the original parrot said to have lived with the duchess for forty years. 'It is likely to be one of the oldest surviving stuffed birds in existence; perhaps the oldest.'[24] RM

CONSERVATION HISTORY

1933–4	Some broken fingers and a cracked leg repaired; clothes cleaned; wig and head-dress taken to pieces and cleaned; pastes on stomacher removed and cleaned (V and A). Parrot 'treated' (Natural History Museum).
1973	Full conservation in the Textile Conservation Dept., V and A. Figure stripped and the head and hands removed. The stuffing of the torso redistributed in the canvas cover, augmented where necessary and the back of the neck padded better to fit the gown. The head repaired and some canvas strips added to be used to stitch it back to the body; one finger of the left hand repaired. Stockings, shift, linen sleeves, lace and three underskirts washed; the blue silk of the petticoat, catalogue no. 5, isolated from the wool with silk crepeline. The wool of the outer petticoat was darned and the brocaded silk was supported on nylon tulle with a thermoplastic adhesive, all metal lace, tassels and cords cleaned and lacquered. The taffeta linings of the gown and train were removed, or partially released, to be washed and mounted on nylon tulle. The sleeves of the bodice were rebuilt and lined. The stomacher and corset were repaired and stiffened; fur cleaned and supported on nylon tulle, velvet steamed. Wig cleaned and curls reset; fontage and headdress ornament dismantled; ribbons and jewels cleaned, repaired and reassembled; coronet cleaned. SBL
1987	Wax cleaned, some over-filling of earlier repairs to chest reduced, right hand little finger resecured, eyebrows partly repainted (Plowden and Smith). RM

22 It is illustrated with the necklace and two rosettes in Evans, pl. 136.

23 P. Morris, 'The antiquity of the duchess of Richmond's parrot', *Museums Journal* (Nov. 1981), 153–4.

24 Morris, 153.

XIII. WILLIAM III

For the funeral of William III (d.1702), no funeral effigy was employed, nor was there a hearse at Westminster.[1] However, from the seventeenth until the early nineteenth century, the wages of the vergers and minor canons were augmented by tips paid by those who came to see the tombs. It was therefore to their advantage to attract visitors to the Abbey, and they themselves now commissioned portrait figures to add to the genuine effigies. These were shown to the public for a small extra fee. It was in this way that the figures of King William III and Queen Mary II, Queen Anne, Chatham and Nelson were added to the collection and the figure of Queen Elizabeth was remade. Receipts from the visitors to the tombs were, then, reinvested by updating and augmenting the collection of effigies.

An entry in the account book kept by the Chanter of Westminster Abbey states that 'the Figures of K. Wm and Q. Mary were open'd to be shown on Monday, March 1st 1725' and that the total expenditure on them from 'Mony taken out of the Tombs' was £187 13s 2d.[2] Although no detailed bills have survived, there is a further note that £5 was 'paid out of the Scaffold Mony at the Installment for Q Mary's Petticoat'.[3] Tanner and Nevinson argue that the effigies may well have been modelled by Mrs Goldsmith, who had made the effigy of the Duchess of Richmond in 1702–3. Later, in the case of Queen Anne's portrait figure, the wax head and hands were commissioned shortly after her death, though the effigy was not completed for another twenty-five years. It is just possible that King William's figure, and even that of Queen Mary, may have been produced in advance of 1725, which would increase the likelihood that Mrs Goldsmith was responsible. In March 1695 an effigy of 'her late Majesty of Blessed Memory . . . curiously done to the Life in wax, and Dresst in Coronation Robes' could be seen at her shop.[4] Other possible artists for the Westminster figures are Mrs Salmon (1650–1740), a well-known wax modeller and waxworks owner, or Thomas Bennier, who worked for her.[5] It is significant that the most important of the early waxworks entrepreneurs and many of the most accomplished modellers were women, devoting great skill to a genre not generally regarded as 'art'. As David Freedberg has remarked, realism suppresses awareness of changing conventions of representation and stylistic idiosyncracy,[6] because physiognomic and physical realism are less subject to convention and schematisation than other representational modes. This doubtless contributes to the low aesthetic evaluation of wax effigies: they are less modified by an individual artist's own style and less subject to idealisation (beyond that of pose). One important consequence for the art-historian is that it becomes difficult to attribute the Westminster effigies with any degree of confidence, and since the wax heads and hands could be commissioned sepa-

1 Sandford, 754–5.
2 T and N, 190; WAM 61228B, fo. 4.
3 T and N, 190; WAM 61228B, fo. 4.
4 E.J. Pyke, *A Biographical Dictionary of Wax Modellers* (Oxford 1973), 55, citing the *London Gazette*, Thursday 28 March 1695. In 1702 Mrs Goldsmith was exhibiting an effigy of William III (J.T. Smith, *A Book for a Rainy Day*, cited in Westminster Abbey Library copy of Tanner and Nevinson).
5 Pyke, *Wax Modellers*, 126; see also F.A. Pottle (ed.), *Boswell's London Journal 1762–3* (Harmondsworth 1950), 314. See also above, p. 17.
6 D. Freedberg, *The Power of Images* (Chicago 1989), 236–7.

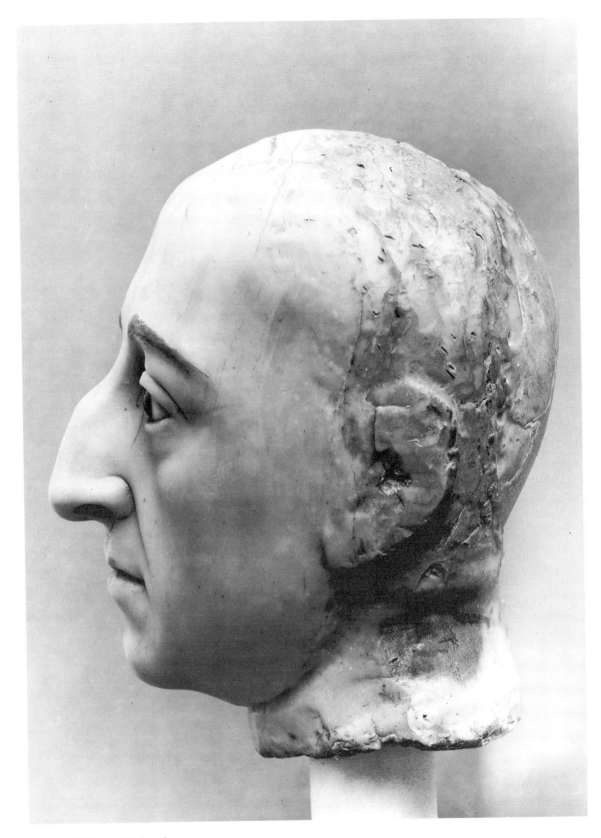

28. William III: head

rately from the rest of the effigy, constructional techniques are also less revealing than might be hoped.[7]

There is no doubt that the modeller achieved a remarkable portrait of King William, which is perhaps based on Godfrey Kneller's state portrait of the king, painted in 1690 for the Council Chamber at Kensington Palace and now at Windsor.[8] Oliver Millar has described the king's portrait as 'the most successful state portrait' between the Van Dyck of (Charles I in) 1636 and Allan Ramsay's George III.[9] Copies were assiduously disseminated (at a cost of £50 per time) in full-scale copies and in large mezzotints by John Smith, and it was quickly recognised as the approved official likeness. Although the Westminster image seems to be modelled on this painted portrait, it does not reproduce its lively and energetic stance. Here, again, the drive towards realistic likeness directly undercuts the assertive grandiloquence of contemporary painted portraiture, where accurate physiognomic and physical realism was tempered by a variety of other, often even more important, concerns. The Westminster figure, at the same time as reproducing, with scrupulous accuracy, the features of the king, enormously reduces the potency of the image to direct our concerns. We notice, for example, that the king was only 5ft 6½ins tall, and that he stands on a footstool to make him nearer the queen's height: his high forehead and large, hooked nose, attract our attention. The transmutation through royal portraiture of the ruler's physical reality into a metaphysical idea cannot take place because the physicality of the image militates against it. Evidence in support of this contention is provided by the comments of a contemporary spectator, who, viewing the Westminster figures of King William and Queen Mary, declared, 'I think they are ridiculous and unnatural in themselves, expressing neither figure like statuary, nor colour like painting: secondly, I am humbly of opinion that they would become a puppet-shew better than a church, as making a mere farce of what should be great and solemn; and, thirdly, I think them highly injurious to the characters they represent, as shewing them like jointed babies, to the stupid admiration of the vulgar, and the contempt of men of sense; instead of characterising their persons, and perpetuating their virtues.'[10]

The structure of the effigy is in line with the constructional techniques employed for that of the duchess of Richmond.

PL

DESCRIPTION

The head and hands are of wax, the body of canvas stuffed with straw and stiffened with wire; there is a wooden post running up the back on which the head is fixed. The legs are of canvas, plaster and glue, bound round with strips of black woollen cloth.

T and N

1. MANTLE

Length (front) 59in, (back) 74in; cape 22in; collar 7in; neck 19½in. Purple woollen velvet, trimmed with rabbit fur and gilt braid, and lined with coarse blue canvas. The mantle is roughly semi-circular in shape, gathered to the neck; there are strips of velvet (about 34in wide) down either side of the front, which is faced with fur and has an inner border of wide galloon. The back is of linen. The deep cape with rows of close-set tails is of fur, as is also the small collar; the cape lies flat, but the collar is stiffened with brown paper and stands out; there is a white silk tie on either side of the cape in front. The plain band collar has two buttonholes through which a

[7] It was not possible to examine the effigies out of their new cases and detailed analysis of their construction was impossible.

[8] Millar i, 142 (no. 335).

[9] Ibid., 23.

[10] J. Ralph, *A Critical Review of the Public Buildings . . .* (London 1734), 85.

thick cord of purple and yellow wool (length 10ft) with 4-ply string centre is passed. There are no tassels. The garment, which has clearly been made for the effigy, has attached to the inside of the train at the back a small piece of fur (14in by 10in) which is probably intended to show between the legs. T and N

2. SURCOAT

Length (front) 44in; collar 10in; hem 31in; sleeve length 43in (25 to elbow slit), width (below shoulder) 8¼in; sleeve width at end 7½in. Purple woollen velvet trimmed with fur and gilt braid to match the mantle. It consists of two side pieces without back. The front is edged with fur, and within this are borders of one narrow and one wider stripe of galloon. The irregular shaped collar pieces are loosely attached to the neck with a point forward. Behind them are attached long false sleeves, hanging to the hem; these have slits at the elbow, trimmed with fur, through which the arms project. Some of the braid and fur has been stripped, but the garment was certainly made for the effigy and would never have been complete. T and N

The braid or galloon on his surcoat looks genuine and could date from 1702. The colour of the metal is excellent. NR

3. WAISTCOAT CUFFS

Length 8in, width (spread out), cuff 9in; top 14in. Lined with white silk. One has six uncut buttonholes, the other six round buttons loosely attached. Sleeved plain waistcoats of the period were often finished with these tight false cuffs (or 'cheats') of richer materials which showed inside the wider coat cuffs (cf. Pitt, no. 3, a pair of later date, and Normanby, no. 2).

T and N

The silk French, c.1702, a typical 'bizarre' silk of the period.[11] Satin, brocaded in silver-gilt thread. NR

4. SHIRTSLEEVES

Length 17½in, width (shoulder) 12in, (wrist) 6in. Linen, evenly gathered at top and wrist; the wristband has two buttonholes and black silk ribbon ties. Single ruffles of bobbin lace. Tape ties at top. T and N

The lace is Flemish. SL

5. STOCKINGS

Length 21in, width (top) 7in. Knitted white silk, with long gore-clocks and large figured crowns above them. The device under the crown may be a W monogram. If so, the stockings may have actually been made for William III. The feet have been cut away. No garters. T and N

6. UNDERSTOCKINGS

Length 22½in, width (top) 7in. Knitted white cotton with small geometrical figured clocks. The tops have been cut, the feet are defective and turned in. T and N

7. SHOES

Pair of white leather buckle shoes, probably alum tawed cattle hide, grain out.
Toe 2½in wide, square domed, with 1¾in toe puff to maintain the shape. A small hole in the centre front at sole level may be subsequent damage, as I have not seen this feature on similar toes.
Heel 2in high, covered in leather which appears to have been blackened over the original brown colour. The breast and top piece are white stitched. The breast incurves, to lighten the weight of these heavy-looking heels. The heel has a large circular cut-out for the effigy support.

11 Illustrated in Thornton, *Baroque and Rococo Silks*, pl. 33a.

Sole is also black leather, flesh out, made straights and continuous through a rightangle and down the heel breast. The sole is domed under the tread, a feature found more commonly in the 1720s–30s on men's footwear, though there are a few examples from the early years of the century, and they continued a little longer on women's. It appears unworn. Nail holes, one at the toe and two at the waist, used before the sole was stitched, are covered with a star stamp. The construction is a white kid rand, ending at the heel breast, finely stitched, with stitches showing on the side, at about 12 to the inch, and stitched through the sole channel. The 10in length is in proportion to William's known height.

Upper consists of vamp and pair of quarters, joined with rightangled dog-leg side seams commencing about 1in behind the heel breast and making short quarters. The vamp extends into a high flared tongue, cut so that the corners are not visible in wear above the quarters' top edge, unlike the tongues on the shoes of William III's reign, the upper patterns of which resemble more closely those of the Marquess of Normanby. The back seam is cut with a V-dip at the top to relieve strain, and was originally bound with white silk braid, as were the top edges (now largely missing). The inside quarter of each shoe is cut to extend into a long pointed strap, which is pierced with two 'button-holes', one horizontal, one vertical, to take either stud or anchor chape buckles. The straps at present fasten with neat, roughly circular buckles of ten rose-cut pastes (one missing on left foot), attached through the horizontal buttonhole with a silver stud. No spike to fasten is visible through the longer strap, but there are single rust stains, indicating single spikes pointing inwards, with the longer strap end therefore pointing out, to avoid rubbing against the other leg. The straps are too wide for these buckles, suggesting either that they are not original (though there is nothing in the appearance which contradicts the date of the shoes), or a carelessness at the time of fitting in the 1720s when more shoes used larger buckles with double spike chapes, which did not need the 'button-holes' in the straps. The rarity of surviving men's shoes of the 1702–24 period which could be used for comparative purposes leaves us unable to specify when the shoes were made.

It is significant that the companion effigy of William's Queen Mary lacks both shoes and stockings, as it was unusual to show more than the tip of the shoe toe appearing from under the dress in the 1690s when she died. JS

8–11. JEWELLERY

The king has very little personal jewellery other than a gilt buckle on his sword belt and paste-set silver shoe buckles.

8. GARTER COLLAR. Cast metal, gilt and painted; the motifs are smaller than those on Queen Anne's collar but are treated in a similar fashion.

9. SCEPTRE. Length 35½in. Carved and gilt wood surmounted by a fleur-de-lys with a cross-pattée having three pearl terminals above; a very approximate rendering of the gem-set Sovereign's Sceptre made for Charles II in 1661, costing £1,025.

10. ORB. Height 7½in, diameter 5in. Gilt metal, open backed, the moulded edges of the zone and front arc bordered by imitation pearls, which also decorate the front of the monde at the junction with the globe. A single large imitation pearl is set in the cross-pattée on top. A summary interpretation of the jewelled Sovereign's Orb executed for Charles II in 1661 and charged at £1,150. The original, like the Sceptre, survives in the regalia at the Tower of London. William's orb is slightly taller than the one supplied for Queen Mary's effigy; the real orb is markedly higher than the one executed for Mary II in 1689.[12]

[12] See Martin Holmes and H.D.W. Sitwell, *The English Regalia: their History, Custody and Display* (London 1972), pl. 11.

11. CROWN (placed between William and Mary). Height 8in. Carved and gilt wood and imitation pearls. Though conforming to standard type and comprising a band, crest of crosses-pattée alternating with fleurs-de-lys and two arches surmounted by a monde and cross, there is no attempt to reproduce the stones on the original crowns used by William and Mary at their coronation. William was crowned with St Edward's Crown, made in 1661; he used Charles II's State Crown, modified. Mary of Modena's two Crowns were reset for Mary II. SB

12. SWORD, GIRDLE AND HANGER

Length: sword, 30in, hilt 6½in; girdle 40in. T and N

The king wears a robe-sword of normal cruciform type, with a straight blade and pommel and cross of gilt metal (brass?); the flat quillons spring from a shield-shaped central block and are of narrow elongated 'bow tie' shape with rounded tips, each with a small central projection, while the small rounded pommel is of lenticular section and has a button. The wooden grip is bound with gilt (silver?) wire with a Turk's head at each end. The sheathed blade and its scabbard, except for the gilt metal chape, are entirely concealed by the king's robes, but Tanner and Nevinson say that the scabbard is of leather 'with gilt chape [*sic* for locket?] and tip'.[13] The girdle and hanger on which the sword is worn are likewise partly concealed. Tanner and Nevinson say they are of leather, and 'the parts about the waist which show when the belt is worn are covered with gilt braid and have a narrow central line of purple velvet'. All the parts appear to be made in one, and the hanger is apparently no more than a single vertical strap ending in a frog and linked to the girdle towards the front by a diagonal restraining strap. The buckle is of gilt metal.

The form of hilt found on this sword, a simple cross, was essentially a medieval one that had gone largely out of use in the sixteenth century in favour of more complex designs. Knights of the Bath, however, continued to be required to have such a sword – presumably because it was thought appropriate to medieval chivalry – and the very large increase in their number under James I produced a limited general revival of the form in the early seventeenth century, no doubt helped by the continuation in the interest in revived chivalric pursuits that had started under Elizabeth I. The type subsequently remained in use for wear with ceremonial robes, especially those of the orders of chivalry, and so came to be called a 'robe sword'.[14] Like the present example, and that on the Duke of Buckingham's figure (q.v.), all these robe swords are very debased successors to the true knightly sword of the middle ages.

According to Tanner and Nevinson, 'the sword is a dummy and does not draw; the hilt is disproportionally large'. The first statement is almost certainly wrong (cf. the similar one about the Duke of Buckingham's sword), and, if the measurements they give are correct, it would have been more accurate to say that the blade is disproportionally short. The fact that the sword could not be drawn from the scabbard was no doubt because the blade had become rusted into it, a very common occurrence.

The fact that the girdle is decorated only where it is visible leaves little doubt that it was made only for display on this figure, and not for actual wear. CB

CONSERVATION HISTORY

1934 Body recovered with new canvas; sceptre, crown and cross repaired.
1935 Clothes cleaned (Sketchley).

[13] T and N, 192.
[14] See C. Blair, 'An English sword with an Ottoman blade in the Swiss National Museum – the hilt and scabbard', in K. Stüber and H. Wetter (eds.), *Blankwaffen* (Zurich 1982), 57–8.

1942 Clothes treated for moth (V and A).

1987 Old break line in left thumb filled, new eyelashes, hands cleaned (Plowden and Smith). Sleeve lace and cravat washed and bleached, robe ribbons washed and mounted, neck cloth washed and pressed (V and A). RM

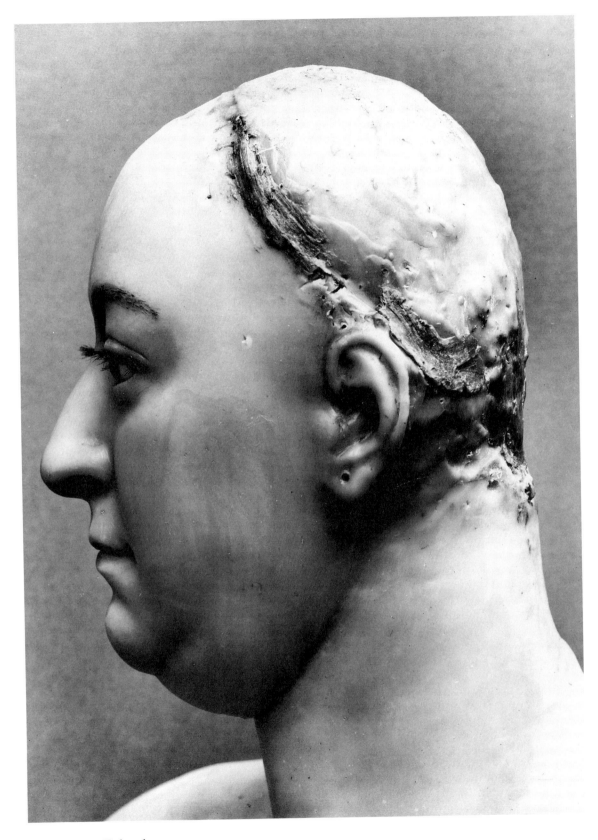

29. Mary II: head

XIV. QUEEN MARY II

On the day of Queen Mary II's death, 28 December 1694, twenty-four members of the Privy Council met at Whitehall, to settle the preliminary details for her funeral. The Earl Marshal asked Garter King at Arms to outline precedents in writing. The precedent drawn on was the funeral of King James I. Officers of arms prepared four rooms at Whitehall to be hung with mourning. In the final room they proposed 'an effigy of her majesty in wax apparelled in her royal coronation robes with an imperial crown on her head and sceptres in her hands, the head resting on a purple velvet cushion fringed and tasselled with gold'. However, at the Council debate, the crucial decision was taken to omit the hearse and effigy: the precedent of Charles II's funeral – where no effigy was deployed – was crucial. Nevertheless, in the end an elaborate hearse designed by Sir Christopher Wren was included, though the effigy was omitted.[1]

The figure of Queen Mary does not appear to have been properly published before and has never received much attention.[2] Queen Mary's image is 5ft 11ins tall and represents her at the age of thirty-two, when she died. An engraving sold by John Overton of London represents the queen's body lying in state.[3] The Westminster figure shows her as a tall and amply built young woman, with good-natured features, a double chin, and prominent bosom. She carries a sceptre and orb. It is again obvious that because wax permits verisimilitude so easily and effectively, there is a tension between the memorial function and the aesthetic status of the object: the maker's artistic personality has a narrowly confined room for self-expression, for idealisation or for any other aesthetic or non-aesthetic intrusions. The figure is much less formal than Kneller's state portrait.[4] To some considerable extent, the directness of the realism of the figure affects us much more directly than contemporary portraiture in other media. Because it is so little modified by period or individual style, the realistic portrait stands in a directly empathetic relationship to the viewer.[5]

The constructional techniques employed for Mary's effigy are the same as those used for that of her husband. No stockings or shoes have ever been added, because her feet and legs would be hidden under the petticoats and skirts. From the first, both these figures seem to have stood in the Upper Islip Chapel. They were described in the 1754 *Historical Description of Westminster Abbey* as 'in good condition and greatly admired by every eye that beheld them',[6] an opinion directly contradicted by the spectator quoted in the entry on William III. PL

DESCRIPTION

The head and bust and hands of wax, the body of canvas stuffed with tow and stiffened with a wooden post running up the back and with wire. The legs similarly stuffed, but no stockings or shoes have ever been added. T and N

1 See Fritz, 65–8.
2 It is not, for instance, illustrated in the text by Tanner and Nevinson, nor in the current (1987) guidebook to the collection. The hearse is shown in Sandford, 721.

3 College of Arms MS I.1, 3.
4 Millar i, 143 (no. 338).
5 Freedberg, 236–7.
6 *Historical Description* 1754, cited by Stanley, 324 n3.

1. BODICE

Length (front) 16in, (sleeves) 13in. Purple woollen velvet, trimmed with rabbit fur and glass pearls. This is not a garment but merely a patchwork of velvet attached to the corset. In front there is a narrow V-shaped piece of fur to which three clasps are attached. The sleeves are cut plain and square and tacked to the shoulders. No lining to bodice. T and N

2. TWO STRIPS (for a skirt)

Length 50in, width 15in. Same materials edged with fur, and with an inner border stripe of gilt braid. These strips are attached to the waist, and fall apart to show the petticoat.

T and N

Gilt braid c.1725–50. NR

3. TWO STRIPS (for a mantle)

Length 64in, width (hem) 18in; neck, 12in. Same materials, edged with fur. Loosely attached by pins to the shoulders. T and N

4. BROCADED SILK

Width 20in, length 44½in. T and N

Two panels used for petticoat: point repeat. Length of repeat 23in. Satin ground, one green pattern weft, the other colours brocaded, bound in twill. The silk English, mid-1720s. This is a new silk in excellent condition.[7] NR

5. PETTICOAT

Length 45½in, waist 28in, hem 92in. Brown leather with large stylised baroque patterns (with some Chinese figures) painted in gold. Broad stripe above hem; the petticoat is roughly gathered to the waist, and cannot have been an actual garment. T and N

6. HOOP PETTICOAT, part

37in; lower hem 50½in. Coarse linen, with three iron wires running horizontally at about equal distances. T and N

7. PAIR OF SLEEVES

Length 14in, width (shoulders) 6in, (elbows) 5in. Linen, with tapes at shoulders, the centre full and gathered to band at elbow. T and N

8. PIECE OF LACE ABOUT CORSAGE-NECK

Length 32½in, width 3in (T and N). Flat needle lace, possibly Venetian. SL

9. PAIR OF SLEEVE-RUFFLES

Length about 10in. Triple, raised Venetian needle lace pieced out with some flat needle lace, possibly also Venetian, mounted on linen. SL, T and N

10. WIG, parts of

Narrow band of brown human hair on net foundation tied over the head from ear to ear. The hair at the back of the head is fixed by pins to an inner linen cap. T and N

The cap is now displayed separately. RM

[7] Illustrated in Thornton, *Baroque Silks*, pl. *and Albert Museum* (Tokyo 1980) i, pl. 137.
26b; cf. *British Textile Design in the Victoria*

11. CORSET

Brown canvas, roughly cut for the effigy; it has never been covered or finished.　　　T and N

12–17. JEWELLERY

The re-dressing of Mary II's effigy continued a couple of months after it, with that of William III, was put on show in the Abbey on 1 March 1725. In June the queen was given a new petticoat from £5 received at the Installation of the Knights of the Bath. Monsieur César de Saussure, who left Lausanne and travelled to London in the spring of 1725, wrote home on 24 May with an account of the sights of London. He had seen the effigies. William and Mary, he wrote, were 'said to be very good likenesses; we were informed that the royal robes they wear are the same [as] the king and queen wore for their coronation, the precious stones and pearls having been replaced by false ones.'[8] De Saussure was misinformed about the robes, which were copied for the effigies, but his story about the ornaments comes nearer the truth. Queen Mary might have worn a stomacher similar in style to the paste ornaments on her effigy at her coronation,[9] but it is perhaps more likely that the set dates to about 1700–3, since they are an inferior version of the piece adorning the Duchess of Richmond's bodice.

12. COIFFURE.

Strings of artificial pearls are wound through the hair and fall as a single long loop on the right of the neck. A single flat pearl drop in the centre of the coiffure is suspiciously like similar pieces on the effigy of Elizabeth I and is probably therefore a later addition.

13. NECKLACE.

A string of large imitation pearls is tied at the back of the neck with a black ribbon bow in a fashion more reminiscent of the eighteenth than the seventeenth century.

14. SHOULDER ORNAMENTS

comprise modest bows of imitation pearls.

15. BODICE ORNAMENTS

(1) The fur edging is decorated with two table-cut red pastes in rectangular rub-over collets with clipped corners, flanking one white paste similarly cut and set.
(2) Three silver stomacher ornaments or clasps, graduated in size, set with white rose-cut pastes. The largest is $3\frac{1}{2}$in long. Each is in three parts, joined at the back by circular- sectioned wire passing through rings, forming a lozenge with blunt sides. The pastes are mounted in textured collets linked by openwork scrolls. The backs are convex but unornamented by engraving or enamelwork, as is shown in a photograph published in the *Illustrated London News* on 5 October 1935. It is clear from the photograph that each piece is fitted with a long vertical pointed hook to thrust through the bodice, a somewhat more lethal version of a well-known form of fastening in the seventeenth and eighteenth centuries. A hook with rounded terminal is attached to a gold, emerald and diamond bodice ornament of about 1700 from the treasury of the cathedral of the Virgin of the Pillar, Saragossa, which has been in the Victoria and Albert Museum since 1870.[10]

16. SCEPTRE.

Length $35\frac{1}{2}$in. Carved and gilt wood with pearl terminals like the one held by William III.

8　De Saussure, 52.
9　See the decoration of a pendant of about 1690 set with rock crystals and an enamelled minia-

10　ture of King William III in Evans, 137.
Evans, pl. 134; Bury 1982, case 14, Board I no. 2.

17. ORB. Height 7in. Slightly smaller than the one executed for William III's effigy, but constructed in the same fashion from identical materials. SB

CONSERVATION HISTORY

1935 Clothes cleaned (Sketchleys).
1942 Clothes treated for moth (V and A).
1986–7 Neck ruffle washed, bleached and repaired, sleeves and ruffles washed and restitched (V and A); wax cleaned, right hand reattached, new right thumb, necklace restrung (Plowden and Smith). RM

XV. QUEEN ANNE

In the Chanter's Account Book is a reference, in 1714–15, to a payment of £13 14s 3d, 'for the head and hands of Queen Anne'.[1] The implication appears to be that a wax portrait head of the queen was made shortly after her death (August 1714), possibly from a death mask, in the expectation that an effigy would be displayed near her tomb in Henry VII's chapel. However, no effigy was apparently set up and it was not until 1740 that the Chanter and other officials spent £67 5s in buying the robes and setting up the effigy.[2] (Some repairs to these robes became necessary in 1765 and 1768 and at that time a black (instead of the correct brown) wig was added by 'Young, the Barber'.)[3] This figure is the only one shown seated and this pose perfectly illustrates the profound change of function which the effigies had undergone. Yet, paradoxically, it was the very continuity of the Westminster tradition of representation which helped it to survive the functional transformations from funeral effigies to memorial figures, from liturgically significant representations to realistic likenesses, retrospectively commissioned by the 'gentlemen of the choir'. Here, the memorial representation provides no more than is necessary to render an effective likeness: the figure does not even have legs, since they were not intended to be seen. Queen Anne seems often to have been depicted seated in painted portraits, such as those by Willem Wissing c.1683, when she was still Princess of Denmark, or Kneller's 1705 portrait which shows her in an ermine-lined cloak, wearing the star of the Garter and holding the George suspended on a blue ribbon in her right hand.[4] This may have been the model on which this effigy was based. As in the case of the images of William and Mary, though, the physiognomic accuracy of the image tends to undermine the propagandistic functioning of the painted portraiture.

The figure represents the queen towards the end of her life. Physically she resembles her sister, Queen Mary: she has the same full figure and similar plump face. There can be little doubt that this gives an extremely accurate portrayal of the queen in her forties. The head appears to have been cleaned by Elmas Foster in 1765 for £2 6s.[5] PL

DESCRIPTION

Head and hands of wax, the seated figure stuffed and covered with canvas. There are no legs.

T and N

1. ROBES (not parts of a wearable garment)

Purple woollen cut-pile velvet. Plain canvas front and lining with open lacing at back. The bodice is roughly shaped and the skirt pieces consist of two strips with mock-miniver edging (black velvet *appliqué* on white satin) and gilt galloon. Tight half sleeves with scallops at elbow; also two long strips attached to shoulders to suggest a full train. The star of the Order of the Garter, of silk and metal thread and leather on the left breast, with rays; it is perhaps a genuine one, not specially made for the effigy.

T and N

1 T and N, 194; see WAM 61228B and 61062. See also PRO E 351/3140 for the expenses of her funeral.

2 WAM 61062 and WAM 61062*.

3 T and N, 194. A correctly coloured wig was donated in 1971.

4 Millar i, 139, 144.

5 WAM 61036.

2. STOMACHER

Length 15in. White silk set with pastes mounted on cards covered with black velvet (cf. Duchess of Buckingham). T and N

The original was replaced in 1934. A portion of the original silk is exhibited separately. RM

3. Additional STOMACHER

Older(?), completely hidden by no. 2. Length 10in. Metal thread and gilt leather *appliqué* on black velvet. Edge cut. T and N

4. PETTICOAT PANEL

Length 35in, width 42in (two widths). T and N

Width of silk 21⅜in, selvages three-sixteenths of an inch; buff and brown stripes woven in tabby. Yellow cannellé (or tobine) ground, the cannellé in groups of 5 paired warp threads, with a brocaded pattern. Width of repeat, single comber, i.e. the full width of the silk. Length of repeat, over 28in.

 The silk English, c.1745–9. It can be dated by reference to the designs of Anna Maria Garthwaite for this period.[6] NR

5. UNDER-PETTICOAT PANEL

Length 35in, width 40in (two widths of 20in). Lined with coarse canvas, cut at waist.
 T and N

Lightweight yellow satin with narrow green selvages, the whole covered in white silk fly-braid, dating from the mid-eighteenth century. Edging: linen tape enriched with silver strip.
 NR

6, 7 and 8. PAIR OF DOUBLE RUFFLES AND BERTHA

Length 8in. Flemish bobbin lace, c.1700–1710, ruffles mounted on cotton band.
 SL, T and N

9. WIG

Human hair on knotted foundation. Much moth-eaten. T and N

10–18. JEWELLERY

The Queen is characteristically shown seated; the effigy has no legs. Afflicted with gout, she suffered herself to be carried in a chair in the traditional walking procession from Westminster Hall to the Abbey on her coronation day on 23 April 1702.[7]
The long delay in dressing the effigy, for which the hands and head were purchased in 1714–15, after the queen's death, indicated that the ornaments equally span several decades up to about 1740, when the figure was robed. Though the Garter Star embroidered on the bodice is said to be genuine, the main stomacher ornaments are dressmaker's pieces which were presumably added in 1740.

10. CROWN. Height 9½in. Gilt metal with a band and crest of crosses-pattée alternating with (presumably) fleurs-de-lys. The two crossing arches are surmounted by a monde and cross.

[6] See *Silk Designs*, especially pls. 226–43. [7] Christopher Morris (ed.), *The Journeys of Celia Fiennes* (London 1949), 300.

Embellished with pastes and imitation pearls, but the present disposition does not entirely correspond with the holes pierced in the metal. This may be due to losses. For instance, the back half-arch, now plain, is pierced for a pearl border; only the moulded edge remains. The cross and two flanking fleurs-de-lys at the back were never pierced, for it was never intended that they be visible. But there are considerable alterations and replacements, even in the dressed parts. The rosettes in the centre of one fleur-de-lys are set with modified brilliant-cut pastes (incidentally appropriate to a queen who was the first English monarch whose coronation records show that she had hired brilliants as well as rose-cut diamonds set in her regalia) and step-cut red ones, with a marquise-shaped white paste forming the upper petal of the flower; the two side petals are each adorned with two large pearls and a step-cut green paste. There are significant variations in the treatment of the other flowers, in which the rose-cut predominates among the white pastes. The coloured pastes, mainly red and green, usually have a flat table but a few green ones are pyramidal. The crosses also vary. White and green pastes, with a few in blue, are set in clusters, rosettes or as singletons over the crown; the band and the three decorated half arches are also edged with pearls, all of which are imitations.

11. COIFFURE ORNAMENTS. A rosette of white pastes in clawed collets is set in the front hair on each side of the face.

12. EARRINGS. Paste-set silver earrings of the top and drop variety. One top is of arch-shaped openwork with a quatrefoil in front decorated with white rose-cut pastes. The other is nearer to a rosette; a flat border on the reverse. The drops are the same, each headed by a row of three pastes with a rosette below, terminating in three rings presumably for small pendants now missing. The back of the drops, enamelled in blue and black on opaque white enamel, indicate that a pair of existing earrings pre-dating 1700 were adapted for use on the effigy. They are probably the ones which, together with the necklaces described below, were drawn and engraved for *A View*.[8]

13. NECKLACE(S). Two rows of artificial pearls placed sufficiently far apart to clear the pearl drop on the top one; the lower string also has a drop.

14. SHOULDER ORNAMENTS comprise pearl bows.

15. BODICE ORNAMENTS. The larger items are dressmaker's work, consisting of two shuttle shapes cut out of card, covered with black velvet and sewn with pastes; the deeper one is placed below the other, with two rosettes between. A triangular piece is placed on the lowest part of the bodice, also sewn with pastes in the same way as the ornaments on the Duchess of Buckingham's effigy. The main difference is that summary brilliant-cut pastes mingle with the white roses. Two step-cut pastes in gilt collets with clipped corners flank the middle rows of white pastes in silver mounts on the shuttle shapes; one also appears with white pastes in the triangle below. The two rosettes are each set with a red step-cut paste surrounded by seven white roses in cut-down settings.

16. Part of a GARTER COLLAR in cast metal, gilt and painted, falls from the shoulders across the bodice. From it depends the George, the group of St George and the dragon modelled virtually in the round, cast in lead and painted.

17. ORB. Gilt metal set with pastes and imitation pearls. The zone and arc are edged with pearls in front, enclosing table-cut white pastes together with two rose-cuts, one white and the other blue; other pastes are missing. The centre of the cross is set with a green stone and a flat

8 *A View*, 2nd ed. 1769, opp. p. 17.

white one in the upper three arms. The original orb was embellished with hired stones (a sapphire and 221 diamonds, one being very large) valued at £9,000,[9] for Queen Anne's coronation.

18. SCEPTRE. Carved and gilt wood. SB

CONSERVATION HISTORY

1765, 1768	Robes repaired and altered, wig added.
1934	Clothes cleaned (Sketchley); stomacher silk replaced, some preserved; mock-miniver edging to robes renewed; new front of wig; left hand little finger repaired (V and A).
1971	New brown wig.
1977	Crown and cushion reconditioned.
1986–7	Neck ruffle washed and bleached, sleeve ruffles washed, bleached and attached to new sleeves, ribbons washed and remounted, pearls rethreaded, flowers steamed, chain and ribbon at left shoulder restitched (V and A); left hand reattached, new thumb, two fingers redowelled and old fillings replaced, new eyelashes, necklace rethreaded (Plowden and Smith). RM

[9] PRO, LC9/46, ff 337–52.

XVI. ROBERT, MARQUESS OF NORMANBY

The figure of her three-year-old son, Robert, styled marquess of Normanby, stands beside that of Catherine, duchess of Buckingham (no. XVIII). Robert (died 1 February 1715) was buried in St Margaret's Westminster, but was moved in 1721 to the family vault in Henry VII's chapel. The effigy is 3ft 3in tall and is dressed in clothes some of which are thought to have belonged to the child, rather than being made specially for the effigy. At his feet is couched a small carved and painted wooden unicorn 11¾in high powdered with ermine and gorged with a wreath of roses: one of the supporters of the family coat of arms. This suggests that Robert's figure may have been made at the time of the removal of his remains into Henry VII's chapel, though no accounts have yet been discovered for its manufacture.[1] If this were the case, then the figure might also have played its part in a 'funeral' ceremonial, though in this instance it would seem to have been used in a translation rather than a funeral; more probably, it is a memorial figure of 1721. The name of the artist responsible for the figure is unknown. PL

DESCRIPTION

The head and bust are of wax and were formerly coloured (height 10½in). The ears, which are concealed under the wig, are modelled in wax. The eyes are of glass; eyelashes are formed of bristles; the eyebrows are indicated by incised lines coloured black. There is a wig of pale brown human hair (couched on net) curled at edges. The body is of yellow canvas stuffed with tow and other materials. The arms, of the same material, stiffened with wire and covered with white (more modern) canvas. The hands and half the fore-arms are of modelled wax, hollow to wrist, the palms still showing traces of pink colour; they are secured by pins and canvas to the wires in the arms. The figure is now supported on an iron bar, bolted to the base; originally it may have been fixed by nails through the soles of the shoes. T and N

1. ROBE
Length 27in. Plain cerise coloured cut-pile silk velvet. The seams covered with silver braid and with froggings; the lining is of pink silk. The front is straight with five froggings of silver braid, the side skirts full, with short slit running up from the hem and a false pocket-slit trimmed with braid (above this there are small projections on the hips). The collar is plain, the back rather narrow, and the tails full and undivided; behind the shoulders are two slits for leading strings. The sleeves rather more than elbow length, with medium-sized cuffs, which are slit at the back, pointed in front, and have a brocade lining. In pink silk lining there

1 It could also have been made at the time his brother's effigy was manufactured, in 1735–6. See *The Illustrated London News*, 22 April 1933, 580, where Tanner suggests that it was not made until 1735, 'when it is probable that the Duchess had the wax effigy of herself made, although she did not die until 1743. On the other hand the clothes worn are definitely of 1715, which suggests that the effigy may have been fashioned at that time and have been carried at the child's funeral'.

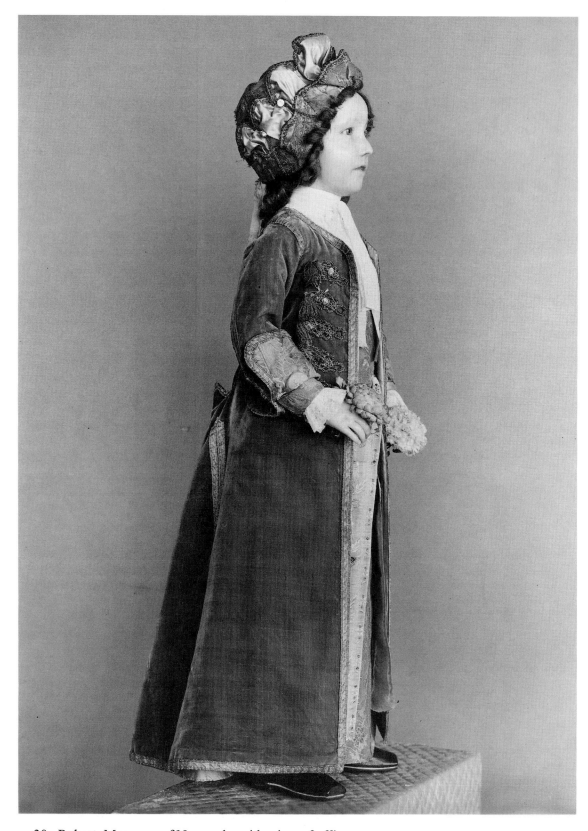

30. Robert, Marquess of Normanby: side view of effigy

are three silk ribbon loops at the back of the waist. As worn the robe does not meet across the chest. It and the other garments were almost certainly not made specially for the effigy.

T and N

The style of the robe is similar to a short nightgown adopted by fashionable men in the early eighteenth century. The cut and style appear to have been adapted from fashionable Polish men's dress of the seventeenth century. This fashion had been strongly influenced by Turkish dress, the identifiable features being the fringed and braided decoration down each front and the intriguing 'points' or projections at each hip. These are bound in silver braid that follows the side seams of the robe.

AH

2. LONG COAT

Length 26in. The pattern is of small naturalistic floral sprigs on large conventionalised scrolling leaves. The front is made to overlap (left over right); the skirts very full, without trimming or pockets. The back (of yellow silk) is cut the same as the robe, with slits for leading strings and gussets under the arms; the tails joined in the centre. The sleeves are of silk (11½in) with slit cuff, 4in long, in the 'cheat' style of the contemporary men's fashion. The coat is lined throughout with pale fawn silk. The sleeves are pieced and may perhaps have been lengthened.

T and N

Lampas, the slate blue satin ground almost entirely covered in silver gilt thread, *filé* and *frisé*, brocaded with coloured silks and bound in 4\1 twill. The coat is lined with a pink (?) silk tabby enriched with a pink flush. The back of the coat is made from yellow figured silk. The cuffs match the coat. The silk of the coat is French c.1714, very fashionable.[2]

NR

The Turkish influence referred to above can also be seen in the cut of the long coat with its diagonal lap-over front and the use of a sash at the waist.

AH

3. CAP

Height 5in. The elaborate cap is round and close fitting. The crown, similar to that of the coat, has a silver-gilt tassel. There is a turn-up brim with undulating edge trimmed with silver-gilt braid and caught up by cords to paste-buttons set on a sort of upper brim of pale blue satin with similar trimming. The cap is shaped downwards a little over the ears and has two small silk ribbons behind. The foundation is of purple canvas; the lining pale blue silk.

T and N

Lampas, pink satin ground almost entirely covered with silver-gilt thread with additional colours in brocaded silks, bound in a 3\1 twill, the silver thread, *filé* and *frisé* used in paired shoots. The silk French, c.1711, different from that of the coat but equally expensive, now a little faded.[3]

NR

4. SASH

Length 64½in, width 3in. Silk warp and silver-gilt weft, patterned with floating warp threads of silk.

T and N

This is a very rare ribbon.

NR

[2] Illustrated in Thornton, *Baroque and Rococo Silks*, pl. 49a; the dating can be confirmed by reference to the designs of James Leman, e.g. 32 and 37 from 1711 and c.1717 in *Silk Designs*.

[3] Dated by reference to the designs of James Leman, e.g. *Silk Designs* 27, dated 1711.

5. SLEEVELESS SHIRT

Length (front) 9½in, neck 10in. Fine linen showing traces of wear down the front. It has a standing band collar about 1in high with buttonholes and pale blue ribbon ties. The front is shaped as a bib, and opens about 6in down over the chest and has narrow edgings of lace. The back is rounded over the shoulders, with a cape effect, and is pleated to the neck all round; the lower edges have original hems and probably have not been cut down.

T and N

6. CRAVAT

Length 16in, width (3 pieces) 5½in.

T and N

7. STOCK

Length about 11in, width (front) about 1½in.

T and N

The stock is made of a fine linen band pleated at each end onto linen tabs and was probably fastened at the back of the neck by tapes. The pleated front of the stock has two horizontal slits placed one above the other at the centre front. These will take the folded lace cravat, which is threaded through the slits in the stock. It is a very simple method of wearing a fine lace neck-cloth with out damaging it by tying a knot. Three lengths of lace have been stitched together and folded lengthwise along the seams, so that they form a long narrow band. One end is passed through a slit from the front and then through the other from behind so that both ends lie flat on the chest, to be adjusted so that they are of equal length. This style became fashionable in the first quarter of the eighteenth century.

AH

The lace ends are made of joined strips of bobbin lace, Flemish in style but possibly French (Valenciennes). Early eighteenth century, likely to date from nearer 1700 than 1715 – so re-used.

SL

8. CUFFS

5½in by 3in. Linen, with bobbin lace frill, two buttonholes, and silk ribbon ties.

T and N

The lace is Flemish in technique and style but is possibly English (Midland Counties). Early eighteenth century.

SL

9. CORSET

Length 11in. Canvas quilted with yellow silk, and is stiffened with cane. In front the point is very low; there are straps with ribbons over the shoulders and four tabs over the hips. The corset is laced at the centre of the back with a string of plaited coloured silk with metal tags.

T and N

The old corset used to support the torso of the figure was originally made for a young or adult woman, not for a child.

AH

10. SHOES

Pair of child's black leather buckle shoes, grain out.

Toe 1½in, square domed, ½in deep in the centre, with ¾in toe puff to maintain the shape.

Heel ¾in covered wedge, white stitched quite finely at about 14 to the inch. There is a one lift top piece above the sole, 2in long. The Tanner and Nevinson report describes them as worm-eaten, which suggests that the wedge is of wood under the leather cover. This method was used for light shoes, mainly women's.

Sole of leather, flesh out, with brown edge finish. Made straights and probably unworn. Length 6in. The construction is a white kid rand extending to just beyond the heel breast, with stitching

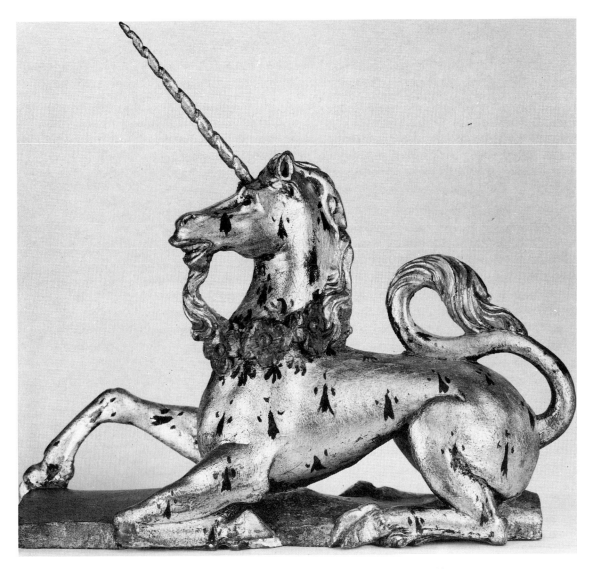

31. Robert, Marquess of Normanby: heraldic unicorn (catalogue no. 12)

visible along the side of the rand at the same stitch length. This construction is usual for women's shoes by this date (see the shoes of the Duchess of Richmond) and was also used occasionally for light, expensive footwear for children, in preference to a turnshoe. It would have been formal wear for a child.

Upper consists of vamp and pair of quarters, joined by a curved side seam starting ¾in behind the heel breast, making short quarters, the seam typical of late seventeenth-early eighteenth century leather shoes. The vamp is cut with a high tongue, the pointed corners wrapping well round the front of the ankle. The back seam is cut with a v-dip at the top, to relieve strain. The inside quarter of each shoe is cut to extend into a long, slightly pointed strap, while the outside quarters extend into a short, square-ended strap, with a 'buttonhole' at rightangles to the end. Through this hole the anchor-type chape attaches an iron buckle, about 1in by 2in, rectangular with cut corners. A single spike pierces the longer strap to fasten, and the buckle is a tight fit on the strap. The spike points inwards, leaving the protruding strap on the outside, to avoid rubbing against the other leg. While this seems logical, portraits show this was by no means consistent, particularly with children where the buckle made dressing difficult. There would have been little choice however with shoes having straps of unequal length. The top edge of the quarters has two rows of white tunnel stitching for reinforcement, which becomes a decorative feature.

Inside The tongue is unlined, and the tunnel stitching implies that the quarters too are unlined. But there is the impression of what is probably the end of the quarters extended to continue the line where the straps join the curved side seam, which would have acted as a reinforcement. Otherwise, there is no indication of a side lining visible on the outside.

While accurately dated children's shoes are rare for this period, the white rand, wedge heel and tunnel stitching make this a smart formal shoe for an aristocratic child, though presumably economy has been made for use on the effigy by the substitution of a cheap buckle, where the straps indicate a slightly deeper buckle was required. Given the owner and style of shoe, one might have expected a silver buckle.

JS

11. JEWELLERY

The stock buckle is missing, but his cap is clasped with two white pastes in cut-down collets.

SB

12. UNICORN

At the feet of the effigy of the infant Robert Sheffield, styled Marquess of Normanby, is a painted wooden unicorn on a green base. Robert was the second son of John (Sheffield) Duke of Buckingham and Normanby KG (1647–1721) by his wife Catherine, illegitimate daughter of James, Duke of York (later King James II) by Catherine Sedley, Countess of Dorchester. Before her first marriage (to the Earl of Anglesey) Roberts' mother was styled Lady Catherine Darnley and by Royal Warrant dated 7 December 1688 she was granted armorial bearings including Supporters consisting of a unicorn and a goat. The former is blazoned 'an Unicorne Ermine his horne Maine and hoofs Or, accolled with a Chaplet of Red Roses Seeded Or, Barbed proper'. As a unicorn does not appear in the heraldry of the Sheffield family at this period the carving must relate to Robert's mother. It also represents her as the sinister supporter in the impaled arms above the Sheffield monument in Henry VII's Chapel.

DHBC

13. TWO FLOWERS

Tinted paper with wire stalks, and appear to be a carnation and a chrysanthemum. The latter flower (*C. Sinense*) seems to have first been introduced in 1798, though the name had been used previously by herbalists for the corn marigold (now *C. Segetum*). The flowers are therefore, probably of nineteenth-century date.

T and N

CONSERVATION HISTORY

1934 Head found to have been broken off and repaired at some time; nineteenth century base removed to reveal original one; arms had been recovered with newer canvas; part of a finger was missing, and repaired; supporting iron bar renewed; unicorn cleaned and sized (V and A).

1987 Lips and eyebrows retouched; some glue removed from scalp; clothes cleaned: shirt, neck band and cravat washed and bleached, lace cuffs washed and repaired (V and A).

RM

XVII. EDMUND, DUKE OF BUCKINGHAM

Edmund Sheffield was the only surviving son of the first duke by Catherine (no. XVIII) and the younger brother of the marquess of Normanby (no. XVI). Born on 3 January 1716, he saw active service in Germany under his uncle the duke of Berwick but ill health forced him to retire to Rome where he died of consumption on 30 October 1735 aged 19. With his death all the family honours became extinct. He was buried in Henry VII's chapel on 31 January 1736.[1] The funeral was of exceptional magnificence and Pope wrote his epitaph.[2]

This effigy (height 5ft 4in) is, uniquely for any of the late wax effigies, recumbent, and, also uniquely, was carried at the funeral. The head of the effigy is evidently based on a death mask. Both the face and the hands are very well modelled; the hands, indeed, are judged the best of any on the effigies by Tanner and Nevinson.[3] Like the head, they are of wax, and must have been cast from the corpse. The duke is dressed in his robes. At his feet is couched a small roughly carved wild boar in wood, one of the supporters of the family coat of arms. The body is of canvas stuffed with straw, and stiffened with wood supports (the wooden parts were replaced in 1934) and wire; the legs are of wax resin reinforced with cloth and covered with silk. There are no feet, the shoes being stuffed and tied on with braid.

This is the last of the genuine funeral effigies. It was placed in a separate case after the funeral ceremony, and stands directly in the line of the great Westminster tradition of funeral effigies, stretching back to the time of Edward III. One point of note, though, is that the duke's eyes are shown shut; this is a reflection of the changed attitude to the depiction of the dead in tomb effigies. The eighteenth century, indeed, was to see some dramatic innovations in the area of tomb-monuments and monumental sculpture.[4] A second, and related, point of importance is that this figure was always displayed recumbent, the closed eyes precluding its being raised to the vertical like the earlier effigies. Sheffield's effigy, though, is in many senses a throwback to the earlier tradition and it is significant that his mother's figure, which was also used in her funeral service, marks the definitive end of this tradition. The three effigies associated with her are some of the most important examples of the traditional use of the effigy, but functionally they mark the end of that tradition.

PL

[1] Complete Peerage ii, 401.
[2] For details of his mother's attempt to borrow the duke of Marlborough's funeral car see P. Toynbee (ed.), *Reminiscences Written by Mr Horace Walpole in 1788 for the Amusement of Miss Mary and Miss Agnes Berry* (Oxford 1924), 95–6; and W.S. Lewis, W.H. Smith and G.L. Lam (eds.), *Horace Walpole's Correspondence with Sir Horace Mann* (London 1955) ii, 192–3 n12. See the account of the funeral in *The Old Whig*, 5 Feb. 1735/6, no. 48, referred to in Westminster Abbey Library annotated copy of Tanner and Nevinson.
[3] T and N, 186.
[4] M. Whinney and J. Physick, *Sculpture in Britain 1530–1830* (Harmondsworth 1988).

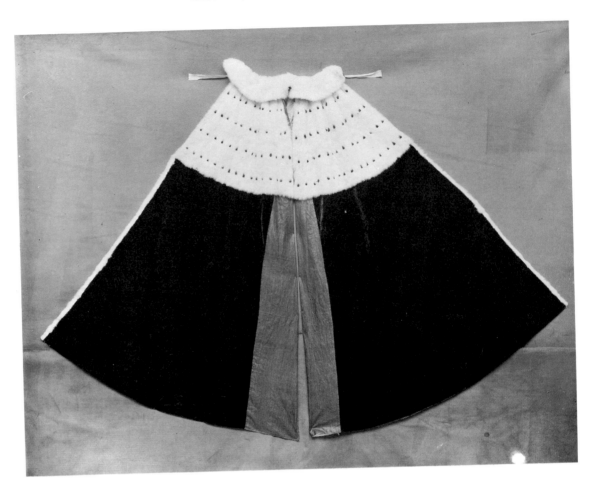

32. Edmund, Duke of Buckingham: mantle (catalogue no. 1)

DESCRIPTION

This effigy is the only recumbent one and remains as it was carried at the funeral, apart from damage in 1737, and cleaning in the 1930s and in 1987–9. Some of the clothes were worn by Edmund Sheffield, while others seem to have been pieced together for the effigy. JA

1. MANTLE

Tanner and Nevinson describe this as part of the duke's coronation robes, 'red velvet' trimmed with miniver and lined with white silk. Red canvas foundation and back. Only one breadth of velvet (23in) and a gored piece 16in wide remain on either side. There is a 16in miniver cape (with four lines of tails) falling over the shoulders, and a 4½in falling collar of ermine lined with red velvet. Small white silk ribbon ties.'

The mantle seems to have been assembled for the effigy from velvet which had been used for some other purpose, although it is possible that the front only of an original peer's robe has been used. It measures 60in from centre front neck to hem. Both front panels have added gores at the sides which are cut off the grain, apparently from odd pieces of material. The back is made of two strips of dull brick red linen, and the centre back seam is open, with some white cotton threads where it had been stitched at one time. The cape is 18in deep and widens at the bottom to extend over the back for 4½in. There are four rows of black tails on the white fur, which is backed with deep red velvet, ten on the top row, twelve on the second, fourteen on the third, and sixteen on the bottom row. The tails are made of strips of skin with stiff black fur folded in half and pushed into the white fur through small pinks and stitched firmly at the back. A ¾in wide strip of white fur is stitched beneath the front edges of the deep red velvet mantle. The collar is also of deep red velvet, pieced from small scraps and with stitching holes from earlier use, covered with white fur. The lining is cut from lengths of 18¼in wide ivory silk taffeta cut in a widely gored shape, gathered to fit the neck. It would appear that the back panel is missing and the side seams are pulled round to form the centre back seam, which is undone. An ivory silk ribbon tie, 1⅛in x 10¼in, is stitched on each side of the neck edge. JA

2. SURCOAT

Described by Tanner and Nevinson as 'red velvet edged with ermine. Strip of left front with 8in falling collar. Lining and part of canvas back as preceding number.'

Only the left front of the surcoat survives, of deep red velvet matching the mantle, with a back of dull red linen. It is 50½in long. Both front and back are lined with ivory fine silk, similar to Jap silk. The velvet collar is 8in deep and bordered with white fur which overlaps the edge by 2in. A strip of ⅝in white fur is stitched down the front edge. A ribbon tie of 1⅛in x 13in ivory grosgrain ribbon is stitched at the neck. It is possible that this surcoat has been made from the back of the mantle. It is not known what has happened to the right front. JA

3. SWORD BELT

Leather stiffening is cut to a curved shape 2in wide x 47in on the lower edge. Deep red velvet is wrapped round it and the turning glued down on the back. A lining of ivory silk is hemmed to the velvet. The hangers are made in the same way. Gilt metal buckles and slides are used for the fastenings. JA

4. SLEEVED WAISTCOAT

This is a sleeved waistcoat which might be worn without a coat. It is made of deep geranium pink ribbed silk (grosgrain), slightly faded in places, for the fronts and the ends of the sleeves,

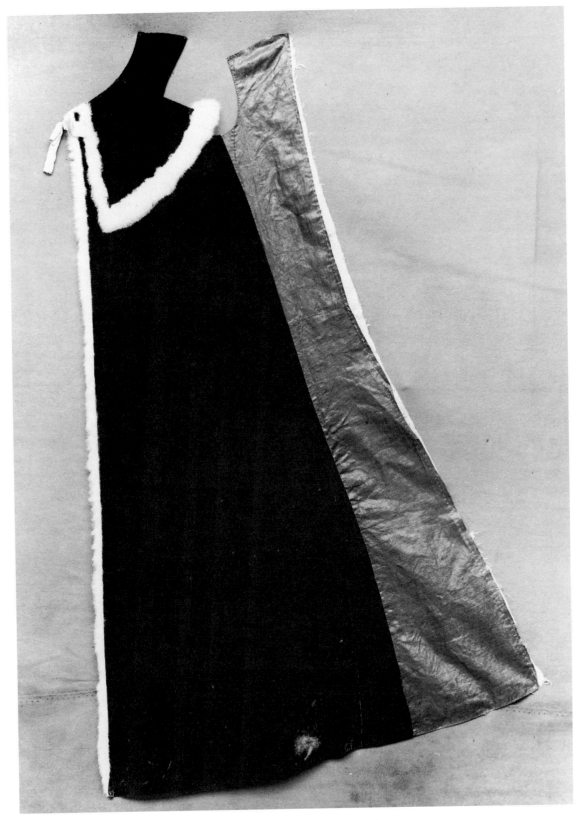

33. Edmund, Duke of Buckingham: surcoat (catalogue no. 2)

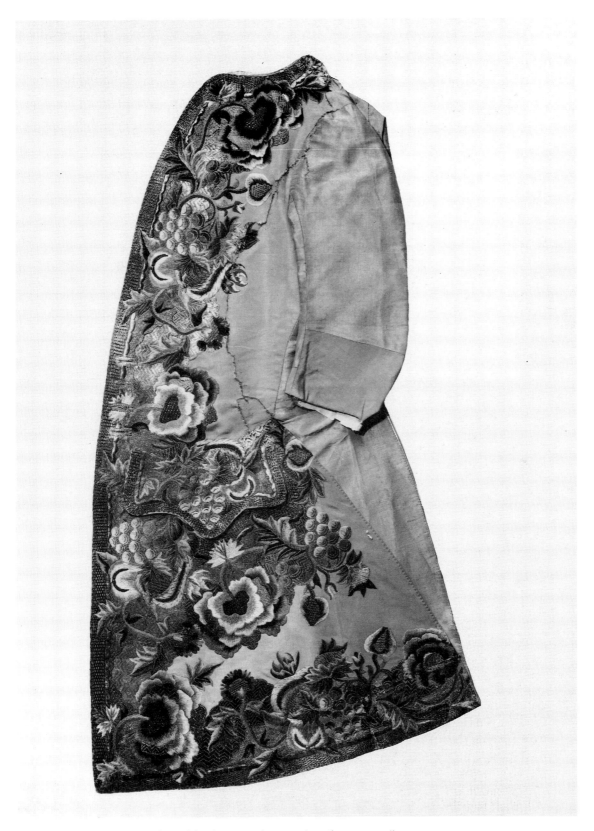

34. Edmund, Duke of Buckingham: waistcoat (catalogue no. 4)

which are embroidered with silk and metal thread. The back of the waistcoat and the upper parts of the sleeves are in a slightly lighter pink ribbed silk: this has a shot (changeable) effect, as it is woven with pink warps and ivory wefts. The fronts are slightly curved and 39in in length. Twenty four buttons with wooden bases worked over with silver thread remain on the right front, but as the bottom 8in of the skirts have been hacked off, it is not known how many are missing. On the left front there is one buttonhole at the neck and four at the waist. The pocket flaps have six buttons matching those at the front sewn beneath them, but no buttonholes are worked. The waistcoat is lined with plain lightweight ivory silk taffeta. The sleeves are lined with white linen of two sorts, odd pieces used up. The embroidery is extremely rich, in a design of foliage, bunches of grapes, and flowers, carried out in ivory, tan, black, yellow, light green, yellowish green, deep forest green, three shades each (light, medium and dark) of blue, pink, bluish green and beige, and two shades of mauve. The ground is filled in with silver and gilt metal threads, now discoloured, with silk cores, some smooth, some with a bouclé texture, couched with fine ivory thread in chevrons. The right front and the cuffs had been cut off, the occasion being noted in *The Daily Gazetteer* on 15 June 1737: 'On Monday night last some villains concealed themselves in Westminster Abbey and having broken the glass case which was over the Effigie of the late Duke of Buckingham found means to carry off the Flap of his gold Waistcoat; some of the Blood of their Fingers was perceived on his Ruffles'. In 1989 earlier repairs were removed and conservation work was carried out on the jagged cuts on the front, and imitation cuffs were made to replace the embroidered ones which were not recovered from the thieves.　　　　JA

The ground is a salmon pink gros de tours, the cuffs match the colour but are made from a different, finer silk. The breeches of cut silk velvet match the waistcoat, which the robe does not. The waistcoat is complete on the left hand side.

Probably French. The decoration is entirely embroidered, although the treatment of the metal thread imitates that of a woven textile, as does the shading of the coloured silks with *points rentrés*, a method of shading only introduced that year by the Lyon designer, Jean Revel. It is embroidered to shape with a waistcoat flap and a simulated silver braid along the lower edge. It can be compared with the descriptions of the waistcoats worn at the wedding of the Prince of Wales in 1736 with patterns of large flowers, 'some wove in the silk and some embroidered'.　　　　NR

5. BREECHES

These are made of very heavy silk velvet with a close, firm pile which shows a fine corded effect in the weave, when viewed at certain angles. The colour ranges from a deep orange tan to light pink where it has faded. The breeches are completely lined with white twill weave fustian (linen warp and cotton weft). The lining is made up separately from the breeches, so that all the seams are concealed. Velvet and linen are gathered up separately at the back and on each side of the front waist to fit the deep, shaped waistband, which fastens at the front with two buttons. There is a fly front closing with three buttons, and a flap on the front of a $7\frac{1}{2}$in opening at the side of each leg, closing with five buttons. The leg openings are finished with a $\frac{7}{8}$in wide legband, fastening with one button and a steel buckle. The two buttons on the waistband are $\frac{3}{4}$in in diameter, of wood, worked over with yellow flossed silk and flat metal strip with coiled wire and a flat sequin on top, of discoloured silver or silver-gilt. The three buttons at the front fly opening are $\frac{5}{8}$in in diameter, worked in a similar way to those on the waistband, but without the sequin. The five buttons on each leg opening are $\frac{1}{2}$in in diameter and match the buttons on the waistband in design. A panel of white spotted silk is stitched behind each leg opening. There is one small chamois leather pocket bag concealed in the waistband, and one small welt pocket opening on each side of the front waistband, fastening with a velvet covered button. Below these pockets are another pair of pockets with pocket flaps fastening with single buttons (now missing).　　　　JA

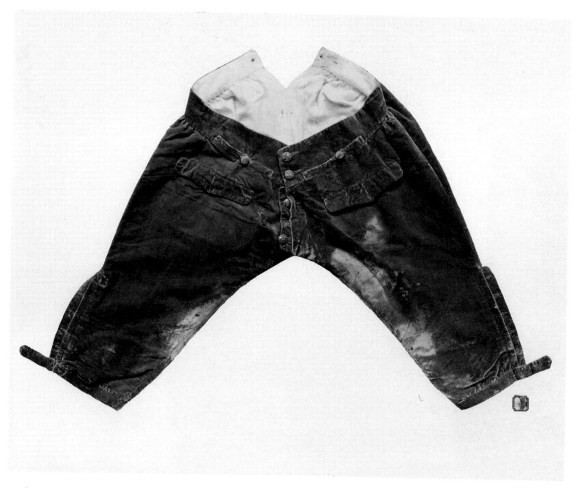

35. Edmund, Duke of Buckingham: breeches (catalogue no. 5)

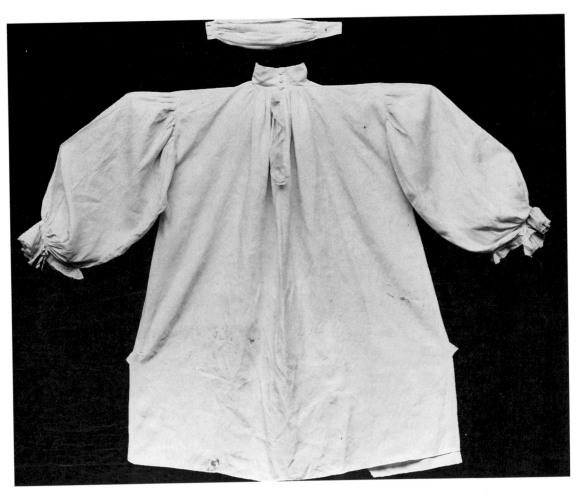

36. Edmund, Duke of Buckingham: shirt and stock band (catalogue nos. 6 and 7)

6. SHIRT

The shirt is made from one long continuous strip of linen 35¼in x 76in running up the front, over the shoulders, and down to the back hem, with selvedges on each side. The latter are oversewn together from the right side, making a slight ridge, for the side seams. The back is 1¼in longer than the front. The neck opening is made from a T-shaped slit, which is gathered into a collar band 13¼in long and 2⅜in deep, fastening with three Dorset buttons of wood, worked over with linen thread. The 8in front opening is bordered with 1in deep exquisitely fine bobbin lace which is attached to a narrow linen tape. This is then stitched to the wrong side of the opening. Reinforcing strips of matching linen 7¼in x ½in are stitched across each shoulder. Small gussets are inserted at each side of the neckline and at the tops of the openings at the bottom of each side seam. A tiny coronet is embroidered in deep blue silk by the little gusset on the right front. The sleeves are made from two rectangles of linen 30½in across the shoulder edge x 21in from shoulder to wrist band. The fullness of the linen is taken in with about 26 small tucks across the shoulder, and a 3¼in square gusset is inserted under the arm. The bottom of each sleeve is gathered into a narrow wrist band with a 3in deep frill bordered with 2½in deep fine bobbin lace gathered up to fit a tape which is stitched inside the wrist band.

<div align="right">JA</div>

The lace on his shirt front and at the cuffs is fine Valenciennes bobbin lace.

<div align="right">SL</div>

7. STOCK BAND

This is made of a rectangle of the finest white linen cambric 19½in deep, with the selvedge running round the neck, and 10½in wide. The long sides of the rectangle are gathered into 1¾in to fit two small strips of linen with three worked buttonholes on one side. The buttons are missing. A tiny coronet is embroidered in blue silk on the wrong side of the button flap. The cambric is ruched into soft folds across the front of the neck, and the stock band fastens with the buttons and buttonholes in the small strips at the centre back.

<div align="right">JA</div>

8. STOCKINGS

Machine-knitted white silk stockings which originally may have been pale blue and faded with washing. They have a shaped back seam, and seams at toes and heels of the feet. The side gussets are decorated with clocks in the knitted pattern incorporating scrollwork, curving lines and tiny coronets. There is a doubled hem at the tops of the stockings for extra strength. Each stocking measures 26¼in from top to toe at the front. The length of the foot from toe to heel is 7in.

<div align="right">JA</div>

9. WIG

A campaign wig, which measures approximately 24in round the head, made of curled hair, probably mixed with a little horsehair. This is grey, blonde, brown and white in colour, giving a greyish appearance. Tanner and Nevinson noted that the wig had been cleaned and re-powdered with orris root.[5] It is made with tresses of hair knotted between three threads, each row stitched to a net coif with green silk. The coif is made of ivory silk knotted with a square mesh which is eased in at the crown to fit the shape of the head. A strip of white linen is stitched from the forehead almost to the nape of the neck, on top of the net. A green silk stay ribbon ¼in wide is stitched on top, 2¼in up from the white linen strip at the centre front on each side, going round the side of the head to 2½in from the centre back. A pink and white, very narrow striped silk ribbon, 1¼in wide, is used inside the edge of the coif, round the face,

5 T and N, 187.

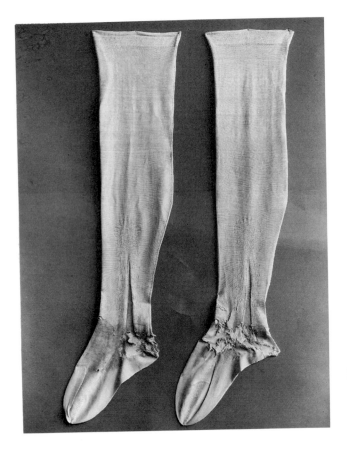

37. Edmund, Duke of Buckingham:
stockings (catalogue no. 8)

38. Edmund,
Duke of Buckingham:
wig (catalogue no. 9)

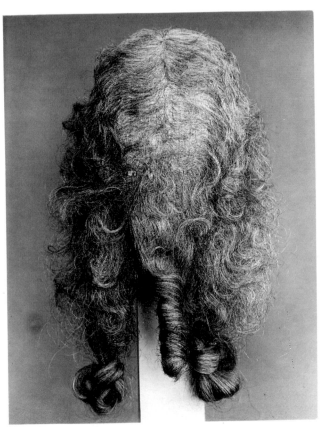

as a stay. This is folded and darted to mould the net to the shape of the head. The strips of hair are mounted on top of the linen strip and net, with rows of green silk stitching on the inside of the coif. The curls hide the rows of stitching on the right side. At the back of the neck hangs a short twisted queue between two large hanging curls which are doubled up and knotted at the ends. A small round paper label is stuck inside the crown of the wig. It is 1½in in diameter, and printed in faded black ink 'FRANCIS CARAFFA PERUKE MAKER next door to the RUMMER TAVERN in Gerrard Street St Ann's, Soho LONDON'. At the top is written 'H:G:yᵉ:D. of Buckingh. .', and at the bottom '1735'.

<div align="right">JA</div>

10. SHOES

Pair of buckle shoes of white leather, made grain out.

Toe typical of its date, oval prow style, upcurved (1½in toe spring).

Heel 1⅞in, of wood, covered in red goatskin, 3in long at seat, 3⅛in at top piece. Fine white stitching at seat and breast edge, about 17 to 1in. The top piece is attached, flesh out, by irregular sized pegs round the outside, with a slight rise in the centre, made for lightness, with a large central hole for the heel nail which went through to the insole during making. When at rest, its poor contact with the ground and the lack of white stitching to attach the top piece suggest the heel may have been lowered about ¼in, to nearer the fashionable height of the 1730s. 1¾in channel at breast edge with 5–6 stitches to attach sole. The top piece edge is brown finished.

Sole of polished brown leather, grain out, unworn. Made straights. Stitched at about 8 to 1in, probably turnshoe. Domed at tread. Nail hole at toe and waist, where attached to last before stitching, covered with ⅛in cross-hatched circular stamp. Length to heel breast 7⅜in, making total length 10⅜in. Width at tread 3½in, heel breast 2½in. Sole continues through acute angle down heel breast, pegged in position and stitched through top piece channel.

Upper consists of vamp and pair of quarters. Rigidity at toe indicates 2in puff inside at sole seam, decreasing to 1¾in centre top. Vamp rises to high tongue, rounded down to side seam. All seams butted and finely stitched. Quarters cut in V at top of back seam, to relieve strain, with a large hole near the seat to attach shoe to effigy. The 3in long dog-leg side seams start close to the back seam. Each quarter is extended into flared strap, overlapping, to take the buckle, now marked with rust from the chape, and several pairs of holes, some stretched through mishandling. The number of holes indicates the buckles have been removed and re-attached several times, and it is now difficult to be certain which were the original holes, or indeed if these are the original buckles.

Inside Unlined, apart from 1in tapering side linings of white kid from toe puff to close to the back seam, lasted into the sole seam, the upper edge whipstitched to the upper with tunnel stitches. The puff of brown leather, flesh out, is whipstitched to and overlaps the grain insole, which would have caused discomfort in wear. No stitches can be felt where it joins the upper, implying it was attached with paste. The insole is cut narrower at the heel seat.

Buckles The overlapping straps fasten with eighteenth century buckles, with steel chape of small pitchfork type. The oblong ring is of silver, 1⅝in x 2in, slightly incurved on each inner long side. Set with 5 x 7 clear facetted pastes.

The colours and quality of workmanship, which is good for its period, are consistent with aristocratic wear of this date though there are slight variations in detail between the two shoes. It is surprising to find a young man of 19 in the high heels which were becoming unfashionable, as was also the red colour. The size seems rather large for his small height and the 7in stockings. It may have been felt appropriate to find a pair of red-heeled shoes for the effigy, which were not in fact from the wardrobe of Edmund Sheffield. The buckles have been removed several times, but are acceptable for the date until more dated buckles are found to prove otherwise.

<div align="right">JS</div>

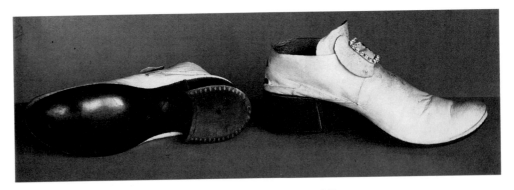

39. Edmund, Duke of Buckingham: shoes (catalogue no. 10)

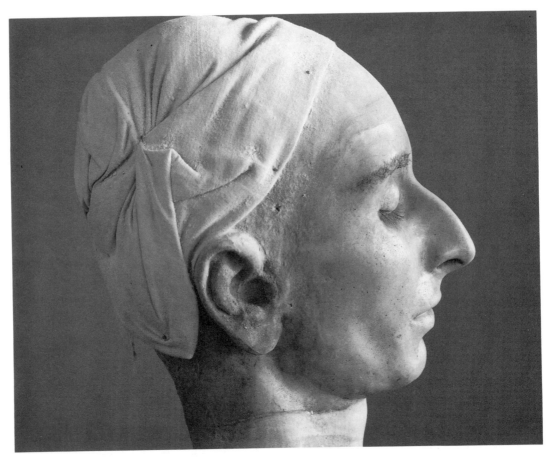

40. Edmund, Duke of Buckingham: profile of head

11. CORONET

Height 10½in. Gilt metal with ducal crest of strawberry leaves over a pleated red velvet cap with a linen lining. Tanner and Nevinson suggested that this was a replacement for a coronet stolen by thieves who broke into the glass case containing the effigy in June 1737. The replacement must appear in the engraving in *A View* in 1768,[6] which shows it on the head of the effigy.

SB

12. SWORD

The figure is accompanied by a robe-sword similar to that of William III (q.v.), apparently resting loose on the body, and not attached to the girdle. The pommel and guard are of unidentified metal, probably brass, painted gold, the wooden grip is bound with gilt silver (?) wire with Turk's heads at top and bottom. The upper part of the narrow straight blade projects slightly above the mouth of the scabbard and shows that it is double edged with a rectangular ricasso and a narrow central gutter. The scabbard is of leather (?) covered with crimson velvet. It is not fitted with a locket and the chape, if it exists, is concealed by the duke's robe. According to Tanner and Nevinson[7] the hilt has been repaired. Length 39in.

Tanner and Nevinson state that the sword is a dummy. This is not correct, since, as pointed out above, it is fitted with a real blade. The commentary on the sword on William III's figure also applies to it.

CB

For the sword belt see no. 3 above.

13. WOODEN STICK

Length 44in; gilt; held in right hand.

T and N

14. THREE CUSHIONS

(a) 23½in by 17in, stuffed with tow;
(b) 8½in by 13in, stuffed with down;
(c) 18in by 12½in, plain linen cushion kept (1994) in the Reserve Collection.

T and N
RM

15. MATTRESS

Length 81in; width 29½in. The top had a breadth of silk on either side, plain linen band down centre; check canvas underneath.

T and N

16. COFFIN BOARD

Length 74in, greatest width 20in. Covered with canvas and roughly painted with crude flowers on a tarnished silver ground.

T and N

17. BOAR

Beneath the figure stands a roughly carved wooden representation of a boar couchant Or. This must be a Sheffield beast as the family bore for their crest a gold boar's head erased and as Barons Sheffield and Earls of Mulgrave they had long used two golden boars as supporters. Compare the unicorn associated with the effigy of Edmund's elder brother Robert Sheffield, styled Marquess of Normanby. The use of these heraldic devices would seem to be a reemergence of the use of such figures upon medieval tombs. In view of the paucity of

6 *A View*, opp. p. 27. 7 T and N, 186.

surviving examples of wax and other effigies which may have been carried in seventeenth and early eighteenth century funerals any definitive evidence of continual use would seem to be un-available.

DHBC

CONSERVATION HISTORY

1737	Robbery necessitates replacement of coronet; damage to waistcoat.
1934	Wooden body supports replaced; clothes and 'mattress' cleaned (Sketchley), wig cleaned (V and A); waistcoat lining removed and mounted separately.
1987	Alterations found to have been made to body shape, probably in 1930s, removed; 1934 base board cut to body shape; wires holding legs in place removed; under-garment to cover body added. Lace and neck band removed and washed. Velvet and cushions dusted. Ribbons of shoes conserved. Osterley Outside Work Scheme, V and A. SBL
1989	Full conservation, Osterley Outside Work Scheme, V and A. Wax head and hands, Plowden and Smith.

Head found to have been restored at some time; cracks to neck, temples and face filled; wooden supporting post shortened, removable extension to it made; neck and wrists reinforced with fabric lining; chipped middle finger repaired.

VK

Figure stripped and head and hands removed (see above). Wooden base of torso and centre pole from 1934 removed to be made a less prominent shape; stuffing of grass rearranged within canvas cover and canvas re-stitched along original lines; altered base and pole replaced and figure covered with white t-shirt. Wires connecting legs to wooden base left out to prevent distortion to breeches. Shirt, neck band, lace and stockings washed and repaired; waistcoat reconstructed after removal of rough stitching of slashed embroidery, cuffs made up from new material. Surcoat surface cleaned and silk lining conserved. Mantle surface cleaned and lining conserved. Shoes, scabbard and sword belt cleaned. Cushions fully conserved, the inner pads being removed as necessary.

SBL and RM

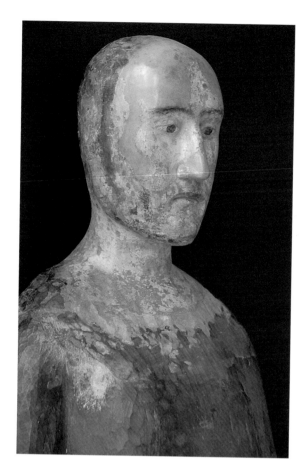

I. Edward III, 1377, detail of head.

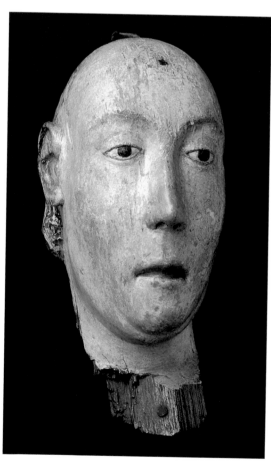

II. Anne of Bohemia, 1394.

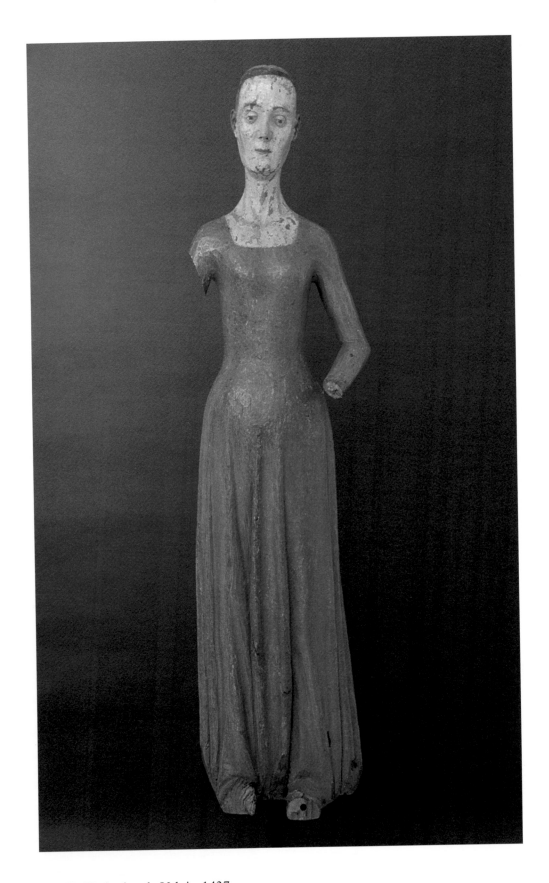

III. Katharine de Valois, 1437.

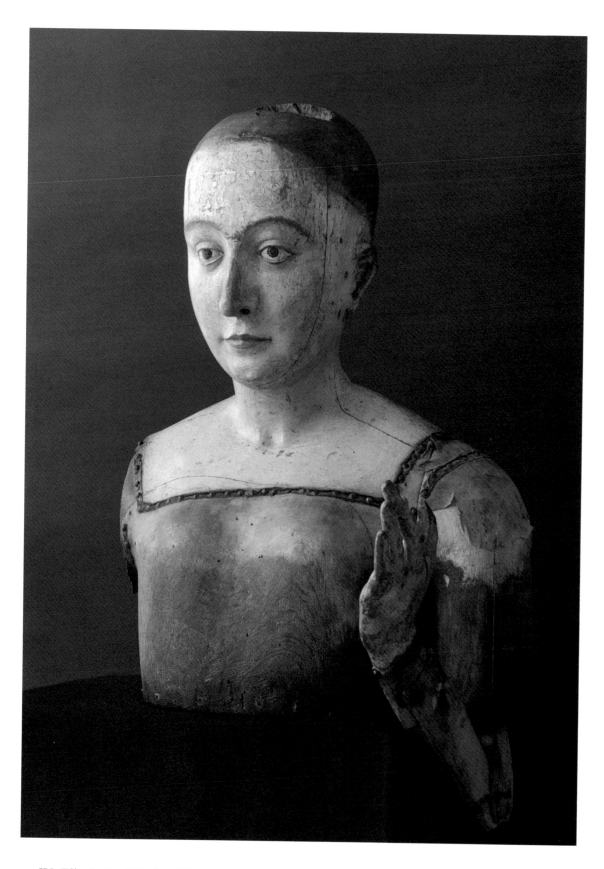

IV. Elizabeth of York, 1503.

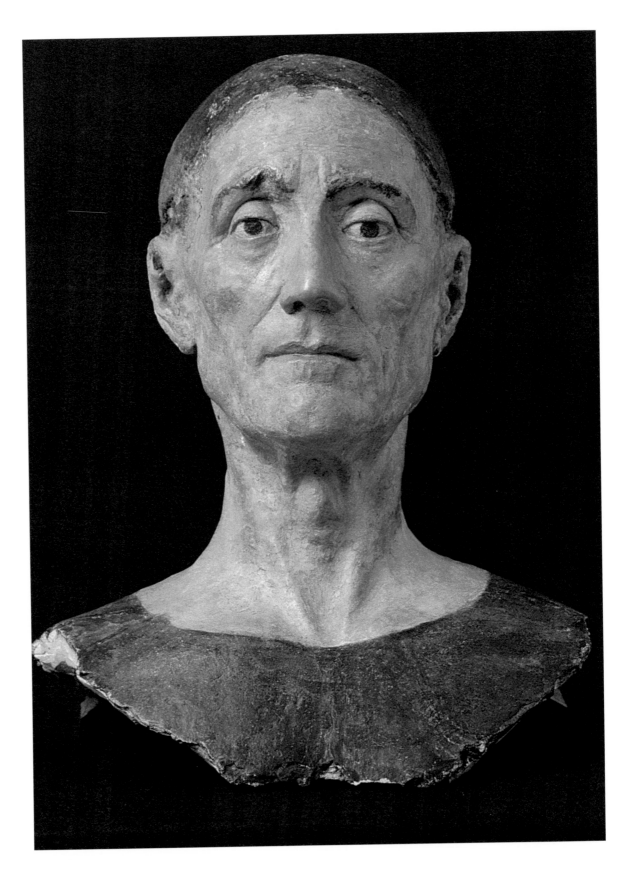

V. Henry VII, 1509.

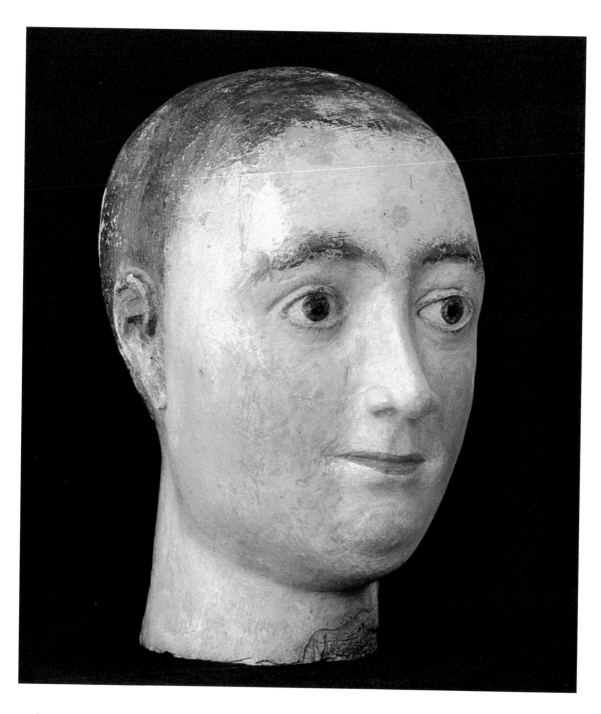

VI. Mary Tudor, 1558.

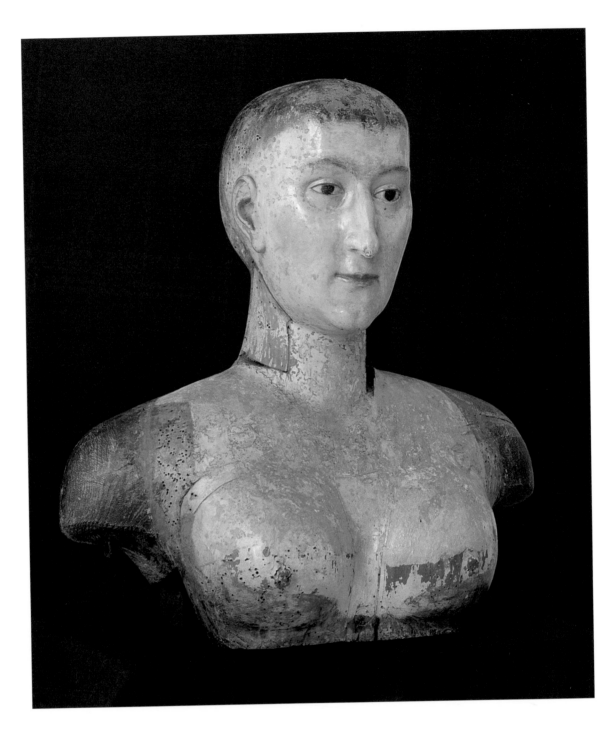

VII. Anne of Denmark, 1619.

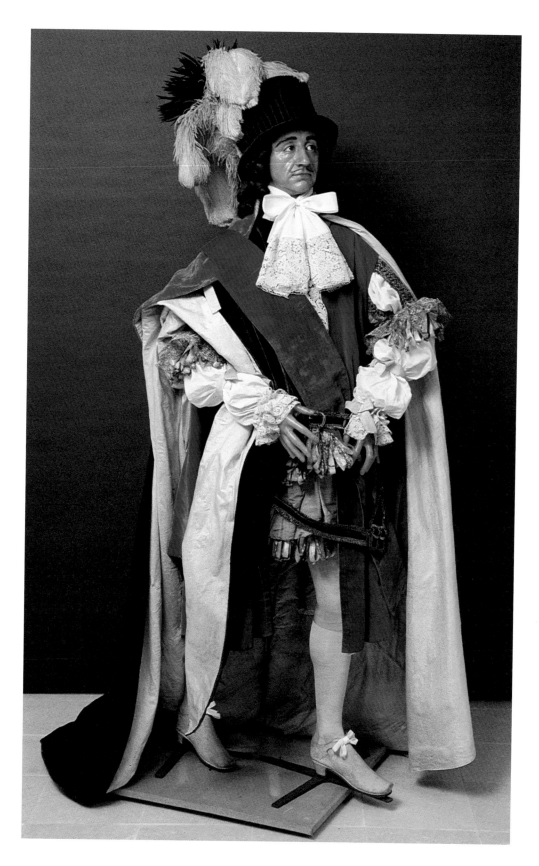

VIII. Charles II, 1685.

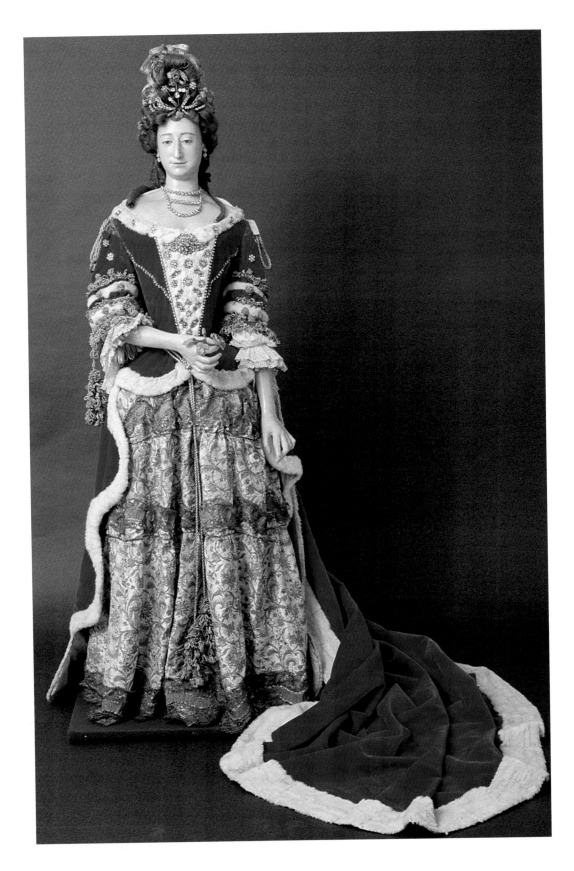

IX. Frances, Duchess of Richmond, 1702.

X. Duchess of Richmond,
 detail of petticoat (catalogue no. 4).

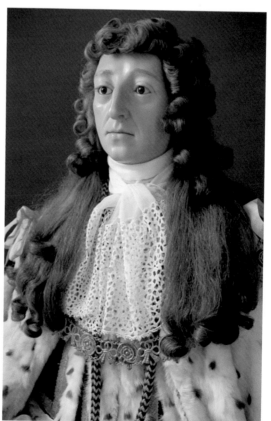

XI. William III, head and upper body.

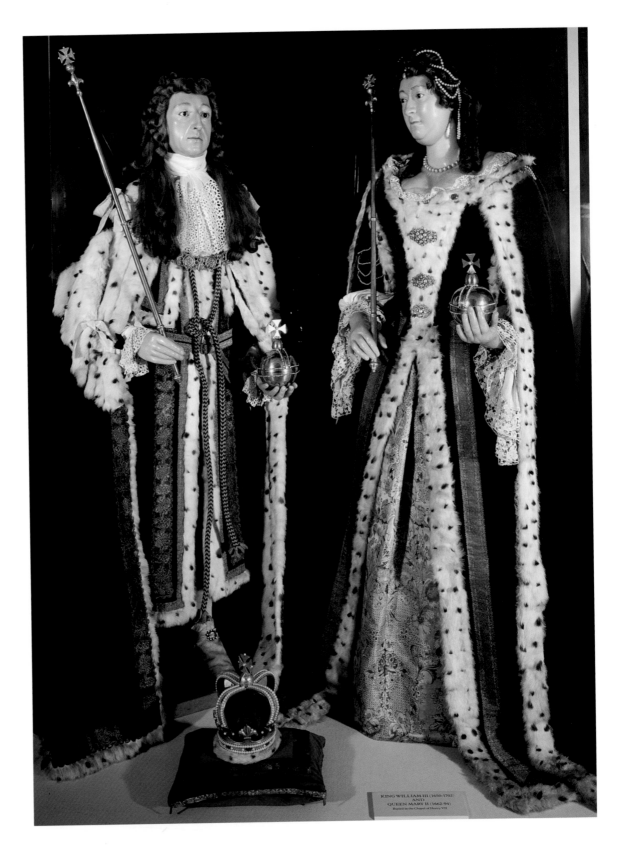

XII. William III and Mary II, c.1725.

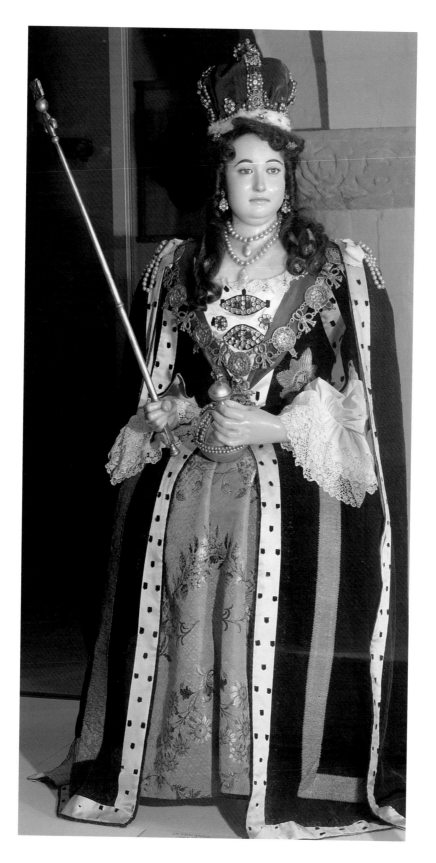

XIII. Anne, head and hands 1715, effigy 1740.

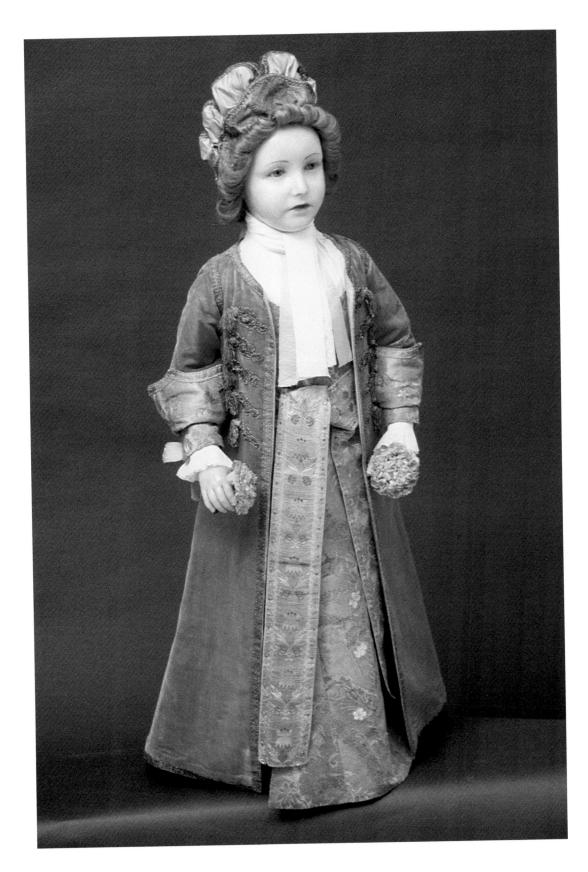

XIV. Robert, Marquess of Normanby, clothes c.1714.

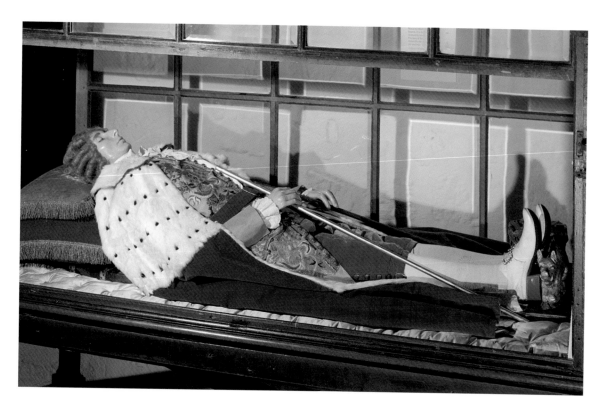

XV. Edmund, Duke of Buckingham, 1735.

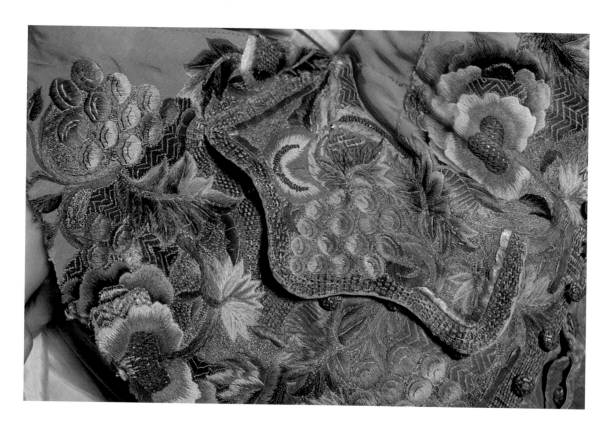

XVI. Edmund, duke of Buckingham, detail of waistcoat (catalogue no. 4).

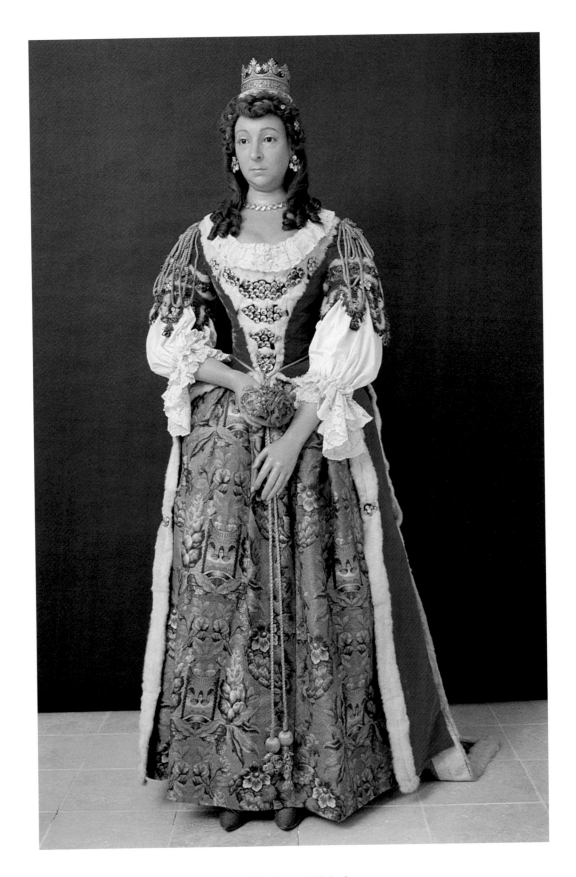

XVII. Catherine, Duchess of Buckingham, 1735–6.

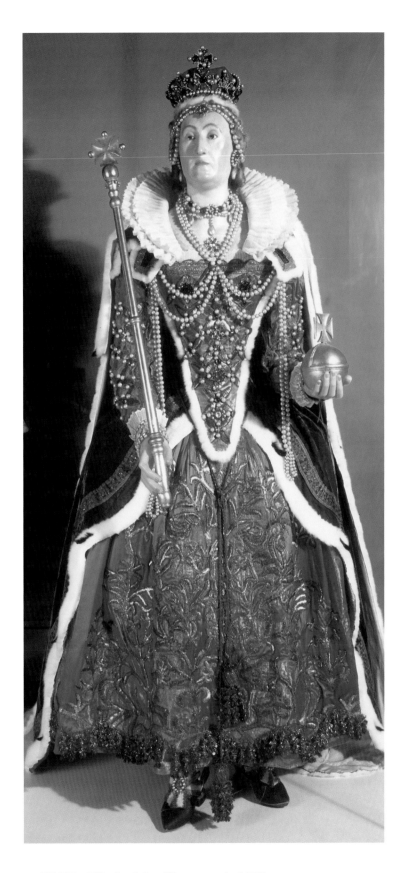

XVIII. Elizabeth I, effigy remade 1760.

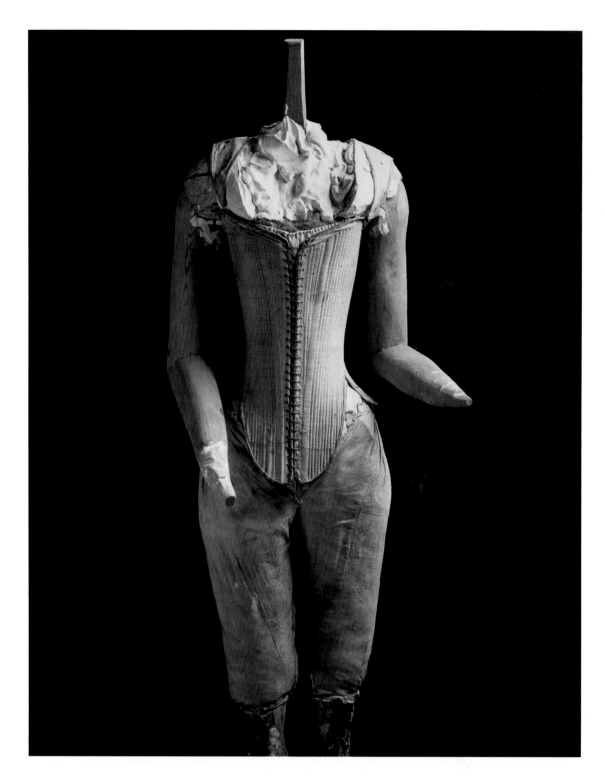

XIX. Elizabeth I, corsets from the original effigy, 1603.

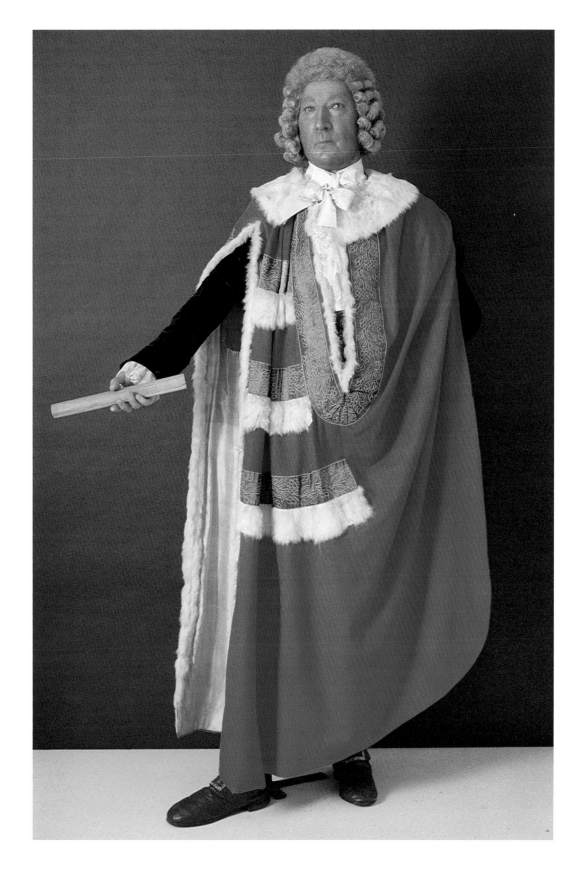

XX. William Pitt, Earl of Chatham, head before 1775, effigy 1779.

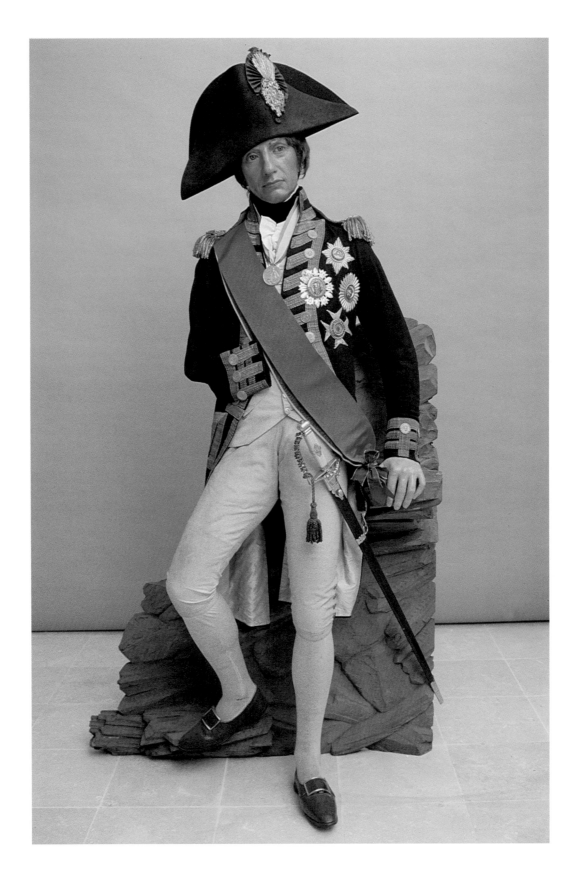

XXI. Horatio, Viscount Nelson, head c.1800, effigy 1806.

XVIII. CATHERINE, DUCHESS OF BUCKINGHAM

The effigy of Catherine, duchess of Buckingham (wife of John Sheffield, first duke of Buckingham), the illegitimate daughter of James II, was made during her lifetime and was dressed under her personal supervision.[1] It was the last Westminster effigy actually carried at a funeral and definitively marks the end of a long tradition. The account of her funeral in the *Gentleman's Magazine* states that 'her Effigy in wax (which she had by her ever since the Duke her Son's Funeral) dress'd up in her Coronation Robes, was placed under a Canopy of State, with two Ladies of Her Bedchamber at her head and feet, and drawn in a car by six horses cover'd with black velvet.'[2]

The effigy is 5ft 9in high. The face is skilfully modelled and is evidently intended to be a portrait. It must have been 'approved' by the duchess herself and resembles a portrait of the duchess as a widow at Southill House.[3] Plainly, the relaxed pose is sharply distinct from the portrait figure of the duchess on the tomb of c.1721 to her husband in Henry VII's chapel, based on a design by Denis Plumier (though executed by Delvaux and Scheemakers), which shows her as a grieving widow in classicising dress.[4] It is unfortunate that the name of the modeller of the wax effigy is unknown (he or she was clearly also responsible for the figure of Edmund, Duke of Buckingham, as Tanner and Nevinson note, concluding 'there is little doubt that it was made at the time of her son's death in 1735').[5]

Almost exactly contemporary with this effigy is that of Sarah Hare, also by an unknown artist, in Stow Bardolph church, Norfolk. In her will, dated 10 August 1743, Sarah Hare required

to have my face and hands made in wax with a piece of crimson satin thrown like a garment in a picture, hair upon my head, and put in a case of Mahogany with a glass before and fix'd up as near the place were my corps lyes as it can be, with my name and time of death put upon the Case in any manner most durable.[6]

This still surviving effigy is the only English one known to exist outside Westminster Abbey and testifies to the spread of the tradition for effigial representation near the tomb outside the Abbey. Jean Fraser's conservation report of 1984 revealed that the effigy had originally been coloured to make it as life-like as possible and that the face was 'almost certainly made from a mask made either in life or death'.[7] It seems likely that the same techniques were employed to produce the duchess of Buckingham's figure.

PL

1 W.S. Lewis, W.H. Smith and G.L. Lam (eds.), *Horace Walpole's Correspondence with Sir Horace Mann* (London 1955) ii, 192–3 n12. Walpole relates anecdotes about the duchess's extraordinary pride. See also *The Illustrated London News*, 22 April 1933, 578–9 for illustrations of the effigy and its clothing.
2 *Gentleman's Magazine* xiii (1743), 191; see above, 15–16.
3 See H. Clifford Smith, *Buckingham Palace* (London 1931), plate on p. 15, cited by T and N, 181.

4 M. Whinney and J. Physick, *Sculpture in Britain 1530–1830*, 157–9. The duchess was buried beside her husband.
5 T and N, 180.
6 M. Dance, 'The Saving of Sarah Hare', *SPAB News*, Autumn 1987, 14.
7 For this effigy see Pyke, *Biographical Dictionary* (1973), Appendix II, and Dance, 'Sarah Hare', 14–16.

DESCRIPTION

The figure consists of a wax head and arms, and a stuffed bust, mounted on four irons, two passing through the legs, which are separate from the body. The wax head is finely modelled; the ears, which are partly hidden by the hair, are only treated in outline. The eyes are glass, with blue irises, the eyelashes of human hair. The scalp is smooth, the back of the head is covered with discoloured silk. The wax, which is rather yellow, continues as far as the middle of the bust. The body is stuffed with tow, and covered with coarse white linen canvas; the upper arms are similarly made and stiffened with iron rods, and there are marked projections over the hips. The canvas is secured by pins in most cases. The fore-arms and hands are of wax, formerly painted. The body is set on a square wooden base through which the four irons are bolted. The irons have staples for two screws at their lower ends. The legs, which are separate, are of stuffed canvas above; below the knee a stiff surface has been produced by pasted paper over linen and a lime-wash finish.

T and N

1. ROBE

Length of bodice (front) 14¾in, of front skirts 41½in; width (shoulders) about 24in; length (train) about 69in.

T and N

The robe is of pieced cut silk velvet, lined with a light-weight eighteenth-century white silk taffeta.

NR

Trimmed with ermine, silver bullion work and pastes. It is so defective that it is hard to decide whether it was made for the effigy or was altered from an actual robe. The bodice is fastened behind, the back is missing. In front there is a stomacher of fur, decorated with lines of ermine tails, and over these are sewn pastes in gilt and silver mounts in groups upon black velvet. The sides of the bodice are of velvet and there is a rounded basque at the waist. A strip 8in wide, edged with fur, alone remains of each side of the skirt, and the train consists of a strip 20in wide with the same trimming. The sleeves are short (12in over all) carefully finished with tabs edged with fur and silver bullion work, and there is an applied band of similar work at the top of the arms. The bodice is lined with black canvas, the sleeves with white silk; the seaming is made with silk or rough linen thread.

T and N

Ten fragments of eighteenth century playing cards used to stiffen the velvet behind the pastes were removed in 1933 and are exhibited separately (see below, no. 17).

RM

2. BROCADED SILK, to serve as petticoat front

Length 44in, width 63in (three pieces of 21in). The piece has been gathered in loose folds at the top and stitched with yellow silk for fitting to the effigy. Placket slit on upper edge, showing that the piece originally formed part of a petticoat.

T and N

Width of silk 21in between selvages, the latter five-sixteenths of an inch. Point repeat, the length is 13¼in.

Lampas, woven in silver or silver-gilt thread in *filé* on a *frisé* ground. The silks are all brocaded and the pattern is bound in 3\1 twill.

The silk French, c.1736–9. It can be compared with the silks dated 1736 in the Richelieu Collection in the Bibliothèque Nationale in Paris which were made for the queen of Portugal. It is a new silk, unused. The architectural style with a balustrade and sculpture was one deplored by Mrs Delany in several letters.[8]

NR

8 Lady Llanover (ed.), *The Autobiography and Correspondence of Mary Granville, Mrs Delany, with interesting reminiscences of King George* the Third and Queen Charlotte (London 1861), from a letter of 1739.

41. Catherine, Duchess of Buckingham: detail of petticoat (catalogue no. 3)

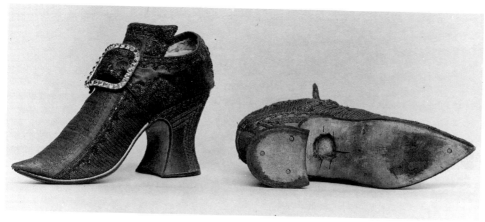

42. Catherine, Duchess of Buckingham: shoes (catalogue no. 12)

3. PETTICOAT

Length 40in; waist, 48in (fixed band, 36in); hem 142in. Gathered to fixed waist-band with smooth panel down the front, and bunches on the hips above pocket slits; there are short draw-strings behind.

T and N

Quilted very light-weight carnation coloured satin with a quilted flounce 13in deep. There is a very fine lining of the same silk.

NR

4. UNDER-PETTICOAT

Length 32in; waist 41in; hem 94in. Quilted linen. The lower part consists of a strip of linen, quilted in floral patterns, stained and mildewed, and above, a strip of dimity gathered to a band. Worn and probably altered.

T and N

5. STOCKINGS

Length 25in, foot 9in; width (top) 7½in. Knitted pink silk, not worn. Seam at back, shaped to leg, wide tops. There is a large figured clock with a stylised floral pattern. The upper hem sewn over for draw-string to be inserted. No garters.

T and N

6. CORONET CAP

Height 5in, diameter 5in over all. Red velvet pleated at the sides; it has a flat top with a large knot of corded gilt bullion work; the lower edge is trimmed with fur, now very much moth-eaten. Lined with white silk, and with four tabs for attaching.

T and N

7. WIG

Length about 17in. Human hair (pale brown). It is composed of long narrow tresses made up and bound to a knotted linen foundation with mauve silk. There are four long curls on each side, and a small peak over the forehead. The top much moth-eaten.

T and N

8. SLEEVE RUFFLES

Diameter (as gathered) 13in; depth about 5in. Point lace. The ruffles are double and slightly deeper behind the elbow; the lower ones are mounted on stiff gauze; they are attached to a white silk sleeve for pinning into the robe.

T and N

The lace edging on her chemise and that on the sleeve ruffles is of high quality needle lace. The fine thread and complex filling patterns suggest that it was made in Brussels, with raised outlines added in France (Alençon or Argentan). This is known to have happened. The dense pattern of the lace suggests a date in the late 1720s or early 1730s. There are also several joins, indicating that it has been re-used.

SL

9. BERTHA

Length as mounted about 40in; depth 2½in. Lace as ruffles. Several pieces of lace joined, pleated on stiff gauze and gathered over shoulders. In front there is a vertical band with eight small rosettes.

T and N

10. SHIFT

Length (back) 45in, (front) 37in, width (neck) 11in, (shoulders) 23in; sleeve, length 12in; diameter at gusset 14in; cuff 10in. White linen. The shift is longer at the back than at the front, the neck is cut very low and has a draw-string. On each shoulder are two pairs of strings for holding the décolletage low. The quarter sleeves are full, gathered towards the elbow to a small frilled band.

T and N

11. TWO FLOWERS

Rose and bud, length 8in; carnation (stem broken), length 2½in. Wire and painted(?) cotton.

<div align="right">T and N</div>

12. SHOES

Pair of green silk satin buckle shoes, the colour matching one of the colours in the brocade petticoat front.

Toe needlepoint, upcurved, with rigid puff.

Heel 3¼in covered, white stitched. White finish on top piece, with 2 + 1 ring stamps.

Sole of leather, ?flesh out. Made straights and probably unworn. It continues down the heel breast. Brown edge finish, with white finish all over the rest. 1 + 2 ring stamps cover the nail holes used in making. The construction is white kid rand, ending at the start of the heel curve, finely stitched at about 20 to the inch through the sole channel, with stitches showing on the side of the rand. Length 9½in, which would fit neatly the 9in stockings (size given by Tanner and Nevinson). The centre waist is pierced for the effigy support.

Upper consists of vamp and pair of quarters, joined by dog-leg side seam. The vamp extends into high, flared tongue, with acute angled corners. The outside quarter is cut with a slight square extension, with a worked 'buttonhole' at rightangles to the front edge, to take an anchor chape buckle. The inside quarter extends into a narrow (1in) longer pointed strap to fasten with the point on the outside, to avoid rubbing against the other leg. The present buckle is too wide for the strap and has the pitchfork and double spike anchoring chape, which was in general use from about this period through to the 1790s, but unusable on shoes with this type of strap in normal wear. (The straps have in fact been stitched down to secure.) The buckle is oblong, 1¾in by 2½in, of silver, set with 6 × 8 Georgian pastes, with a half-rounded one in each corner.

The upper is decorated: the vamp has a broad band of gilt braid from toe to tongue, edged with scalloped gilt lace. The seams, top edges, heel seat and back are also edged with the scalloped lace. In between, the silk has rows of close appliqued narrow green silk braid, matching the ground colour, at right angles to the sole seam, giving a striped effect. The heel has a similar silk braid of a slightly different shade, applied in three rightangled rows, which is more typical of eighteenth century braid appliqué patterns than the simple stripe of the upper, where the quarters are particularly unusual.

Inside The tongue has traces of pink ribbed silk lining to support the height. The quarters are lined with white kid, which is pierced with the stitches attaching the braid appliqué, that is, upper and lining were treated as one, which gives a firmer material, though good quality shoes may have the stitches concealed under the lining.

The quality of the workmanship and unusual appliqué suggest expensive shoes, consistent with the wearer's status.

<div align="right">JS</div>

13–19. JEWELLERY

The Duchess of Buckingham's ornaments range from genuine pieces such as her coronet, the rosettes (perhaps the heads of hairpins) in her coiffure, others on her sleeves and groups of single white pastes in collets furnished with shanks on various parts of her costume, to dressmaker's pieces assembled for the effigy, presumably in 1735–6.

13. CORONET.

Height 3½in, diameter 5in. Silver-gilt with a ducal crest of strawberry leaves, two points of which are broken. The cap is of pleated red velvet, with a top knot of corded gold bullion work and a fur edge at the base. The coronet is certainly contemporary and was noted on the head of the effigy at the Duchess's funeral on 8 April 1743.[9]

[9] T and N, 180.

14. COIFFURE. The engraving of the effigy in *A View* depicts at least five rosettes on the wig, as well as ropes of stones or pearls. Tanner and Nevinson refer to six hairpins and three stars; what remains is a white rose-cut paste rosette and a single paste-set collet on each side of the forehead.

15. EARRINGS. Length 1½in. According to Tanner and Nevinson these are copper gilt and were probably purchased, if not made for, the effigy. Of girandole form, a type which was inherited by eighteenth century jewellers from their predecessors in the preceding century and usually comprising a top with brackets or intermediate units such as bows supporting five or three oval drops, the Duchess's earrings are modestly equipped with three pendants. They have a cushion-shaped white paste top, brackets of scrolling openwork open-set with small white pastes; tear-shaped rose-cut pastes in closed settings form the drops. The earrings differ in minor details. The fact that the effigy came to the Victoria and Albert Museum in 1933 with only one earring raises two possibilities: the first that the other earring had been preserved and was handed over with the effigy, the second that the piece was lost and a copy was therefore made by the Museum craftsmen.

16. NECKLACE. The piece supplied for the effigy and illustrated in *A View*[10] consists of a single row of stones. This necklace has a string of white rose-cut pastes held by a series of small triple claws in open-backed collets. Unbacked collets were highly unusual in 1735–6, but can be accepted on the basis that the necklace was either the cheapest form of costume jewellery available or was specially commissioned by the effigy maker, in which case it was unnecessary to follow the usual (and time-consuming) practice of mounting the pastes in foiled collets with closed backs.

17. STOMACHER ORNAMENTS. These are mainly dressmaker's work. The three brandenburg shapes and a triangular terminal were roughly cut out of eighteenth century playing cards (now exhibited separately, the holes where the pastes were attached visible) and covered with black velvet. The pastes, mainly colourless roses but including four green ones in gilt collets, are individually set in clawed silver mounts having metal loops or rings at the base through which a needle and thread were passed to secure them to the velvet-covered ground. The threads rotted in the course of time and numerous collets were lost but were perhaps collected up and handed over to the Victoria and Albert Museum in 1933.

The upper ornament, in three parts, contains a rose-cut green paste in a clawed gilt collet surrounded by white pastes in the two outer units. Two more, similarly cut and set, appear towards the outer edge of the central component. Flanking this ornament are two rosettes, each with a central white rose-cut paste bordered by seven smaller pastes in silver settings. These are independent items of jewellery.

The remaining three units of the stomacher are all sewn with white pastes.

18. SLEEVE ORNAMENTS. Each sleeve is decorated with a rosette of white pastes in rub-over silver collets and two clusters of white pastes (one of three, one of four), each in a cup-shaped clawed collet with a shank, which might have served as buttons.

19. SKIRT ORNAMENTS. The fur of the robe is held on each side of the petticoat by a larger cluster of eight white roses, in the same position as in *A View*.

SB

10 *A View*, pl. opp. p. 23.

CONSERVATION HISTORY

1933 Clothes and wig cleaned; two fingers on right hand repaired (V and A).

1986–7 Left thumbnail retouched, wax cleaned (Plowden and Smith). Sleeves replaced, lace washed and bleached, robes cleaned, effigy arms recovered with calico (V and A).

 RM

XIX. QUEEN ELIZABETH I

The Original Effigy

The full set of accounts for the funeral of Elizabeth I survives in a manuscript book compiled by Sir John Fortescue, Master of the Great Wardrobe, in the Public Record Office, as well as in a more abbreviated form on parchment among the Foreign Accounts enrolled by the Clerk of the Pipe.[1] The accounts show that there was over a month between the queen's death and her funeral ceremony, much of which must have been occupied in the extensive preparations for her funeral. Two woollen drapers were paid for black cloth to cover the barge that brought the late queen's corpse from Richmond, where she died, to Whitehall, and to drape the other barges which accompanied it. The room in which the corpse was first placed at Whitehall was entirely draped in black, as were neighbouring chambers. The communion table, pulpit and the interior of the chapel were hung with black baise. The same material, of varying qualities, was also used for hanging Westminster Abbey church, for the hearse there and for the stables.[2] Very large sums of money were spent on cloths of estate at Whitehall, around the bedstead where the corpse was first laid after being brought from Richmond, and upon the hearses in the chapel at Whitehall and at Westminster.

The funeral effigy of Queen Elizabeth cost £10:

> And to John Colte for the Image representing her late Majestie with a paire of straight bodies a paire of drawers, Bombaste, fower screwing irons, a pair of lastes, lace and peints and also a chest to carry the same.[3]

The late queen's tailor, William Jones, earned 13s 4d for making the robe of crimson satin for the queen's representation. The materials – the ten yards of crimson satin at 16s the yard, and the six yards of white fustian to line it at 18d the yard, the three-quarters of a yard of cloth of gold for the sabatons and the coif at 50s the yard – were supplied by William Marshall.[4] John Colt's funeral effigy is listed with 'a pair of straight' bodies. The reference can be compared with the similar provision of 'a paire of Bodyes' in the accounts for Anne of Denmark's 'representation', carved by John Colt's brother, Maximilian. In both cases, the reference applies to a pair of stays rather than a separate body for the image. As has been argued above, it was only for the funeral obsequies of King James I that two entirely distinct funeral effigies were provided, at increased expense.

The funeral effigy of Queen Elizabeth is shown in the pictorial record of the funeral procession in BL MS Add. 35324, where the hearse is also represented.[5] Giovanni Carlo Scaramelli, writing to the Doge and Senate of Venice on 8 May 1603, described the funeral to his masters as follows:

1 M.S. Giuseppi, *A Guide to the Manuscripts Preserved in the Public Record Office* (London 1923) i, 118–19, *sub* Declared Accounts (Pipe Office), E351.
2 PRO E351/3145, 22–7.
3 PRO E351/3145, 25.
4 Hope may well be correct (p. 353) in assuming

5 that the order of entries has been interrupted by careless folding of the quires by the binder. It was reproduced in contemporary engravings and is also shown in *Vetusta Monumenta*, III, 1791, pls. XVIII–XXIV (from BL MS Add. 5408) and R. Davey, *A History of Mourning* (London 1889), fig. 31. See also R.

The coffin will lie for a month under a catafalque, and on it is the queen's effigy, carved in wood and coloured so faithfully that she seems alive . . . The magnificence of the (funeral) ceremony consisted merely in the universal mourning worn by all the ladies and gentlemen of the Court, which cost an immense sum; but at the actual funeral service little else was done except the chanting of two Psalms in English and the delivery of a funeral oration, as I have been informed . . .[6]

He added in a letter of 28 May that the effigy (and therefore the catafalque) had already been removed.[7] A full account of 'the proceeding at Queen Elizabeth's funerall, from Whitehall to the Cathedral Church at Westminster on Thursday the xxviijth of Aprill 1603' with paintings of the standards, the banners, the horses covered with black cloth, the coat of royal arms and other things carried in the procession, is in the Vincent Collection at the College of Arms.[8] PL

The Original Robes

The effigy is shown in one of a series of watercolour paintings of the funeral procession,[9] dressed in the 'Clothe of golde and silver tissue kirtle' of the Robes of Estate, which are listed as 'the Coronacion robes' in the inventory of the Wardrobe of Robes made in 1600.[10] The crimson velvet Parliament mantle, lined with ermine, lies beneath the effigy. Another contemporary observer described 'the lively Picture of her Majesties whole body in her parliament robes' in the funeral procession from Whitehall to the Abbey church of Westminster on 28 April 1603. These are the robes which are shown on Queen Elizabeth's tomb in Westminster Abbey. It is not certain exactly which robes were originally used for the effigy carried in procession. The complete sets of both Coronation and Parliament robes appear in the inventory of the Wardrobe of Robes made in 1600 and were still there when checking was carried out in 1604, so presumably had been returned to the Wardrobe of Robes after the funeral, whichever had been used.[11] JA

The Present Effigy

By 1708, Queen Elizabeth's funeral effigy was in deplorable condition.[12] Vertue saw the figure in 1725 and described it as 'not tall, midling her head cutt in wood. antient a little wrinkley her face. tho the truest countenance of her face'.[13] In their 1936 *Archaeologia* paper, Tanner and Nevinson claimed: 'It has always been an Abbey tradition that parts of the original figure, which was made by John Colte for the funeral in 1603, were utilized for the new effigy. A thorough examination has shown, however, that the figure, with the possible exception of the wooden legs, was entirely remade in 1760.' They concluded, 'Nothing of the early effigy appears to remain'.[14] (Plate XVIII) Tanner and Nevinson's discussion of Queen Elizabeth's funeral effigy directly contradicted Sir William St John Hope's 1907 account of its construction, based on his own

Marks and A. Payne (eds.), *British Heraldry from its Origins to c.1800* (London 1978), 48–9.

6 H.F. Brown (ed.), *Calendar of State Papers and Manuscripts relating to English Affairs existing in the Archives and Collections of Venice* x *(1603–7)* (London 1900), 22.

7 Ibid., 41.

8 L. Campbell and F. Steer, *A Catalogue of Manuscripts in the College of Arms Collections* i (London 1988), 387. See also M.A.E. Green (ed.), *Calendar of State Papers,*

Domestic 1603–10 (London 1857), 5, for drafts.

9 BL Add. 35324, Rothschild Bequest, vol. xv fo 376. Illustrated in J. Arnold, *Queen Elizabeth's Wardrobe Unlock'd* (Leeds 1988), 63.

10 The crimson satin robe (above, 155) has not survived.

11 Full details in *Queen Elizabeth's Wardrobe Unlock'd*, 255–6.

12 Stanley, 323.

13 *Vertue*, 158, from BL Add. 23069, fo 51v.

14 T & N, 189.

examination of the effigy.[15] Hope declared 'there are good reasons for believing the naked trunk of [the 'roiall representacion' manufactured in 1603 by John Colte for the queen's funeral] . . . was utilized for the restoration . . . of Queen Elizabeth's effigy in 1760. In the present state of this figure it is difficult to see how the upper part is constructed, but the hips are still padded with "bombast," and the legs, which were cut down in 1760 to fit them into a pair of high-heeled boots, are certainly those of an older figure'.[16] Sheila Landi kindly made it possible for me to see the effigy in her conservation workshop in February/March 1995; from this examination, it emerged that Hope was right and that the nucleus of the present figure *is* essentially that of 1603, albeit drastically remodelled in 1760.

The main structure of the effigy, the cross-piece which forms the shoulders, the trunk and the cut-down legs, are all clearly from the effigy for which John Colte was paid £10 in 1603 and which is shown in contemporary representations of her funeral procession. (Plate XIX) However, the central post on which the wax head is fixed, the crude plaster which retains it in place, and the wooden arms, all date from the eighteenth-century restoration. Also from 1760 are the shoes, which are actually made of cast-lead: the original legs (which have traces of what appear to be original paint) were crudely cut off below the knee, and the stumps fitted into the new replacement legs, with the shoes attached. The head of the queen carved by Colte in 1603 and seen by George Vertue in 1725, was replaced, with a new wax head, in 1760; the wax hands also date from the remodelling of the effigy.[17] A payment of £56 2s 3d on 30 May 1760 doubtless covered these extensive alterations and the cost of redressing the effigy;[18] the original hips filled out with bombast and the 'pair of straight bodies' or stays were, however, retained; the stays and drawers are the subject of a separate note by Janet Arnold.

One final point which should be discussed here is Martin Holmes's suggestion that a carved wooden head of Queen Elizabeth I in the collection of the Royal Armouries was the original head supplied by John Colte (and, he thought, probably carved by John's more celebrated brother, Maximilian) for the funeral effigy.[19] Holmes's ingenious suggestion must be rejected: first, the polychromy and construction of the head seem more appropriate for the eighteenth century than for the early seventeenth; secondly the resemblance between the head of the *tomb*-effigy in Westminster Abbey, carved by Maximilian Colte in 1608, and the wooden head can be readily explained by supposing that the latter was based on the former (a model to which any eighteenth-century artist might be expected to turn) or on a good painted portrait; thirdly, there is no evidence on this head of the wrinkles seen by Vertue – a point on which the latter was hardly likely to be mistaken – and, finally, there is unequivocal documentary evidence dating from 1782 that the well-known painter Benjamin Wilson supplied the figure of Queen Elizabeth on horseback – from which the head comes – at a cost of £21, which commission he received in 1779.[20]

PL

15 Hope, 554.
16 I am indebted to Sheila Landi for permission to see the effigy and for guidance as to its construction. The conserved figure was first exhibited and catalogued by T. Cocke, *900 Years: the Restorations of Westminster Abbey* (London 1995), 122. I am also indebted to the late Janet Arnold for her comments on this revised text in January 1995.
17 WAM Chapter Book, 3 January 1760: 'The Gentlemen of the Choir having requested leave that they may set up a waxen effigy of Q. Elizabeth within the Tombs at their own ex-

pense, the said request was agreed to, and it was ordered that the College Carpenter do make a wainscot case for the same at the College expense as hath formerly been done on the like occasions.' Cf. WAM 33791, 47867A.
18 WAM 61033. See also WAM 48065 A–C, 61062 and 61062*.
19 M.R. Holmes, 'A carved wooden head of Elizabeth I', *Antiquaries Journal*, 40 (1960), 35–45.
20 WO 47/94 fo 348; 47/98 fo 158; 47/99 fo 311; 47/100 fo 214. I owe these references to Mr Geoffrey Parnell of the Royal Armouries.

43. Elizabeth I: pannier (catalogue no. 2)

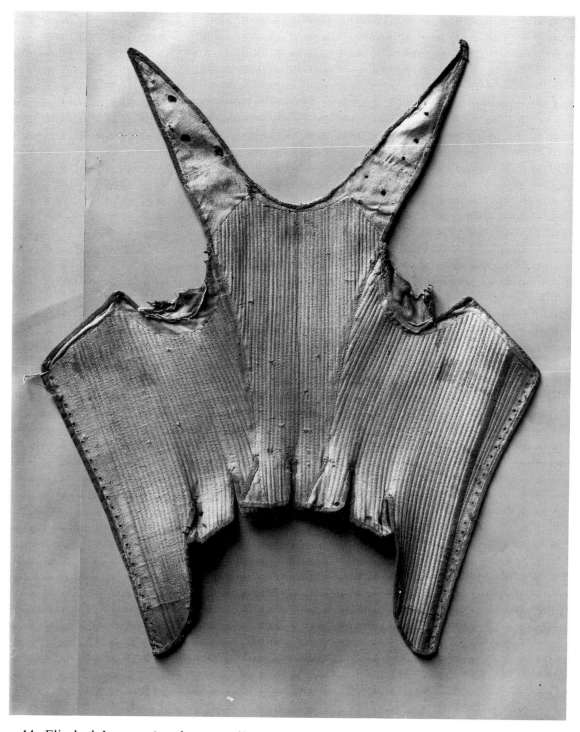

44. Elizabeth I: corset (catalogue no. 3)

The present clothes 'appear to be a cheap and tawdry attempt to represent the dress said to have been worn by the queen at the Thanksgiving Service for the defeat of the Armada in 1588,' as Tanner and Nevinson described them.[21] Parts of the present costume date from the eighteenth century or possibly earlier, while others appear to have been added in the late nineteenth century, some in 1933–6 when the effigies were refurbished, and finally in 1951. JA

The sleeves, stomacher and petticoat of red satin decorated with paste jewels, etc., are almost certainly adapted from a theatrical costume contemporary with the conversion of the figure. Each item, especially the petticoat, was altered to correspond more closely to an eighteenth-century idea of a sixteenth-century costume. The velvet over-skirt and mantle were real garments from a different source. The bodice consisted of two roughly-cut pieces of velvet pinned to the corset. SBL

DESCRIPTION

The head and hands are of wax. The wax is thin and set on a plaster base. The feet are of cast lead, possibly made from actual eighteenth century shoes with pointed toes and large heels. The core of the figure is of tow stiffened with wood, and arms and legs of carved wood (the latter painted white). The sceptre and orb are wood, re-gilt. T and N

1. MANTLE AND OVERSKIRT

Of purple velvet in poor condition possibly dating from 1760, trimmed with metallic braid (galloon) and imitation ermine. The latter remained until 1933–6, when Tanner and Nevinson recorded that the fur was moth-eaten and, as it could not be cleaned, was replaced with new fur (presumably still imitation ermine). This was removed in 1951, presumably again because it was moth-eaten, and replaced with a curious white angora wool knitted strip, as new fur was too expensive in the post-war years. JA

2. PANNIER OR HOOP PETTICOAT

This rare garment dating from c.1760 could be examined only by lying on the ground and looking under the skirt. Tanner and Nevinson give the measurements of waist 25in and depth (back to front) 16½in. They describe it as of 'red, blue and white check cotton, stiffened with cane. The pannier is attached to the waist by tapes; at either side are two cushions of the same material stuffed with hay.' Since that time, presumably in 1951, a large, heavy piece of lead had been crudely stitched to the bottom of the pannier to weight the figure. This was removed in 1988, at which time the pannier was extremely dirty and the colours could no longer be distinguished, though the check pattern in the weave was visible. It seems likely that the material is linen, not cotton. A close inspection in good light is required. JA

3. STAYS OR CORSET

The 'pair of straight bodies' provided by John Colte were probably made by Queen Elizabeth's tailor, William Jones, or one of his journeymen; full details of the maker are not given in the accounts. They were probably made specially for the effigy and are unlikely to have been an old pair worn by the Queen, as those listed in the tailors' warrants for her Wardrobe of Robes are covered with silk or satin.

The 'pair of straight bodies', or stays, are made of two layers of what is probably fustian (linen warp, cotton weft), with a twill weave originally white, and now discoloured. The front

21 T and N, 189.

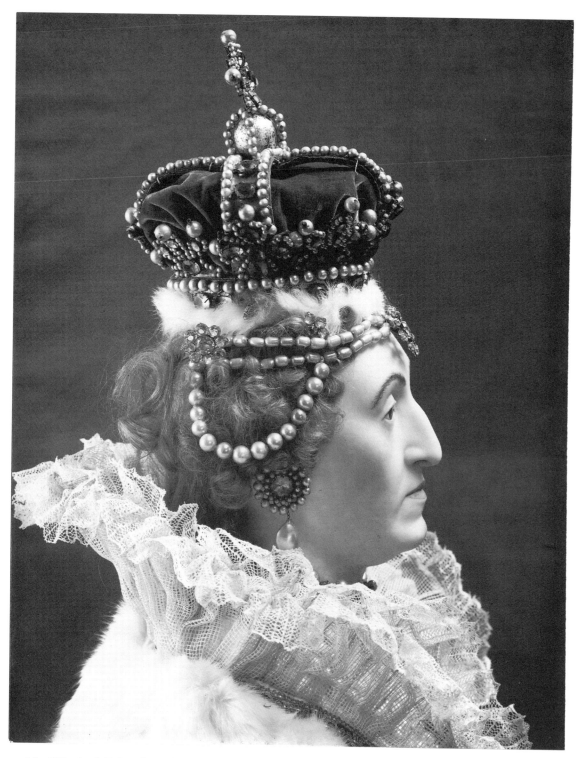

45. Elizabeth I: head profile showing collar, crown and jewellery (catalogue nos. 5, 8–10)

opening is laced together through 29 eyelet holes worked in linen thread on each side. The centre fronts gradually widen above the waist, sloping off the straight grain by about 1½in at the neckline. The side back seams are slightly curved. The centre back is cut to a fold on the right side, while the inner layer is joined with oversewing with linen thread. The front skirts are cut into two tabs beside each side of the centre panels. The back has a single tab on each side, left open to the waist at the centre back and on both side back seams. There is a ½in wide whalebone on each side of the front held by two lines of running stitches in linen thread on the straight grain: 38 lines of running stitches, parallel with this bone, including the short ones at the side back, hold ¼in wide whalebones in position. There are 45 lines of stitching right across the back at shoulder level to hold the whalebones. The shoulder pieces are made of a single layer of material with what seems to be a worked eyelet hole at the end which is tied with a point, or lace, to the hole at the side front neckline. The fragments of a leather point remain in the hole on the right front. The whalebones reach a line below the neckline and armholes, grading from between ¼in at the centre back to 1in under the arms, and ½in at the front. The neckline, shoulder pieces, centre front and tabbed skirts are all bound with green leather with a suede finish, ¼in finished width on the right side. Pairs of eyelet holes are worked in linen thread at the waist level, immediately above the openings of the tabs, for attaching the farthingale.

The 'pair of drawers' provided by John Colte were studied on the effigy, as the garment had been nailed into position, presumably in 1760. The pattern shape taken may therefore not be entirely accurate. However, the drawers are much narrower than two embroidered pairs in the Metropolitan Museum, New York.[22] They are made of what seems to be fustian, similar to that used for the stays. The fullness of the drawers is gathered into the waistband which measures 24½in and is ?in deep. There are 13 eyelet holes on the right side, worked in linen thread, ¼in down from the folded top edge. Presumably there were the same number on the left side, but they could not be counted as they were covered with linen from the body of the effigy. It is possible that the drawers were made by a hosier, based on the patterns of close breeches for a youth, simply for holding what seems to be hemp (not tested) padding the legs and hips of the effigy. The method of supporting breeches by means of lacing through worked eyelet holes in the waistband and attaching the points to worked eyelet holes in the doublet skirts, or in a strip inside the doublet waist, may be studied in numerous examples.[23] JA

4. WIG

Tanner and Nevinson describe this as 'fair hair, short and curled'. It would appear to date from the late nineteenth century but it was not possible to remove it from the head and examine the net base to date it accurately. JA

5. COLLAR

Tanner and Nevinson describe this as 'net and bobbin lace, stiffened with wire. Much of the net was replaced by new.' The collar resembles those made for period fancy dresses of the late nineteenth century. JA

The bobbin lace edging to her ruff dates from the late eighteenth century. It is very simple and could have been made anywhere in Europe, including England. The net to which it is attached is probably also eighteenth century. SL

22 Illustrated in *Queen Elizabeth's Wardrobe Unlock'd*, 302, 303.

23 See Janet Arnold, *Patterns of Fashion: the Cut and Construction of Clothes for Men and Women, c.1560–1620* (1985), 53, 55, 59, 60, 62, 63, 66, 70, 72, 76, 77, 78, 80, 82, 84, 86, 88, 90, 92.

6. SLEEVES, STOMACHER AND FOREPART

Of red satin mounted on cotton, embroidered with metal thread, imitation pearls and paste jewels.

JA

7. SHOES

Though the effigy is not dressed in real shoes, it is worth commenting on the style of the cast lead imitations, made in the 1760 'Van Dyck' style. They are painted blue.

Toe is pointed, with slight toe spring, typical of the 1760 date.

Heel 1¾in covered, thick Louis, with stitching down the heel breast and above the top piece. The top piece is painted red.

Sole is also painted red, imitating the newly revived vogue for red soles and heels. Made straights. The construction is the white rand, a method abandoned in Britain in the 1760s.

Upper has vamp and quarters, with a dog-leg side seam moulded (though there is no back seam, unlike contemporary shoes) starting from just behind the tread, giving short vamp and long quarters in the new style of George III's reign. The throat has moulded binding. The front is decorated with a Van Dyck rose, made of three pieces of ivory silk, one horizontal above the other two crossed, edged with serpentine gilt braid. In the centre is a circular 'jewel' of 12 pearls surrounding a large (⅝in) pinky-red glass stone, facetted and set on foil, attached directly into the lead. The top edge of the quarters is decorated with 1in wide scalloped gilt lace.

It is interesting that the newly popular 'Van Dyck' style, vaguely imitating seventeenth century fashions with the rose trim, was thought suitable for the remodelled effigy of Elizabeth in 1760. Seventeenth century footwear rarely combined rose and buckle, the roses generally being earlier and abandoned when the buckle fastening was introduced in 1660. Where rose and buckle were worn together the rose was usually placed to the side. I know of no other eighteenth century examples of the Van Dyck style which combine mock rose and buckle. So perhaps this was a rather crude attempt at a historic style, rather than an imitation of the new eighteenth century fashion.

JS

8–15. JEWELLERY

On 2 December 1933 A.J. Wace, the Keeper of Textiles at the Victoria and Albert Museum, wrote to Sir Edward Knapp-Fisher, the Chapter Clerk, mentioning the work to be done on the effigy: 'The velvet robes, of course, can be cleaned and so also the paste and other cheap jewellery though this will take a good time.'[24] The work was completed the following spring, but there is no reference to any replacements or re-ordering. It is clear however from an article in *The Times* on 26 March 1934 that this effigy, made in 1760, was not greatly esteemed, for it mentions that 'the rather tawdry Royal robes and other garments are covered with a profusion of coloured glass pastes and imitation pearls in the best eighteenth century Wardour Street manner.' (The painter Dante Gabriel Rossetti was to haunt the same street in pursuit of costume or theatrical jewellery in the Victorian era.) The ornaments garnishing the effigy are however striking instances of the mid-eighteenth century passion for polychromy.[25]

8. CROWN.

Gilt metal set with artificial pearls and with white and coloured pastes over a cap of red velvet. The band, edged with two rows of pearls, is further decorated with red, yellow and blue pastes in clawed settings. The crosses on the crest alternate with flower motifs truncated at the lower edge, all decorated with pastes. The arches are likewise bordered by pearls and set with pastes; the topmost cross has pearl terminals.

9. COIFFURE ORNAMENTS.

Two strings of pearls, frankly fakes in their tubular shape, are wound through the hair. On each side of the face is a loop of spherical pearls, attached to a rosette set with modified brilliant-cut white pastes held in open-clawed collets. In front, over

24 Copy of letter in V and A files 33/4576, 34/805. 25 See Evans, pl. XI.

the forehead, is a shaped rosette with a large white brilliant paste in the middle surrounded by a row of red pastes within a border of white ones, all in clawed settings. This last piece is not evident in the engraving of the effigy made in 1768 and published as the frontispiece to *A View*.

10. EARRINGS. Large button tops composed of a flat red paste bordered by two rows of pearls, the inner ones smaller than the outer. The boss shape reflects a contemporary vogue, demonstrated by the huge button earrings worn by Mary, Countess Howe in her portrait of about 1763–4 by Thomas Gainsborough. The painting is one of the glories of the Iveagh Bequest, Kenwood. In a vain attempt to evoke sixteenth century fashions, however, the buttons adorning the queen (who is rarely if ever depicted with earrings) were each further embellished with a flattish oval pearl pendant which has a ring at its base, suggesting that another drop had been added.

11. NECKLACES

(1) To judge by the engraving in *A View*, cited above, the upper necklace was originally a choker of a type still much favoured by women in the 1760s.[26] It probably comprised three rows of pearls admixed with pastes. The present central rosette set with a white brilliant-cut paste in a clawed collet within a pearl border might have been transferred from elsewhere on the effigy at a later date, when the lowest of the three rows of pearls and pastes was rearranged to form two pearl festoons, each with a flattish oval pearl drop. The festoons are attached in front to the rosette, which is flanked by two rose-cut red pastes in clawed settings. The two upper rows, conjoined, consist of a pair of tubular pearls followed by two spherical ones, interrupted by a rose-cut or other coloured paste spanning the two rows. A red paste in a clawed setting is suspended from a blue paste to fall above the pearl festoons. An elaborate pendant in several stages depends from the central rosette. It consists of three pearls terminating in a rose-cut tear shaped emerald green drop followed by a large rosette of white rose-cut pastes interspersed with clusters of small red ones and having a pearl drop. The engraving in *A View* shows the rosette attached directly to the lowest string of the necklace and having three drops in its turn, but the engraver may have misunderstood the complex structure noted by the artist.
(2) A row of spherical pearls is slung below the necklace described above, serving as lining to another, longer string of pearls which is joined at the top centre of the bodice and then festooned across it, together with a further string of pearls, as far as the shoulders, from whence they fall in two long loops terminating in pearl tassels.

12. BODICE ORNAMENTS. Three large rosettes with centres of rose-cut coloured pastes, red in the middle one and green on each side, in clawed collets edged with white pastes, form a variety of stomacher ornament. Below these are three rosettes in line, all set with pastes in clawed collets. The first is white, with a separate coloured paste above and below; the second mainly red with a white paste in the centre; and the third, white and red. The large colourless or white pastes are all brilliant-cut. The bodice is also sewn with individual claw-set pastes, the white ones chiefly brilliant-cut and the coloured (largely red, blue and yellow/green) variously step- and rose-cut. Each is surrounded by four large spherical pearls.

13. SLEEVE ORNAMENTS. Individual pastes and spherical pearls decorate the sleeves.

14. The CUFFS are overlaid with four rows of tubular pearls.

15. SCEPTRE and ORB. Plain. The sceptre has a larger cross than the others; the spherical terminals are gilt.

SB

26 See one set with gems in Evans, pl. 144.

CONSERVATION HISTORY

Late 19th century Wig and collar replaced?

1934 Robes and wig cleaned; old imitation ermine replaced, ruff and cuffs partly replaced.

1942 Clothes treated for moth (V and A).

1951 Fur again replaced.

1987 Wax cleaned, fillings on hands replaced and cracks reinforced, hands reattached, loose necklace strand rethreaded (Plowden and Smith).

1994 Full conservation of figure and costume (Sheila Landi). The figure was stripped and the head and hands removed (by Plowden and Smith). The discovery that the wooden figure, corset and drawers were original to 1603 led to the decision to display them separately. Thus a totally new figure was constructed to display the costume, head, hands and feet, reflecting as closely as possible the method of manufacture, proportions and stance of the original, which were by no means 'realistic'. A new corset was made from spartary steamed into shape over the top of the original. The ankles and shoes of lead were reused, the new legs held in place by plaster of Paris to give stability and a more vertical stance. Chipped paint on lead shoes touched in with acrylic paints. The ribbons and jewels of the pom-poms cleaned, supported and reassembled. The ruff and cuffs were also reconstructed using the eighteenth-century lace in the best available way to create an approximation of sixteenth-century fashions, based on the evidence of the nineteenth-century versions, which were discarded. The "fur" of knitted angora was replaced with synthetic ermine as used for judicial and parliamentary robes. Some real black tails were retained and reused. All jewels cleaned and restrung where necessary, some anomalies mentioned in description being sorted out. Eighteenth-century panier of linen and cane washed and repaired; missing pad reconstructed using hay for padding. The red satin of stomacher, sleeves and petticoat supported with new silk inserted behind; jewels stitched to new support to relieve weight; false busk added to back of stomacher. Pleats around back of petticoat stitched in place. Purple velvet overskirt repaired at waistline and the original waistband of black wool repaired and reused; silk lining covered with new silk for protection. Similar treatment given to the mantle, the section beneath fur collar made up with dyed new wool to match section in back of overskirt (on evidence of one remaining fragment). Pieces of velvet making up bodice supported on cotton. An extra hooped petticoat was included to help support red silk one during display. The original figure, corset and drawers underwent minimal cleaning and conservation for display purposes with the canvas holding the stuffing in place reinforced beneath the corset. All work carried out in the theatrical spirit of the eighteenth-century creators.

 SBL

XX. WILLIAM PITT, EARL OF CHATHAM

In the eighteenth century St Paul's Cathedral was increasingly to rival Westminster Abbey as the burial place for British heroes, but despite the entreaties of the City of London, on the death of William Pitt, Earl of Chatham, Parliament decided that he should be buried in the Abbey so that he could rest 'near to the dust of kings'. He was accordingly buried in the centre of the north transept of the Abbey.[1]

The effigy (Plate XX) was modelled by Mrs Patience Wright (née Lovell, 1725–86), the first American wax modeller of any significance, who worked on both portrait profiles in wax and full-scale figures. She arrived in England in 1772, 'to make figures in wax of Lord Chatham, Lord Lyttelton and Mrs Macaulay' according to Horace Walpole.[2] Mrs Wright had come to England determined to repeat her great success in 1771 when she and her sister Rachel Wells held a very successful exhibition of life-sized wax figures in New York (the waxwork was later moved to Philadelphia and Bordentown, New Jersey).[3] None of her American figures apparently survives.[4] In England she quickly repeated her American success.[5] The importance of her patrons, who included the royal family, together with her 'incessant volubility', masked the fact that she was, apparently, working as a spy for Franklin;[6] and according to Rachel Wells's own account, letters were ingeniously enclosed in the duplicate wax heads which Mrs Wright sent to her sister for exhibition in America.[7] A more recent commentator, however, has queried the significance of her communications, claiming that 'the vague apocalyptic chaffering of her letters implies a call to command rather than accurate and intelligent service'.[8]

The effigy of Chatham was taken from the life, and was finished by November 1775, when it was seen in her studio.[9] A notebook once in the possession of Richard Clark (lay vicar 1828–52), contains a great deal of information about the making of Lord Chatham's effigy.[10] On Saturday 5 September 1778 a meeting of the Gentlemen of the Choir of Westminster was held at which it was agreed to appoint a committee of four to negotiate with Patience Wright about commissioning an effigy of the Earl of Chatham. The following thursday, this committee met Mrs Wright at the Abbey and showed her the existing figures, explaining what they required from her: she agreed to provide a wax bust and hands for 20 guineas,[11] of which ten were paid to her in advance. On Saturday 12 September, Mrs Wright again met the committee; they agreed to

1 See above, 17.
2 P. Toynbee (ed.), *The Letters of Horace Walpole* viii (Oxford 1904), 237. For the date of her departure from America see C.C. Sellers, *Benjamin Franklin in Portraiture* (Yale 1962), 87.
3 E.J. Pyke, *A Biographical Dictionary of Wax Modellers* (Oxford 1973), 158–9.
4 T and N, 195.
5 *London Chronicle* 4–7 July 1772, quoted by Sellers, *Franklin*, 88.
6 Cf. Wesley's Journal, 24 January 1774: 'I am desired by Mrs Wright of New York to let her take my effigy in waxworks'. *London Magazine* (1775), 555–6; E.S. Bolton in *Antiques* October 1931, 207; W.B. Willcox (ed.), *The Papers of Benjamin Franklin* (Yale 1975), vol. 19, 93; for her letters to him see vol. 23,

445–50, vol. 24, 43–5, vol. 25, 149–51, 340–1, and vol. 26, 190–2.
7 Sellers, *Franklin*, 426–8. C.C. Sellers, *Patience Wright* (Middletown, Conn., 1976), 247 n.20.
8 In his later work Sellers argues that the wax heads with messages for Congress inside had ceased to come after open hostilities began (p. 120).
9 *London Magazine*, 555. See now P.M. Macek, 'The discoveries of the Westminster Retable', *Archaeologia* 109 (1991), 103.
10 WAM 60000 (to which I was led by Dr Macek's important paper).
11 Mrs Wright's receipt for the advance is on the rear inside cover of this MS (after fo 33r the MS has to be turned upside down and read

place the figure in Edward the Confessor's Chapel and spoke to Mr Blower about a case to fix it in. After the intervention of the Bishop of Rochester (Dean Thomas), the location for the effigy was instead fixed for Abbot Islip's chapel and Mr Shakespeare was selected as the carpenter who would provide the case in which the effigy would be exhibited.[12] Accordingly, Shakespeare met Mrs Wright and the committee on 15th September and took directions for fitting up the Press in Islip's Chapel. On the 17th, Mr Catling (a verger and member of the committee of four) applied to Mr Marsalt[13] about painting the inside of the Press (as a result of which, as Dr Macek relates, severe damage was done to the Westminster Retable, which was then functioning as the top of the Press). On the same day, a Mr Stone was consulted about a Robe for the figure, and on the 18th, Mrs Wright and Catling met Stone to consult further about the Parliamentary robe for the effigy. The following day, Stone met the committee at Mrs Wright's, with a pattern of lace (this is for the braid with yellow silk warps which give a pattern of flowers and foliage against the metal ground, found in three horizontal bands on the right and left sides and on the front opening, as described by Janet Arnold), at which meeting it was agreed that Mr Stone should make the Robe, which he said would come to about £10 (it eventually cost 10 guineas, as will appear below). Mrs Wright informed the committee that the case would require a curtain of Velvet or silk, and it was agreed that green silk should be provided.

By Friday 25th September, the figure and the robe were finished, but the curtain was only fixed in place, after a shortage of material had been remedied, by Miss Phoebe Wright (Patience Wright's daughter), on Monday 28th. She was given a present of two guineas by the committee for assisting her mother with her work on the effigy and for her assistance in putting up the figure. On the evening of the 18th, several of the ushers and king's scholars viewed the figure and it was shown to the public from the following day. Finance for the figure was provided by applying 'tomb money' (fees for showing the monuments) to the bills, and an advertisement was drafted to announce the appearance of the figure in the newspapers.[14]

One very interesting point highlighted by the documents is that the parliamentary robe – costing 10 guineas – was actually commissioned and completed in the space of a few days – 17th to 25th September. The accounts confirm Janet Arnold's argument below that the robe is eighteenth century. In her analysis of the garment, she discusses whether it was originally Pitt's or whether it was specially provided for the figure: the documents prove that her latter conjecture was correct.[15] The other clothes, shoes and buckles are also mentioned in the accounts for the expenses of the effigy on fo 33v of WAM 60000, as detailed below:

from the rear cover inwards). It reads 'Rec'ved ten guineas of the Revd Doct Baily for a Busto of the late Ld Chatham which Mrs Wright has Promesd to Execute with a honest heart acording (sic) to the full Intent and Meening (sic) as soon as Possable (sic). As Witness, My hand Sept 10th 1778, Patience Wright. At the Broad sanctuary Westminster after atending a Committe of gentelmen on the above occasion'. The remainder of the sum was paid on 28 September to Phoebe Wright (fo 34r). This can be compared with the £13 4s 3d paid for the head and hands of Queen Anne in the early eighteenth century: WAM 60000, fo 29v.

12 Macek, 103, suggests that the bishop's frugality was the cause of the change of plan, but it seems more likely to me that he objected to the proposed location of the effigy: all the other effigies, with the exception of that of Edmund, Duke of Buckingham (which was in the Confessor's chapel, according to Dr Mortimer, above, p. 24), were located either in Henry VII's chapel or Islip's chapel at this date.

13 Identified as Morris Marsalt, by Macek, 103.

14 The *Public Advertiser* duly produced an advertisement about the effigy on 15 May 1779 (according to a note opposite p. 196 in the Abbey's annotated copy of Tanner and Nevinson's paper, from the Tanner bequest).

15 See below, pp. 172–5.

1778 Monies Paid

September 10th	to Mrs Wright	£10 10s 0d
	Mrs Maberley	£ 0 2s 9d
15th	to Clarke and Hunt for moving the Figures and cleaning the Press	
		£ 0 2s 0d
16th	to the Carpenters	£ 0 0s 6d
17th	to the Carpenters	£ 0 0s 3½d
19th	for some Velvet for Sleeves &c	£ 0 15s 0d
21st	Carpenters	£ 0 0s 7d
23rd	Carpenters	£ 0 0s 7d
24th	Carpenters	£ 0 0s 10½d
25th	Carpenters at the finishing the Work	£ 3 1s 0d
26th	A Man to sweep out the Place &	£ 0 1s 0d
	Paste Board	£ 0 0s 5d
	Packthread	£ 0 0s 3d
	Brown Paper	£ 0 0s 3d
	Brandy and Chocolate for Mrs Wright	£ 0 1s 0d
	at Mrs Mableys (*sic*)	£ 0 6s 5d
28th	Boucher the Mercers Bill	£ 0 16s 3d
	Cards	£ 0 0s 6d
	To the Men who put up the Glass Frame	£ 0 1s 0d
	Miss Wright	£10 10s 0d
	A Compliment to Miss Wright	£ 2 2s 0d
	at Mrs Mableys	£ 0 0s 6d
29th	Mr Thorne for the Ruffles, Shoes and stockings	£ 0 18s 6d
30th	Mr Willans Bill for Silk	£ 1 13s 8d
	Mr Legge for a Padlock and two keys	£ 0 1s 5d
Octr 31st	A pair of Gilt Buckles & an India Mott (*sic*)	£ 0 12s 6d
Novr 24th	Smith's Bill	£ 0 16s 0d

The structure of Chatham's figure was provided by carpenters in the employment of the committee at a cost, apparently, of £3 10s 0d. The total cost of the figure recorded above – £29 17s 3d – was increased by the payment of 10 guineas to Mr Stone for the robe, £7 13s 0d to Mr Shakespeare for fitting up the Case, £2 16s 0d to Mr Loton for glazing it, and £1 2s 6d to Mr Marsalt for Painting.[16] The final cost of the effigy was therefore reckoned at £51 18s 9d.

In 1992–3 the effigy of Chatham was conserved in the workshop of the textile conservator Sheila Landi.[17] Astonishing revelations about the carpentry work for the effigy emerged during the conservation of the effigy's clothing, revelations which help explain why the woodwork cost so little. When the figure's clothing was removed for conservation, it was discovered that the torso had been built up using card, cut and roughly shaped before being nailed onto the effigy: further pieces of card had been tacked over the shoulders. When the card was removed, a flat piece of board was discovered, nailed across the front of the torso and covering a hollowed out section. The torso had been cut horizontally at the base of the spine and divided from the lower half with a block of newer wood inserted to increase the height, resulting, as Sheila Landi notes, 'in very ungainly proportions'. 'The head, once integral, [had] been cut away to make room for

16 WAM 60000, fo 33r.
17 Unfortunately I did not have access to this figure during its conservation. Sheila Landi has kindly allowed me to quote from her conservation report. I am indebted to her and to Janet Arnold for their comments on this entry.

William [Pitt's] head of wax. The arms were attached to the shoulders with hand-cut screws, with a triangular block of new wood inserted to change the angle of the upper arm. The lower arms were both of new wood, turned rather than carved, joined with a tongue and groove joint pinned through with dowelling, so that it partially swivelled.' The right leg had been cut off and attached with two metal plates. At the top of the right leg, a new piece of wood had been set in, and the repair covered with nailed down card. The feet were cut off just above the instep. The figure was supported on a metal bracket, screwed to the floor on a cross piece, inserted into a hole drilled between the legs. In sum, it is clear from Sheila Landi's examination of the effigy that it was a reused figure, with additions and extensions to fit it for its new role, and with Mrs Wright's wax portrait head of Pitt and hands added on. The description of the original head as integral suggests that the effigy must have dated from the sixteenth, or, more probably, the seventeenth century, and forms a counterpart to the reuse of parts of Elizabeth I's effigy described above.

As it was completed, the figure of William Pitt is 5ft 11ins tall, and represents him standing in his parliamentary robes, and holding a scroll of paper in his right hand. The face is apparently modelled with remarkable accuracy. Tanner and Nevinson were able to place the wax head side by side with a death-mask of Chatham: 'the resemblance was most striking and convincing'.[18] The effigy was put on display in the Abbey on 29 September 1778.[19] Such was the public interest in seeing the effigy and the tomb, that it was possible to recoup the outlay on the effigy by doubling the fee for showing the effigies from 3d to 6d.[20] PL

DESCRIPTION

The head of wax is attached to the shoulders by cardboard strips. The trunk, of wood, has been made up from a smaller, presumably older, one cut through at the hips with a block of wood inserted to increase the height by approximately 11in. The shoulders are pieced out with cardboard, and the forearms, since 1933, made of wood. The left leg is in one with the trunk, the right leg has been cut and turned outwards, and the thigh made with small pieces of wood held by string. The body is supported at the back by an iron which fastens to a wing screw in a cavity in the trunk. The hands are of wax. veined and tinted by coloured underslips, and with hairs on the surface. RM, based on T and N, and SBL

1. PARLIAMENTARY ROBE

Bright red wool broadcloth 58in wide, trimmed with white fur identified by Tanner and Nevinson as rabbit (it should be miniver, the white bellies of squirrel skins), and gilt lace (braid) with yellow silk warps which give a pattern of flowers and foliage against the metal ground. The wefts are of gilt metal strip wrapped round a yellow silk core. The original gold may still be seen at the top of the front strips: the rest is discoloured. The robe is cut in two panels flaring out from the shoulders, and is slit at the centre back to fit the effigy. The front panel measures 56in from neck to hem, and is slit open at the top for 20½in on the fold line from the cloth manufacture, which is still visible below. This opening is bordered with 3in wide gilt lace (braid) pleated at the bottom to fit the shape. White fur is stitched inside, approximately ½in being revealed round the edge. The lower edge of the front panel is curved up 30in on the left side to the side seam, for the arm to emerge. This curve is then shaped sharply

18 T and N, 196 n3.
19 Stanley, 324–5, quoting a guide book of 1783. Cf. J. Kerslake, *Early Georgian Portraits* (London 1977), 49.
20 Stanley, 325. Macek, 103.

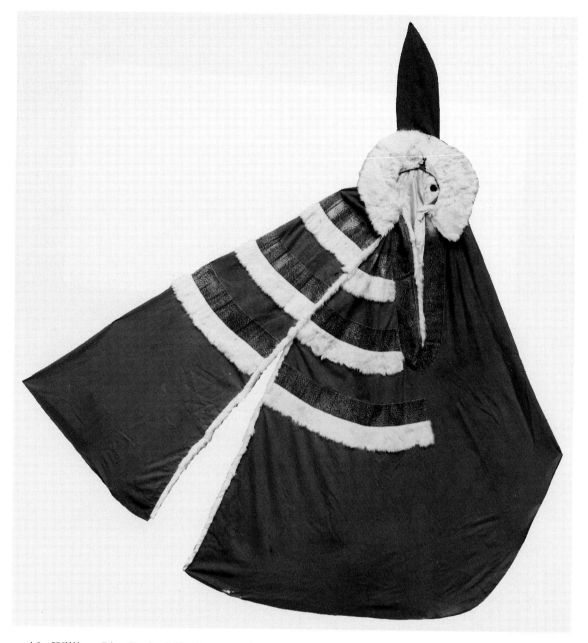

46. William Pitt, Earl of Chatham: parliamentary robe (catalogue no. 1)

down towards the back. The centre back measures 63¾in in length and is slit on the straight grain, rather unevenly, from the hem upwards for 57¾in. A small wedge formed from these panels curving above and below is stitched, from the bottom upwards, for 11in on the left side only, and trails out forming a small train. These pieces would seem to be part of a curving shape cut from the hem of the robe and then stitched on in this way when the effigy was originally dressed.

The robe is open on the right side from 5in below the neckline down to the hem. The full length of the opening measures 53½in. Both sides are bordered with white fur, ½in showing on the right side. Three bands of gilt metal lace (braid) matching that on the front opening, with a band of white fur 3in deep beneath each one, are arranged horizontally on the right side of the robe, on each side of the opening. The upper two bands reach to the metal braid at the front, and the third to the centre front fold below. All three bands meet the centre back slit.

On the left side seam, 3in down from the neckline, an eyelet hole ⅞in in diameter is worked in red silk, in buttonhole stitch. This is for cord and ribbon to loop up the fullness of cloth over the arm. The wide neckline is gathered up with brown linen thread to approximately 16in, to fit the flat collar of red cloth covered with white fur, leaving the braid-covered fronts to lie flat. At the back of the neck, stitched in with the collar, is a pennon-shaped hood, in the form of a small curved bag 6½in wide, with the length of the straight joined edge measuring 19in. The hood is flattened down, join on top of join, the curved seam wrinkling underneath, the vestigial tippet of a medieval hood, now termed a hood, but no longer to be worn on the head.

The robe is partially lined with ivory sarcenet, a lightweight silk taffeta, 19in wide. Straight strips are placed on each side of the long right side opening, on the left side of the back beside the slit, on the lower edge of the left front, and on the edge of the wedge-shaped piece stitched at the lower edge of the back slit. The lining is stitched with white silk running stitches where it is joined, and with red silk running stitches where it is attached to the wool. The raw edges of the silk are turned under, and the selvedges are left flat. This lining would appear to have been put in when the robe was mounted on the effigy in 1775. The front neck fastens with white ribbon ties.

It seems that some distinctive official dress in the form of a robe or mantle with an ermine cape for the peerage originated some time during the late fifteenth century. During the sixteenth century, for some classes of peers there is evidence for two sets of robes: the 'investiture' or 'coronation' robe, or the robe of estate, and the parliamentary robe.[21] By the seventeenth century both sets of peers' robes were very much as they appear today: parliamentary robes consisted of mantle, kirtle and hood. The full mantle was open from the shoulder on the right side, with a short slit at the front of the neck. From centre front to centre back of the mantle, across the right side and shoulder, were placed miniver guards each consisting of a strip of gold lace (braid) with white fur beneath. Indications of rank were given by the number of guards: for a duke, four rows; for a marquess, three and a half rows; for an earl, three rows; for a viscount, two and a half rows; for a baron, two rows. These distinctions are the same today. Robes might be passed from father to son, and extra guards were added if an earl was created duke.[22]

Pitt's robe certainly dates from the eighteenth century. If originally worn by Pitt it would seem to date from August 1766, when he was created earl of Chatham. The roughly cut slit at the centre back, enabling it to be mounted on the effigy, required further investigation for an explanation. A pattern taken of the robe shows that it is very narrow in comparison with two others surviving from the mid-eighteenth century. The parliamentary robe nearest to it in shape is that worn by William Henry Cavendish Bentinck, third Duke of Portland K.G. (1738–1809), which presumably dates from 1762 when he succeeded to the title.[23] This has a wedge-shaped panel 33in wide at the hem, narrowing to 1in at the top, inserted at the centre back. Perhaps a panel of

21 Alan Mansfield, *Ceremonial Costume* (London 1980), 3.
22 Ibid., 5.
23 The Costume Museum, Nottingham, Portland Collection, no. 1.

this shape should have been stitched into the slit at the back of Pitt's robe. Pitt's robe may have been made specially for the effigy, and the panel not inserted into the back for reasons of economy. Alternatively Pitt may have preferred a narrower cut of robe and it had to be slit at the back to enable it to be mounted on the effigy. Whatever the reason for the shape of the robe, the little train piece was probably added to make it appear more full at the hem when viewed from the front.

JA

2. WAISTCOAT

Dark purple silk velvet restored to its original shape in 1992. This garment was described by Tanner and Nevinson as 'COAT . . . Fragments of purple silk velvet (from a waistcoat) in very poor condition. Two sleeves with false turnback cuff made for the effigy, and both fronts and neck-piece of a waistcoat from which the galloon has been stripped and the whole cut out and mounted on brown paper (on which is written in ink the name of Miss Wright). There are wide shaped pocket flaps, all buttonholes are cut, and four velvet-covered buttons remain near the top. The front of the waistcoat is slightly curved and may date from about 1760–70. The fragments were remounted on casement-cloth in the recent cleaning.'

In 1992 the sleeves of this 'coat', which had been cut out of both fronts and back of the waistcoat, were restored to their original position by Sheila Landi. The measurement of the centre front, neck to waist, which is cut off the grain and curves slightly, is 24½in, and the front skirts are 9in from waist to hem. The centre back measures 19in from neck to waist, and there are traces of a hem at the bottom. The sloping shoulder seam is 4½in long and the chest measures 45in. The velvet-covered buttons on the right front are 1in in diameter, and thirteen buttonholes on the left front are 1⅝in long, worked in aubergine silk thread, ⅜in in from the edge. The collar is a straight strip of velvet ½in deep at the centre front, narrowing to ¼in at sides and back, turned over the edge and clipped to make it lie flat. At one time there was some trimming, silver or gold metal lace, braid or galloon, ¾in wide round the edge of the waistcoat, over the collar and bordering the pocket flaps; holes remain from two lines of stitching. A strip of black canvas 2¼in wide, is placed behind the velvet on the left front, beneath the buttonholes, and there is a similar strip 1¼in wide on the right front, beneath the buttons. A strip of white twill weave woollen cloth is placed over the former and a strip of coarse beige canvas over the latter, for extra support. Another strip of coarse beige canvas 2½in wide is placed behind the pocket area, where the cut is made.

The pattern shape of the waistcoat is similar to surviving examples dating from around 1760–70.[24] However, the back finishes at waist level; it should continue to almost the same level as the front skirts, without a waist seam, unless another type of fabric was used for the back skirts, and this has been removed at some time. It is not clear if the waistcoat originally belonged to William Pitt, nor why the sleeves were cut out of it and all the pieces attached to a brown paper foundation, as described by Tanner and Nevinson. It is possible that this was simply an economical way of using up an old waistcoat, as very little would have shown beneath the parliamentary robes.

JA

3. TWO WAISTCOAT SLEEVES

Length 15in. Green figured woollen material (Calimanco) with attached cuffs of green watered silk. No buttons. The type is that in vogue before 1750.

T and N

4. STOCKINGS

Length 26in; foot 11½in. White silk, machine knitted. Of the usual cut, the legs, heels and upper part of the feet made in one piece, the sole of the foot and two gores running up the ankles made

[24] Also the diagrams in Panckouke's *Encyclopédie*, printed 1787, illustrated in Norah Waugh, *The Cut of Men's Clothes* (London 1964), 96.

separately and sewn in. Small figured clocks; on the turn-over (for a draw-string?) at top is the mark in blue cross-stitch 'P.12'.

<div align="right">T and N</div>

5. SHIRT (part)

Neck 15¼in, collar 3⅜in deep, front 13in. Linen. Standing collar with three thread-covered, metal-rimmed buttons. The front is open (a strip of bobbin lace attached by pins) and the lower edge hemmed in front but cut away at back. There are no sleeves. A mark 'E.Y.6' in blue cross-stitch on front seam of the neck may have been in the linen before it was made up as a collar band.

<div align="right">T and N</div>

The lace on the shirt is bobbin-made. It is rather coarse and with a simple pattern and was possibly made in the English Midland Counties. Pitt is more likely to have worn fine French needle lace; this seems much too coarse and simple.

<div align="right">SL</div>

6. SLEEVE RUFFLES

Length 8in. Bobbin lace, with narrow cotton band and holes for links or ties.

<div align="right">T and N</div>

7. SHOES

Pair of black pebble grain leather buckle shoes.

Toe wide round.

Heel 1⅛in leather covered, white stitched at seat and top piece. 3in long.

Sole is of substantial leather, also white stitched, quite finely at about 16 stitches to 1in. It continues through a rightangle and down the heel breast, with a row of stitches across the waist in the rightangle. Made straights. It appears to have been worn outdoors. Over the nail holes, used for attaching sole to last before stitching, there are circular stamps of a cross with hatching round the edge, one off centre at the toe, with 2 well down on the waist. The construction is welted, with the sole stitches set in a channel. There is dark edge finish all round, with traces of wheeling over the channel at the waist, with light finish between. 4in wide across the tread; length 11½in, the same as the stockings (stocking size given by Tanner and Nevinson).

Upper consists of vamp and pair of quarters, joined with dog-leg side seam, closed, not bound. The side seam starts at the heel breast, making short quarters, more typical of the earlier part of the eighteenth century, as fashionable in the wearer's youth. The vamp is high cut, ending in a rounded throat, and has a crease down the centre front, indicating that it was folded during cutting, as shown in the first English textbook on shoemaking, John F. Rees, *The Art and Mystery of a Cordwainer*, published in 1813. The quarters are cut high at the back, with a 3in back seam, and each extends into a blunt pointed overlapping strap to take the buckle fastening. The top edges are bound with black silk, with the quarters bound to just beyond the line of the tongue only, leaving the buckle straps unbound.

<div align="right">JS</div>

Buckles. Silver-gilt with foliated decoration; London maker's mark, TR, probably for Thomas Freeth I.

<div align="right">SB</div>

The buckles are rectangular and pierced with a scrolling design, 1¾in by 2¼in. They are attached by a square-ended 2-spike steel chape, with the two fastening spikes pointing inwards, leaving the strap ends on the outside, to prevent rubbing against the other leg. The design of the buckle is acceptable for a date in the 1770s, though its position high on the instep is old fashioned.

Inside. The binding suggests that the shoe is unlined. There is the distinct impression of quite high (about 1in) side lining in the quarters, which possibly also extends into the vamp, narrowing towards the toe.

The shoe is a practical, sturdy example of its period for a seventy year old man, 5ft 11in

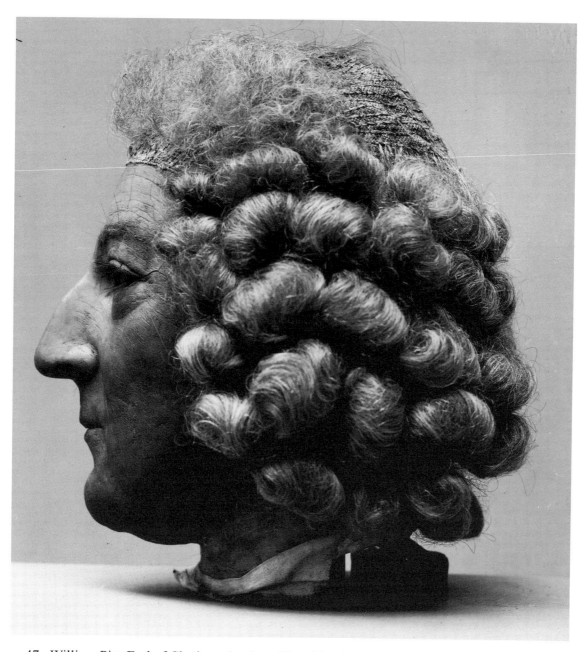

47. William Pitt, Earl of Chatham: head profile with wig (catalogue no. 8)

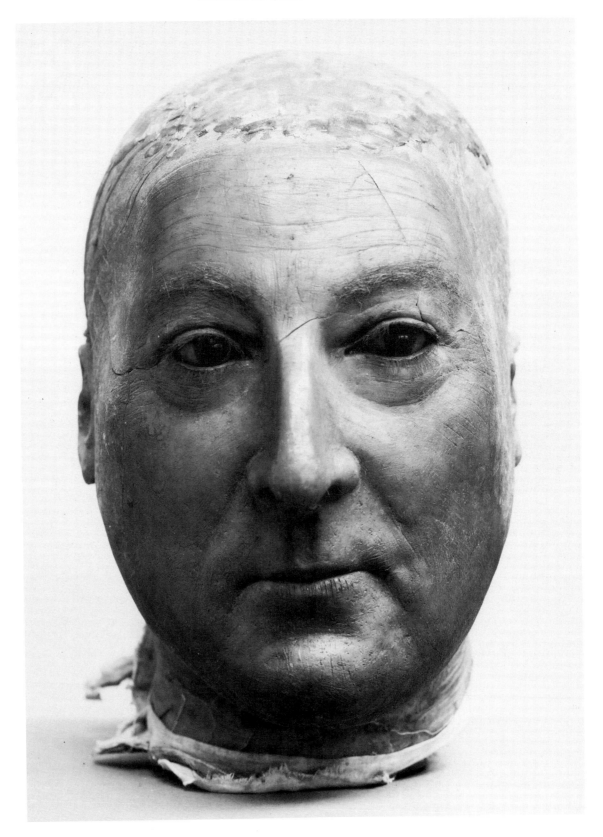

48. William Pitt, Earl of Chatham: head

tall. The dimensions, while appearing large in comparison with other footwear discussed here, look more normal to the modern eye. The dearth of surviving shoes for men from the eighteenth century leaves us with little evidence on the accuracy of the pictorial record. The style of men's buckle shoes varied so little from the 1730s to the eclipse of buckles in the early 1790s that it was possible to continue (as here) wearing out old fashioned styles, provided the buckle accorded with the latest fashion. Somehow the shoes seem in character with the face of the wearer. JS

8. WIG

Length, about 11in. Greyish brown human hair, heavily powdered, moth-eaten, couched on the usual type of net foundation; the edges bound with pink silk. The crown of the head is smooth, there is a small fluffed toupet (damaged) and five rows of rather tight curls at either side. No maker's name.[25] T and N

CONSERVATION HISTORY

1933	Wooden figure: bust made up, shoulders reinforced, forearms replaced. Waistcoat fragments remounted; stockings repaired, understocking added (V and A).
1987	Wax conserved: internal surfaces reinforced and new neck made; old repairs replaced (Plowden and Smith).
1993	Full conservation of figure and costume (Sheila Landi). Wax head and hands removed and replaced by Plowden and Smith. Figure stripped and cardboard padding removed to be cleaned. Iron support bracket repaired and straightened and position of right leg realigned to original position to give greater stability; wood cleaned and protected with layer of cotton. Lace for cuffs and shirt ruff and vestigial shirt washed and new stock band made (original missing). Stockings washed and repaired. Shoes cleaned. Green damask waistcoat sleeves cleaned and attached to new cotton to hold them in place. Velvet waistcoat reconstructed from original fragments and new sleeves and cuffs provided from purple velvet, these attached to same cotton as for green damask rather than to coat itself. A pair of breeches provided (to give a modicum of decency beneath the robe). The parliamentary robe and fur cleaned and the neckline reshaped to make it easier to dress properly. The ribbon tie (washed and mounted on crepeline 1987) replaced.

<div align="right">SBL
RM</div>

25 T and N nos. 5 (pink silk stocking) and 8 (stock band) not found in 1993; the pieces of cloth removed during this conservation are now in the Abbey Museum Reserve Collection.

XXI. HORATIO, VISCOUNT NELSON

The wax figure of Lord Nelson is the final effigy of the long series in the Abbey and this portrait of Britain's greatest naval hero forms a fitting culmination to the whole group. Both the circumstances of its commissioning and the reason why it had no successors deserve some attention.

From the eighteenth century at least, Westminster Abbey had been viewed as the national mausoleum for war heroes, but this standing had been threatened by the decision, taken by Parliament in 1795, to raise monuments to the dead warriors in the as yet undecorated interior of St Paul's Cathedral. The Abbey, by contrast, was full of monuments, a veritable 'warehouse of statuary' as James Gandon commented in the nineteenth century.[1] Lord Hawkesbury, writing to King George III on 10 November 1805, stated that it was this crowding of monuments in the Abbey which was a key reason for the choice of St Paul's for Nelson's tomb and for those of other British heroes.[2] The problem of the sheer number of tombs already in the Abbey was, of course, worsening as new additions were made. Although, in an earlier generation, the suggestion that Lord Chatham should be buried in St Paul's could be resisted in favour of the Abbey,[3] the Parliamentary decision of 1795 ensured that Nelson was buried in St Paul's. He was accordingly laid to rest in the cathedral's crypt, directly under the crossing, on 9 January 1806. There was doubtless ill feeling amongst Westminster Abbey's minor canons and vergers that the money they derived from showing the monuments and effigies in the Abbey was reduced by the lure of Nelson's burial place and funeral-car, which were drawing large crowds, paying a 2d entrance fee, to St Paul's.[4] Accordingly they commissioned, as a counter-attraction, a wax effigy of Nelson in the spring of 1806; it was originally placed in a glass case against the west wall of St Andrew's Chapel, with Nelson's famous words at the battle of St Vincent, 'Victory or Westminster Abbey' somewhat ironically inscribed on the front of the case in gold letters.[5]

The effigy was modelled by Catherine Andras (1775–1860), a well known wax modeller, who had exhibited wax portraits at the Royal Academy from 1799, her first one being that of the miniaturist Robert Bowyer, her adoptive father.[6] In 1802 she had been appointed 'modeller in wax to Queen Charlotte', and in the same year was awarded the 'Larger Silver Pallet' by the Society for the Encouragement of Arts, Manufactures and Commerce for models in wax of Princess Charlotte and Lord Nelson.[7] It might seem from this that she was the obvious choice to execute the wax effigy of Lord Nelson for Westminster Abbey, but all the rest of her extant portraits, including some of Nelson, are small-scale profile reliefs: Nelson had perhaps given sittings to Miss Andras for just such a profile in wax in 1800.[8]

1 J. Gandon and T. Mulvany, *The Life of J. Gandon . . . with original notices of contemporary artists and fragments of essays* (Dublin 1846), 178–9, quoted in A. Yarrington, *The Commemoration of the Hero 1800–1864: Monuments to the British Victors of the Napoleonic Wars* (New York and London 1988), 62.

2 Ibid., 79–80.

3 See above, 131.

4 Not to the tomb, *pace* Tanner, 197: this was only set up in 1808. Walpole, *Anecdotes of Painting*, 566.

5 Stanley, 325 n3. Dean Stanley acidly observes that this is a counterpart to the rivalries over relics between Westminster Abbey and St Paul's in the middle ages.

6 E.J. Pyke, *A Biographical Dictionary of Wax Modellers* (Oxford 1973), 5.

7 Ibid.

8 R Walker, *Regency Portraits* (London 1985) i, 358–67 for portraits of Lord Nelson; W.T. Whitley, *Art in England, 1800–1820* (Cambridge 1928), 99, for a second figure of Nelson exhibited in Pall Mall and dressed in one of the

The notebook in the Abbey Library which provided details about Pitt's figure also contains information about that of Admiral Nelson.[9] Pasted in on fol. 31 verso is a receipt from Catherine Andras dated 7 March 1806, for £84 14s 9d 'which with twenty Pounds before received is in full of all demands respecting the wax figure of the late Admiral Viscount Nelson placed in the said Church with the Dress, Ornaments, Painting the case, and finishing the same'. Thus the total fee paid for this effigy to Miss Andras was £104 14s 9d.[10] This receipt implies that – contrary to the position with Chatham's figure – responsibility for supplying Nelson's effigy, with its dress and ornaments and the painting of the display case, was the responsibility of Miss Andras, who will doubtless have subcontracted some elements of her work. Janet Arnold's suggestion that the vice-admiral's coat was 'made specifically for display purposes' can therefore be confirmed, though it is clear that other items of clothing had actually been owned by Nelson, who had sat to Miss Andras a few years before his death.[11]

Sheila Landi conserved the Nelson effigy and its clothing, in 1992–3.[12] She describes the figure as follows: 'carved figure of a man, in wood, possibly Columbian (?) pine, very red in colour. The blocks from which the arm, legs and trunk are carved are made up from planks, about 5cm thick, glued together before carving. The head rests on a spike 17cm long. The hand attaches to the arm with a linen strap behind which a tongue is left to slot into a groove in the wooden "stone boulder" against which the figure rests. The legs and arm are carved separately and joined to the trunk with large screws with round heads. The carving is vigorous and straight-forward, the surface left rough in most places.' The carpenters, then, used a laminated structure for the figure (a technique which had been employed for the head and bust of Elizabeth of York as early as 1503) and were evidently quite skilled sculptors of the human form. The greater cost of this effigy than that of Pitt may be partially explained by the fact that the effigy itself was not a reused earlier effigy but a specially produced figure of good quality.

Another Westminster manuscript, WAM 59997 (3), (which postdates the 1836 removal of all the remaining effigies into the Islip chapel) shows the layout of the display cases in Upper Islip, where it is clear that Nelson was by then placed between Queen Elizabeth (this effigy, a replacement of that made in 1603, cost £56 2s 3d in 1760[13]) and Charles II.[14] The Earl of Chatham's effigy flanked a closed case containing 'the ragged regiment' (early royal effigies), the other side being occupied by Queen Anne's effigy.

The wax figure has always had a great reputation for authentically portraying Nelson. It was described in *The Times* of 22 March 1806 as 'a very striking resemblance to the late Lord Nelson . . . modelled from a smaller one for which his Lordship sat. It has been seen by an illustrious

admiral's own uniforms; it was also modelled by Andras. See also A. Earland, *John Opie and his Circle* (London 1911), 69–70; cf. letter from Charlotte B. Wolstencroft in the *Times*, 10 June 1935, quoting MS family reminiscences of Robert Bowyer and Miss Andras which state 'On the death of Lord Nelson, who had previously sat to her for his model (at the same time when Mr Bowyer was painting his miniature), she was requested to furnish a full-length figure for Westminster Abbey, for the robing of which his family furnished a suit of his own clothes'. Wolstencroft continues, 'We have in our family several wax models done by Miss Andras, one of which is believed to be that of Lord Nelson'. There is a small wax profile of Nelson by Miss Andras at Greenwich and there are others in private hands.

9 WAM 6000.
10 On the other hand, a note on WAM 60016 (iv) implies that the total cost was £245 6s 8d.
11 See below pp. 182–4.
12 Conservation report of work 1990–1. I am indebted to Sheila Landi for permission to quote this section of her report and for her comments on this entry.
13 The man who adapted and added to the original effigy is not known, but a bill from the carpenters for making the case, and altering those of the ragged regiment and Queen Anne, paid on 24 July 1760, reveals that the figure maker was based in Fleet Street: WAM 48065 A.
14 For the 1836 removal, see Mortimer, above, p. 26. For Elizabeth's effigy, see above p. 157.

personage, and several of the Nobility and Gentry, and is considered by them to be a strong and exact representation of the features and person of our departed hero.'[15] Nelson's nephew said that the figure was more like Nelson than any portrait, whilst Lady Hamilton declared that 'the likeness would be perfect if a certain lock of hair was disposed in the way his lordship always wore it.' She was allowed to make the alteration.[16] However, one apparent mistake in the effigy is the rendering of his blind eye as his left instead of his right one.[17] For the pose and general disposition of the 5ft 5½in. tall figure, which stands against a painted rock background of wood, the left hand and right foot resting on ledges, Andras depended very heavily on Hoppner's full-length portrait, commissioned in 1800, as Professor Geoffrey Callender first noted: Hoppner's portrait was engraved in mezzotint by Charles Turner and this was the version used by the wax modeller.[18] Andras was personally responsible only for the head and left hand, which are of wax: the body of the figure, apparently rather skilfully carved, is made of wood.[19]

Despite the success of Nelson's figure, it was the last to be made for the Abbey. During the eighteenth century, criticism of the practice of exhibiting such effigies in Westminster Abbey grew more vociferous, perhaps most forcibly expressed by Joseph Nollekens, as J.T. Smith recounts in his scabrous biography of the sculptor.[20] Nollekens enquired, in a conversation with John Catling, a verger, what had happened to the early effigies, the 'ragged regiment'. Catling replied that they had all been taken out for John Carter, the noted antiquarian, and the young J.T. Smith to draw: 'They are put up in those very narrow closets, between our wax figures of Queen Elizabeth and Lord Chatham in his robes, in Bishop [sic] Islip's chapel . . .' Nollekens retorted: 'I wonder you keep such stuff . . . I don't mind going to Mrs Salmon's wax-work, in Fleet Street, where Mother Shipton gives you a kick as you're going out [but] Oh dear! you should not have such rubbish in the Abbey.' Whether Nollekens was here referring to all the effigies, as seems most likely, or solely to the later ones, is less important than the context his remark establishes. Mrs Salmon's exhibition of waxworks had originally been located at the Golden Salmon, St Martin's, near Aldersgate, where it was a popular attraction in the early eighteenth century. It subsequently moved to Fleet Street and on Mary Salmon's death in 1740 the collection was purchased by a surgeon, whose widow continued to exhibit the effigies until 1785.[21] The popularity of large exhibitions of wax figures (Mrs Salmon showed 140 of them) inevitably affected the attitude towards the Westminster effigies. Criticism could come from a variety of different viewpoints, but the most serious objection was expressed by Nollekens. With the commissioning of Lord Nelson's effigy, which had, for the first time, no connection whatsoever with his burial place, the association at Westminster between effigy and tomb was decisively broken. Inevitably, this affected the attitude to the existing effigies. Many commentators thought it inappropriate that the Abbey should house effigies which were more readily associated in the public mind with popular amusements, such as Mrs Salmon's waxworks. Public taste and expectations of the Abbey, too, had become more sophisticated. Such objections inevitably had their effect, and the effigies were gradually removed from view.[22] Henceforth, until the 1930s, the wax effigy, the descendant of the royal funeral effigy, was to be entirely divorced from its original function, and to be found in waxworks such as Madame Tussaud's rather than in Westminster Abbey.

PL

15 *The Times*, 22 March 1806.
16 Quoted in T and N, 198.
17 Ibid. *The Times*, 4 June 1935, 17–18.
18 Walker, *Regency Portraits*, 366.
19 T and N, 199.

20 J.T. Smith, *Nollekens and His Times* (London 1949), 86.
21 Pyke, 126.
22 See above, 27–8.

DESCRIPTION

The head and left hand are of wax, the body of wood, carved with some skill. Two fingers broken and partly restored. The figure (height, 5ft 5½in) stands against a painted rock backgound of wood, the hand and right foot resting on ledges.

<div align="right">T and N</div>

1. VICE-ADMIRAL'S COAT

Dark navy blue woollen cloth full dress coat: Tanner and Nevinson point out that this pattern of uniform went out of fashion around 1811. The front curves out over the chest, is cut away below the waist, and meets the back in a low sloping shoulder seam and gently curved side back seam. The back is narrow and the centre back seam is curved slightly to give a closer fit. This seam has been unpicked and left open to ease the coat onto the dummy. The coat fastens edge to edge with two hooks on the right side and two eyes on the left, the top ones 6in down from the centre front neck, and the lower ones 2in below them. Both front and back measure 42in from the base of the neck to the hem, and there is a 3in high standing collar, sloped back on the front edges to avoid overlapping. The chest measures approximately 39in. The hem of the skirts is left raw, as is usual with good quality cloth coats of this period. A 1¼in allowance is made for a simulated pleat in the side back skirts, running down from the side back seam. This pleat is stitched down at the hem. The lapel is 5in wide at the top, curving down to 3in at the waist, 18½in long on the curving front edge. The raw edge of the cloth lapel is stitched down to the coat, and it is bordered all round with 1in wide silver-gilt lace (braid) set back ⅛in from the edge. This lace (braid) continues down the edge of the front skirt, finishing at the hem, set back ⅛in from the raw edge in the same way. The buttonholes on the lapels are formed from ½in wide silver-gilt braid folded rather clumsily at the ends. On the left front there are six at the top, then a gap where two are missing, then one more at the waist. On the right front there are three at the top, then two missing and four below. The missing buttonholes are in the position where the sash passes across the chest. At the end of each buttonhole is a gilt button 1in in diameter, bearing an anchor in a circle and a wreath below, inscribed on the back 'J. & M. Hunter'. On the left front the fourth button down and the bottom button are missing. On the right front the second button up is missing. On both sides of the coat there are large pocket flaps, the raw edges bordered with 1in wide gilt lace (braid) and outlined on the coat with matching braid. The flaps may be lifted, but there are no pocket holes cut beneath them, nor pocket bags. There are three buttonholes made of ½in braid on each flap, matching those on the lapels. On the left flap the centre and side buttons are missing. On the right flap the side button is missing. The collar is a single layer of cloth with raw edges at the top, folded under on both fronts with 1in wide braid all the way round. There is no stiffening in the collar or beneath the lapels, but there is a strip of linen about 2½in wide on the edge of the front skirts from the hem up to about the level of the fifth button up. The collar is lined with white twill weave silk. There is a gilt button ⅝in in diameter, stitched about 4in back from the front, on each side of the collar. The two-piece sleeves are 23in in length. The ends are folded back to form a simulated cuff 4½in deep, bordered at the upper edge with 1in wide silver-gilt braid, ⅛in away from the raw edge, and two horizontal bands of braid ¾in wide beneath. On top of this are three vertical buttonholes made with ½in wide braid with gilt buttons to match those on the front and pockets. On the right sleeve, inside the cuff, there is a knot of dark blue ribbed silk ribbon with pink borders, now faded to pale blue. It is pinned to a piece of black tape, which is pinned inside the cuff. The sleeves and most of the body of the coat are not lined. The skirts of the coat are lined to the level of the top of the pocket with white twill weave silk. This comes to within ⅛in of the raw edge of the hem, and is top-stitched into position all round, covering the pleat in the skirt. There are two worked eyelet holes on each shoulder for attaching epaulettes. The silver-gilt braid is stitched on both edges with white silk thread. The stitches show and the effect is rather clumsy. The braid buttonholes are not folded back

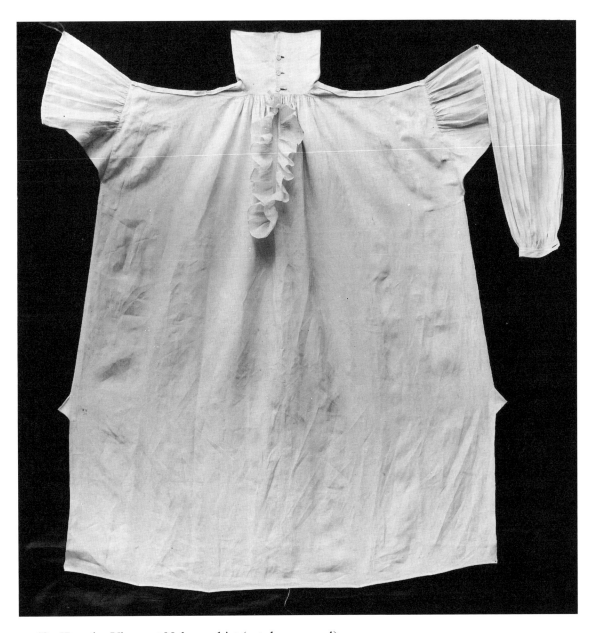

49. Horatio, Viscount Nelson: shirt (catalogue no. 4)

very neatly. The finish of the coat suggests that it may have been made specifically for display purposes.

<div align="right">JA</div>

The epaulettes, 7½in long, 2in wide, are covered with gilt braid, and have two sizes of curled gilt fringe hanging on the shoulder; each has one small and one larger star on the strap; the under pad is covered with yellow silk, and there are two eyelet-holes in the coat for attachment. On the left shoulder is a gold pin to mark the place of the fatal wound (added in 1822).

<div align="right">T and N</div>

2. WAISTCOAT

Ivory, now discoloured, twill weave woollen cloth with a heavily milled surface, described as kerseymere by Tanner and Nevinson. The front curves in to the neckline and is cut away below the waist level. It fastens with twelve gilt buttons, one missing, each with an anchor and wreath on the front and stamped 'B. Bushby in(?) St Martins Lane' on the back. The top of the waistcoat, beneath the buttonholes, is faced with wool and the lower part, from the sixth buttonhole, with cream twill weave silk to match the 2¼in deep lining of the front skirts. The back of the waistcoat is made of cotton with a slightly fluffy surface, and the whole waistcoat is lined with plain cotton which is pilling slightly. The front measures 19in from the base of the neck to the waist, and 2½in below. The back measures 26in. The standing collar is 2½in high at the centre back, sloping down to 2¼in at the front. It is lined with wool and there is no stiffening inside. There is a pocket flap on each side lined with silk and cuts beneath for pocket bags, which are made of heavy cotton. There are two gilt buttons stitched just beneath each flap, but no sign that there was ever a third, and there are no buttonholes. The buttonholes at the front are ⅞in long worked with very small, neat stitches, apparently without gimp, with round ends and small square bars. The centre back join has been undone from hem to shoulder level to get the waistcoat onto the figure. The bottom was originally open for 2¾in. There are two pairs of tapes to tie the back together. Collar, both fronts, pocket flaps and front hems are stitched about 1/16in away from the edge with exquisite, very close stitches giving the appearance of piping. The cotton lining is hemmed close to the edge of the armholes, the stitches passing through to the right side, giving a neatly stitched edge with a similar effect to the collar, front edges and pocket flaps.

<div align="right">JA</div>

3. BREECHES

Ivory, now discoloured, twill weave woollen cloth which matches the waistcoat. Outside leg measurement 26in, inside leg measurement 18in, centre back seam length 16in and front seam length 11in, with a waistband 3½in deep at the front, tapering down to 2⅞in at the centre back. The waist measurement is approximately 32in. The centre back seam has been unpicked to ease the garment onto the figure. The breeches open with a front fall fastened at the top by one small self-covered button ½in in diameter, and two gilt buttons on each side of the front, one plain and one with the anchor pattern matching those on the waistcoat. The front waistband is fastened with three buttons and is faced with white cotton. There are two worked eyelet holes on each side of the back, which may be laced across to tighten the breeches. On the left side there is a ¾in deep welt pocket. The front fall is faced with white glazed linen and there are 1½in wide strips of the same linen doubled behind the buttonholes for the openings on the side seams at the ends of the legs. These are 5in long, with four buttonholes ⅞in long at the front, worked in ivory silk with round ends and small worked bars. A 1in underlap is left on the back, with raw edges, and four gilt buttons with the anchor pattern to match those of the waistcoat. The bottom of the leg is finished with a ⅞in wide band, with a small strap and gilt buckle caught through a ⅞in worked buttonhole. The leg band is faced with white glazed linen.

<div align="right">JA</div>

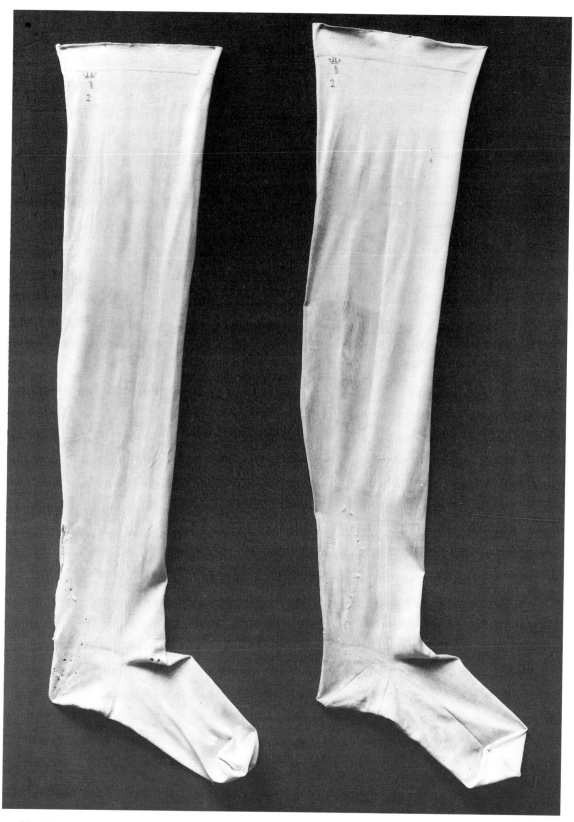

50. Horatio, Viscount Nelson: stockings (catalogue no. 5)

4. SHIRT

Fine white linen, now discoloured, and slightly stained. The thread used for stitching is as fine as that in the weave, so the stitches sink in and are almost invisible. The shirt is made from one continuous length of linen running from the front hem, up over the shoulder, down to the back hem, 38½in in length at the front and 39in at the back. Straight strips of linen 1in wide are back-stitched over the shoulder ⅛in from each edge, as a reinforcement, from sleevehead to collar. There are also strips to reinforce the shoulder lengthways, where the sleeves are joined on. The linen is 34½in wide and the selvedges are oversewn together without seam allowances at the sides. The neckline is slit across for 21in and downwards for 10in at the front. This front opening is neatened with ⅛in hems on both sides. A 2in deep frill of fine cambric with a 1/16in hem round the edge is whipped onto the edge, with the hem lying uppermost when the frill is smoothed back on each side. Small triangular gussets are inserted at each end of the neck slit and then the fullness is gathered up to fit the neckband, which is 15in long and 5in deep. It fastens with three Dorset buttons and worked buttonholes. The left sleeve is a rectangle of linen 24in wide and 21½in long. It is gathered into 9½in over the shoulder in tiny cartridge pleats, very neat and even, and into a 7¼in long wristband. The laundress pressed the fullness into fourteen ½in pleats, with ½in between each one, running down the length of the sleeve. The wristband is ⅝in wide with a ⅝in worked buttonhole at each end for ties. The right sleeve is only 6¼in long, with a drawstring running through a ⅜in wide hem acting as a casing, to pull it in and cover the stump. The right sleeve has an underarm gusset 5¼in by 5½in and the left gusset measures 4¼in square. The side seams are open for 11¾in at the bottom on each side, with small gussets at the top to take the strain. The centre back has been torn open to allow the shirt to be fitted on the effigy. The initials HN, with 24 beneath them, are embroidered in cross stitch with blue silk at the front, level with the gusset in the right side seam. The letters are 3/16in high and ⅛in across; they act as a laundry mark. JA

5. STOCKINGS

Machine knitted white silk, with a shaped seam at the centre back and a seam under the sole of the foot. The long narrow clock is also in white. There is a double welt at the top of the stockings, with a pink stripe along the edge. The stocking measures 30½in at the front and approximately 9in for the length of the foot. The initials HN, with 2 beneath and a coronet above them, are embroidered in blue silk at the top of each stocking, just below the welt. JA

6. SHOES

Pair of black waxed calf shoes with buckles.

Toe shallow, narrow oval, typical of the more practical style of the war years. The toe spring is exaggeratedly high on one, distorted by the angle at which it has been displayed. The other too is high for the period, which may indicate that the shoes were not kept on the last long enough, a tendency which was spreading with the huge quantity of ready-mades available by the late eighteenth century, which would have been accentuated by wartime difficulties when huge quantities of footwear were required for military purposes.

Heel 1 lift, the seat stitching neatly concealed with a crease impression. The top piece is attached by stitching, four to one inch, set in a channel on his right foot (n.b. for convenience, these will henceforward be referred to as right and left, although both are made straights), but standing proud on the left, a sign of bad workmanship as they would quickly be damaged in wear. The breast edge of the right is irregularly cut and much coarser in finish. There are also three wooden pegs in the centre front and two holes in the centre, probably for temporary attaching before stitching. They are stamped with the maker's initials, ID, so far unidentified.

Sole of grain leather, made straights, and unworn. A ring stamp covers the nail hole at toe and just behind the tread, with the initials ID again near the tread stamp. The size 7 above something

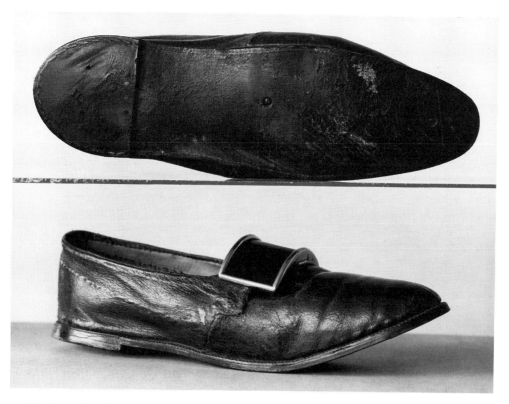

51. Horatio, Viscount Nelson: shoes (catalogue no. 6)

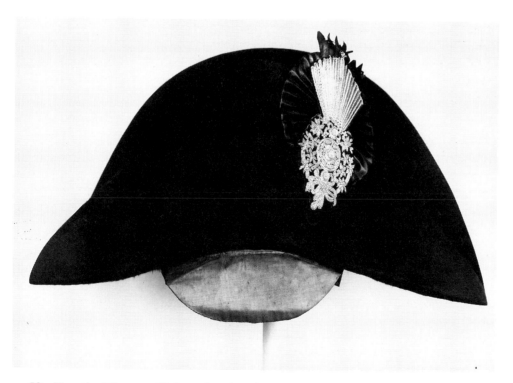

52. Horatio, Viscount Nelson: hat (catalogue no. 7)

illegible is scratched at the toe. The construction is welted, with the upper-welt stitches rather coarse at 3½ to 1in, and the sole stitched in a rather shallow channel at 10 to one inch. Welt and sole protrude rather noticeably about ⅛in beyond the upper. The length is 11in, the size 7 exaggerated by the extended welt and narrow toe, though the internal measurements are more compatible with the 9½in stockings (size given by Tanner and Nevinson). The right has a black stained finish, with the brush marks still visible, while the left has also been black finished with a substance which has crazed.

Uppers consist of vamp and pair of quarters, joined by a short dog-leg side seam starting just behind the tread, giving quite long quarters. The vamp has a crease centre front, like William Pitt's. It is cut square across the throat. The number of black reinforcing stitches, using waxed thread, at the angle on the side seams varies, this time the left being coarser than the right. This suggests that the side seams were closed by one person, and the lining done by another. While the upper sewing was (and still is) normally women's work, the black waxed stitches may be men's. The quarters extend into narrow oval latchets over the tongue, but do not meet, leaving a ¾in gap. On neither shoe is the back seam vertical: the right most noticeably, with one quarter 2¼in deep, the other 2in (on the left shoe both are 2⅛in). A hole is pierced near the top of each back seam where sale pairs were tied together, a common feature of mass-produced footwear. Inside, the edges of the back seam are not so well flattened on the right shoe. The top edges are bound with a narrow strip of black leather attached on the outside, turned and whipstitched inside, giving a piped effect, a new method of the early nineteenth century. The design of the latchets indicates that they were intended to be pierced for a lace, but being unworn, this was not effected.

They are covered with a rectangular plain gilt copper buckle, 1⅝in × 2½in, with a high curve typical of the 1780s–90s, the centres filled in with a black calf leather insert, the edges of which are so sharp as to suggest a replacement of the 1930s conservation. The gilt ends are stamped with the maker's initials TF in a plain rectangle (no pellet), possibly Thomas Freeth I, who registered silver marks in 1787, 1790, 1792 and 1797, when he was at 9, Queen Street, Islington (Northampton Museum has a pair in silver by this maker, hallmarked 1797). They are inadequately attached (because of lack of buckle straps on the shoes) by a spring-hinged steel chape, the type patented 1784, unusually also gilt, with two small sections, one to anchor with two spikes, the other of small H type to fasten. Though the buckle would have been of no great age when the effigy was made, this type would not have fastened on this style of latchet shoe in normal wear. The Hoppner portrait shows wider buckles with a wider and decorated rim.

Inside. The vamp is lined with natural coloured linen, the right insecurely stitched under the binding and now pulled out. The quarters have a long brown kid lower lining, sloping down to the side seams. The left is whipstitched fairly neatly in matching thread, but the right is coarsely stitched in glaring black thread, which has penetrated through the upper in a number of places, crude unacceptable work which would make the shoe a reject.

But the most conspicuous bad work is the insole. The left is joined obliquely across the tread, normally only done in repair work. There is also puckering over the nail hole at the tread, which would have made it very uncomfortable to wear. The right is, if anything, worse with a 3in × ¾in piece missing from the centre forepart, underlain with a replacement which was presumably originally stuck in position, though now it has moved, again making the shoe very uncomfortable.

The variations between the two shoes indicate that they were carelessly selected from a quantity of straights of the same size, cheaply made in a factory, where a number of people were involved in closing the uppers and making the shoes. The low standard of work makes it certain that they did not belong to Lord Nelson; they may be from stock mass-produced by a Navy contractor, though hopefully rejects. The buckles are slightly better quality. JS

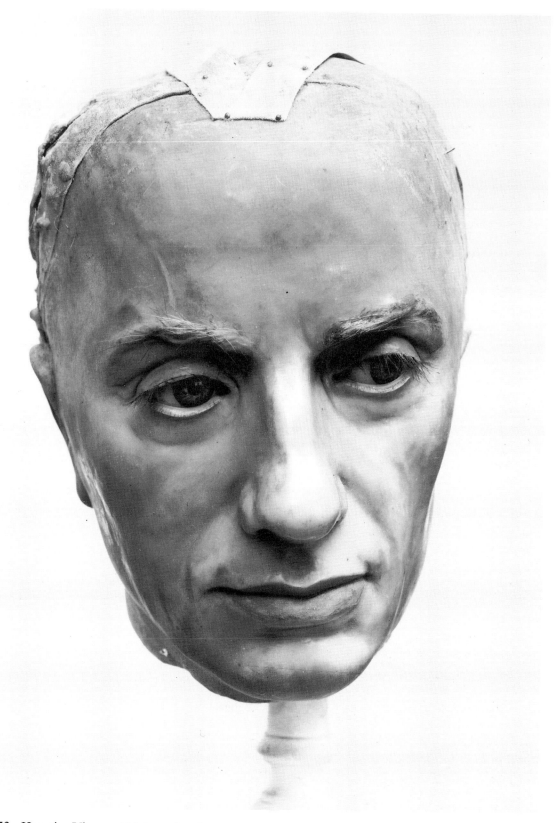

53. Horatio, Viscount Nelson: head

7. COCKED HAT (undress)

Black beaver. Height 9in, width 18in. The rounded crown is hidden by two high flaps at front and at back, held by hooks. On the left is a cockade of sequins, metal thread (not a very successful imitation of the 'chelengk'), with black glazed cloth rays and black silk braid and button below. Hat lined with cotton and leather. Paper label with 'JAMES LOCK HATTER, St James's Street, LONDON'. Stamp in white 'STAMP OFFICE NO 57. HAT DUTY. VALUE ABOVE TWELVE SHILLINGS NOT EXCEEDING EIGHTEEN SHILLINGS. TWO SHILLINGS.' In the centre under the brim is a crescent-shaped green silk shade, length 9in, greatest depth 3in. This is creased and turned in so as not to show where the hat is worn. T and N

8. WIG

Light brown human hair on net foundation; there is a short tight queue behind, bound with black ribbon (length about 9in). No label. The wig has been powdered, but is hardly curled at all. Nelson, though he lived in an age of wigs, did not wear one himself. T and N

9–15. MEDAL, EMBROIDERED STARS AND SASHES

Nelson's effigy wears one medal, four embroidered stars of orders which Nelson had made for each of his uniforms, and the sashes of two of these orders.

9. MEDAL. Battle of the Nile medal, 1798. After the battle of the Nile Nelson's prize agent, Alexander Davison, gave medals to all who had been present at the battle, the first occasion on which medals had been given to everyone. The medal worn by the effigy is one of these.

Nelson was properly entitled to wear two Naval Gold Medals, those for the battles of St Vincent (1797) and the Nile (1798). These were official medals awarded by the king to the Flag-Officers present at the battles. Nelson's were eventually displayed in the Painted Hall at Greenwich, from where they were stolen in 1900.

The blue and white ribbon from which the Davison medal is suspended is that for a Naval Gold Medal of the period.

Stars of Orders
10. STAR OF THE ORDER OF THE BATH. In the centre the badge of the order (three crowns) on a red ground, surrounded by the motto TRIA JUNCTA IN UNO. Nelson was created a Knight of the Bath in 1797 for his part in the battle off Cape St Vincent.

11. STAR OF THE ORDER OF THE CRESCENT. In the centre a silver crescent and star on a blue ground now faded to green. Nelson was awarded the order by the Sultan of Turkey in 1799 as a reward for his victory at the battle of the Nile.

12. STAR OF THE ORDER OF ST FERDINAND AND MERIT. Six bundles of golden rays separated by six Bourbon lilies enclosing the standing figure of St Ferdinand surrounded by the motto FIDEI ET MERITO. Nelson was awarded this order of the Kingdom of the Two Sicilies in 1800.

13. STAR OF THE ORDER OF ST JOACHIM. A star of eight points, in the centre on a white ground a green cross patée surrounded by a laurel wreath and the motto JUNXIT AMICUS AMOR 1755. This obscure order was founded by some German noblemen in 1755, and was awarded to Nelson in 1802 at the instigation of his friend Levett Hanson, who was chancellor of the order.[23]

Sashes
14. SASH OF THE ORDER OF THE BATH, red; length 38in, width 4in.

[23] J.C. Risk, 'The Order of St Joachim', *Journal of the Orders and Medals Research Society* (Winter 1973), 196–202; Minor Myers jnr., The "Polish Order" of 1783 identified', *Orders and Medals Research Society Miscellany of Honours* 3 (1981), 11–19.

15. SASH OF THE ORDER OF ST FERDINAND AND MERIT, blue moiré bordered with red largely faded to white; length 66in, width 4½in.

In neither case is the badge of the order attached to the ribbon. PBB

16. SWORD

Measurements unsheathed: length overall 35½in; blade 30in; width blade at base 1in.

The sword has a hilt of standard 'bead' or 'five-ball' pattern with guard and pommel of gilt brass, and reeded ivory grip. The straight stirrup guard is of ribbon section, terminates in a short lobe-shaped rear quillon, and is shaped in the centre to form five characteristic beads or balls, as is the single oval side-ring, which also frames a fouled anchor; at the top of the knuckle-guard is a loose ring for attaching a sword-knot. The 'cushion' pommel is of octagonal section, and the grip is encircled at the top, bottom and centre by gilt brass bands, the central one incorporating an oval cartouche on the outside, engraved with a fouled anchor. The tapering double-edged blade is of flattened hexagonal section at the forte, changing to flattened hollow diamond section until some twelve inches from the point, where it has been broken off and a rough welded iron strip substituted. Both faces of the forte are lightly etched with scrollwork involving, on one face, the crowned *G.R.* monogram, and, on the other, the full royal arms as used between 1714 and 1801. The etching would have been gilt originally.

The sword is fitted into a black leather scabbard with plain gilt brass mouth-locket, centre locket and chape, all engraved with horizontal lines. The mouth-locket has a cusped shield-shaped extension on the outer side, fitted with a stud for a belt-frog, and both it and the centre locket also carry suspension-rings.

Wrapped round the knuckle-guard and secured to the ring at its upper end, is a plaited blue silk and gold bullion sword-knot with a tassel embroidered with a fouled anchor.

Partly concealed under the coat of the figure is what appears to be a narrow black leather belt with a steel buckle[24] and, on the left, two vertical suspension straps ending in steel spring-hooks which engage with the corresponding rings on the scabbard of the sword.

This form of sword seems to have been introduced first into the Army, for infantry officers, as the result of an official order of 3 April 1786. Naval officers, however, soon adopted it, and it remained in use until their first truly regulation pattern sword was introduced in 1805.[25] The presence of the pre-1801 royal coat-of-arms on this sword indicates that it must date from between then and 1786. It could, therefore, very well have belonged to Nelson, though its roughly repaired broken blade perhaps suggests that it is more likely to be an old sword supplied from stock by a costumier. CB

CONSERVATION HISTORY

1934	Two fingers found to have been broken and restored.
1987	Fingers of left hand removed and redowelled, hands resecured with tapes; some right eyelashes replaced, some areas of lost polychrome tint on nose toned in (Plowden and Smith).
	Substitute shirt neck frill placed over old one; whitework removed and washed, outer clothes surface cleaned; hat conserved (private conservator).

24 But Tanner and Nevinson, who presumably examined it at close quarters, describe it (p. 202) as 'SWORD FROG. Metal covered with black leather, and two short leather straps, with steel split spring fasteners'.

25 See W.E. May and P.G.W. Annis, *Swords for Sea Service* (2 vols., London 1970) i, 30–3.

1990 Full conservation of figure and costume (Sheila Landi). Wax head and hands removed and replaced by Plowden and Smith. The figure stripped and the wood sanded down and sealed with a solution of Paraloid B72; right leg removed to ease handling during conservation work; torso padded and covered with white cotton; nylon stockings provided for arms and legs. Shirt and neck band washed and bleached; breeches and waistcoat dry-cleaned. Epaulettes and medals cleaned and lacquered; shoes cleaned and lace holes repaired. Shirt repaired and replaced on body before head put back; silk lining of waistcoat conserved by inserting a support of new silk. Stockings lined for repair with cotton stockinette; back seam re-stitched on figure to fit leg. Collar of coat lined with new silk following traces of original and lining of coat fronts supported and gold lace repaired. For re-dressing the braces were lengthened with tape and a sword belt manufactured from webbing. Wig brushed and curls set. SBL

APPENDIX
A GENERAL NOTE ON THE JEWELLERY

Shirley Bury

The ornaments are significant not only as artefacts but also because the effigies afford a provenance for them. This is particularly important because it has been impossible to examine the jewellery properly, as it is firmly attached to the figures. Happily during the 1930s, when the effigies were restored by the Victoria and Albert Museum, a few photographs were taken of the front and back of the major ornaments on the effigies of the Duchess of Richmond and Queen Mary II. Though the glass negative showing the reverse of the duchess's pieces was broken to destruction, a photograph printed from it was published in the *Illustrated London News* on 25 November 1933.

It is apparent nevertheless that the ornaments fall into two main categories. The first constitutes work which, though set with imitation stones, might have been worn in real life. Even in the upper reaches of society, there was no prejudice against paste, nor had there been for centuries. It was a useful supplement to the best-equipped jewel case, though it is probably going too far to assert that the paste jewels on the Duchess of Richmond's effigy had formerly been used by her. The effigy maker, Mrs Goldsmith, who dressed it in 1703 with the robes worn by the duchess at Queen Anne's coronation the previous year, did her best to adorn it with appropriate and fashionable ornaments, one of which relates stylistically to items of regalia in the Tower of London.

The second category of object might be called dressmaker's jewellery, exemplified by the individual collets set with pastes which were sewn onto velvet-covered cards to form the stomacher ornaments of Queen Anne and the Duchess of Buckingham.

The high quality of much of the paste under discussion was due to English innovations in the seventeenth century. Craftsmen from Venice, paramount in glassmaking since the early middle ages, were slowly disseminated throughout Europe. Their improved method of producing the traditional soda-lime (or alumina) silicate was widely used in England when a decree of 1615 prohibiting the employment of wood in glasshouse furnaces prompted a change in technology. The substitution of coal for wood required the glass to be made in closed instead of open pots to protect it from contamination by sulphurous fumes. Lead oxide was added to the flux to lower the melting-point. In about 1675 George Ravenscroft made changes to the basic Venetian recipe, using English flints and potash with a much higher level of lead oxide to produce colourless (or 'white') flint glass which was acclaimed for its lustrous qualities, enhanced by its amenableness to polish. Where colour was required, various metallic oxides were added in the traditional manner.

The glass or paste used in jewellery was shaped by cutters into at least approximate forms of fashionable gemstones. The table-cut, evolved from the natural octahedral of the diamond, its tip ground away, survived from the renaissance into the seventeenth century, as did the rose-cut, which often had a flat or flattish base and a convex top covered in triangular facets, usually 16 or 24, though the number might be varied. A newer cut, the brilliant or old mine cut, was an elaboration of the table-cut diamond. Above the girdle, the widest part, were facets tapering upwards to a flat table, while the faceted underside terminated in a tiny base facet, the culet. It

was certainly being used for some large diamonds in England during the closing years of the seventeenth century but as far as can be judged did not spread into paste until towards 1740, and then only partially. The true brilliant cut ranged from 58 to 64 facets exclusive of the table and culet, but the pastes on Queen Anne's effigy are not nearly as elaborate. The most popular cut for coloured pastes was the step or trap cut, characterised by a large flat table with or without the progressive side facets accorded to genuine stones, but some coloured pastes were cut as tables with vertical side facets or as roses.

The paste-cutters were skilled and valued members of the trade in the seventeenth and eighteenth centuries, for all their occasionally summary treatment of some cuts. They lost prestige in the nineteenth century. The pastes were individually shaped to fit into a cup-shaped metal collet lined with foil and the metal worked up round the paste to provide an airtight enclosure. This was the rub-over setting, the walls of which might be elaborated. It gave way in the eighteenth century to the cut-down setting, reinforced with ribs on the outside; its use permitted more of the stone to be exposed. The setters of pastes roughly conformed to these methods of mounting, also adopting a later development, using tiny claws which protrude from the collet to grip the paste. Change was slow: the lobed walls of medieval and renaissance settings survive on the rub-over collet holding the largest paste in the Duchess of Richmond's stomacher ornament, which dates to about 1700–3. The rest of the setting is more modern, the rub-over collets having scalloped bases. In the seventeenth century the closed backs of the settings, invariably convex, were enamelled, but towards 1700 some articles began to be decorated with engraving instead. By and large, the closed-back method of mounting pastes persisted into the nineteenth century, which relegates the unbacked settings of the Duchess of Buckingham's necklace, for instance, to the dark area of cheap costume, theatrical or dressmaker's trinkets.

The vogue for diamonds in the seventeenth and early eighteenth centuries is reflected in the predominance of white over coloured pastes in the effigies of the period. For a decade or so each side of 1730, when the rococo style predominated, polychromatic jewellery was in high favour. The stronger the hues the better. The effigy of Queen Elizabeth I, commissioned in 1760, is bedizened with bright blue, green and red pastes (perhaps also with yellow, now faded), set off by swags and clusters of artificial pearls.

The manufacture of imitation pearls was an established trade. The huge pearls decorating the costume of the Virgin Queen herself in the sixteenth century were reckoned by some to be false. Glass imitations were produced in Venice, while 'Roman' pearls made from alabaster beads dipped in a nacreous solution were popular. Paris was nevertheless preeminent for its adaptation of the Venetian technique. As Dr Martin Lister observed in *A Journey to Paris in the Year 1678*, some decades earlier a rosary maker named Jaquin had been granted a patent for an improvement which involved coating the insides of hollow glass globules with an essence containing the pounded scales of the *ablette* (bleak).[1] It was found that the best way of keeping the coating in position was then to fill the globules with wax. The technique was naturally copied in other countries. England had its practitioners in London and elsewhere. The nascent Birmingham trade took it up; a Bisset directory of Birmingham for 1800 lists one John Moore as a manufacturer of jewellery, gilt toys, wax and pearl beads, etc.[2] The technical skills of eighteenth century craftsmen went beyond the direct imitation of nature. The effigy of

[1] Martin Lister, *A Journey to Paris in the Year 1678* (London 1699), 142.

[2] *Bisset's Directory*, 1800, 54.

Elizabeth I is garnished not only with spherical pearls but with others of tubular form and, even more strikingly, large flattish oval drops with rounded edges. One might have transmigrated to the front of Mary II's coiffure.

It is conceivable that some paste articles were replaced in the course of restoration work by the Victoria and Albert Museum in the 1930s. A record photograph of the Duchess of Buckingham's effigy taken on arrival at the museum shows numerous pastes missing from the stomacher ornaments and an earring lost from the left ear. Possibly the ornaments had ben collected as they fell off and handed over to the museum. Unfortunately the museum files and the Chapter Office records are mute on this point. The ornaments are given scant mention, though on one occasion J.L. Nevinson reported to his senior colleague in the Department of Textiles on the progress made on Elizabeth I's effigy by 17 March 1934: 'the paste jewels were removed and cleaned in AWR . . . Sceptre part re-gilt.'[3] AWR (Art Work Rooms), the precursor of the museum's Conservation Department, was staffed by qualified craftsmen. The metal-workers would have been competent to undertake the setting of replacement pastes.

3 V and A, files 33/4576, 34/805.

GLOSSARY

Bizarre A term used to describe the extraordinary woven patterns of the years 1700–12, arising from the title of the book *Bizarre Designs in Silk*, by Vilhelm Slomann (Copenhagen 1953).

Cannellé In eighteenth century England known as 'tobine'. A weave with transverse ribs formed by warp floats and when the construction is not qualified by an adjective, the construction is an extended tabby repeating on two ends but with two or more picks in each shed. This is a much more limited use for the word than the English 'tobine'. Fundamentally a cannellé/tobine is a warp patterned material, the pattern made by an additional warp.

Cere-cloth Waxed linen used as an outer shroud prior to soldering-up the body within its anthropoid lead shell.

Chape The part of a buckle concealed in wear, consisting in the seventeenth to eighteenth centuries of stud or anchor (to go through 'buttonhole' on shoe) or, later, two spikes to attach to anchoring strap of shoe, with one or two spikes or tongues to fasten through the second strap.

Comber The repeat in a drawloom woven textile was determined by the comber board above the loom. 'Single comber' indicates that there is no repeat of the design in the width of the silk. Since the design took up the full width of 19–22 inches it allowed the designer considerable freedom – and it was also expensive to weave.

Filé and frisé In England these threads were known as 'plain' and 'frost'. Filé is made by winding a silver, silver-gilt or gold strip on a silk or linen core. Frisé is made by winding any of these threads on a core, one end of which is wound more tightly than the other, giving a crinkled effect. The metal thread thus sparkles.

Flesh The inner surface of a piece of leather originally next to the animal's body. Hence, flesh out – shoe made up with the flesh side on the outside.

Galloon A heavy woven braid. The term is often used for those edging tapestries.

Grain The outer surface of a piece of leather originally bearing the hair, fur, wool etc. Hence, grain out – shoe made up with the grain on the outside.

Gros de Tours A heavy tabby, defined as having two picks (or wefts) in each shed.

Heel breast The front surface of the heel.

Lampas A patterned textile with weft floats bound by a binding warp and a main weft. There are thus two warp and two weft systems. The ground may be tabby, twill, satin etc. and the wefts pattern (going right across the textile) or brocaded (only used for the width of the motif). There were many variations throughout the seventeenth and eighteenth centuries.

Lift A layer of leather used in heels.

Louis heel The front surface of the heel (the breast) is covered by a downwards extension of the sole to the top piece.

Quarters The sides of a shoe upper, joining onto the vamp at the front, and each other at the back of the foot. One piece quarters are cut in one piece, avoiding a back seam.

Rand A narrow strip of leather stitched in the upper/bottom seam, for strengthening. In sixteenth to early nineteenth century shoes, it may be used folded, or more generally extended and folded over, with a second row of stitches through the edge to attach the sole.

Satin of 8 (or 5) The points of binding are set over in a satin weave so that they never touch, giving a smooth glossy surface very suitable for silks and, indeed, table linen. The weave repeats upon 5 warp ends until the early eighteenth century when 8 becomes more usual. There is no fixed date when this happens.

Selvage The warp threads at the edges of a woven textile which are often a little thicker or stronger than those of the rest of the textile. They must be to preserve the tension during and after weaving. In many European silk industries there were regulations about quality. Silks of a certain quality were supposed to have coloured or other special threads. They seldom did after the middle ages and never in England.

Straights Symmetrical shoes/soles, not shaped left and right, to be worn on either foot.

Top piece The bottom lift of the heel, which rests on the ground. Called top piece as shoes are made sole up.

Turnshoe The shoe is made inside out by sewing the lasting margin of the upper to the edge of a single sole, and then turned right way out.

Vamp The front section of an upper, covering the toes and part of the instep.

NR, JS

BIBLIOGRAPHY AND ABBREVIATIONS

Aubrey	John Aubrey, *Brief Lives*, ed. A. Powell (London 1949).
Binski, *Westminster*	Paul Binski, *Westminster Abbey and the Plantagenets: Kingship and the Representation of Power, 1200–1400* (Yale 1995).
Binski, *Death*	Paul Binski, *Medieval Death: Ritual and Representation* (London 1996).
BL	London, British Library.
Camille, M., *The Gothic Idol. Ideology and Image-Making in Medieval Art* (Cambridge 1989).	
Complete Peerage	G.E. Cokayne, Vicary Gibbs, H.A. Doubleday, Duncan Warrand and Lord Howard de Walden, *The Complete Peerage* (12 vols., London 1910–59).
Crull	Jodocus Crull, *The Antiquities of St Peter's or the Abbey Church of Westminster* (London 1711).
Dart	John Dart, *Westmonasterium, or the History and Antiquities of the Abbey Church of St Peters Westminster* (London 1723).
De Saussure	Mme Van Muyden (ed. and trans.), *A Foreign View of England in the Reigns of George I and George II: the Letters of M. César de Saussure to his Family* (London 1902).
DNB	*Dictionary of National Biography* (31 vols., Oxford 1908–).
Evans	Joan Evans, *A History of Jewellery, 1100–1870* (2nd ed., London 1970).
Evelyn	E.S. de Beer (ed.), *The Diary of John Evelyn* (6 vols., Oxford 1955).
Freedberg	David Freedberg, *The Power of Images* (Chicago 1989).
Fritz	P.S. Fritz, 'From "Public" to "Private": the royal funerals in England, 1500–1830', in J. Whaley (ed.), *Mirrors of Mortality: Studies in the Social History of Death* (London 1981), 61–79.
Ginzburg, C., 'Représentation: le mot, l'idée, la chose', *Annales* 46 (1991), 1219–34.	
Gunnis	Rupert Gunnis, *Dictionary of British Sculptors, 1660–1851* (London n.d.).
Historical Account 1755 (etc.)	*An Historical Account of the Curiosities of London and Westminster* (London, for J. Newbery, 1755).
	———— (London, for T. Carnan, 1782).
Historical Description 1754 (etc.)	*An Historical Description of Westminster Abbey, its Monuments and Curiosities* (London, for J. Newbery, 1754).
	———— (London, for J. Newbery, 1767).
	———— (London, for T. Carnan and J. Newbery, 1770).
	———— (London, for A.K. Newman and Co., 1827).
	———— (London, for A.K. Newman and Co., 1836).
HKW	H.M. Colvin (ed.), *History of the King's Works* (London, in progress).
Hope	W.H. St John Hope, 'On the funeral effigies of the Kings and Queens of England', with a 'Note on the Westminster tradition of identification' by Joseph Armitage Robinson, *Archaeologia* 60 (1907), 517–70.
Howgrave-Graham, 'New Light'	R.P. Howgrave-Graham, 'The earlier royal funeral effigies: new light on portraiture in Westminster Abbey', *Archaeologia* 98 (1961), 159–69.
Howgrave-Graham, 'Royal portraits'	R.P. Howgrave-Graham, 'Royal portraits in effigy: some new discoveries in Westminster Abbey', *Journal of the Royal Society of Arts* (29 May 1953), 465–74.
Keepe	Henry Keepe, *Monumenta Westmonasteriensia, or an Historical Account of the original, Increase, and Present State of St Peter's, or the Abby Church of Westminster* (London 1683).

Litten J.W.S. Litten, *The English Way of Death: the Common Funeral since 1450* (London 1991)

Lindley, 'Absolutism' P. Lindley, 'Absolutism and Regal Image in Ricardian Sculpture', in D. Gordon, L. Monnas and C. Elam (eds.), *The Regal Image of Richard II and the Wilton Diptych* (London 1997), 56–83.

Llewellyn, 'Royal body' N. Llewellyn, 'The royal body: monuments to the dead, for the living', in L. Gent and A. Llewellyn (eds.), *Renaissance Bodies* (London 1990), 218–40.

May, W.E. and Annis, P.G.W., *Swords for Sea Service* (2 vols., London 1970).

Millar O. Millar, *The Tudor, Stuart and Early Georgian Pictures in the Collection of her Majesty the Queen* (London 1963).

Neale and Brayley J.P. Neale and E.W. Brayley, *The History and Antiquities of the Abbey Church of St Peter, Westminster* (2 vols., London 1818).

Nichols, J.G., *The Diary of Henry Machyn* (Camden Society, London 1848).

Pepys Robert Latham and William Matthews (eds.), *The Diary of Samuel Pepys* (11 vols., London 1970–83).

Piper, *Catalogue* D. Piper, *Catalogue of Seventeenth Century Portraits in the National Portrait Gallery 1625–1714* (Cambridge 1963).

PRO Public Record Office, London.

Robinson, see Hope.

Sandford Francis Sandford, *A Genealogical History of the Kings and Queens of England and Monarchs of Great Britain* (London 1707).

Silk Designs *Silk Designs of the Eighteenth Century in the Collection of the Victoria and Albert Museum* (London 1990).

Smith, *Nollekens* J.T. Smith, *Nollekens and His Times* (London 1949).

Stanley A.P. Stanley, *Historical Memorials of Westminster Abbey* (5th edn, London 1882).

Stone Lawrence Stone, *Sculpture in Britain. The Middle Ages* (2nd edn, Harmondsworth 1972).

T and N L.E. Tanner and J.L. Nevinson, 'On some later funeral effigies in Westminster Abbey', *Archaeologia* 85 (1936), 169–202. Contributions from this article have been edited by RM, in some cases with assistance from JA.

Thornton, Peter, *Baroque and Rococo Silks* (London 1965).

V and A Victoria and Albert Museum, London.

Vertue *Vertue's Note Books* (Walpole Society 18, 1930).

A View Henry Roberts, *A View of the Wax Work Figures in King Henry the 7th's Chapel* (London 1769).

Walpole, *Letters* Peter Cunningham (ed.), *The Letters of Horace Walpole* (9 vols., London 1857–9).

WAM Westminster Abbey Muniments.

Whinney Margaret Whinney, *Sculpture in Britain 1530–1830* (2nd edn, Harmondsworth 1988).

Wilson, *Westminster* Christopher Wilson, Pamela Tudor-Craig, John Physick and Richard Gem, *Westminster Abbey* (New Bell's Cathedral Guide, London 1986).

Young, R., 'Medieval and Modern English royal burial reconsidered', *Journal of Medieval Archaeology* 5/6 (1995/6), 155–74.

INDEX

The numbers refer to pages, followed by colour and black-and-white plates.